ILLUMINATING
THE END OF TIME
The Getty Apocalypse Manuscript

ILLUMINATING
THE END OF TIME

The Getty Apocalypse Manuscript

FACSIMILE EDITION
WITH A COMMENTARY BY

Nigel J. Morgan

The J. Paul Getty Museum | Los Angeles

Getty Museum Monographs on Illuminated Manuscripts
Elizabeth Morrison, General Editor

Published in the United States of America in 2012 by
the J. Paul Getty Museum, Los Angeles

Getty Publications
1200 Getty Center Drive, Suite 500
Los Angeles, California 90049-1682
www.gettypublications.org

This volume is based on a manuscript in the collections of
the J. Paul Getty Museum (MS Ludwig III 1), formerly
known as the *Dyson Perrins Apocalypse*

Designed and produced for Getty Publications
by The Folio Society Ltd, London, United Kingdom

Library of Congress Cataloging-in-Publication Data
Illuminating the end of time: the Getty Apocalypse / WITH A
COMMENTARY BY Nigel J. Morgan. – FACSIMILE EDITION.
 88 pages 22.5 x 31.9cm
 English commentary and translations.
 Includes bibliographical references and index.
 ISBN 978-1-60606-071-1 (hardcover)
1. Bible. Revelation–Illustrations. 2. Getty Apocalypse. 3. Manuscripts,
Latin (Medieval and modern)–California–Los Angeles–Facsimiles.
4. Illumination of books and manuscripts, English. 5. Illumination of
books and manuscripts, Gothic–England. 6. J. Paul Getty Museum.
I. Morgan, Nigel (Nigel J.), 1942 – writer of added commentary.
 ND3361.R52D954 2012
 745.6'70942–DC22

 2010052165

Printed in the United Kingdom

CONTENTS

ILLUSTRATIONS

Pages from Apocalypse, British Library Add. 35166. (© *The British Library Board. 2011*)

The Getty Apocalypse Manuscript Credits:
Photography by Rebecca Vera-Martinez
Color correction by Johana Herrera and Michael Smith
Manuscript handling by Ron Stroud, Lynne Kaneshiro, and Christine Sciacca

History and Context of Illustrated Apocalypses
in Thirteenth-Century England

THE FINAL BOOK of the New Testament canon, the Apocalypse of John, is part of a visionary and prophetic genre which was characteristic of both Jewish and Christian writings of the first century A D. The Greek word 'apocalipsis' means 'revelation' or 'unveiling' and such texts aim to reveal things that are hidden and also to present prophecies of future events. The date of composition of this 'revelation' of John is controversial, as is the identity of its author, who gives his name simply as John, and the dating ranges from c.65–95.[1] In the Middle Ages the author of the book was beyond dispute considered to be the same as the 'beloved disciple' of Christ, the author of the fourth Gospel. It was also considered at that time to have been written certainly during the reign of the Emperor Domitian (81–96), who supposedly exiled John to the island of Patmos where he experienced his visions. The 'revelation' of John is presented in a prophetic and eschatological framework ending with the judgement and the appearance of the New Jerusalem. It is written in highly allegorical language in which a conflict between good and evil, between God and the Devil, is presented as a series of visions, some of them in series of sevens, each introduced to John by an angel. The powers of good, God, Christ, the Woman in the Sun, the angels and the righteous of the Church, are opposed by the Devil, who is the Dragon, the Antichrist, the Beast, the False Prophet, the Great Harlot, and the unbelievers in Christ who persecute and malign the Church.

The separation of the Apocalypse of John as an individual book apart from the New Testament as a whole very likely resulted from the frequent interest in exegesis of its text, whose complex language and difficult imagery particularly necessitated explanation. Jerome's *Epistola ad Paulinum*, which later came to be used as a prologue to the Vulgate, points to the particular importance given to the book in the early centuries of the Church, an importance which would continue throughout the Middle Ages, saying: 'The Revelation of John contains as many mysteries as words. I have said too little, and indeed all praise is insufficient in proportion to the merit of the book: in each of its words are concealed many meanings.'[2]

There had been a tradition of Apocalypse illustration in the Early Middle Ages, above all in Spain. From the late ninth century until the first half of the thirteenth century there is a continuous series of illustrated Spanish Apocalypses with the commentary of the eighth-century Benedictine monk Beatus of Liébana.[3] There was probably at an even earlier date in England, before the Spanish examples were created, an illustrated Apocalypse made c.700 in Northumbria, known through two derivatives of the ninth century (Valenciennes, Bibliothèque municipale MS 99, of c.800–25; Paris, BnF MS nouv. acq. lat. 1132, of c.875–900) perhaps made in North-East France.[4] The English theologian and chronicler Bede, in the early eighth century, had written a commentary on the Apocalypse, introducing the highly influential division of the text into seven visions.[5] Bede, in his *Historia abbatum*, records that Benedict Biscop, Abbot of Monkwearmouth, had c.675 brought back from Rome pictures of the Revelation of St John, which were placed on the north wall of his church. No followers of this early illustrated Northumbrian Apocalypse exist from England, and when Apocalypse illustration begins there in the mid-thirteenth century it seems to be completely independent of this Early Medieval tradition deriving from the c.700 Northumbrian manuscript. The Carolingian Apocalypses, Trier, Stadtbibliothek MS 31, of c.800–25, Cambrai, Bibliothèque municipale MS 386, of c.900–50, and the Ottonian Bamberg Apocalypse, Bamberg, Staatsbibliothek MS Bibl. 140, represent other early versions illustrating the text.[6]

At certain times in the history of the Church these illustrated Apocalypses became popular. These often coincide with periods when there were predictions of the ending of the world with the coming of the Antichrist. Although only mentioned four times in the Bible, in the first and second epistles of John, from the early days of the Church there had been extra-biblical references to him, particularly in commentaries on the Apocalypse.[7] A good example of such a time, of particular relevance to the Getty Apocalypse, would be the middle years of the thirteenth

[1] Prigent 2001, 36–9, 68–84, gives the most recent assessment of the authorship and dating issues.

[2] 'Apocalypsis Iohannis tot habet sacramenta quot uerba; parum dixi (parum dictum est), et pro merito uoluminis laus omnis inferior est: in uerbis singulis multiplices latent intelligentiae': Berger 1904, 69, no. 311. This excerpt from Jerome was frequently placed at the beginning of the Apocalypse text and is used in some of the English thirteenth-century Apocalypses, such as the Lambeth Apocalypse (London, Lambeth Palace MS 209): Morgan and Brown 1990, 127.

[3] Williams 1994–2003. A fragment in Silos, Bibl. Monasterio de Santo Domingo, MS frag. 4, can perhaps be dated to the closing years of the ninth century, suggesting the earliest example may date from before 900.

[4] Klein 1979, 138–40, and Klein 1992, 177–8. Klein's articles as a whole provide the best survey of Apocalypse illustration in medieval Europe. For specific discussion of these two manuscripts as part of an Early Medieval English tradition see Alexander 1978, 82–3, no. 64. A facsimile of the Valenciennes Apocalypse is forthcoming in 2011 with a commentary by Peter Klein.

[5] Lobrichon 1986, 77–81.

[6] On these see Omont 1922, Klein and Laufner 1975 and Harnischfeger 1981. A reduced-size version of Klein and Laufner 1975 with an abbreviated commentary is available as Klein 2001. The Trier Apocalypse probably derives from an illustrated Apocalypse of the fourth or fifth century.

[7] The biblical references are: I John 2 vv. 18, 22; I John 4 v. 3; II John v. 7. On the Antichrist in writings and art of the Middle Ages see: Poesch 1966, Emmerson 1981, Poesch 1981, Wright 1995, Lewis 1997 and McGinn 2000b.

century. The Calabrian abbot, Joachim of Fiore, had predicted the end of the world in 1260, and certain events in the preceding years had given rise to the belief that there might be some truth in this prediction. In 1241 the Tartar tribes had invaded eastern Europe, and were identified with Gog and Magog in the text of chapter 20 of the Apocalypse, which tells that the Dragon, who is Satan, 'will be let loose from his prison, and he will come out and will deceive the people who are at the four corners of the earth, Gog and Magog, and he will gather them together for battle'. In Ezekiel chapter 38, verses 15–16, Gog and Magog are described as coming 'in the latter days' and 'riding on horses'. The persecutions of the Franciscans by the Emperor Frederick II in the 1230s and 1240s led him to be described as the Antichrist or the Beast who rose from the sea.[8] In 1239 he was excommunicated by Pope Innocent IV, and deposed by him in 1245. Such signs of the end of the world at that time might have led to a fashion for illustrated Apocalypses beginning in England in the 1240s.[9] Although, some twenty years earlier, in the illustrated Bibles made for the French royal family, the *Bibles moralisées*, there was a precursor which might have influenced this fashion in England.

The Apocalypse in the *Bibles Moralisées*

In the thirteenth century the earliest fully illustrated Apocalypse, save for two late examples of the Spanish Beatus Apocalypse tradition produced in the first third of the century, is that found in the first copies of these *Bibles moralisées*.[10] These are picture-books with illustrations of extracts from the biblical text, together with a short theological commentary on those passages of text, which also receives an illustration. The commentary text in the Apocalypse part of these *Bibles moralisées*, as short extracts set beside the pictures, was extracted from a then-recent Latin commentary of the first quarter of the thirteenth century which does not survive in its complete text, but was possibly of Franciscan authorship.[11] The earliest *Bible moralisée* copies were produced c.1220–30, either at the very end of the reign of Louis VIII (d. 1226), or early in that of his son Louis IX, perhaps involving the patronage of Blanche of Castile, mother of the young king and in effect regent during his minority.[12] A copy of the *Bible moralisée* was in England in the middle years of the thirteenth century, and it has been

argued that it may have belonged to Henry III and his queen, Eleanor of Provence, perhaps a gift from the king of France when the English royal family spent the Christmas of 1254 as his guests.[13] This *Bible moralisée* may have had some influence on the creation of a similar book in England in the middle years of the thirteenth century, but restricted to the Apocalypse, and in a format quite different from that of the *Bible moralisée*. Most of these English Apocalypses accompany the text with short passages of theological commentary, which is a similar arrangement to that in the *Bibles moralisées*. But while many of the themes of the English commentaries parallel those in the French Bibles, the commentaries themselves are mostly completely different. If there has to be a catalyst for the production of these Apocalypse manuscripts with accompanying commentary in England, that can be considered to be awareness or direct influence of the *Bible moralisée*. There are, however, additional reasons in regard to historical context and possible patrons, which may have led to their production.

Illustrated English Apocalypses c.1240–90

In England in the middle years of the thirteenth century illustrated Apocalypses were made with texts and commentaries in both Latin and the vernacular Anglo-Norman, the language read and spoken by the upper classes. The majority are in Latin with the selected passages from the commentary of Berengaudus, a man about whom virtually nothing is known and whose writings have been given dates ranging from the ninth to the eleventh century. The most convincing suggestions for the dating of his work are by the French scholar Guy Lobrichon, suggesting that he was writing in the second half of the eleventh century.[14] In rare cases the artists of these Apocalypses modified their iconography to take notice of some point made in the commentary.[15] The most famous with Latin texts and the Berengaudus commentary are the Metz (Metz, Bibliothèque municipale MS Salis 38 – destroyed in World War II),

[8] McGinn 1979, 168–79.

[9] The particular situation in England at that time is discussed by Morgan in McKitterick, Morgan, Short and Webber 2005, 9–17.

[10] These Spanish manuscripts are the Las Huelgas (1220) and Arroyo (c.1220–35) Apocalypses. On these see Williams 2003, nos 24, 25.

[11] Guest 1995, 21–4, on the sources of the commentary texts of the *Bibles moralisées*, and Stork 1996, 39–42, for the suggestion (p. 41) of the dependence on 'an as yet undiscovered Latin Apocalypse commentary from the beginning of the 13th century'. For part transcriptions of the *Bible moralisée* Apocalypse commentaries of Vienna, Österreichische Nationalbibliothek MS 1179 and New York, Pierpont Morgan Library MS M. 240 see Bradley 1906, 18–30, and Breder 1960, 16–54.

[12] On these books see Lowden 2000, I, 55–187. The three thirteenth-century examples containing the Apocalypse are Vienna, Österreichische Nationalbibliothek MS 1179 (c.1225); Toledo, Cathedral Treasury, of which part is

New York, Pierpont Morgan Library MS M. 240 (c.1230); London, BL MS Harley 1527 (c.1240). On their Apocalypse illustrations see Christe 1997 and Lowden 2004.

[13] Stirnemann 1998 and Lowden 2000, I, 185–6, 216; II, x, 202, the latter suggesting that it was a gift of Louis IX to Henry III at the time of Henry's visit to Paris for Christmas 1254.

[14] It has been convincingly argued that Berengaudus' commentary is of a character suggesting a late eleventh-century contemporary of Anselm of Laon, and that it was written in East France, South-East Belgium, or even possibly England: Lobrichon 1984, 109, and Lobrichon 2003, 125 n. 58, 193 n. 36. Visser 1996, 2–10, 87–103, argues for the more traditional, but no longer acceptable, identification with the ninth-century Berengaudus of Ferrières. To the best of my knowledge no extant manuscript of his commentary antedates the second half of the eleventh century. On an early manuscript belonging to the Benedictine Abbey of St Benet Hulme, which contains an author portrait of Berengaudus, see Michael 1984. Many copies of the text are recorded in English medieval libraries. On these see McKitterick, Morgan, Short and Webber 2004, 5–6, 19 nn. 18, 19.

[15] Lewis 1991 and Lewis 1992a. It is noteworthy how different in interpretation the various commentaries on the Apocalypse are. A recent study, Gumerlock 2009, has compared the interpretations of the Seven Seals over a series of commentaries, and it is astonishing how diverse they are.

Getty (Los Angeles, J. Paul Getty Museum MS Ludwig III 1), Lambeth (London, Lambeth Palace MS 209), Gulbenkian (Lisbon, Museu Calouste Gulbenkian MS LA 139), and Douce (Oxford, Bodleian Library MS Douce 180) Apocalypses.[16] The Trinity Apocalypse (Cambridge, Trinity College MS R. 16.2) has both the biblical text and the commentary of Berengaudus in Anglo-Norman translation.[17] The other mid-thirteenth-century example in Anglo-Norman, the Paris Apocalypse (Paris, BnF MS fr. 403), has a different commentary which may derive from the Latin commentary found in the *Bibles moralisées* or the source of it.[18] The format for all those English Apocalypses mentioned, excepting Trinity, is a rectangular miniature set above a two-column or single-column text, with the text and commentary passage directly relevant to the picture on that page. Trinity places framed miniatures of varying size at various positions within the text, preceding the Apocalypse text passage and commentary to which they relate. There are two other English Apocalypses of the same period, which are picture-books with abbreviated passages of text in Latin on scrolls and placards within the pictures (New York, Pierpont Morgan Library MS M. 524 (fig. 24); Oxford, Bodleian Library MS Auct. D. 4.17).[19] It is possible that these reflect most closely the archetype of English illustrated Apocalypses, which may have been a picture-book, although this is debatable. Two other very simple picture-books, without any commentary texts, only having short captions in Anglo-Norman, were also produced in England at the same time: London, Lambeth Palace MS 434 and Eton, College Library MS 177.[20]

All these illustrated Apocalypses were produced in the third quarter of the thirteenth century and they contain different series of pictures, Apocalypse text extracts and commentary extracts, although some are almost identical in some or all of these aspects. In 1901 the French scholars Léopold Delisle and Paul Meyer laid the groundwork in an exhaustive account of both illustrated and unillustrated Latin and French Apocalypses resulting from their edition of Paris, BnF fr. 403 which has a vernacular text in Anglo-Norman.[21] It was an unfortunate consequence of their exhaustive fundamental publication that the Paris Apocalypse assumed the status of an archetype in thirteenth-century English Apocalypse illustration, whereas subsequent research has shown it to be a somewhat 'dysfunctional' manuscript in regard to the idiosyncratic relationship between its illustrations and its text.[22] First, in 1909, in his commentary to the facsimile edition of the Trinity Apocalypse,[23] another highly idiosyncratic manuscript in the vernacular Anglo-Norman, the great English manuscript scholar M. R. James carried the work of Delisle and Meyer further in grouping the various manuscripts and defining special iconographic characteristics of the various groups, but with an emphasis on the iconography of its illustrations rather than on text contents. His interest was mainly in the English illustrated copies of the thirteenth and fourteenth centuries, and in two further facsimile commentaries on the Douce and Getty (then called Dyson Perrins) Apocalypses he developed these theories further.[24] Although James made a great contribution to an understanding of these books, his arguments for dating and places of production have subsequently been shown often to be in error. One of the earliest of the English Apocalypses, the Metz Apocalypse, he considered to have been produced in France, and in consequence never studied it in detail.[25] As it is one of the earliest of these Apocalypses to be made, and fundamental to an understanding of their development, this was particularly unfortunate. M. R. James also divided the English thirteenth-century Apocalypses into two basic groups, which he considered to have been products of the two Benedictine abbeys of St Albans and Canterbury, St Augustine's.[26] Those in tinted drawing he considered to be produced at St Albans, and those with full painting and gilding he considered to be Canterbury products. Although James's somewhat simplistic theories have been disproved in the work of Robert Freyhan, George Henderson, Jessie Poesch, Peter Klein, Suzanne Lewis and the present author, even today his errors are sometimes repeated.[27] Of these authors, Henderson elucidated stylistic differences between the manuscripts, and Poesch, Klein and Lewis clarified iconographic groupings and interrelationships. These last three presented much more convincing discussions of the iconography than Henderson, whose fundamental contribution was above all in his subtle understanding of issues of dating and style.[28] Klein, in particular, made it clear that there are several 'missing links' of lost copies which, had they survived, would have made the interrelationship between text contents and iconography easier to understand. The issue as to

[16] On these see Morgan 1988a, nos 108, 124, 126, 128, 153. For facsimiles of Lambeth and Gulbenkian see Morgan and Brown 1990; Morgan, Lewis, Brown and Nascimento 2002.

[17] McKitterick, Morgan, Short and Webber 2005.

[18] Otaka and Fukui 1981; Morgan 1988a, no. 103. The contents and themes of this commentary are well characterised by Fox 1912.

[19] On these see Morgan 1988a, nos 122, 131. The Bodleian copy is published in facsimile in Coxe 1876.

[20] On these see Morgan 1988a, nos 97, 137.

[21] Delisle and Meyer 1900–1.

[22] The complicated relationship of its text and pictures has been brilliantly elucidated in Lewis 1990. The 'dysfunctionality' is best expressed in her

words: 'Its vernacular glossed text represents a disruptive intrusion into the sequence of text images established for the Morgan (Apocalypse) cycle by a Latin text based on a different commentary.' Although the scribe, artist and designer had a lot of problems caused by this situation, they were remarkably successful in trying with much ingenuity to provide the best compromises in the text–picture relationships.

[23] James 1909. For reassessments of James's views see Morgan 1988a, no. 110, and Morgan and Brown 1990, 23–4, 52, 80, 89.

[24] James 1922 and James 1927.

[25] Certain leaves were missing from the Metz Apocalypse, but the iconography of all its pictures can be reconstructed from the *c*.1260–7 copy, the Lambeth Apocalypse, and a late fifteenth-century German copy of it, Düsseldorf, Kunstakademie A.B. 143. The latter is discussed in Haussherr 1978, reconstructing the original set of pictures in Metz.

[26] James 1909, 25–6.

[27] Freyhan 1955; Henderson 1967, 1968; Poesch 1966; Klein 1983; Lewis 1990, 1991, 1992a, 1995; Morgan 1988a; Morgan and Brown 1990; Morgan, Lewis, Brown and Nascimento 2002.

[28] This judgement should be qualified by crediting Henderson with having proposed considerably more sophisticated iconographic relationships than James.

where these Apocalypses were made is still a problem after over a hundred years of research. It can now be said that almost certainly they were not made either at St Albans or Canterbury, as M. R. James had proposed, and it is highly likely that some were made in London, although firm proof is lacking. Some might have been intended for members of the royal family, and the fact that their main residences were at Westminster Palace, Windsor Castle, Winchester Castle and Clarendon Palace near Salisbury might suggest commissioning of books at Winchester or Salisbury as well as in London.[29] The other well-documented centre of illuminated book production in mid-thirteenth-century England is Oxford, in the work of W. de Brailes and his followers, but none of the Apocalypses show either figure style or ornament characteristic of Oxford manuscripts. The majority of these illustrated Apocalypses seem to have been made for people outside the royal circle, and there is no evidence whatsoever to associate them with a type of book made predominantly for the royal family as the *Bibles moralisées* were in France. Although refinements of dating and iconographic analysis doubtless will still be made in future research, the following grouping of the manuscripts and approximate datings can be presented with some confidence.

A. *Morgan–Bodleian–Paris group*:

Paris, Bibliothèque nationale de France MS fr. 403	c.1250–5
(*The Paris Apocalypse*)	
New York, Pierpont Morgan Library MS M. 524	c.1255
(*The Morgan Apocalypse*)	
Oxford, Bodleian Library MS Auct. D. 4.17	c.1260
(*The Bodleian Apocalypse*)	

B. *Metz–Lambeth group*:

Metz, Bibliothèque municipale MS Salis 38 (destr. 1944)	c.1250–5
(*The Metz Apocalypse*)	
Oxford, Bodleian Library Tanner MS 184	c.1255
(*The Tanner Apocalypse*)	
Cambrai, Bibliothèque municipale MS 422	c.1260
(*The Cambrai Apocalypse*)	
London, Lambeth Palace Library MS 209	c.1260–7
(*The Lambeth Apocalypse*)	
Lisbon, Museu Gulbenkian MS L.A. 139	c.1265–70
(*The Gulbenkian Apocalypse*)	
London, British Library Add. MS 42555	c.1270
(*The Abingdon Apocalypse*)	

C. *Westminster group*:

Los Angeles, J. Paul Getty Museum MS Ludwig III 1	
(*The Getty (or Dyson Perrins) Apocalypse*)	**c.1255–60**
London, British Library Add. MS 35166	c.1255–60
Oxford, Bodleian Library MS Douce 180	c.1265–70
(*The Douce Apocalypse*)	
Paris, Bibliothèque nationale de France MS lat. 10474	c.1265–70

D. *Eton–Lambeth group*:

London, Lambeth Palace Library MS 434	c.1250–60
Eton, College Library MS 177	c.1260–70
(*The Eton Apocalypse*)	

In addition to those listed there is one famous isolated manuscript of c.1255–60 with iconography not directly related to any of the groups, the Trinity Apocalypse (Cambridge, Trinity College MS R. 16.2).[30] Although in the above list the manuscripts have been put in chronological order, this does not imply that the later manuscripts in each group are necessarily derivative of the earlier ones. Group A, the Morgan–Bodleian–Paris group, is a good example of this. The earliest surviving member, the Paris Apocalypse, presents an extensive reinterpretation of a manuscript containing very similar pictures to those in the Morgan and Bodleian Apocalypses, which are considered to be the closest to the archetype of English thirteenth-century Apocalypse illustration. This archetype, perhaps produced in the 1240s, has been lost, and may have been a picture-book like the Morgan and Bodleian Apocalypses, with captions containing Apocalypse and commentary text set within the pictures.[31] In the following chapter a similar situation will be discussed for the manuscripts of the Westminster group, of which the Getty Apocalypse is a member. Peter Klein elucidated the interrelationships of these Apocalypse manuscripts in a diagram, proposing lost copies which clarify the interrelationships. A slightly modified version of his schema is presented opposite.

It is now apparent that the production of illustrated Apocalypses in England from the 1240s until c.1270 was a very complicated process in which the artists and scribes must have been to a large degree directed by a clerical adviser with theological expertise who stipulated text contents and advised on the iconography of the pictures. Although some of these manuscripts are almost identical in the arrangement of text passages from the Apocalypse and selected passages from the commentary of Berengaudus, most of them differ to a large degree in the passages of these texts used on each page. Similarly, although a few have almost identical iconography for their pictures, others have many significant differences. Thus in the Morgan and Bodleian Apocalypses as one case, and the Metz, Lambeth and Gulbenkian as another, text content and iconography are almost the same in all the books. As each new Apocalypse was made, the clerical adviser must in some cases have initiated a process of editing and revision of text and pictures, and this would inevitably have involved collaboration with the artists.

<center>✳</center>

29 Although royal commissioning of works of art in the palaces is well documented, the documentation on the ordering of books is almost entirely lacking. On the painting in the royal palaces see: Borenius 1943; Tristram 1950, 86–115, 178–87, 208–19, 235–9, 528–9, 566–77, 610–11, 622–3; Binski 1986.

30 Brieger 1967, Otaka and Fukui 1977, and McKitterick, Morgan, Short and Webber 2005 for the most recent study.

31 It is not completely out of the question that it was a manuscript with rectangular pictures set at the top of text passages of the Apocalypse and selected passages of the Berengaudus commentary. Lewis 1990, 33 agrees with this in saying, 'The Morgan prototype itself was very probably based on a half-page picture cycle, created for a Latin Berengaudus-glossed text resembling those in Metz and Ludwig III. 1 (i.e. Getty).' For this reason, departing from Peter Klein's diagram, I have distinguished in the following schema the archetype from the Morgan–Bodleian–Paris prototype. An American doctoral thesis, Fisher 1984, with some good reasoning, questioned that the Apocalypse, Paris, BnF fr. 403, derived from a picture-book like Morgan.

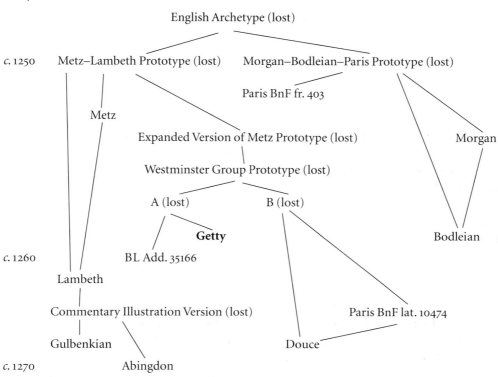

c. 1240

English Archetype (lost)

c. 1250 Metz–Lambeth Prototype (lost) Morgan–Bodleian–Paris Prototype (lost)

Paris BnF fr. 403

Metz

Expanded Version of Metz Prototype (lost) Morgan

Westminster Group Prototype (lost)

A (lost) B (lost)

Getty Bodleian

c. 1260 BL Add. 35166

Lambeth

Commentary Illustration Version (lost) Paris BnF lat. 10474

Gulbenkian Douce

c. 1270 Abingdon

(Schema adapted from Klein 1983 with omission of the Trinity Apocalypse)

By the fourth quarter of the thirteenth century there seems to be a falling-off in popularity of illustrated Apocalypses in England, although two in Anglo-Norman were made c.1270–90, London, Lambeth Palace MS 75, and Paris, BnF MS fr. 9574.[32] Their text and commentary is almost identical to the Paris Apocalypse (BnF fr. 403) but their illustrations, of a rather simplified schematic sort, are completely different from those in that manuscript. The reason for the falling-off in popularity of this type of book might be because the mid-century interest in prophecies of the end of the world had waned, Joachim of Fiore's prediction of the end in the year 1260 not having materialised in any cataclysmic event. However, during the first half of the fourteenth century many English copies were made, almost all of them being in the vernacular of Anglo-Norman.[33] This predominance of vernacular copies implies that the majority were made for lay men and women, although some were made for the religious, who doubtless preferred to read in Anglo-Norman rather than Latin.[34]

Although up to the early thirteenth century Spain had been the country most productive in illuminated Apocalypses, in the thirteenth and fourteenth centuries it is from England that the greatest number of surviving copies have come down to us. In the highly creative period from around 1250 to 1270, in which the Getty Apocalypse was made, a new phase of Apocalypse illustration was initiated, and from the late thirteenth century onwards spread beyond England to France and Flanders, where many illustrated Apocalypses derived from English thirteenth-century models.[35] Indeed, as will be discussed in the next chapter, the Getty Apocalypse itself, or a manuscript almost identical to it, was copied twice in Savoy, once in the second half of the fourteenth century and again in the second quarter of the fifteenth century (figs 3–8).

[32] For a French fourteenth-century copy almost identical to these two (London, BL MS Yates Thompson 10) see the facsimile with commentary by Morgan, Kidd and Burrows 2010.

[33] There are two notable exceptions of Latin copies made for monastic patrons: Cambridge, Magdalene College MS 5 and Oxford, Bodleian Library MS Canonici Bibl. lat. 62. On these see Sandler 1974, 62–3, 100–7, figs 136–295, and Sandler 1986, nos 92, 93.

[34] Camille 1992, 276–8.

[35] Morgan 2000 assesses the influence of the English manuscripts in France.

The Getty Apocalypse and the Westminster Group

SINCE Peter Klein's commentary for the 1983 facsimile of the Douce Apocalypse, one group of English thirteenth-century Apocalypses has come to be called the Westminster group.[1] The reason for this naming is that these manuscripts have a stylistic link with works of art connected with Westminster Abbey and the patronage of King Henry III, namely the illustrated copy of the Life of St Edward the Confessor (Cambridge, University Library MS Ee.3.59), the paintings once in the Painted Chamber in Westminster Palace, and the panel painting, the Westminster Retable, which some have argued was installed as the high altarpiece of the abbey in 1269, and was certainly painted before 1270.[2] These stylistic connections will be discussed later in this chapter in regard to the Getty Apocalypse. The four extant Apocalypses which constitute the Westminster group span the period c.1255–70, but several intermediary manuscripts in the iconographic and textual development of the group have been lost, as has been explained in the preceding chapter and presented in the schema of interrelationships between the manuscripts.

The Iconography of the Getty Apocalypse

The cycle of pictures in the Getty Apocalypse has a number of idiosyncratic iconographic features which set it apart from earlier illustrated English Apocalypses. The two other groups, Morgan–Bodleian and Metz–Lambeth, contain eighty and seventy-eight Apocalypse illustrations respectively, although the passages of text illustrated differ between the two groups.[3] Morgan–Bodleian in fact contain eighty-three scenes but three of those scenes are interpolated from the Life of Antichrist which is not in the biblical text. The Morgan–Bodleian group, but not the Metz–Lambeth group, also contained a few scenes of the Life of St John before and after the Apocalypse. Allowing for the ten scenes missing from the end of the book, Getty increased this number to ninety scenes. It has in addition two scenes of the Life of St John preceding the Apocalypse text, and probably once had four others at the end of the book.[4] A key aspect of the development of the illustration of these books in England in the twenty years between 1250 and 1270 was to split up the Apocalypse text extracts on each page into more sections, thus increasing the number of pictures. This would reach a peak in the final manuscript of the Westminster group, the Douce Apocalypse, which originally had 103 scenes of which six have been lost. The increase in the number of text extracts, and consequently the number of pictures, might have resulted either from a desire to include more of the commentary of Berengaudus, or from a desire for more illustrations.[5] An intention to include more Berengaudus text certainly seems to have been the case for Getty, which contains considerably more of the commentary text than the Metz–Lambeth group. Furthermore, the commentary extracts are for the most part different, and this new selection must have been planned by the clerical director of the production of the book.

Among the new scenes introduced in the Getty Apocalypse the most important are: the People rejoicing over the Death of the Witnesses; the Appearance of the Temple in Heaven as an isolated picture; the Woman clothed in the Sun as an isolated picture; the Woman drunk with the Blood of the Saints. Other differences with the Metz–Lambeth group are mainly in making different combinations of scenes within the same picture, or separating out into individual pictures two episodes which had been combined.[6]

The Figure of St John

A special feature of the Getty Apocalypse is the very frequent placing of John outside the frame of the picture looking in through a small aperture to behold the vision. This feature does occur in several other English Apocalypses of the period, but in none of them is there such a range of poses of John, in many of which he reacts psychologically to the events in the vision revealing his fear, horror, wonder or curiosity. This idea of a 'peeping Tom' who looks in through the frame at a scene occurs in a few scenes in Matthew Paris's illustrated lives of saints. In his Life of St Alban (Dublin, Trinity College MS 177), perhaps of c.1240–50 but possibly from the previous decade, this motif is used when Alban opens the shutter of a window to look in at Amphibalus praying before an altar, and when a 'Saracen' spies on Amphibalus baptising Alban.[7] The earliest extant English illustrated Apocalypse, the Paris Apocalypse,

[1] On this group see: Klein 1983, 33–49, 51–63, 68–158, 164–70, 179–229; Morgan 1988a, nos 124, 125, 153, 154; Morgan 2007, 21–9, 41–103. Earlier writers on the English Apocalypses, such as James, Freyhan and Henderson 1970, had of course postulated that some Apocalypses and other illustrated manuscripts in mid-thirteenth-century England were associated with Westminster, but only with Klein's detailed analysis of manuscript interrelationships did this group become precisely defined.

[2] On the Westminster paintings see Wormald 1949, Binski 1986, Binski 1995 and Liversidge and Binski 1995. On the dating issue of the Retable see Binski 2004 and Binski, Massing and Sauerberg 2009, 30–40, 90–2. It is noteworthy that Christopher Wilson argues for a possible dating in the early 1260s, and for a Parisian painter as its creator.

[3] As Paris, BnF fr. 403, the third member of this group, represents an idiosyncratic reinterpretation of Morgan–Bodleian, never copied in any subsequent manuscript, its seventy-six illustrations are not representative.

[4] See p. 16 for the evidence for this conclusion.

[5] The fullest analysis of the issues of interrelationships of text, commentary and iconography over the full range of English thirteenth-century Apocalypses is the perceptive scene-by-scene discussion in Lewis 1995, 58–204.

[6] This process of combining and separating of scenes is clearly evident in the tables of English thirteenth-century Apocalypses in Morgan 1988a, 201–14.

[7] Lowe, Jacob and James 1924, pls 3–5.

BnF fr. 403, of the early 1250s, always places John inside the frame, but does contain the 'peeping' motif when the pagans spy on John baptising Drusiana in the Life of St John scene at the beginning of the book.[8] Within a few years' time, in the Metz Apocalypse, of 1255 at the latest, he is placed outside the frame peeping through an opening in some of the pictures (ff. 3v, 4r, 6r, 2v (out of sequence), 8r (out of sequence) and 14v).[9] Also in the Tanner Apocalypse, contemporary with Metz, a few scenes have John outside the frame (six scenes in all).[10] In Getty no less than thirty-three pictures have John outside the frame, making the most extensive use of this device in all English Apocalypses. Of the other manuscripts in the Westminster group BL Add. 35166 has six only (e.g. figs 1, 13),[11] BnF lat. 10474 has ff. 6v, 7r, 11r, 15r, 15v, 27v (within a subframe), 39r (within a subframe), 39v (half in and half out), 41v (walking out of the frame into the border), 42v (walking out of the frame into the border), and Douce has pp. 12, 20, 54, 78, 79 (usually as a subframe within the frame). Although there may have been some John figures exterior to the frame in the lost prototype of the Westminster group, it seems beyond doubt that it was a conscious decision of the artist of the Getty Apocalypse to exploit this device by increasing their number greatly. It is noteworthy that the latest member of the group, the Douce Apocalypse, deliberately minimises the use of this device.

There has been much speculation as to the motivations of the artist in including so many of these external figures.[12] In the early examples in the Metz and Tanner Apocalypses they stand calmly looking through the opening in the frame. In Getty, some are similar, with the tall figure of John quietly observing the scene. In other cases the artist of Getty varies his pose as he looks through the window hole, whose shutter he is opening in one case (f. 13v). He is shown kneeling in reverence (f. 5r) when the Lamb appears in Heaven, falling to his knees (f. 10v) when the Altar in Heaven is censed by the Angel, and genuflecting (f. 26v) when the New Canticle is sung before the Lamb and the Throne of God. In other cases the window hole is placed low in the frame so that he has to bend down to peer through it, a pose which emphasises his curiosity and desire to see (ff. 4v, 17r), or in a less exaggerated way leans forward to put his eyes to a

higher placed window hole (ff. 5v, 12v, 18r, 24r, 37v). In several cases he is in a contrapposto pose, turning his head back to look as he moves away from the awesome or horrific event of the vision (ff. 5v, 21v, 22r, 24v, 25v). On occasions, vigorous hand gestures or body pose express his reaction to the vision, as when at the blowing of the Third Trumpet the star 'Wormwood' falls upon the Earth (f. 12r), or when he throws up his hands as the Seed of the Woman fight the Dragon (f. 22v), and makes a similar gesture within the frame when the birds eat the flesh of Kings (f. 40v). When the angel pours the vial on the sun which scorches men with great heat (f. 33r), John is inside the frame and covers his head with his cloak to shield himself from the sun. Also within the frame he gesticulates in horror as frogs come out of the mouths of the Dragon, Beast and False Prophet, signifying their diabolic spirits (f. 34v). In one case, on f. 10r, his back is turned to the viewer as he looks through a large window in an architectural construction projecting from the frame at the Giving of the Trumpets. In a few cases he interacts with figures in the visions: the Eagle, one of the living creatures, who announces the Rider on the Pale Horse at the opening of the Fourth Seal, flies through the hole in the frame towards John (f. 7v); the Ancient who explains to him the Multitude who adore the Lamb, steps partly out of the frame to grasp John's wrist (f. 9v); John crouches down with hand to head below the Woman disappearing into a cloud as she flees from the Dragon into the Wilderness (f. 20r); he looks up through the window hole as the Woman, having been given wings, flies away as the Dragon casts out a Flood at her (f. 22r); within the frame on f. 35v the angel pulls him by his cloak to see the Great Harlot seated on the waters, and in the next scene on f. 36r he shies back towards the angel as the Harlot appears riding on the Beast.

Most of these actions are very physical in their form and emphasise to the viewer that the visions are experienced in a very corporeal way.[13] Although in theological terms John's apocalyptic visions were in most writings considered to be 'spiritual' seeing in regard to St Augustine's three-fold division of seeing into corporeal, spiritual and intellectual, the way that he reacts bodily to his visions in the Getty Apocalypse must surely have seemed a very physical response to the owner of the book. Except perhaps when he kneels in adoration, he reacts and even participates in the corporeal action of the visions. The artist may have made use of this device to draw the reader and viewer into the action of the picture, and there are few cases where the earthly world of both the viewer and St John is clearly distinguished from the heavenly, supernatural world of the visions. Thus, any interpretation of the figure of John as an expression of visionary experience needs to be treated with caution.

The Life of St John Scenes

Many, but not all, of the English Apocalypses of the thirteenth century place at the beginning and the end of the Apocalypse scenes a number of scenes from the apocryphal Life of St John

[8] Otaka and Fukui 1981, col. pl. on p. 17.
[9] For a complete reproduction of the illustrations of the Metz Apocalypse see Morgan and Brown 1990: unnumbered plates following p. 280.
[10] Morgan 1988a, no. 107 with fig. 50 as an example of John outside the frame; Sandler 1974, fig. 319, for another example, and on pp. 100–7 a discussion of the manuscript and its iconographic derivatives, Cambridge, Magdalene College MS 5, and Oxford, Bodleian Library MS Canonici Bibl. lat. 62, both of which copy the same figures of John outside the frame as those in Tanner (Oxford, Bodleian Library Tanner MS 184).
[11] As thirty-two to thirty-six scenes are missing from the middle part of this book, there may have been a few more.
[12] Henderson 1968, 103–8; Lewis 1992b, 57–9; Lewis 1995, 32–6 et passim; Klein 1998, 263–8; Klein 2010a, 193–200. Klein 2010a presents the best summary discussion of the ways these figures can be interpreted. Although often differing in their interpretations, all of these commentators provide sensitive analyses of this motif. In recent years both literary historians and art historians have shown a particular interest in visions and the way that visionary experience is conveyed in text and image.
[13] This has been emphasised in Klein 2010a.

(fig. 2).[14] These begin with the events leading up to his exile by the Emperor Domitian to the island of Patmos. Then follow the visions of the Apocalypse, the central experience of his life, and lastly a series of scenes of the final period of his life in Ephesus after he returns to that city when his exile on Patmos is ended, thus framing the visions, with their mostly supernatural content, with his earthly life. In the case of the Getty Apocalypse there are two pictures at the beginning (on ff. 1r and 1v), the first containing two scenes of John before Domitian and John in the Cauldron of Boiling Oil, and the second a single scene of John disembarking from the boat on the island of Patmos. These are accompanied by a text that begins with the words *Piissimo Cesari*, the opening of a letter from the proconsul of Ephesus denouncing John to the Emperor Domitian, but continues to describe the events after Domitian's receipt of the letter leading to John's exile to the island of Patmos.[15] This text very rarely occurs in the English Apocalypses, but is also in BL Add. 35166, the two Savoyard copies of a manuscript very similar to Getty, and Cambridge, Trinity B. 10.2 which copies Add. 35166. As the last few leaves of the Getty Apocalypse have been lost it can only be speculated how many John scenes there were at the end. If the final gathering, of which only a single leaf survives, containing two Apocalypse scenes (ff. 41r, 41v), was of eight leaves (four bifolios) like all the others in the book, then, as the last ten Apocalypse scenes are missing, that would leave space for four Life of St John scenes. A book very similar to the Getty Apocalypse must have reached Savoy by the third quarter of the fourteenth century, when it was copied, and another copy was made there in the second quarter of the fifteenth century, perhaps using another English manuscript of the fourteenth century. These Savoyard Apocalypses will shortly be discussed in more detail, but they are first mentioned here because they are particularly relevant to the number of scenes of the Life of St John once contained in Getty. The earliest, Paris, BnF MS lat. 688 (called by some the 'Apocalypse of the Green Count'), has the same two pictures as Getty at the beginning, the first containing the two scenes of John before Domitian and John in the Cauldron of Boiling Oil (fig. 3), the second containing his disembarkation on Patmos. The iconography is very close to Getty for all three scenes, suggesting beyond doubt that the model was a manuscript almost identical to Getty. At the end of the Paris manuscript there are four pages of John scenes, some of them containing two scenes within a single picture. These are: f. 47r John welcomed by the people of Ephesus, John raising Drusiana (fig. 4); f. 47v Two men, Atticus and Eugenius, bringing sticks and stones to John; f. 48r John drinks from the Poisoned Chalice and the Criminals who had died from drinking from the Poisoned Chalice are raised when John's Cloak is held over them; f. 48v John's Last Mass, John's Death. This Savoyard Apocalypse has forty-eight folios which would correspond to the six regular gatherings of eight leaves which it is proposed that the Getty Apocalypse once had. On the basis of this comparison it is highly likely that there were once four pictures of the Life of St John at the end of Getty, probably with the same iconography as in BnF lat. 688. This conclusion is supported by the second Savoyard copy, El Escorial, Biblioteca del Monasterio MS E. Vitr. V, of the second quarter of the fifteenth century, which has two pictures containing the same three scenes of John's life at the beginning, and four pictures at the end, although these are not of quite the same iconography as in BnF lat. 688. The same English model used by the artist of BnF lat. 688 may have been used by the artists of Escorial, but they seem to have changed the iconography to more accurately reflect the text of the Life of St John placed below the miniature.

The Savoyard Copies of an Apocalypse of the Westminster Group

The first of the Savoyard Apocalypses, Paris, BnF MS lat. 688, of *c*.1350–70, has the same format of rectangular miniatures set above the text passages which they illustrate as in the English copies of the thirteenth century.[16] Also, its commentary text is written in red ink in contrast to the black used for the biblical text.[17] It was originally considered to have belonged to the 'Green Count' of Savoy, Amadeus VI, who was count between 1348 and 1383, but was made for Galoys de Viry, a seigneur of Savoy.[18] Its iconographic model was a book very close to the Getty Apocalypse, and possibly might have been the Getty Apocalypse itself, although Rivière-Ciavaldini has argued against this. It follows the Getty Apocalypse in having thirty-five figures of St John placed outside the frame (e.g. figs 5–8). It has three more instances than the Getty Apocalypse itself because three occur among the ten scenes at the end which are lacking in Getty. Unfortunately, the artist of BnF lat. 688 lacks the variety of facial expression and subtlety of pose. Although a complete text collation has not been possible, specimen sections show the Apocalypse text extracts and Berengaudus commentary extracts to be almost identical between the two books. As in Getty, the Apocalypse text is written in black ink and the commentary in red. One difference in the text is that in cases where the commentary text is long it overlaps on to the next page.

A very similar set of pictures was used in part for a luxurious Apocalypse of *c*.1428–35, El Escorial, Biblioteca del Monasterio E. Vitr. V, also made in Savoy.[19] The Escorial Apocalypse

[14] The fullest discussions of these are in Ivanchenko and Henderson 1980, Morgan and Brown 1990, 51–5, 269–70, and McKitterick, Morgan, Short and Webber 2005, 63–73, 76–8, 95–101, 129–30.

[15] Stegmüller 1958, 372, no. 9694.

[16] Gardet 1967; Emmerson and Lewis 1985, no. 113; Edmunds 1991, 93–4; Morgan 2000, 143–4; Rivière-Ciavaldini 2000a; Castronovo 2002, 208–19, figs 54–61, 63, 65; Saroni 2004, 52–4, 185–9; Rivière-Ciavaldini 2007, *passim*. The last of these publications contains an excellent, convincing, very detailed discussion of the English models for the Savoyard Apocalypses.

[17] A colour plate of a full page is in Paravicini Bagliani 1991, pl. XXXV.

[18] Rivière-Ciavaldini 2000a and Rivière-Ciavaldini 2007, 83–4. I have not made any close comparison of the iconography of this manuscript with the Getty Apocalypse, but the four plates included of it can be compared by the reader with the corresponding images in Getty, and will be seen to be very close: fig. 5 (Getty f. 3v); fig. 6 (Getty f. 5v); fig. 7 (Getty f. 10v); fig. 8 (Getty f. 21v).

[19] Edmunds 1964, 133–5; Gardet 1969; Santiago Agut 1980; Edmunds 1991; Rivière-Ciavaldini 2000b; Saroni 2004, 48–56, 80–8, 183–9; Rivière-Ciavaldini 2007.

also has almost identical extracts of the Apocalypse text and the Berengaudus commentary to Getty. The artists were not using BnF lat. 688 as a model, nor the English mid-thirteenth-century Apocalypse used by the artist and scribe of BnF lat. 688. Edmunds has argued for another Westminster group model similar to the Douce Apocalypse being used.[20] The detailed analysis of Rivière-Ciavaldini suggests a fourteenth-century English Apocalypse, whose pictures were derived from Getty, Douce, and possibly an Anglo-Norman verse Apocalypse similar to Cambridge, Corpus Christi College MS 20.[21] The first artists to work on the book were Jean Bapteur and Perronet Lamy, but it was left unfinished and had to be completed by Jean Colombe over fifty years later *c.*1490. Although the iconography shows partial dependence on the pictorial tradition of the Getty Apocalypse both artists change many features, and it does not have the value of the close copy in BnF lat. 688. It seems, as Laurence Rivière-Ciavaldini has demonstrated, that Jean Colombe also knew a Neapolitan tradition of Apocalypse illustration which has been preserved in a panel painting (Stuttgart, Württembergische Staatsgalerie) and in some mid-fourteenth-century Neapolitan Bibles.[22]

The Late Fourteenth-Century Westminster Copy

A copy of a manuscript very close to the Getty Apocalypse, although not the Getty Apocalypse itself, was made *c.*1380–90 in a book made for Westminster Abbey (Cambridge, Trinity College MS B. 10.2).[23] The model might have been BL Add. 35166, to whose iconography it is much closer than to Getty's. As in these two manuscripts, the commentary is written in red ink. There are two reasons why this late fourteenth-century manuscript has an indisputable provenance of Westminster Abbey. The first is that it contains at the end of the Apocalypse pictures a set of coloured drawings of the Life of St Edward the Confessor, whose relics were at the Abbey, and it has been demonstrated that these drawings derive from a series of tapestries made for Abbot Richard de Berkyng at some date between 1222 and 1245.[24] The second is that it was the iconographic model for the late fourteenth-century wall paintings of the Apocalypse in the Chapter House.[25] The iconography of many scenes closely resembles BL Add. 35166 and it is different from Getty's in several features.[26] One marked difference is that the few figures of John outside the frame follow those instances of

this feature in the British Library manuscript. The scenes which resemble Add. 35166 and differ from Getty are: John before Domitian and John in the Cauldron of Boiling Oil are treated as separate pictures; there is an additional picture of John leaving on the boat to Patmos before the picture of his disembarkation on the island; the bow of the departing boat is shown in the opening scene of John on Patmos approached by the angel; the angels are in two rows in the Seven Churches of Asia; the Ancients are separated in the groups of six as three figures on each side in the Vision of Heaven; an additional man on the right is included in John consoled by the Ancient; the living creature is positioned on the left of John in the Four Riders, not in front of him as in Getty; John is placed inside the frame for the Fourth Rider; there are only two angels in the Souls below the Altar, and the souls are placed under three arches; there is no standing king in the Earthquake at the Sixth Seal; there is an angel in the bottom right corner in the Four Winds; God sits beside the Lamb in the Adoration of the Lamb by the Multitude; the altar is placed on the right at the Giving of the Trumpets; a group of angels stand behind the First Angel blowing the Trumpet; John is seated rather than standing in the scene of the Eagle crying 'Woe'; the Locusts and Abaddon are not shown coming up when the star falls, but depicted in a separate picture on the next page; in the Appearance of the Great Angel John is not included at a desk receiving a pen; the Fourth Angel with the Vial stands to pour his vial on the sun rather than flying out of a cloud.

Apart from its iconographical importance as a late witness of the Westminster group, this book of *c.*1380–90 has the distinction of being the last extant illustrated Apocalypse to be produced in medieval England. No copies have come down to us from the fifteenth century.

The Historiated Initials

A feature of the Getty Apocalypse that makes it unique among other English Apocalypses of the time, is the frequent use of historiated initials at the beginning of the passages of the Apocalypse text below the pictures, in contrast to ornamental intitials containing foliage, dragons, birds and occasional decorative male and female heads. Most of these historiated initials contain human figures, but occasionally birds and animals in a 'narrative' context, such as the fable of the fox and the stork. Several contemporary English Apocalypses have just one historiated initial at the beginning of the text, which shows John writing or John preaching, and the latter subject is also used for that initial in the Getty Apocalypse. In these other Apocalypses this is the unique historiated initial, the others only containing ornament, but in Getty there are forty-two more which are historiated. The subjects are: f. 5r, a man standing amid coils pointing up to the picture above; f. 5v, an elephant, a lamb on a pedestal, two men wrestling; f. 9v, a woman's head, with a grotesque man's head in the stem and a man throwing a stone in the terminal of the initial; f. 10v, a man and woman struggling with each other; f. 11r, a woman standing over a man who clings to the bar of the

[20] It seems hardly credible that two Apocalypses in the iconographic tradition of the Westminster group found their way to Savoy, one used by the artist and scribe of BnF lat. 688 in the fourteenth century, and another used for the Escorial Apocalypse in the fifteenth.

[21] Rivière-Ciavaldini 2007, 135–40.

[22] Rivière-Ciavaldini 2000b and Rivière-Ciavaldini 2007, 212–27; Wright 2004 on the Stuttgart panels and Bräm 2007 on the Bibles.

[23] Sandler 1986, no. 153; Binski 1991, 87, 88; Stocks and Morgan, 2008, 42–3, no. 10.

[24] Binski 1991.

[25] Hansen 1939, 18–27, 89–131, gives a detailed comparison of the iconography with several plates of the Trinity manuscript.

[26] Rivière-Ciavaldini 2007, 82, 103, 107, 111, 116, 136, 140, has come to the same conclusion that BL Add. 35166 seems to be the model for Trinity B. 10.2.

initial; f. 12r, a boar with an archer below; f. 13r, two men wrestling and pulling hair on the bar of the initial; f. 13v, a man shooting at the text with a crossbow; f. 14r, a standing man with his hands held up to his ears; f. 14v, a man holding a stick leaning on the bar of the initial; f. 18r, two men wrestling; f. 18v, the fable of the stork and the fox; f. 19r, a tonsured cleric ringing bells in a belfry; f. 20r, a man leaning on a stick looking upwards; f. 21v, either a man warming himself by the fire or a personification of *luxuria*;[27] f. 22r, an acrobat seated on the bar of the initial; f. 22v, two grimacing male heads; f. 23r, a man looking up and pointing at the scene above; f. 23v, a fool holding a bauble and disc; f. 24r, a musician beside a miser holding a bag of money, personifying avarice; f. 24v, a standing man holding an ape and a bird; f. 25r, a musician playing before a dancing man and woman; f. 25v, an acrobat exercising on the bar of the initial; f. 26r, two shepherds looking up at the star of Bethlehem; f. 27r, a sower; f. 27v, two musicians with wind instruments standing in turrets; f. 29r, a man leaning on a stick and pointing to his eye; f. 30r, a jug on a table with another hanging from a bar on which a cloth hangs; f. 30v, David harping, accompanied by a musician; f. 32r, a bird perched on the initial bar with dogs or sheep below; f. 33r, three men shielding their eyes and bodies to protect themselves from the sun; f. 33v, an acrobat exercising on the bar of the initial; f. 35v, a back-turned man pointing up to the picture above; f. 36v, a woman pouring wine from a drinking horn into a cup; f. 37r, a king's head; f. 37v, a crouching man or woman holding a stick and pointing to his or her head; f. 38r, a baker kneading dough in a bowl; f. 38v, a standing man holding a staff with his hand held to his head; f. 39v, a tonsured man writing at a lectern; f. 40r, an acrobat performing on the bar of the initial; f. 40v, a dancing man holding a trumpet and pointing up to the picture above; f. 41r, a fallen eagle.

Looking at these subjects as a whole, it is clear that most of them are of a secular nature: ordinary men and women, acrobats, musicians, dancers, and occasional animals and birds. Only two subjects, David harping and the shepherds looking at the star of Bethlehem, are biblical. The secular figures are just the sort of subjects that will come to be found in marginal images in Psalters and Books of Hours, a genre which was just beginning at the time of the making of the Getty Apocalypse.[28] Indeed, the first extensive example of the use of marginal images, the Rutland Psalter (London, BL MS Add. 62925) is exactly contemporary with the Apocalypse (fig. 9).[29] Earlier, in the first half of the thirteenth century, in some English Psalters there are historiated initials or line endings containing secular subjects of this nature – Cambridge, Trinity College MS B. 11.4; London, BL MSS Arundel 157, Harley 5102, Lansdowne 420, Lansdowne 431, Royal 1.D.X; Munich, Bayerische Staatsbiblio-

thek Clm 835; New York, Pierpont Morgan Library MS M. 43.[30] To take specific examples, the fable of the fox and the stork is found in Trinity B. 11.4, ff. 6r, 9r, and in the Rutland Psalter, f. 34r, and archers shooting arrows in Arundel 157, f. 56v, and Rutland, f. 67v. The fable of the fox and the stork is a very common subject in later marginal images.[31] In the middle years of the century these subjects of musicians, acrobats, animals and birds 'escape' into the margins and marginal illustrations begin, as is clearly seen by numerous such images in the Rutland Psalter.

Both Suzanne Lewis and Peter Klein have attempted to explain the reason for the unique occurrence of these historiated initials in an English Apocalypse.[32] Some of their interpretations are convincing, and others less so. Suzanne Lewis considered that many of them were related to the Apocalypse pictures or to words in the text. The most convincing explanations are David harping in the singing of the New Canticle, the three men shielding their eyes and bodies to protect themselves from the sun, mimicking St John in the scene when the Fourth Angel pours his vial on the sun, and finally the woman pouring wine from a drinking horn into a cup below the scene of the Great Harlot drunk with the Blood of the Saints. She also explained some of them as serving a memorising function for some of the pictures or parts of the text. Peter Klein emphasised that they were of the same humorous or moralising character as marginal images and in general were only occasionally connected with the picture above or the text beside, and for the most part disagreed with Lewis's interpretations. Some, he argued, could represent the vices, just as is the case for some of the subjects in Romanesque sculpted capitals. Others, such as the sower below the scene of the Angel with the Eternal Gospel, may make a biblical reference, in this case to the parable of the sower in Matthew's Gospel, which is a parable about the spreading of the Gospel. The baker kneading dough beneath the Angel casting the Millstone into the Sea results from the common association of flour. Some are a response to what is happening in the picture, like the figure of John outside the frame. Thus, when the Great Harlot goes up in flames a man in the initial puts his hand to his head, lamenting. In seeing them as a parallel to marginal images in manuscripts like the Rutland Psalter, in parodying rather than paraphrasing picture or text, Klein is right on the mark, although he failed to realise that some of these subjects existed as historiated initials in English Psalters of the first half of the century, and that the Getty Apocalypse is a late example of such use.

In conclusion, the artist of these historiated initials, who may be different from the artist of the Apocalypse pictures and related to one of the artists of the Rutland Psalter, seems to have been up to date with the contemporary trend in decorated Psalters to introduce marginal images of a mainly secular nature, a few related to the text but most not. The introduction of such images may well have been deliberately intended to introduce a less serious element into books containing biblical or devotional texts in order to provide some relaxation for the

[27] The interpretation as *luxuria* (Klein 2000, 111) notes that the fire is hardly visible and that the sloppy falling-down stockings, as in the case of the drunken Harlot in the Apocalypse scene, signify moral laxitude.

[28] Randall 1966 provides a catalogue of the subject matter found in marginal images.

[29] On the Rutland Psalter see Millar 1937; Morgan 1987; Morgan 1988a, no. 112; Klein 2010a, 199–200.

[30] Morgan 1982, nos. 23, 24, 28, 30, 37, 39, 40, 51.

[31] Randall 1957, 104; Randall 1966, 97.

[32] Lewis 1992b, Klein 2000 and Klein 2010a.

secular owner from the seriousness of the main text. This mixing of sacred and secular genres, which characterises the capitals and corbels of Romanesque churches, the inhabited initials of Romanesque manuscripts, the roof bosses of Gothic churches, the misericords of Gothic choir-stalls, and the marginal 'grotesques' of Psalters and Books of Hours, had a continuous history in medieval art from the second half of the eleventh century onwards.[33] To the modern understanding it might seem a profanation or trivialisation of the sacred context in which such imagery is placed, but, with a few exceptions such as St Bernard, it is remarkable that these subjects were very seldom condemned by medieval clerics and scholars.[34]

The Content of the Berengaudus Commentary in the Getty Apocalypse

The majority of the English Apocalypses of the thirteenth century have extracts of the commentary of Berengaudus accompanying the passages of the biblical text. His full commentary is very long, and the extracts from it are probably much less than a quarter of its total length. The theologian who compiled the selections of extracts is therefore, as a result of his choice, in effect constructing his own commentary by accepting certain passages of Berengaudus and rejecting others. Some writers, in making a characterisation of the Berengaudus commentary in these Apocalypses, fail to realise that it is no longer in effect his commentary, but a selective 'scissors and paste' interpretation of his ideas, very probably made by an English Franciscan.[35] The themes of the commentary interpret the allegories of the struggle between good and evil in terms of: (i) past history in which the Patriarchs, Prophets, Jews and Romans are often referred to; (ii) Christ, the Virgin Mary, the Apostles, the Fathers of the Church, Saints, Preachers, and the Church as an institution; (iii) the Devil and the Antichrist; (iv) the faithful and the disbelievers, who will ultimately become the elect and the damned. The Metz Apocalypse, with framed tinted drawing illustrations set above a two-column text, is the earliest extant copy which contains extracts from the Berengaudus commentary, just as in the Getty Apocalypse, and it was probably produced c.1250–5.

In the period c.1255–60, the Getty Apocalypse and the stylistically related Apocalypse, London, BL MS Add. 35166, were made. Either the theologian who compiled the text extracts from the Apocalypse and the Berengaudus commentary did not know a manuscript with the pictures and text contents of the Metz Apocalypse, or he deliberately decided to create a new version of text extracts and a corresponding change in the iconography of the pictures. The decision was made to increase the number of pictures for the Apocalypse from the

seventy-eight scenes once in Metz to the ninety-two originally in Getty.[36] In the Getty and British Library Apocalypses, despite general iconographic similarities, the text content varies slightly in the Apocalypse extracts and also in those from Berengaudus' commentary. These books are far from being identical copies in terms of iconography and text as are the Metz Apocalypse and its copy Lambeth.[37] The comparative plates in this commentary on the Getty Apocalypse include eleven scenes from the British Library Apocalypse which give an indication of the extent of iconographic differences between the two books (figs 1, 10–19).[38] Although the artists of the two books are closely related and probably worked together in a 'workshop' situation, their interpretations of many scenes differ in details. The artist of the Getty Apocalypse includes more details of architecture and landscape and some extra figures, whereas the British Library artist presents simpler compositions. It seems likely that both derived their pictures from an earlier lost manuscript, adding or eliminating some details according to their own interpretations.

As a result of the loss of intermediary manuscripts it is difficult to relate these two Apocalypses with any precision to the iconography of earlier books like the Metz Apocalypse, from whose images some of the Getty pictures are certainly derived. During the 1250s and 1260s there seem to have been elaborated revisions and edited versions of the pictures and text extracts, in particular by increasing the number of text extracts from the Apocalypse with a corresponding increase in the number of pictures. Klein has proposed that an expansion of the number of pictures in Metz or its prototype took place, and such a manuscript was the source of the Westminster Group Prototype which made further expansion and iconographic changes. This expanded version of the Metz–Lambeth set of pictures may have a direct descendant in an Apocalypse made in Lorraine c.1290, the Burckhardt-Wildt Apocalypse,

[33] The best general account of the visual development of this imagery is Baltrusaitis 1960, which, despite its title, discusses Romanesque as well as Gothic art.

[34] I refer to St Bernard's famous censure of such imagery in his letter to Guillaume of St Thierry, discussed at length in Schapiro 1947.

[35] McKitterick, Morgan, Short and Webber 2005, 11–12, 14–15, for the evidence for Franciscan involvement in its composition.

[36] The last ten scenes have been lost in Getty, and have been supplied from the closely related London, BL MS Add. 35166. The British Library Apocalypse has thirty-two to thirty-six scenes missing from the central part of the book. In both cases these missing parts, in view of the completeness of the copies made of them in Savoy and in Trinity B. 10.2, were presumably excised in the post-medieval period.[3]

[37] In the commentary volume on Lambeth by Morgan and Brown 1990 there is a complete set of plates comparing the Apocalypse scenes of Metz and Lambeth, which reveals how very close the iconography of the pictures is. A third Apocalypse in the Gulbenkian collection is also compared, but in many instances its artist alters the iconography of Metz and Lambeth in adding or changing details.

[38] A substantial number of iconographic differences in BL Add. 35166 have already been listed in the discussion of the late fourteenth-century Cambridge, Trinity B. 10.2 Apocalypse, which may be a copy of BL Add. 35166. I have not included a detailed comparison of the scenes in the British Library Apocalypse, but interested readers may wish to compare the images themselves, for which I give the corresponding folio reference in the Getty Apocalypse: fig. 1 (Getty Apocalypse, f. 41v); fig. 10 (Getty Apocalypse, f. 2v); fig. 11 (Getty Apocalypse, f. 5v); fig. 12 (Getty Apocalypse, f. 7v); fig. 13 (Getty Apocalypse, f. 9v); fig. 14 (Getty Apocalypse, f. 14r); fig. 15 (Getty Apocalypse, f. 33r); fig. 16 (Getty Apocalypse, f. 35r); fig. 17 (Getty Apocalypse, f. 36r); fig. 18 (Getty Apocalypse, f. 39r); fig. 19 (Getty Apocalypse, f. 40v).

which in its original state had eighty-eight pictures, that is ten more than Metz, and two less than Getty.[39] It was originally thought to be English, possibly from York, because of its close dependence on English iconographic traditions, but Alison Stones and Patrick de Winter have proved it to have been made in Lorraine.[40] Peter Klein has suggested the following schema of interrelationships for the Westminster group in the period *c*.1250–70:[41]

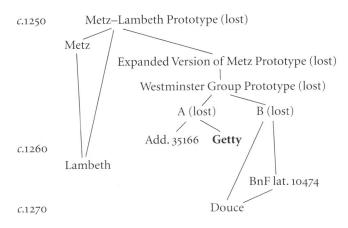

The Style, Date and Provenance of the Getty Apocalypse

The pictures of the Getty Apocalypse are in tinted drawing, that is drawings in ink with colour-wash tinting. In addition, gilding has been used for haloes and some other details, and in rare cases also silver. The drawing style for some figures shows fine-line troughed folds – e.g. ff. 4v (the ancients), 5r (the ancients), 29v (the central angel), 31v (John and the foremost man in the group), 33v (central angel), and the rider on the white horse on 41r – a style of drawing which was used in England in the second quarter of the thirteenth century. In many of the figures the tinting is employed to create light and shade areas to achieve modelling, by grading the colour from shadow to highlight, and occasionally emphasising the highlight with white paint. A few figures (e.g. St John on f. 36v) show the beginnings of the angular broad folds of the so-called French court style which had much influence in England from the mid-1250s onwards, and this is more evident in the drapery of some of the figures in the Cambridge Life of St Edward, a later work perhaps by the same artist. The new style had originated in French sculpture and required the painter to convey plasti-

city in the fold forms without the use of line, but rather as a flow of surfaces using colour modelling in light and shade. The earlier style in the Cambridge Life of St Edward has figures with fine-line troughed folds (fig. 22), a style which first appeared in England in the 1220s. In manuscript painting the new style in France is clearly seen in the *c*.1250 Old Testament Picture Book, New York, Pierpont Morgan Library M. 638 (fig. 23). Tinted drawing had been employed in England since its extensive use by the Anglo-Saxons in the tenth and eleventh centuries. During the first half of the thirteenth century there was a revival of this technique, particularly from the 1220s onward, in the troughed-fold style mentioned above.[42] It was used by artists of various styles of drawing, and cannot be associated with any particular centre. The older critical literature, deriving from the views of M. R. James, associated it particularly with St Albans Abbey and the monk-artist Matthew Paris, one of its leading practitioners. Subsequent research has shown this to be simplistic, a classic case of over-attribution of works to a named artist and his supposed 'school'. Although Matthew Paris played a prominent role in the illustration of lives of saints in this technique, no illustrated Apocalypses in tinted drawing are by him, nor were they produced at St Albans as M. R. James had proposed, nor did he have a 'school'. There is little convincing evidence for the place of production of any of the earliest illustrated Apocalypses in this technique: the Paris, Metz, Morgan, Bodleian and Getty manuscripts, spanning the decade *c*.1250–60. Neither is there any evidence regarding the ownership of any of these books, but although it is a simplistic argument, the subsequent ownership of the Paris Apocalypse in the fourteenth century by the French king Charles V might suggest that it had passed to him as a gift from some high aristocratic or royal English owner.

Looking at the problem of date and place of origin of the Getty Apocalypse from the point of view of the special characteristics of its drawing style is a more fruitful approach. The artist is very close to, and perhaps the same as, the artist of the Life of St Edward the Confessor (Cambridge, University Library MS Ee. 3.59) and the Morgan Apocalypse (figs 20, 21, 24). The BL Add. 35166 Apocalypse of the Westminster group seems to be by a different but closely related artist. Although the Morgan Apocalypse has no evidence of ownership or provenance, there is some evidence, albeit not firm, for that of the Life of St Edward. The original text of this Anglo-Norman life was written by Matthew Paris in the mid-1230s and almost certainly he accompanied the text with a set of pictures.[43] His poem was dedicated to Eleanor of Provence, Henry III's queen, whom the king married in 1236, and the poem was probably written around this time. The extant copy in Cambridge was produced some twenty years later *c*.1255–60, and its illustrations are very different in style to that of Matthew Paris, even though the iconography is probably based on Matthew's pictures in the

[39] The fate of this manuscript is a very sad story. In the early nineteenth century the book was cut up, the text disposed of and the miniatures pasted into a scrapbook for Daniel Burckhardt-Wildt of Basel. The scrapbook contained only seventy-two of the eighty-eight Apocalypse pictures, and the other sixteen are presumed lost. When the scrapbook came up for sale at Sotheby's on 25 April 1983, lots 31–68, it was dismembered and the individual pictures sold as separate lots – they are now scattered in collections across the whole world! The iconography is discussed in Morgan 2000, 140–2, 144–52.

[40] De Winter 1983 and Morgan 1983, the latter acknowledging the help of Alison Stones.

[41] I have slightly modified Klein's schema in substituting A and B for his X³ and X⁴ in his more comprehensive schema, these being the two lost books which derive from the Westminster Group Prototype.

[42] Morgan 1982, 28 and nos 21, 22, 43, 47, 51–61, 78–94, for discussions of the many manuscripts in this technique made during this period.

[43] Binski 1991, 92–5, convincingly argues against my assertion in Morgan 1988b that this Life of St Edward was perhaps not composed by Matthew Paris.

first 'edition' of the 1230s. That said, the artist working in the 1250s may well have changed some of the iconographic compositions, and it is simplistic to view these scenes as if they were exact copies of Matthew's originals, particularly in view of the special talent of the artist who was involved in illustrating this manuscript. The constant changes made by artists at the time in the iconography of Apocalypse scenes are a reminder that artistic creativity in devising new imagery should never be forgotten. The Cambridge 'copy' of the 1250s could of course have been made for the dedicatee, Eleanor of Provence, but it is likely that she had received an illustrated version of the Life shortly after Matthew Paris had written it and did not require a second copy. If it was made for a royal owner another candidate has to be found. In 1254 Henry III's son Edward, the future Edward I, married Eleanor of Castile, daughter of Ferdinand III of Castile, in Las Huelgas in Spain, the newly-wed couple returning to England in 1255. Could the Cambridge copy of the life of England's royal saint, to whom Henry III had a very great devotion, have been made, at some time shortly after her arrival in England, for the Spanish princess, the wife of his son Edward? It would indeed be a particularly appropriate book to inform the princess on the life of this great saint of such importance to the royal family. It has been noted that Eleanor of Castile did indeed possess a copy of the Life of St Edward, which was 'repaired' in 1288.[44] If this theory is acceptable, then a date for the production of the Cambridge Life of St Edward at the time shortly after the arrival of Eleanor in England in 1255 seems possible. As the original Matthew Paris Life of St Edward was probably still in the possession of Henry III's queen, Eleanor of Provence, this second edition is likely to have originated as a royal commission. However, there is no particularly strong reason why Henry III had to commission books in London, for although he spent much time at Westminster Palace, he also was often at Clarendon Palace, near Salisbury, Winchester Castle, Windsor Castle and Woodstock near Oxford, and wall and panel paintings were made for him at these places.[45] A great problem is as yet undis-

covered documentary records of payments for the production of books in royal accounts of Henry III's time.[46]

Wherever these three books, the Cambridge Edward, the Morgan Apocalypse and the Getty Apocalypse, were made, and whoever commissioned them, the likelihood that they were all by the same artist, and that they all probably fall within the five-year period c.1255–60, is strong. Of all the artists of mid-thirteenth-century England he is the most sensitive in his portrayal of narrative by gesture, pose and facial expression. The complexity of pose and gesture with many variations puts him in a special position. Others of the time, such as Matthew Paris or the main artist of the Trinity Apocalypse, also have complexity in their figure compositions, but it is more mannered and stronger in expression. The artist of the Edward and these two Apocalypses is more sensitive, restrained and subtle, drawing the viewer into the narrative by his portrayal of psychological interrelationships through complex gestures and poses, or, in the case of the Getty Apocalypse, by using the figure of St John within or without the frame to help the viewer interpret the picture. In this feature above all his original attitude to narrative and psychological portrayal is evident. Earlier, it was suggested that his pictures in the Life of St Edward are likely to have transformed Matthew Paris's original pictures into a different mode of seeing. Similarly, he transformed the Apocalypse pictures from the lost model, the Westminster Group Prototype, used also less imaginatively by the artist of BL Add. 35166. The artist of Add. 35166 is related to him, but does not achieve the same subtlety of figure pose, gesture, narrative and psychological expression in his pictures.

The Getty Apocalypse stands out as one of the most original interpretations of the illustration of John's visions of its time. It contains features such as the exterior figure of John and the historiated initials which make it unique, and in the subtlety of the figure style expresses the drama of the events of the visions in a special way that sets this book apart among the remarkable series of illustrated Apocalypses created in thirteenth-century England.

[44] This speculation about the possible ownership of the Cambridge Edward by Eleanor of Castile and the discovery of the 1288 account is taken from Binski 1990, 339–40, and Binski 1991, 96–7. I agree completely with his theory, and only take issue with him in his suggestion (1991) that a Life of Thomas of Canterbury, also mentioned in the 1288 account, was perhaps bound together with the Edward. The 1288 account refers to 'repairing bookbindings [libros cooperiendos] of the queen of the life of Blessed Thomas and St Edward', and I would assume from this wording that the lives of the two saints were separate books. A possible reason for Binski's suggestion that the two lives were bound together is that Matthew Paris, in a note in his hand on the flyleaf of his Life of St Alban, refers to 'the book about St Thomas the Martyr and St Edward which I translated and illustrated'. Although this undoubtedly provides evidence that Matthew did make a book in which the two saints' lives were bound together, there is no reason to assume the Cambridge Edward was once part of such a dual text. If it were part of a dual text it seems to me to weaken the argument that the Cambridge Edward was made for Eleanor of Castile shortly after she arrived in England in 1255, possibly as a gift from her father-in-law, Henry III. The king's intense devotion to Edward the Confessor, whose cult he wished to promote, would make it unlikely that he would 'dilute' his instruction of his daughter-in-law concerning that saint with a Life of Thomas of Canterbury.

[45] See earlier mention of these on p. 12.

[46] Kent Lancaster 1983 discusses these issues.

Codicological Description

A late nineteenth- or early twentieth-century binding of red morocco by Katharine Adams (1862–1952) with gilt tooling at the centre and at the corners. She was a friend of Sydney Cockerell and first set up her bookbinding workshop in 1897. It is uncertain whether this binding took place before 1906, or after, that year marking the acquisition of the book by C. W. Dyson Perrins.

PROVENANCE

There is no evidence of ownership of the manuscript until it came into the possession of Charles Fairfax Murray (1849–1919) in the late nineteenth century. In 1906 he sold it to Charles Warner Dyson Perrins, whose bookplate is on the flyleaf.[1] It was MS 10 in his collection and until it was acquired by the J. Paul Getty Museum was commonly referred to as the Dyson Perrins Apocalypse. After his death in 1958 the book was sold at Sotheby's, 1st December 1959, lot 58, and acquired by the New York bookseller H. P. Kraus.[2] In 1975 it was acquired by Dr Peter Ludwig – the bookplate of Irene and Peter Ludwig.[3] In 1983 the entire Ludwig collection of manuscripts was purchased for the J. Paul Getty Museum.

GATHERINGS

Five gatherings of eight leaves plus a single leaf at the end, originally part of a sixth gathering which was possibly also of eight leaves: 1^8 (ff. 1r–8v), 2^8 (ff. 9r–16v), 3^8 (ff. 17r–24v), 4^8 (ff. 25r–32v), 5^8 (ff. 33r–40v), 6^1 (f. 41).

CONTENTS

The book consists of 41 ff. but originally perhaps contained 48 ff. The last ten scenes of the Apocalypse are lacking, which would occupy 5 ff., and there very probably were two folios with four pictures of the final period of St John's life on his return from the island of Patmos to Ephesus, ending with his death, to complete the Life of St John scenes on ff. 1r and 1v.[4] Only one leaf

survives of the final sixth gathering. If this last gathering was regular like the five preceding, consisting of eight leaves, it would have contained the five missing leaves with ten Apocalypse scenes and two missing leaves with four scenes of the end of St John's life. A strong argument that there were just four scenes at the end of John's life is provided by an Apocalypse of c.1350–70 (Paris, BnF MS lat. 688) made in Savoy, copying an English manuscript almost identical to the Getty Apocalypse that contains this number of scenes at the end.[5] The average dimension of the leaves is 320 × 224 mm, and the very generous wide margins to the text–picture area suggest that there has been little trimming of the page size since the making of the original book. Each page has a picture over the text of dimensions ranging in width from 160 to 164 mm and in height from 104 to 106 mm. The text is in two columns of varying numbers of lines from three to twenty-four, with ff. 22v, 24r, 30r containing no text in the second column. On those pages on which the full text space is filled the number of lines is seventeen to twenty-four, but on many pages there is insufficient text to fill up the text area in both columns. The width of the columns varies somewhat from page to page, ranging from 66 mm to 70 mm with the total width of the text area ranging from 145 mm to 149 mm. Thus, on all pages the picture width extends approximately 8 mm on either side beyond the width of the text block. The combined height of picture and text ranges from 219 mm to 222 mm. The Apocalypse text is written in black and the commentary text in red, by one or perhaps two scribes, in Gothic textualis script.[6] On some pages the size of the script for the commentary is smaller than that for the Apocalypse text. This results in the Apocalypse text in the left-hand column not exceeding twenty-one lines, whereas the commentary text in the right-hand column can extend to twenty-four lines. Occasional marginal corrections have been made by a later scribe (ff. 1r, 22r, 36r).

The text–picture area, averaging 162 mm width and 220 mm height, corresponds to almost identical dimensions in two manuscripts very probably illustrated by the same artist, the Morgan Apocalypse (New York, Pierpont Morgan Library MS M. 524) and the Life of St Edward the Confessor (Cambridge, University Library MS Ee.3.59). The former is a picture-book with framed pictures averaging 160 mm in width and 220 mm in height, whereas the latter has a three-column text and on some pages rectangular framed pictures over the text columns as in the Getty Apocalypse; the text–picture area averages 165 mm in width and 216 mm in height. These remarkably close codicological features argue strongly for production of these

[1] Warner 1920, 35–40, for a full catalogue description.

[2] Kraus 1974, 51, no. 10; Kraus 1978, 82, no. 27.

[3] Von Euw and Plotzek 1979, 191–8.

[4] The last ten scenes of the Apocalypse have been supplied from a closely related Apocalypse, London, BL MS Add. 35166. As the number of scenes of the end of John's life varies considerably among English thirteenth-century

Apocalypses, it is impossible to be certain how many further folios in Getty contained these pictures, and it would certainly be unwise to assume the same large number as in the British Library Apocalypse, which has sixteen at the end of the book.

[5] This issue of the iconography of the Life of St John scenes is discussed on p. 16.

[6] Division of scribal hands has not been attempted.

manuscripts at the same centre by the same artists and scribes, and that centre is very probably London. Although many different artists and scribes worked on English Apocalypses and Lives of the Saints in the period *c*.1250–70, there are close codicological correspondences between the manuscripts.[7]

ff. 1r–41v The Apocalypse text in Latin is presented as a series of extracts on each page. Most of the biblical text is included, but some verses are omitted, particularly in chapters 2–3, which contain the letters to the churches of Asia; chapter 17, vv. 8–18, which contain the angel's long explication of the Great Harlot and of the Beast on which she sits; and finally chapter 18, vv. 12–20, containing the full text of the lament concerning the merchants of Babylon. Why these last two sections are omitted is difficult to understand in view of the interesting comments they contain. It may be because these passages do not lend themselves to illustration. Each extract from the Apocalypse is accompanied by an extract from the commentary of Berengaudus varying in length. These texts are set below rectangular framed miniatures with illustrations in tinted drawing in pale shades of blue, pink, red, green, grey, blue-grey and beige-brown, with haloes and a few other details in burnished gold, and in rare cases also silver (e.g. a sword on f. 25v). A special form of multiple gold nimbus formed of six small part circles is used for the Rider on the White Horse on ff. 40r, 41r, 41v.[8] The tinting colours are applied in such a way as to provide modelling of draperies and other three-dimensional forms in light and shade, with occasional use of white paint to emphasise the highlights. Quite often the tinting colour is applied across a whole surface, varying the tones to achieve modelling. Illuminated initials with burnished gold grounds, many historiated but some only containing ornamental foliage, are on every page at the beginning of the Apocalypse text. The gold ground of the initial at the opening of the text on f. 2r has diaper patterns incised on the gold. Simpler ornamental illuminated initials are at the beginning of the Berengaudus commentary extracts. These have gold stems with alternating blue and pink infills and frames decorated with white rinceaux patterns.

f. 1r John before Domitian; John in the Cauldron of Boiling Oil

f. 1v John disembarks on Patmos

f. 2r John on Patmos woken by the Angel (*Revelation 1 vv. 1, 9–11; 2 vv. 1, 8, 12, 18; 3 vv. 1, 7, 14*)

f. 2v The Seven Churches of Asia (*Revelation 2 vv. 1–2, 7–8, 12, 17–18, 26, 28; 3 vv. 1, 5, 7, 12, 14, 21*)

f. 3r The Vision of Christ and the Seven Candlesticks (*Revelation 1 vv. 12–18, 20, 19*)

f. 3v The Vision of Heaven (*Revelation 4 vv. 1–8*)

[7] Morgan and Brown 1990, 114, presents a comparative table of dimensions.d
[8] Scheller 2007, 90, notes that this occurs in several other English thirteenth-century Apocalypses, and derives from a passage in Berengaudus' commentary: 'by the many diadems is expressed the multitude of the saints'. Although this passage is not in the Getty Apocalypse, the commentary on f. 40r, when the Rider on the White Horse appears, says: 'The Lord shall come among his saints, that he should fight through them against Antichrist and his followers.'

f. 4r The Angel proclaims 'Who is worthy?'; John weeps and is consoled by one of the Ancients (*Revelation 5 vv. 2–5*)

f. 4v Adoration of God by the Twenty-Four Ancients and the Angels (*Revelation 4 vv. 10–11*)

f. 5r The Lamb appears in Heaven (*Revelation 5 v. 6*)

f. 5v The Lamb takes the Book with the Seven Seals (*Revelation 5 vv. 7–14*)

f. 6r The First Seal: The Rider on the White Horse (*Revelation 6 vv. 1–2*)

f. 6v The Second Seal: The Rider on the Red Horse (*Revelation 6 vv. 3–4*)

f. 7r The Third Seal: The Rider on the Black Horse (*Revelation 6 vv. 5–6*)

f. 7v The Fourth Seal: The Rider on the Pale Horse (*Revelation 6 vv. 7–8*)

f. 8r The Fifth Seal: The Souls of the Martyrs (*Revelation 6 vv. 9–11*)

f. 8v The Sixth Seal: The Earthquake (*Revelation 6 vv. 12–17*)

f. 9r The Four Angels holding the Winds; The Angel with the Sign of the Living God (*Revelation 7 vv. 1–3*)

f. 9v The Multitude adore God and the Lamb; The Ancient explains to John (*Revelation 7 vv. 9–15*)

f. 10r The Seventh Seal: The Giving of the Trumpets (*Revelation 8 vv. 1–2*)

f. 10v The Angel receives Incense and Fire from the Altar in Heaven; The Angel empties the Censer upon the Earth; The Thunders, Lightnings, Voices and Earthquake (*Revelation 8 vv. 3–5*)

f. 11r The First Trumpet: The Rain of Hail, Fire and Blood upon the Earth (*Revelation 8 vv. 6–7*)

f. 11v The Second Trumpet: A Mountain of Fire falls on the Sea and a Third Part is turned to Blood and Ships are destroyed (*Revelation 8 vv. 8–9*)

f. 12r The Third Trumpet: The Star 'Wormwood' falls on the Rivers and the Fountains of Waters (*Revelation 8 vv. 10–11*)

f. 12v The Fourth Trumpet: A Third Part of the Sun, Moon and Stars becomes dark (*Revelation 8 v. 12*)

f. 13r The Eagle flies across the Heavens crying 'Woe' (*Revelation 8 v. 13*)

f. 13v The Fifth Trumpet: The Star and the Key fall from Heaven and the Locusts come up from the Bottomless Pit led by their King, Abaddon (*Revelation 9 vv. 1–11*)

f. 14r The Sixth Trumpet: The Four Angels in the Euphrates (*Revelation 9 vv. 12–16*)

f. 14v The Horsemen destroy the People (*Revelation 9 vv. 17–21*)

f. 15r The Great Angel and the Seven Thunders; John is told not to write (*Revelation 10 vv. 1–7*)

f. 15v The Great Angel gives John the Book to eat; John eats the Book (*Revelation 10 vv. 8–11*)

f. 16r The Angel gives John the Rod to measure the Temple of God (*Revelation 11 vv. 1–2*)

f. 16v The Witnesses appear preaching and breathing out Fire against their Enemies (*Revelation 11 vv. 3–6*)

f. 17r The Beast comes up to oppose the Witnesses; The Witnesses are killed by the Beast (*Revelation 11 vv. 7–8*)

RULING

The ruling in plummet is very faint and almost illegible on many pages, but the prick marks which provided a guide for the ruling are clearly visible.

Prick holes

Picture area

Text area

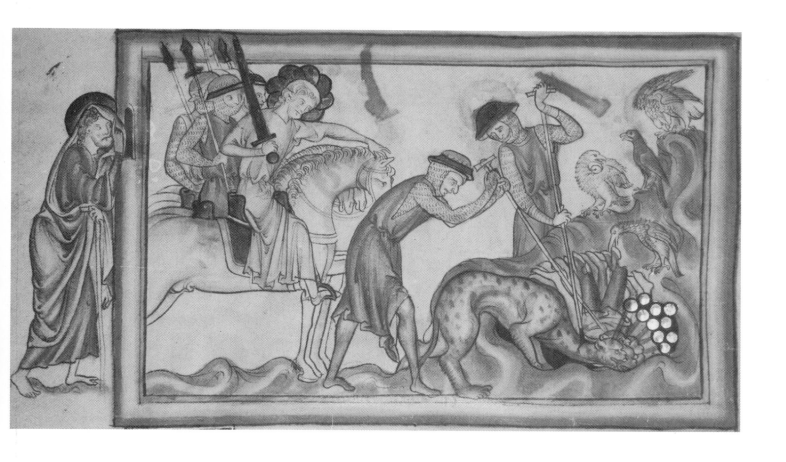

1 The Beast and the False Prophet cast into the Pool of Fire, Apocalypse, London, BL Add. 35166, f. 25v

2 John in the Cauldron of Boiling Oil, Apocalypse, London, BL Add. 35166, f. 1v

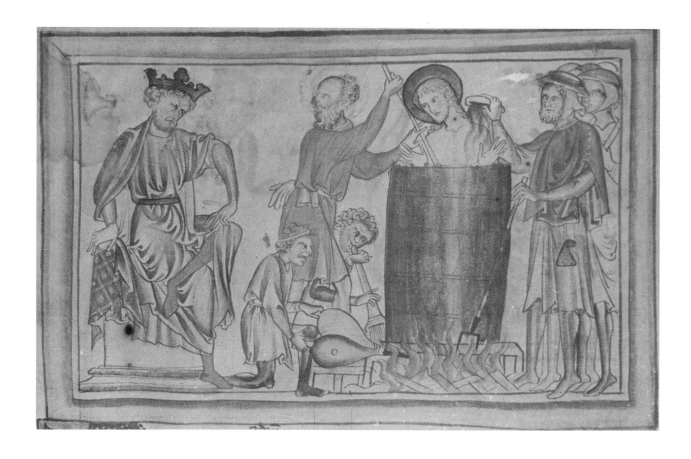

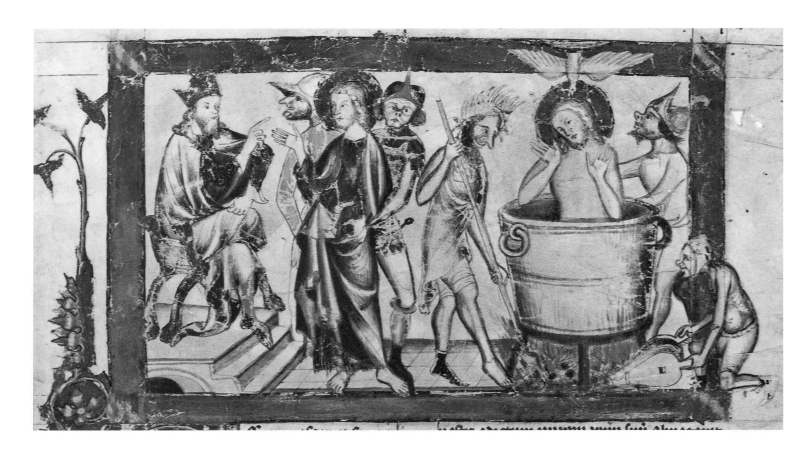

3 John before Domitian; John in the Cauldron of Boiling Oil, Apocalypse, Paris, BnF lat. 688, f. 1r

4 John returns to Ephesus; Raising of Drusiana, Apocalypse, Paris, BnF lat. 688, f. 47r

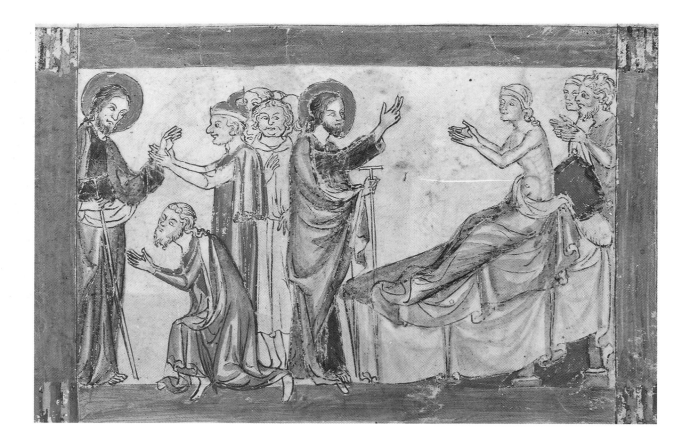

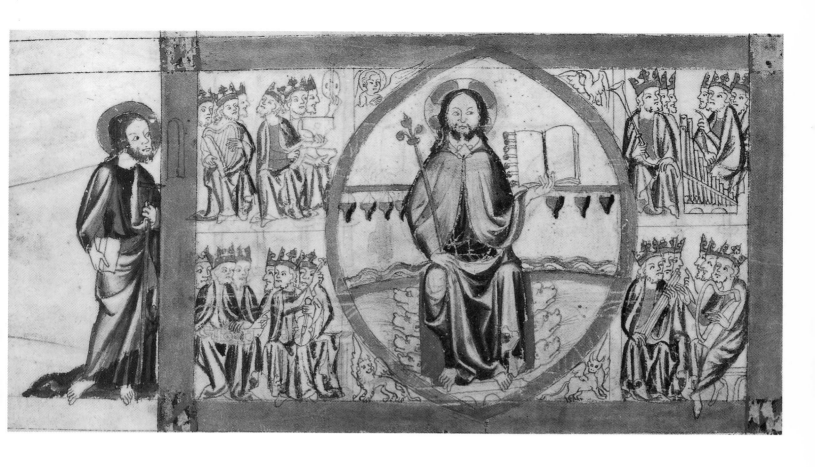

5 The Vision of Heaven, Apocalypse, Paris, BnF lat. 688, f. 3v

6 The Lamb takes the Book with the Seven Seals, Apocalypse, Paris, BnF lat. 688, f. 5v

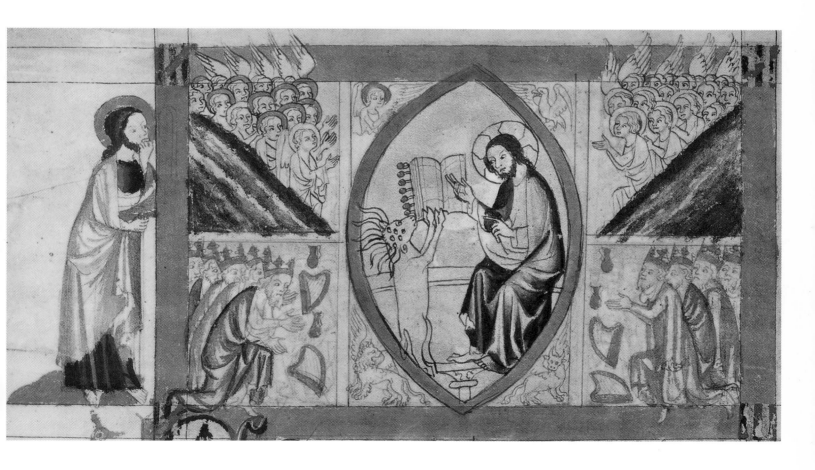

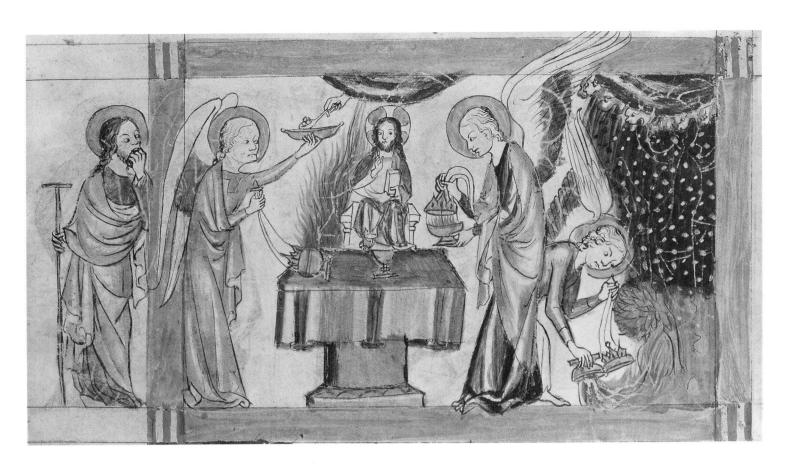

7 The Angel censing the Altar in Heaven; The Angel empties the Censer on the Earth, Apocalypse, Paris, BnF lat. 688, f. 10v

8 The Dragon persecutes the Woman who is given Wings of an Eagle, Apocalypse, Paris, BnF lat. 688, f. 21v

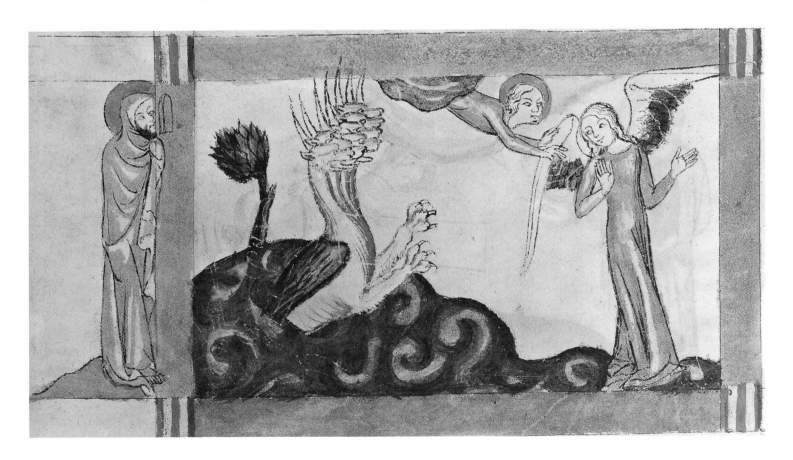

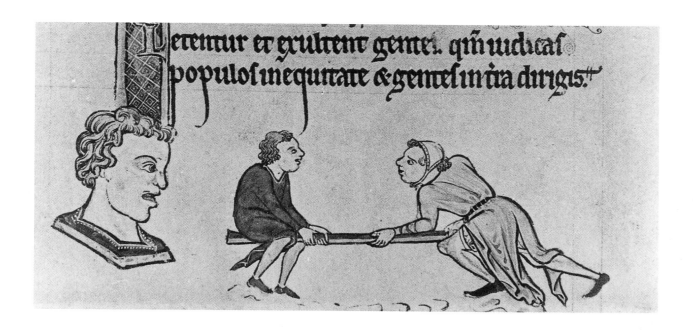

9 Marginal grotesque of two men on a bar, Rutland Psalter, London, BL Add. 62925, f. 65v

10 The Seven Churches of Asia, Apocalypse, London, BL Add. 35166, f. 3v

11 The Lamb takes the Book of the Seven Seals, Apocalypse, London, BL Add. 35166, f. 6v

12 The Fourth Seal: The Rider on the Pale Horse, Apocalypse, London, BL Add. 35166, f. 8v

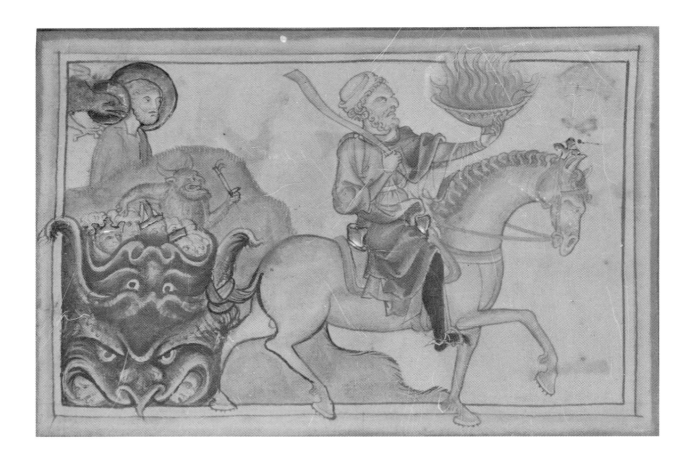

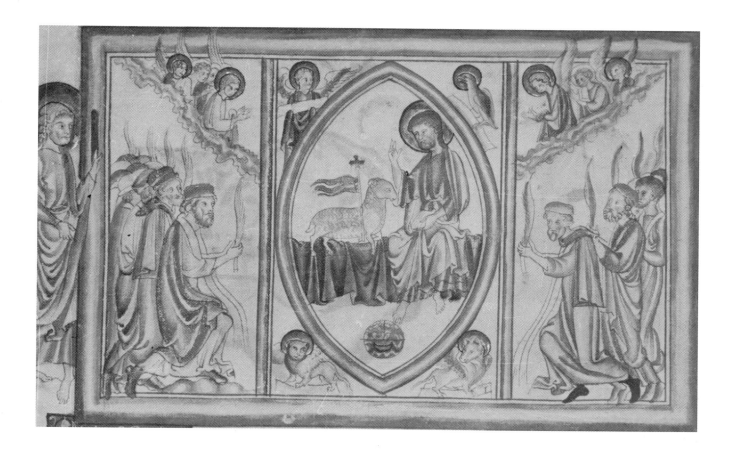

13 The Multitude adore God and the Lamb, Apocalypse, London, BL Add. 35166, f. 10v

14 The Sixth Trumpet: The Four Angels in the Euphrates, Apocalypse, London, BL Add. 35166, f. 15v

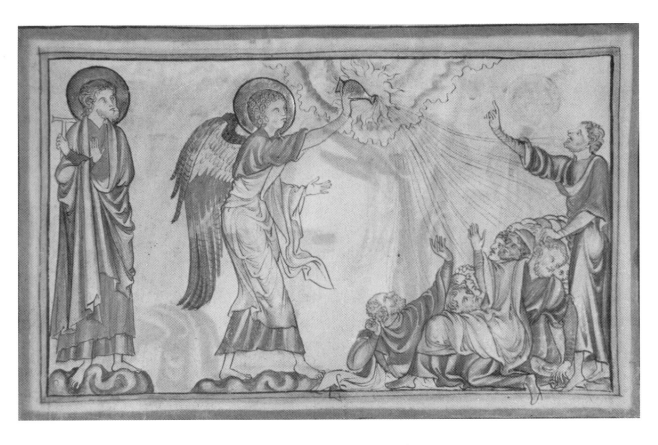

15 The Fourth Vial poured on the Sun, Apocalypse, London, BL Add. 35166, f. 17r

16 The Seventh Vial poured on the Air: The Earthquake destroys the Cities of the Earth, Apocalypse, London, BL Add. 35166, f. 19r

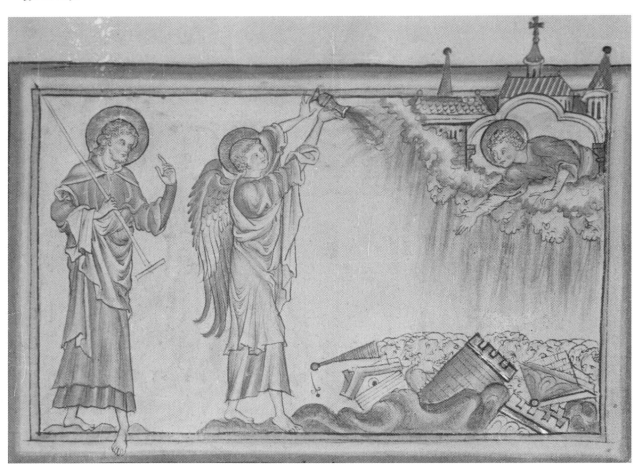

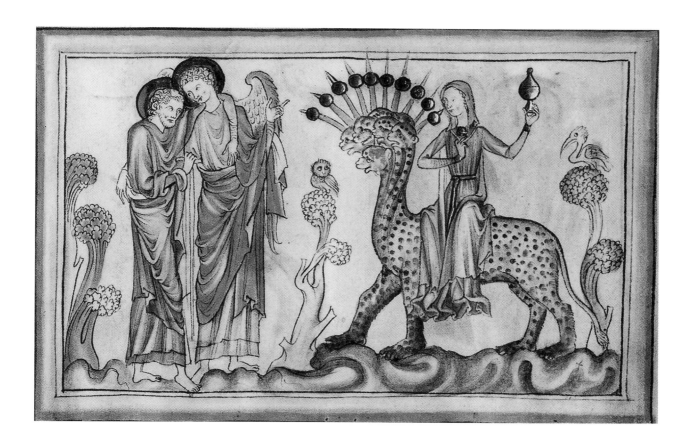

17 The Great Harlot seated on the Beast, Apocalypse, London, BL Add. 35166, f. 20r

18 The Marriage Feast of the Lamb, Apocalypse, London, BL Add. 35166, f. 23r

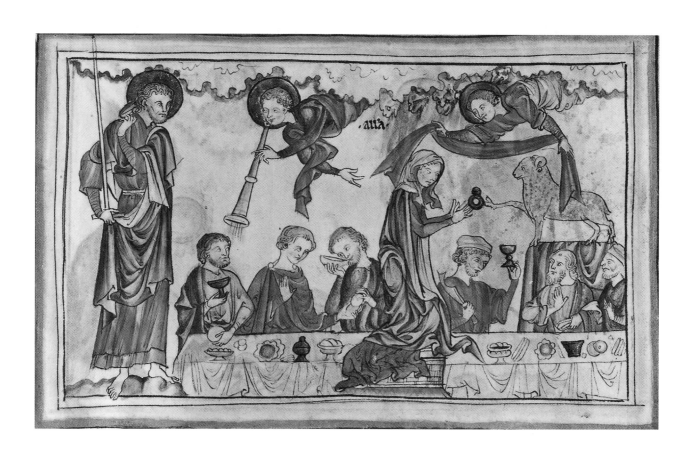

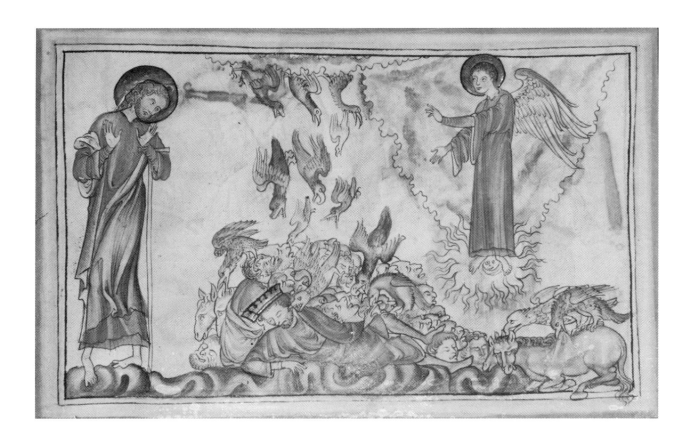

19 The Birds summoned by the Angel standing in the Sun, Apocalypse, London, BL Add. 35166, f. 24v

20 Godwin meets the young Alured; Alured brought before King Harold Harefoot, Life of St Edward the Confessor, Cambridge, UL Ee. 3.59, f. 5v

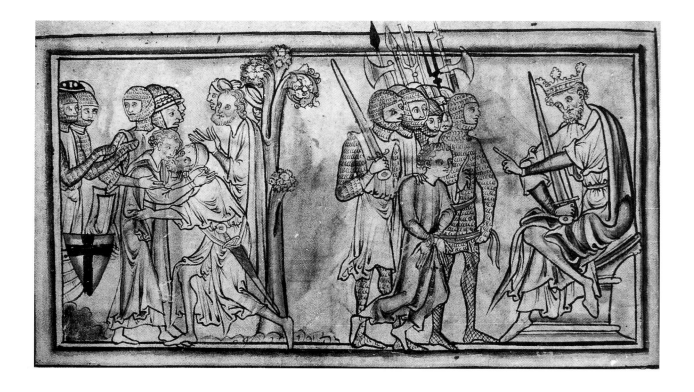

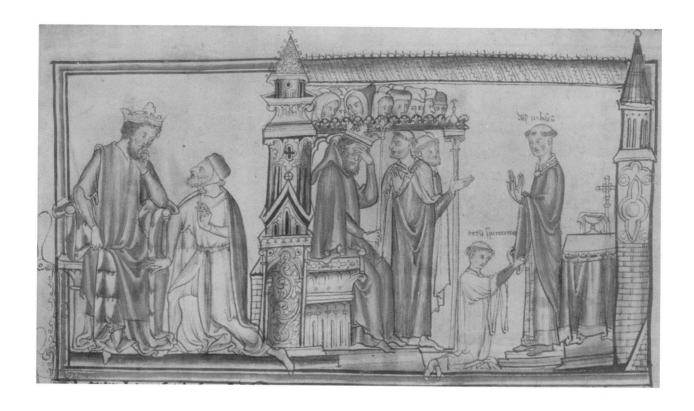

21 Harold kneeling before Edward; Edward at Mass, Life of St Edward the Confessor, Cambridge, UL Ee. 3.59, f. 27v

22 Kings Alfred, Edgar and Ethelred, Life of St Edward the Confessor, Cambridge, UL Ee. 3.59, f. 3v

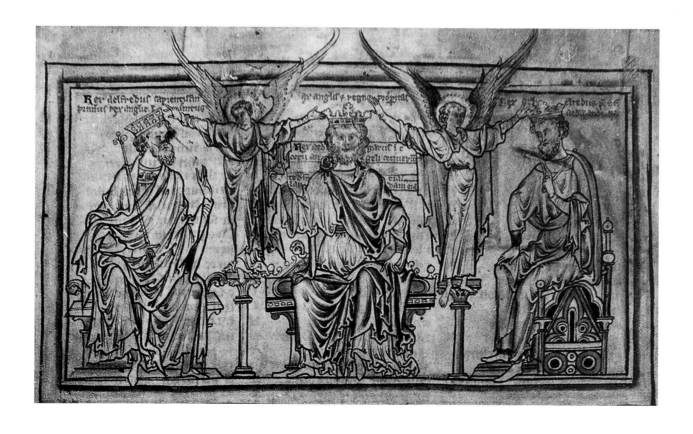

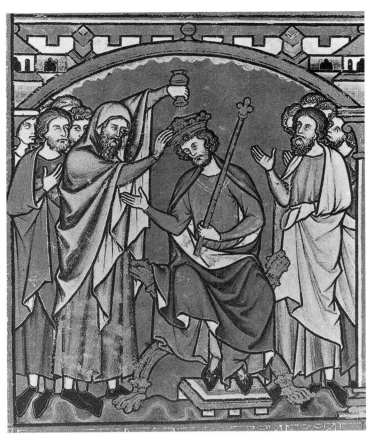

23 Anointing of Saul, Old Testament
Picture Book, New York, Pierpont
Morgan Library M. 638, f. 23v

24 The False Prophet orders men to
be marked; The Lamb adored on
Mount Sion, Apocalypse, New
York, Pierpont Morgan Library
M. 524, f. 12r

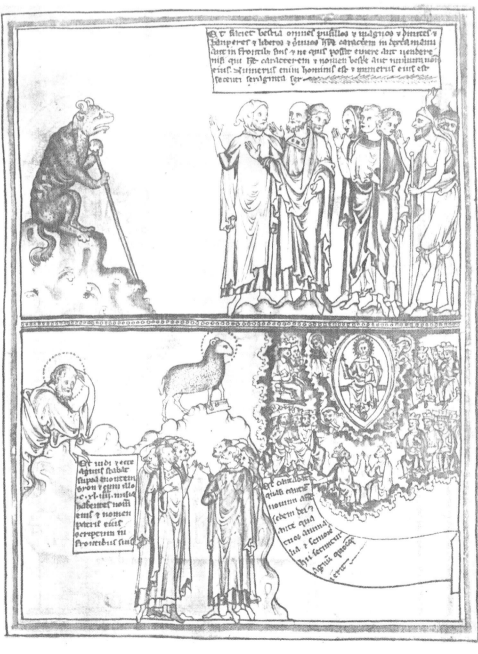

The Illustrations and Texts of the Getty Apocalypse*

Folio 1 recto

John before Domitian; John in the Cauldron of Boiling Oil

John is brought before the Emperor Domitian when he has been sent to Rome by the proconsul of Ephesus. Domitian orders him to be tortured in a cauldron of boiling oil. The text is introduced by an ornamental initial with two hybrid creatures and scrolls on gold, with an extension into the border incorporating a grotesque head and a rabbit.

PROLOGUE:[1] Greeting to the divine Caesar and always majestic Domitian, from the proconsul of Ephesus! We bring to your knowledge, glorious lord, that a man called John, of the race of the Hebrews, has come to Asia to preach Jesus Christ crucified, and he asserts that he is truly a god and son of God. He destroys the cult of our invincible gods and endeavours to completely destroy the venerable temples set up by our predecessors. This enemy, who seems to be a sorcerer and to commit sacrilege against our imperial law, with his magic arts and preaching leads all the people of the city of Ephesus to honour a man who died by crucifixion. But we, who are zealous to preserve the cult of the immortal gods, have ordered that he is to be handed over to our courts of justice, such that he, according to the decree of your sovereign power, by persuasion or threat, should abjure his Christ and offer libations as pardon to the all-powerful gods. Having not been able to persuade him by any means, we have reported this matter to you, in view of your authority, that we should know the will of your majesty in this affair. After reading the letter of the proconsul, the furious Domitian wrote to him that John was to be sent in chains from Ephesus to the city of Rome. The proconsul, in obedience to the imperial will, took the blessed John the apostle in chains to Rome, and announced his arrival to the Emperor Domitian. In indignation, the very cruel Domitian ordered the proconsul to have John plunged into a cauldron of boiling oil in front of the gate called 'Latin' in the presence of the Senate, after first having him scourged. And that was what was done. The grace of God protecting him, he came out completely unharmed, preserved whole from any damage to his flesh.

Folio 1 verso

John disembarks on Patmos

John is exiled to the island of Patmos by Domitian. Here he dis-

* Capitalisation, punctuation and spelling in the translation of the commentary into English follow modern conventions, but the texts from Holy Scripture and psalm numbers follow those of the Douay-Rheims Version of the Vulgate Bible, taken from the Baronius Press edition, London, 2008. In cases where the text in the Getty Apocalypse is illegible through deterioration of the ink, the reading has been supplied from the Escorial Apocalypse.
[1] This letter, supposedly written by the proconsul of Ephesus to the Emperor Domitian, was sometimes used as a prologue to the Apocalypse.

embarks from the boat on to the island, roughly pushed by one of the boatmen.

PROLOGUE (cont.): Seeing him coming out of the cauldron refreshed and not burnt, the proconsul was completely amazed, and wished him to be set free; and might have acted so, but feared to go against the instruction of the ruler. When that which had taken place was reported to Domitian, he ordered that John the apostle should be exiled to an island named Patmos, where he saw and wrote down the Apocalypse that is read as being in his name. As for Domitian, he was killed by the Roman Senate in the same year that he ordered John to be exiled. To worthily praise the memory of the most holy apostle and evangelist John, and the apostolic constancy of this adorer of Christ, a splendid church was later built in the aforementioned place before the Latin Gate, where the faithful still assemble today to celebrate his feast. After the assassination of Domitian by the Senate, John's exile was ended and he returned to Ephesus. There, all the bishops and priests of Asia appealed to him to refute the wiles of the heretics. Although they already had in three books of the Gospels texts on the humility of the Saviour, they wished that he should speak of his divinity, leaving his writings for posterity, chiefly such that he might suppress the heresy of those who were saying that Christ could not have existed before Mary. The blessed apostle at first refused what they had asked of him. He only asked of those sinners that, persevering in prayer in their heart, they should pray to the Lord during a fast for three days. That they did, and on the third day he was filled with grace by the Holy Spirit such that he was able to give an exact interpretation, and inspired in the spirit to behold the divinity of the Father, the Son and the Holy Spirit, and to drink at the most pure fountain of eternal grace, such that he was able to express it wholly to us. That is why his Gospel begins with the words: In the beginning was the Word, and the Word was with God, and the Word was God.

Folio 2 recto

John on Patmos woken by the Angel

St John, with a book behind his head, lies asleep on the island of Patmos to which he has been exiled. The island is surrounded by four smaller islands, each labelled with its name: Tilis, Garmasia, Sardis and 'Bosforum Mare', the latter probably referring to the location of the island in the Bosphorus, rather than giving it a name. The angel comes to waken John, laying his hand on his shoulder. The historiated initial below shows John standing preaching to a group of seated people, set against a gold ground with an incised diaper pattern. He holds a scroll which bears the words: 'Blessed is he that readeth and heareth the words of this prophecy' (Revelation 1 v. 3). An extension from the initial ends in a foliate coil.

TEXT: *Revelation 1 vv. 1, 9–11; 2 vv. 1, 8, 12, 18; 3 vv. 1, 7, 14. Here begins the Apocalypse of John the apostle.* The Revelation of Jesus Christ, which God gave unto him, to make known to his servants the things which must shortly come to pass: and signified, sending by his angel to his servant John. I John, your brother and your partner in tribulation, and in the kingdom, and patience in Jesus, was in the island, which is called Patmos, for the word of God, and for the testimony of Jesus. I was in the spirit in the Lord's day, and heard behind me a great voice, as of a trumpet, saying: What thou seest, write in a book, and send to the seven churches, to Ephesus, and to Smyrna, and to Pergamum, and to Thyatira, and to Sardis, and to Philadelphia, and to Laodicea. And write to the angel of Ephesus. And to the angel of Smyrna write. And to the angel of Pergamum write. And to the angel of Thyatira write. And to the angel of Sardis write, and to the angel of Philadelphia write. And to the angel of Laodicea write.

COMMENTARY: Apocalypse signifies revelation. This revelation has been given by the Father to the Son in virtue of his being man, and that he himself was the Son, such that he was able to know his divinity in the form of man that he had taken upon himself. *To make known to his servants the things which must shortly come to pass.* This book tells not only of the future but also of the present and the past. Why does it say that Our Lord Jesus Christ only reveals to his servants future events? Because clearly the present is easily known by seeing, the past by hearing, but the future cannot be known if not through the teaching of Holy Scripture, or by the revelation able to be known by them from God. *And signified, sending by his angel to his servant John.* The Lord Jesus sent his angel, and by this same angel revealed to his servant John that which must shortly come to pass. *I John etc.* He calls his disciples his brothers because they have been redeemed through the blood of Christ, and they are incorporated in the one mother Church. They were united together in the second persecution because the persecution of Domitian disturbed all the churches. *I was in the spirit (in the Lord's day) etc.* He says that he was in the spirit because all the mysteries that follow are able to be understood, not by the eyes in the flesh, but seen spiritually. *But the sensual man perceiveth not these things that are of the Spirit of God* (I Corinthians 2 v. 14). As for the Lord's day, this signifies the time of the Gospel.

Folio 2 verso

The Seven Churches of Asia

John stands outside the frame of the picture in which the seven churches of Asia are shown, each surmounted by its angel: Ephesus, Smyrna, Pergamum, Thyatira, Sardis, Philadelphia and Laodicea. The initial at the beginning of the Apocalypse text contains ornamental coils and heads of a man and a woman.

TEXT: *Revelation 2 vv. 1–2, 7–8, 12, 17–18, 26, 28; 3 vv. 1, 5, 7, 12, 14, 21.* These things saith the Lord to the church of Ephesus. I know thy works and thy labour and thy patience and how thou

canst not bear them that are evil. To him that overcometh I will give to eat of the tree of life, which is in the paradise of my God. And write to the angel of Smyrna [the text lacks what was to be written to Smyrna, and also omits 'And write to the angel of Pergamum', introducing what follows, that is to be written to Pergamum]. These things saith he that hath the sharp two-edged sword. To him that overcometh I will give the hidden manna, and will give him a white counter, and in that counter a new name written, which no man knoweth, but he that receiveth it. And to the angel of Thyatira write: These things saith the Son of God. Whoever shall overcome, and keep my works unto the end, I will give him power over the nations, and I will give him the morning star. And to the angel of Sardis write: Whoever shall overcome shall thus be clothed in white garments, and I will not blot his name out of the book of life. And to the angel of Philadelphia write: Whoever shall overcome I will make him a pillar in the temple of my God. And to the angel of Laodicea write: Whoever shall overcome I will give to sit with me in my throne, as I also have overcome, and am set down with my Father in his throne.

COMMENTARY: These seven churches, as the interpretation of their names shows, refer to the one Catholic Church. Ephesus is interpreted as will or counsel. Smyrna, their song. Pergamum, the division of the horns. Thyatira is the enlightened. Sardis, the source of beauty. Philadelphia, preserving the inheritance of God. Laodicea, the family pleasing to God. Ephesus, however, placed at the head, signifies the beginning of the conversion of each of the others. Smyrna here is supposed to be interpreted as those who sing their song. Song in a good manner, with the contrition of the heart, is prayed for the mercy of its founder. Pergamum is interpreted as the division of horns, for we have divided the horns when, discerning between good and bad, we drive away the bad from us, and embrace good. Thyatira, following, is interpreted as the enlightened, because by carrying out the commandments of God the beauty of the soul increases. Sardis is interpreted as the source of beauty, because the beauty of the saints begins in this life and is made perfect in eternal bliss. Philadelphia is said to maintain the inheritance of God, that is for all the multitude of the elect. Laodicea is interpreted as the family pleasing to God, for the family pleasing to God is all of the elect who establish the Church by renouncing vice and practising virtue, who are called the family pleasing to God.

Folio 3 recto

The Vision of Christ and the Seven Candlesticks

John prostrates himself before the vision of Christ seated between the seven candlesticks. Christ has the two-edged sword in his mouth, and holds in his left hand a pair of keys and a book inscribed Alpha and Omega. The ornamental initial below has foliage coils coming out of a man's mouth.

TEXT: *Revelation 1 vv. 12–18, 20, 19.* And I saw seven golden candlesticks: and in the midst of the seven golden candlesticks,

one like to the Son of man, clothed with a garment down to the feet, and girt about the paps with a golden girdle. And his head and his hairs were white, as white wool, and as snow, and his eyes were as flame of fire, and his feet like unto fine brass, as in a burning furnace. And his voice as the sound of many waters. And he had in his right hand seven stars. And from his mouth came out a sharp two-edged sword: and his face was as the sun shineth in his power. And when I had seen him, I fell at his feet as dead. And he laid his right hand upon me, saying: Fear not. I am the First and the Last, and alive, and was dead, and behold I am living for ever and ever, Amen. The mystery of the seven stars, which thou sawest in my right hand, and the seven golden candlesticks. The seven stars are the angels of the seven churches, and the seven candlesticks are the seven churches. Write therefore the things which thou hast seen, and which are, and which must be done hereafter.

COMMENTARY: *And I saw seven candlesticks.* The seven golden candlesticks signify the seven churches, and the seven churches the one Catholic Church. These candlesticks are said to be of gold on account of the persecutions that the saints have suffered in the centuries on account of the wisdom that has enlightened them. In the midst of them Christ appears standing, as it is said in the Gospel: *Behold I am with you all days, even to the consummation of the world* (Matthew 28 v. 20). It continues *clothed with a garment down to the feet etc.* The long robe, which is a tunicle extending to the heels, signifies the just who were before the Flood. By the girdle, the patriarchs and those just people who were before the Law are signified, and it is said to be of gold because many tribulations are known to have tested them as gold in the furnace. By the paps are signified the two precepts of charity. *And his head and hairs were white, as white wool, and as snow.* By the head the Law is signified, by the hairs which come out of the head are signified the multitude which have been saved by the Law. By the eyes, however, are signified the prophets who have long obtained foresight of things to come in the future. By the feet the apostles are signified. By the sword the elect who shall be born at the end of the world, and who shall fight against the Antichrist.

Folio 3 verso
The Vision of Heaven

John peeps through a small window at the vision of God enthroned in heaven in a mandorla surrounded by the four living creatures, the angel (or man), the eagle, the lion and the calf (or bull as it is usually termed), and by the twenty-four crowned ancients,[2] seated in groups of six. God holds a sceptre and the book with the seven seals, from his throne come animal heads, representing the lightnings, thunders and voices, and behind him are the seven lamps. The ancients hold a variety of musical instruments. The ornamental initial below contains foliage coils and has the bust of a man in the terminal of its stem.

TEXT: *Revelation 4 vv. 1–8.* After these things I looked, and behold a door was opened in heaven. And behold there was a throne set in heaven, and upon the throne one sitting. And there was a rainbow round about the throne, in the sight like unto an emerald. And round about the throne were four and twenty seats; and upon the seats, four and twenty ancients sitting, clothed in white garments, and on their heads were crowns of gold. And from the throne proceeded lightnings, and voices, and thunders; and there were seven lamps burning before the throne, which are the seven spirits of God. And in the sight of the throne was, as it were, a sea of glass like to crystal; and in the midst of the throne, and round about the throne, were four living creatures. And the first living creature was like a lion: and the second living creature like a calf: and the third living creature, having the face, as it were, of a man: and the fourth living creature was like an eagle flying. And they rested not day and night, saying: Holy, holy, holy, Lord God Almighty, who was, and who is, and who is to come.

COMMENTARY: *After this I saw a door open in heaven.* By the door, is understood Christ, who said: *I am the door: whosoever enters through me shall be saved* (John 10 v. 9). And the door is said to be open, because for all wishing to come to him, however much weighed down with guilt, the door of his mercy is worthy to open. *And behold there was a throne.* The throne that is in heaven signifies the hearts of the saints living in the Church. Sitting above on the throne is God, who dwells in the hearts of his saints, as the apostle says: *For the temple of God is holy, which you are* (I Corinthians 3 v. 17). *And there was a rainbow etc.* The rainbow in its curve around the seat of God, is the Church, which surrounds us with its mercy, protects, governs and defends us against invisible enemies. *And round about the throne there were seats etc.* The twenty-four ancients in this book represent the fathers of the Old Testament, and sometimes of the New, sometimes both at the same time. *And from the throne,* that is to say the Church, *proceeded lightnings and voices.* By the lightnings are signified the miracles that God has worked through his saints. By the voices, preaching is signified. By the thunders is signified the terror of the fire of Gehenna.[3] The seven lamps are the seven gifts of the Holy Spirit. By the sea of glass is symbolised the New Testament. The four animals are called the four evangelists.

Folio 4 recto
The Angel proclaims 'Who is worthy?'; John weeps and is consoled by one of the Ancients

On the right of a tree, holding a scroll which has not been inscribed, the angel proclaims: 'Who is worthy to open the book?' As nobody comes forward, John weeps, and is consoled by one of the ancients who also holds a scroll inscribed with the words: 'And one of the ancients said to me "Do not weep".' The ornamental initial below contains foliage coils.

[2] I have used the word 'ancients' because this is used as the translation of 'seniores' in the Douay-Rheims Bible. The King James Bible uses 'elders', which may be more familiar to some readers.

[3] The commentary, as in the Apocalypse text, usually uses the word 'infernus' for Hell. Here, 'Gehenna' is used to mean 'Hell', a word which occurs several times in the Gospel of Matthew.

TEXT: *Revelation 5 vv. 2–5.* And I saw a strong angel, proclaiming with a loud voice: Who is worthy to open the book, and to loose the seals thereof? And no man was able, in heaven, nor in earth, nor under the earth, to open the book, nor to look on it. And I wept much, because no man was found worthy to open the book, nor to see it. And one of the ancients said to me: Weep not; behold the lion of the tribe of Judah, the root of David, hath prevailed to open the book and loose the seals thereof.

COMMENTARY: The strong angel signifies the Fathers of the Old Testament, who prophesied with a loud voice; for they prophesied that Christ would come to redeem the human race. *Who is worthy to open the book and loose the seals?* The angel's question signifies the wish of the saints; the saints wished to see Christ in the flesh, and to hear his words; for they knew that all the mysteries of the Old Testament were to be revealed by him. *And nobody was found worthy etc.* No angel inhabiting heaven, no just man on earth, none of those who had already paid their debt to death, no longer in the world, appeared, such that he should redeem the human race from the power of the Devil, yet that redemption is revealed in the Old Testament. *And I wept much etc.* John wept that nobody was worthy to open the book, but one of the ancients says that it is by the lion, that is to say by Christ, that the book is to be opened. So by the strong angel are signified those desiring the coming of Christ who are asking at what time he shall come. John represents those who wept because this time was so long delayed. The ancient signifies the prophets who said how and at what time he would come. By the lion, however, is to be understood the tribe of Judah, that is Christ, who as the descendant of David is of the tribe of Judah. He is called the lion, who on account of his strength conquered the Devil and rescued the elect from his power. Thus the lion of the tribe of Judah, the root of David, conquered the Devil in order to open the book and its seven seals, because the book cannot be opened until the Devil is conquered, a victory which is revealed in the Old Testament. How he will open the seals we speak of later.

Folio 4 verso

Adoration of God by the Twenty-Four Ancients and the Angels

John bends down to peep through a small opening in the picture frame to behold the vision of God, seated on the rainbow, holding the book of the seven seals and an orb. On both sides the ancients stand and kneel in adoration, some offering their crowns to God, and, above, the angels kneel before him. The ornamental initial below contains foliage coils and a dragon, and a grotesque shooting an arrow is perched at the bottom of its stem.

TEXT: *Revelation 4 vv. 10–11.* After this I saw the four and twenty ancients before him that sitteth on the throne, adoring him that liveth for ever and ever. And they cast down their crowns before the throne saying: Thou art worthy, O Lord our God, to receive glory, and honour, and power: because thou hast created all things; and for thy will they have been created.

COMMENTARY: The twenty-four ancients can be understood here as the fathers of the New Testament. They fell down before him who sat on the throne and adored him that liveth for ever, because the saints of God throughout the world, hearing the teaching of the Gospel, humble themselves in the presence of God that liveth for ever. *And they cast down their crowns etc.* By the crowns we say is to be signified good works: the saints therefore place their crowns before the throne, for whatever good things they do they attribute to God, not to themselves, according to the instruction of the Apostle: *He that glorieth, let him glory in the Lord* (II Corinthians 10 v. 17). But let us hear what they are saying: *Worthy is the Lord our God to receive glory and honour and power.* It has been said before that the four living creatures give glory and honour and blessing to God: in this case the four and twenty ancients are saying that the Lord has received glory and honour and power, power being substituted for blessing. Therefore the saints give glory to God when they do anything good, for they do it with zeal such that God is glorified through them, just as it says in the Gospel: *That they may see your good works, and glorify your Father who is in heaven* (Matthew 5 v. 16). They give honour when in all that they do they seek the honour of God, and not of themselves. Earlier, in the third place, has been put blessing. Here, however, it is also with power, because the saints through their great works are blessed among men, power with blessing. Then follows, *Because you are the Creator of all things etc.* Here the sense is to be understood that they were created by him who made all things that will be. All creatures were formerly created in the will and power of God, but they were created at the time determined by God. He created all things from nothing, yet in us he creates a pure heart. *Who (lives and reigns etc.).*

Folio 5 recto

The Lamb appears in Heaven

John kneels, placing his head through an opening in the frame, to look at the Lamb standing on an altar-like structure, surrounded by the four living creatures. Blood from his side pours into a chalice, he has seven horns and seven eyes, and holds a banner surmounted by a cross. The twenty-four ancients sit in four groups of six, some holding musical instruments. The historiated initial contains a man standing amid coils pointing upward.

TEXT: *Revelation 5 v. 6.* And I saw: and behold in the midst of the throne and of the four living creatures, and of the ancients, a Lamb standing as it were slain, having seven horns and seven eyes: which are the seven spirits of God, sent forth into all the earth.

COMMENTARY: By the throne and the four living creatures and the ancients one Church with all its orders is signified. The Lamb is certainly not slain, but seen as if slain; because he experiences death but in passing, shortly afterwards rising up, *dieth now no more, death shall no more have dominion over him* (Romans 6 v. 9). Who is seen as having *seven horns and seven*

eyes. What of the seven eyes that he shows, when it adds *which are the seven spirits of God, sent out into the earth?* By the horns, kingdoms are often signified. But for me the horns seem to have one meaning and the eyes another. By the seven horns all the elect are signified that are called to the kingdom of God, and this multitude we divide into seven parts. The first horn pertains to the elect who were before the Flood; the second to those who were after the Flood to the time of the Law; the third to those who were under the Law; to the fourth the prophets; to the fifth the Jews who believed in Christ; to the sixth the people of the Gentiles; to the seventh those who are born at the end of the world and are to fight with Antichrist. For Christ is sometimes called the Lamb, other times the lion. The lion, on account of his strength, has conquered the Devil, and has released his elect from his power. The Lamb, however, is called Christ on account of the gentleness with which he is endowed.

Folio 5 verso
The Lamb takes the Book with the Seven Seals

John again looks through an opening in the frame to behold the vision of the Lamb taking the book with the seven seals from God. The four living creatures surround the mandorla, and the angels above adore the Lamb. The ancients, kneeling, have cast down their harps and vials before the Lamb. The historiated initial below shows an elephant at the top and at the bottom a lamb on a pedestal beside two men wrestling.

TEXT: *Revelation 5 vv. 7–14.* And I saw, and behold the Lamb took the book out of the right hand of Him that sat on the throne. And when he had opened the book, the four living creatures, and the four and twenty ancients fell down before the Lamb, having every one of them harps, and golden vials full of odours, which are the prayers of the saints: and they sung a new canticle, saying: Thou art worthy, O Lord, to open the book,[4] and to open the seals thereof; because thou wast slain, and hast redeemed us to God, in thy blood. And I beheld, and I heard the voice of many angels round about the throne, and the living creatures, and the ancients; and the number of them was thousands and thousands, saying with a loud voice: The Lamb that was slain is worthy to receive power, and divinity, and wisdom, and strength, and honour, and glory, and benediction. And every creature, which is in heaven, and on earth, and under the earth, and such as are in the sea, and all that are in them: I heard all saying to Him that sitteth on the throne, and to the Lamb: Benediction, and honour, and glory, and power, for ever and ever. And the four living creatures said: Amen.

COMMENTARY: Earlier we have said that by him that is sitting on the throne Christ was signified, but because he himself said: *I am in the Father and the Father is in me, and whoever sees me sees the Father* (John 14 vv. 9, 10), in this case he that is sitting on the throne signifies the Father. On the right of the Father is the Son, for the Lamb symbolises the humanity that Christ has assumed. Therefore the Lamb receives the book from him that

[4] The text reads 'to take the book' in the Vulgate.

sits on the throne, because Christ the man receives from his own divinity, what he revealed in the mysteries of divine scripture. The ancients fall down before the Lamb when, meditating on divine scripture and considering the immense mercy of God, they humble themselves in the presence of their creator. The golden vials are said to be the hearts of the saints full of perfumes.

Folio 6 recto
The First Seal: The Rider on the White Horse

John, now within the frame of the picture, his hand held by the angel (man), who is one of the living creatures that speaks to him, looks on as the crowned rider on the white horse shoots an arrow with his bow. The ornamental initial below contains foliage coils coming out of a man's mouth, and at the base of the stem an ape and a male head.

TEXT: *Revelation 6 vv. 1–2.* And after that I saw that the Lamb had opened one of the seven seals, and I heard one of the four living creatures, as it were the voice of thunder, saying: Come and see. And behold a white horse, and he that sat on him had a bow, and there was a crown given him, and he went forth conquering that he might conquer.

COMMENTARY: The opening of the first seal refers to those who were before the Flood. The Lamb opens the first seal when those that were before the Flood are understood by the Doctors of the Church in the spiritual manner that the grace of the Holy Spirit opened up. *And I heard one of the four beasts etc.* The first beast has the same meaning as the second, third and fourth, for they signify the Doctors of the Church. For when he says *Come and see* he calls out to our spiritual understanding as he said 'Come', not for the satisfaction of the body but for the satisfaction of the spirit, and spiritual understanding of these things of which you have read that have occurred at the beginning of time. *And behold a white horse and he that sat on him had a bow etc.* The white horse signifies the just men that were before the Flood, who on account of their innocence are called white. The horseman is the Lord who for ever presides over his saints. The bow, however, that sends far its arrows, which cause wounds, can signify the vengeance of the Lord, who has condemned the first men for their disobedience, and who has punished Cain seven times over, guilty of fratricide. The crown has no other signification for the white horse than the just people who lived before the Flood. *He went forth conquering that he might conquer* when he decided to destroy by the waters of the Flood the multitude of reprobates. To the conqueror, that he might conquer, honour and glory be for ever and ever. Amen.

Folio 6 verso
The Second Seal: The Rider on the Red Horse

The lion, the second of the four living creatures, flies down to speak to John to introduce him to the second rider on the red horse who brandishes a sword. The ornamental initial below contains two dragons.

TEXT: *Revelation 6 vv. 3–4.* And when the Lamb had opened the second seal, I heard the second living creature saying: Come and see. And there went out another horse that was red: and to him that sat thereon, it was given that he should take peace from the earth, and that they should kill one another, and a great sword was given to him.

COMMENTARY: The second seal relates to the making of the Ark and to the just who were before the Law. By the red horse are signified the just who were after the Flood until the Law. And because the colour red approaches to some extent the colour of gold, just as if you mix blood with the colour gold, the holy men that were before the Law are not unreasonably compared to this colour. That they shone with wisdom is signified in the gold, and that they were constant in persecution and in adversity, is signified by blood. The horseman on this horse is the Lord who dwells with his saints. To this horseman it is given that he should take peace from the earth. If a good peace is from God, in what manner is it taken from the earth? But there is a good peace and there is an evil peace. The sons of God had an evil peace with the sons of man before the Flood, when they took their daughters and gave their own to them, and on account of that they were destroyed with them by the waters of the Flood.[5] But the Lord instructed the sons of Israel that they should not enter into alliance with the Canaanites, or take their daughters, or give their daughters to them.[6] The psalmist has spoken concerning good and evil peace, saying: *And with the elect thou wilt be elect, and with the perverse thou wilt be perverted* (Psalm 17 v. 27). Thus God took away peace from the earth when he separated just men from wicked men in mind, not in body. *And that they should kill one another.* For those from whom peace is taken away, a consequence is that they should be killed by one another. For often the just are those who have killed the unjust, or the unjust have killed the just, as for Aram, the brother of Abraham in Ur of the Chaldees,[7] and as for Abraham killing the four kings.[8] By the great sword we are able to recognise the waters of the flood by which all the world was destroyed.

Folio 7 recto
The Third Seal: The Rider on the Black Horse

John's hand is held by the third living creature, the bull, who introduces a man riding on a black horse holding a pair of scales, to which he points. The ornamental initial below contains two hybrids with male and female heads.

TEXT: *Revelation 6 vv. 5–6.* And when the Lamb had opened the seal, I heard the third living creature saying: Come and see. And behold a black horse; and he that sat on him had a pair of scales in his hand. And I heard as it were a voice in the midst of the four living creatures, saying: Two pounds of wheat for a penny, and thrice two pounds of barley for a penny, and thou hurt not the wine and the oil.

[5] Genesis 6 vv. 1–7. [6] Genesis 28 vv. 1–8.
[7] Genesis 11 v. 28. [8] Genesis 14 vv. 14–17.

COMMENTARY: By the black horse we can understand the Doctors of the Law; the blackness of the horse signifies the obscurity of the law that they taught or its harshness. For Moses had a veil covering his face, because the radiance of his face, which is the spiritual understanding of the Law, could not be seen by eyes which were bleary. The horseman on the horse is the Lord: the pair of scales shows the fairness of the judgement of the Law, that is *A life for a life, an eye for an eye, a tooth for a tooth, a foot for a foot* (Exodus 21 vv. 23–4). *And I heard a voice etc.* The voice in the middle of the four living creatures can be taken to be the voice of the Church, imploring the Lord for mercy. *Two pounds of wheat for a penny, and thrice two pounds of barley for a penny, and thou hurt not the wine and the oil.* Great are the things laid out. Through the wheat, out of which the best bread is produced, we are able to receive divine scripture, which is the bread of souls. Two pounds of wheat signifies the two Testaments into which divine scripture is divided. Out of these two pounds of wheat the holy fathers prepared for us a great abundance of food which they have expounded in many ways. The penny signifies God. For the two pounds of wheat are joined to the penny because of what Holy Scripture says in regard to the one omnipotent, great, good, and austere God, that all the good things that we do for our neighbours come from him, and not from ourselves. By the roughness of the barley the works of the saints are signified, that are hard to carry out, but hope makes them agreeable, just as the Lord says: *For my yoke is sweet and my burden is light* (Matthew 11 v. 30).

Folio 7 verso
The Fourth Seal: The Rider on the Pale Horse

For the vision of the fourth rider John is outside the frame, and the eagle who introduces the rider is flying towards him through a window in the frame. The rider on the pale horse holds a bowl flaming with fire in one hand,[9] and in the other a fleshhook held at the other end by a devil perched amid a group of heads of those in the mouth of Hell. The ornamental initial below contains foliage coils and a dragon.

TEXT: *Revelation 6 vv. 7–8.* And when he had opened the fourth seal, I heard the voice of the fourth living creature, saying: Come and see. And behold a pale horse, and he that sat upon him, his name was Death, and Hell followed him. And power was given to him over the four parts of the earth, to kill with the sword, with famine, and with death, and with the beasts of the earth.

COMMENTARY: The opening of the fourth seal refers to the prophets, who foretold plainly and in various figures the coming

[9] The bowl of flaming fire is explained by a passage in the Berengaudus commentary which is not included in the commentary extract in the Getty Apocalypse. In the English Apocalypse more or less contemporary with the Getty Apocalypse, Oxford, Bodleian Library Auct. D. 4.17, the relevant passage of the commentary text is included in the picture, and reads: 'By the fire that the rider has in his hand, the fury of the Lord is signified, by which the reprobates will be punished.'

[42]

of Christ, his passion, his resurrection and the calling of the peoples. Therefore Our Saviour opened the fourth seal, when he gave the understanding of the prophets to the Doctors of the Church. Concerning the sayings of the prophets it is not necessary for us to speak, as they have been expounded by the Doctors. *And behold a pale horse.* The pale horse represents the prophets. Pallor affects men in various ways, sometimes as a result of fear, sometimes through weariness, sometimes when death takes over their whole body, and they become pale in many other ways. This is why the prophets, who preached to the sinful people, that they should be delivered from plunder, the sword and destruction, are said not inappropriately to have had a pale colour. The horseman is the Lord who dwells in the prophets. But he is seen to be severe because he is named Death. Yet he himself is the life of all the elect as he says: *I am the life* (John 14 v. 6), but if we closely examine the divine scriptures we will find that Our Lord is also called Death. For just as life belongs to all the elect, for every day eternal life is granted to them, so he is able to bring eternal death to the reprobates every day for their crimes, *to destroy both soul and body in Gehenna* (Matthew 10 v. 28). This rider is followed by Hell, because all who despised the threats of the prophets which they brought to the people from the mouth of the Lord, Hell swallows up. It continues: *And power was given to him etc.* By the four parts of the earth, all the land of Israel is signified. The manner by which they shall be destroyed, by the sword, by famine, by death, by the beasts of the earth, the books of the Prophets and the Kings clearly show.

Folio 8 recto
The Fifth Seal: The Souls of the Martyrs

John is again standing within the frame as he sees two angels clothing the 'souls of them that were slain for the word of God', who are also given stoles. The stole is given because, although 'stole' in Latin means 'robes', the word was more commonly used in medieval Latin to denote the vestment, the stole, worn by priests and deacons. The souls of the martyrs are under the altar, on which is a chalice. Above, an angel flies down from heaven, holding a scroll, which probably signifies the message to the souls that they should 'rest for a little time'. The ornamental initial below contains foliage coils.

TEXT: *Revelation 6 vv. 9–11.* And when he had opened the fifth seal I saw under the altar the souls of them that were slain for the word of God, and for the testimony which they held. And they cried with a loud voice, saying: How long O Lord, holy and true, dost thou not judge and revenge our blood on them that dwell on the earth? And white robes were given to every one of them; and it was said to them that they should rest for a little time, till their fellow servants, and their brethren, who are to be slain, even as they, should be filled up.

COMMENTARY: The fifth seal, like the sixth and seventh, as we have said above, relates to the revelation of the New Testament. And although the New Testament is the revelation of the Old Testament, there are nevertheless many things in it that are obscure which it is necessary to explain. Thus the Saviour opened the fifth seal when he conferred on the Doctors of the Church the celestial glory that he promised, and glorified them in the world before men. *I saw under the altar etc.* The altar of God is Christ: the souls that rest under the altar are the saints because, just as the limbs are placed under the head and are connected to it, so the souls of the saints, brought together in heavenly glory, are set under Christ the Saviour, and joined to him by the conjunction of the limbs. *And they cried out with a loud voice etc.* Scripture instructs that evil should not be returned for evil, and the Lord says in the Gospel: *Love your enemies, do good to them that hate you* (Matthew 5 v. 44). Why is it that the saints brought together in heaven are demanding revenge on their enemies? But we know the saints of God long for that last day on which body and soul receive the full reward of their labours from the Lord. *And (white robes) were given to them etc.* The white robes are the glory of the souls of the saints. The saints of God now each possess white robes because, just as their bodies lie in the earth, their souls alone rejoice in eternal bliss. They shall have a second robe when, after the resurrection, their souls together with their bodies shall possess without end the celestial home. For there is only a short time until the day of judgement.

Folio 8 verso
The Sixth Seal: The Earthquake

John stands within the frame closely observing the effects of the earthquake which comes at the opening of the sixth seal. The sun has become black 'as sackcloth of hair' and the moon 'as blood', and the stars are falling down from both onto the earth. Men, including a king, are hiding themselves in the dens and rocks of the mountains. The king holds a scroll written upon in tiny script saying: 'And every mountain and the islands were moved out of their places. And the kings of the earth, and the princes, and tribunes, and the rich, and the strong, and every bondman, and every freeman, hid themselves in the dens and in the rocks of mountains.' The ornamental initial below contains foliage coils and a hybrid bird with a man's head. On the top stem of the initial perches a stork, with a man on the bottom terminal shooting an arrow towards the initial.

TEXT: *Revelation 6 vv. 12–17.* After these things I saw that when he had opened the sixth seal, behold there was a great earthquake, and the sun became black as sackcloth of hair, and the whole moon became as blood and the stars from heaven fell upon the earth, as the fig tree casteth its green figs when it is shaken by a great wind; and the heaven departed as a book folded up, and every mountain and the islands were moved out of their places. And the kings of the earth, and the princes, and tribunes, and the rich, and the strong, and every bondman, and every freeman, hid themselves in the dens and in the rocks of mountains: and they say to the mountains: Fall upon us, and hide us from the face of him that sitteth upon the throne and from the wrath of the Lamb, for the great day of their wrath is come, and who shall be able to stand?

COMMENTARY: The opening of the sixth seal refers to the rejection of the Jews and to the calling of the Gentiles. *And there was a great earthquake.* By the earth in this case the Jews are signified: there was a great earthquake when this people was destroyed by the Romans. *And the sun became black.* By the sun is signified the people of the Jews. The sun becomes black as a sackcloth of hair because the people of the Jews, who as a result of their knowledge of the one God, and on account of their keeping of the Law, shone as the sun in the world among the other nations, but become hateful to all men on account of their iniquities. For it is in sackcloth that penitents are clothed, that shows they are sinners. The sun became black as sackcloth because all people suffered from the crimes of the Jews. *And the moon became (as blood) etc.* The moon represents the synagogue. The moon appears as blood because it is clear to all that the Jews came to be destroyed through the shedding of the blood of Christ and of the saints.[10] *And the stars fell etc.* By the stars the princes of the priests, the scribes and the pharisees, are signified, and by the fig tree we are able to understand the land of the Jews. The green figs of this tree are considered useless fruit when they fall immediately the tree is shaken violently by the wind.

Folio 9 recto

The Four Angels holding the Winds; The Angel with the Sign of the Living God

John looks on at the four angels standing at the corners of the earth, holding heads representing the winds, whose mouths they stop up. The earth, on which there are three trees, is surrounded by the sea. At the right, flying across the frame into the picture, is the angel with the sign of the living God, represented as a document sealed with the sun. A placard comes out of the top right of the frame bearing the text: 'This angel signifies Christ'. The scroll held by the angel contains the words addressed to the four angels: 'Hurt not the earth, nor the sea, nor the trees, till we sign the servants of our God in their foreheads', with the seal of the document having 'the rising of the sun' written above it. The ornamental initial below contains foliage coils.

TEXT: *Revelation 7 vv. 1–3.* After these things I saw four angels standing on the four corners of the earth, holding the four winds of the earth, that they should not blow upon the earth, nor upon the sea, nor on any tree. And I saw another angel ascending from the rising of the sun, having the sign of the living God; and he cried with a loud voice to the four angels, to whom it was given to hurt the earth and the sea, saying: Hurt not the earth, nor the sea, nor the trees, till we sign the servants of our God in their foreheads.

COMMENTARY: *After these things I saw four angels.* By the four

angels is meant the four kingdoms, that is of the Assyrians, the Persians, the Macedonians and the Romans. But because the power of the four kingdoms had been transferred to the Romans, the four angels signify only the Romans, who had assumed the power of the four kingdoms. By the four corners are signified all the nations that are within the four regions of the world that became subject to the Romans. *Holding the four winds etc.* By the winds that chase the clouds to water the earth and to give it a joyful appearance, making it fertile, are signified the peace desired by all mortals. The angel ascending from the rising sun is Christ, of whom it is written: *And his name shall be called (the angel) of great counsel* (Isaiah 9 v. 6). The angel from the rising sun is he of whom it is written: *But unto you who fear my name, the sun of justice shall arise* (Malachi 4 v. 2). Christ comes down from the rising of the sun, that is to say by himself, who is created immaculate flesh out of the flesh of the Virgin. The sign of the living God is his divinity. *And he cried out etc.* His cry is his action, for at his coming he makes peace for the whole earth. In the words of the psalmist: *In his days shall justice spring up and abundance of peace* (Psalm 71 v. 7).

Folio 9 verso

The Multitude adore God and the Lamb; The Ancient explains to John

The vision shows God, seated at the top of the mandorla, surrounded by the four living creatures, within which the Lamb stands on a draped pedestal with its hoof on the book of the seven seals. On either side, the angels and the multitude holding palms adore God and the Lamb. At the left, one of the ancients explains to John who the multitude are, with his scroll inscribed with the words: 'These that are clothed in white robes who are come, and he said to me, with the Lord they rest.'[11] The historiated initial below contains a woman's head, in the stem is a grotesque man's head, and perched on the terminal is a man throwing a stone.

TEXT: *Revelation 7 vv. 9–15.*[12] After these things I saw a great multitude, which no man could number, of all the nations, and tribes, and peoples, and tongues, standing before the throne, and in the sight of the Lamb, clothed with white robes, and palms in their hands: and they cried with a loud voice saying: Salvation to our God, who sitteth upon the throne, and to the Lamb. And all the angels stood round about the throne, and the ancients, and the four living creatures; and they fell down before the throne upon their faces, and adored God, saying: Amen. Benediction, and glory, and wisdom, and thanksgiving, honour, and power, and strength to our God for ever and ever. Amen. And one of the ancients answered, and said to me: These that are clothed in white robes who are come out of great tribulation, and have washed their robes, and have made them

[10] This refers to the commonly held view in the Middle Ages that the terrible destruction of Jerusalem and the Temple by the Roman emperor Titus, in AD 70, was punishment by God for their rejection of Christ as the Messiah, and their rejection of the preaching of the apostles.

[11] The reading of the last two words is uncertain.

[12] The Latin text from the Vulgate in the manuscript omits the second part of v. 13 and the first part of v. 14, which in English translation are: 'Who are they? and whence came they? And I said to him: My Lord, thou knowest. And he said to me: These are they . . .'

white in the blood of the Lamb. Therefore they are before the throne of God, and serve him day and night in his temple: and He, that sitteth on the throne, dwells over them.

COMMENTARY: By the crowd above, which no man could number, are to be understood the elect who labour in the Church of God, each one in his own time. The white robes symbolise the purity of their souls. The palms they hold are signs of victory, for the saints and elect that have the palms possess eternal bliss. *And one of the ancients etc.* The ancient asks in order to teach, and he represents the Doctors of the Church, and John signifies the audience. *And he said to me etc.* Here are shown the things which do not relate to the elect who labour in this life, but to those who rest with the Lord in the celestial life. The saints do not come at a time of great tribulation, but they come to suffer great tribulations in the world, just as Solomon says: *Man is born to labour and the bird to fly* (Job 5 v. 7).

Folio 10 recto
The Seventh Seal: The Giving of the Trumpets

John, his back turned, looks through a large window to behold this vision. God sits on the rainbow in the centre, his hand raised in blessing, while on either side two angels distribute the seven trumpets to those angels who are to blow them. The ornamental initial below contains foliage coils and two male heads on hybrid feathered bodies.

TEXT: *Revelation 8 vv. 1–2.* And when he had opened the seventh seal there was silence in heaven, as it were for half an hour. And I saw seven angels standing in the presence of God; and there were given to them seven trumpets.

COMMENTARY: The opening of the seventh seal relates to the birth of Christ, but it has to be asked why this relates to the seventh and not the fifth.[13] In Genesis it is written that God created all that is in heaven and earth in six days, but that he rested on the seventh day. For that reason the seventh day is called the sabbath, that is rest. What is our rest if not Christ? Thus there is good reason to relate the opening of the seventh seal to the birth of Christ, for he is the rest of all his saints, which is symbolised by the seventh day. *There was silence etc.* By the silence is signified the peace that under Octavius Augustus existed throughout the world, at which time Christ was born. The silence was for but half an hour, because the peace that the Church had under the pagans in the beginning lasted but a short time; for it was broken by the Emperor Nero, and when Peter and Paul had been killed he ordered all Christians to be persecuted. *And I saw seven angels etc.* The manner of presenting these seven angels is explained as follows; for just as a herald is sent before a king or prince to announce his coming, thus

[13] This enigmatic statement probably results from the idea that Christ was born at the beginning of the fifth age of the world, and thus his nativity is associated with the number five, not seven. Also, the commentary on the opening of the fifth seal tells us that this relates to the revelation of the New Testament.

John, because great things were signified by the angels, wished to mention them before he came to their story.

Folio 10 verso
The Angel receives Incense and Fire from the Altar in Heaven; The Angel empties the Censer upon the Earth; The Thunders, Lightnings, Voices and Earthquake

John, in a kneeling position, looks through a small opening at the vision of the angel on the left being given incense, and on the right filling the censer with the fire from the altar of God, over which God is enthroned amidst flames. The angel then casts the fire and incense on the earth, which causes, on the far right, thunders and lightnings, voices, and an earthquake, to come upon the earth. The historiated initial below shows a man and woman struggling with each other.

TEXT: *Revelation 8 vv. 3–5.* And another angel came, and stood before the altar, having a golden censer; and there was given to him much incense, that he should offer of the prayers of the saints upon the golden altar, which is in the sight of God. And the smoke of the incense of the prayers of the saints ascended up before God from the hand of the angel. And the angel took the censer, and filled it with the fire of the altar, and cast it upon the earth, and there were thunders and voices and lightnings, and an earthquake.

COMMENTARY: This angel signifies Christ, for he came into the world through the mystery of the incarnation. By the golden altar the Church is signified. He is said to stand before the altar, for Christ lay dead for the unbelievers who considered him as a man, but for the faithful who believe him to be God he stood up (in his resurrection). He stood before the altar because for the apostles and other believers who make up the Church this makes clear that he is God. The censer that he held in his hand represents the hearts of the apostles and of other believers. It is said that it was of gold because the hearts of the disciples, purified by the faith and wisdom which they learnt from Christ, were as of gold. *And the smoke ascended etc.* By the scented smoke of the incense not only the prayers of the faithful are symbolised, but also the bright flame of their good works for the Church that continually ascends before the face of God. It is said that this smoke ascends from the hand of the angel, because the good things done by the faithful are done by the working of God. *And the angel took etc.* By the fire the Holy Spirit is signified, by the lightnings the virtuous acts done by the apostles, and by the voices their preaching. By the thunder is signified the threat of eternal fire, and by the earthquake the conversion of the Jews.

Folio 11 recto
The First Trumpet: The Rain of Hail, Fire and Blood upon the Earth

John stands outside the frame as the angel blows the first trumpet which causes a rain of hail, fire and blood to come on the earth, destroying the trees and the grass. The historiated initial

below shows a woman standing over a man who clings to the bar of the initial.

TEXT: *Revelation 8 vv. 6–7.* And the seven angels who had the seven trumpets prepared themselves to sound the trumpet. And the first angel sounded the trumpet, and there followed hail and fire, mingled with blood, and it was cast on the earth, and the third part of the earth was burnt up, and the third part of the trees was burnt up, and all green grass was burnt up.

COMMENTARY: By the sound of the trumpet preaching is signified. Holy preachers are always ready to gain for God whoever they can through the teaching of their preaching. By the first angel, as we have said, are signified the preachers who were before the Law. The first angel blows his trumpet because the holy men who lived before the Law knew no other law than the natural law, yet clearly they feared and loved God as creator and did not do to others anything they did not wish for themselves. *And there was hail and fire etc.* By the hail which beats down is signified the words of holy men which strike by their arguments the hearts of depraved men. The mixing of fire and blood is described. The fire is the Holy Spirit dwelling in his saints, made visible in their words. By the blood Christ is to be understood, which has often been foretold by the Fathers, and which is prefigured in their acts. The earth represents the men of this time who have succumbed to sin. *And the third part of the earth etc.* By the third part of the earth we have to understand those who are saved by the example of good men, those who by the fire of the fear of God, and of his love, have what is depraved in them burnt and destroyed. The trees represent those among them who have kept to the rule of law, and by the green grass is signified the elect who lived at that time.

Folio 11 verso

The Second Trumpet: A Mountain of Fire falls on the Sea and a Third Part is turned to Blood and Ships are destroyed

John looks through a quatrefoil opening in the frame to see the blowing of the second trumpet. At this, a great mountain of fire descends on the sea, causing a third part of the sea to turn to blood and a third part of the ships and those in them to be destroyed. The ornamental initial below contains foliage coils.

TEXT: *Revelation 8 vv. 8–9.* And the second angel sounded the trumpet: and as it were a great mountain, burning with fire, was cast into the sea, and the third part of the sea became blood: and the third part of the creatures died, which had life, and the third part of the ships was destroyed.

COMMENTARY: By the second angel Moses and the other Doctors of the Law are signified. *And as it were a great mountain etc.* By the great mountain the Law of Moses is signified, that on account of the heaviness of its weight is likened to a mountain; and on account of the spiritual understanding that shines forth in the Law is said to burn with fire. The Hebrew people on account of their great guilt is signified by the sea. *And a third*

part of the sea etc. All forgiveness in the Law was made through the shedding and sprinkling of blood. Moses sprinkled the people with blood, saying: *This is the blood of the testament which God hath enjoined unto you* (Hebrews 9 v. 20). Moses even sprinkled with blood Aaron and his sons in order to purify them for offering sacrifices to God, for forgiveness was not possible without the shedding of blood. The third part of the sea signifies the elect who lived at that time. By the blood in this instance we are able to understand the forgiveness of sins. The third part of the sea is turned to blood because the elect that were at that time, through their observation of the Law, merited the cleansing of their sins. The third part of those creatures in the sea who had life, and who it is said died, have the same meaning as the third part of the sea which was turned to blood. By the sea, as we have said, the multitude of sinners is signified.

Folio 12 recto

The Third Trumpet: The Star 'Wormwood' Falls on the Rivers and the Fountains of Waters

John, in an agitated pose, looks through a window in the frame at the blowing of the third trumpet, at which a great burning star called 'Wormwood' falls on the rivers and springs, making their waters bitter. The historiated initial shows a boar with an archer below.

TEXT: *Revelation 8 vv. 10–11.* And the third angel sounded the trumpet, and a great star fell from heaven, burning as it were a torch, and it fell on the third part of the rivers, and upon the fountains of waters: and the name of the star is called Wormwood. And the third part of the waters became wormwood; and many died of the waters, because they were made bitter.

COMMENTARY: The angel has the same meaning as the star that signifies the prophets. But it has to be asked why it is said to have fallen from heaven to the earth. The saints in heaven ascend in a certain way when divine love raises them to the contemplation of celestial things, yet they fall on earth when love of neighbour brings them back to the depths, so that sinners through their preaching are led to the path of truth. A burning torch lights up the darkness of the night, and the words of the prophets are torches which dispel the darkness of sin from the minds of men. We are able to understand by the burning torch the Holy Spirit inflaming the prophets that they reformed many from sin and foretold things that were to come. *And it fell on the third part etc.* By the rivers and springs are signified the twelve tribes (of Israel) and their families. By the third part are signified those among them destined for eternal life. The star fell in the third part of the rivers because those people had received the teaching of the prophets, which had taken seed in their hearts, those who were predestined to eternal life. *And the name of the star etc.* Wormwood is very bitter. By wormwood is signified the threats that the prophets utter against sinful people such that they should do penance.

Folio 12 verso

The Fourth Trumpet: A Third Part of the Sun, Moon and Stars Becomes Dark

John looks through a small opening in the frame at the angel blowing the fourth trumpet, causing the sun, moon and stars to become dark. The ornamental initial below contains foliage coils formed of two dragons' bodies.

TEXT: *Revelation 8 v. 12*. And the fourth angel sounded the trumpet, and the third part of the sun was smitten, and the third part of the moon, and the third part of the stars, so that the third part of them was darkened, and the day did not shine for a third part of it, and the night in like manner.

COMMENTARY: The fourth angel symbolises Christ and his apostles. *And the third part of the sun etc.* The sun, moon and stars relate to one thing. For the sun signifies the people of the Jews, and the moon the synagogue. By the stars the chief priests and the pharisees are signified. But if we should wish to relate the darkening of the sun, moon and stars to those who do not wish to believe in Christ, the preceding order would be disturbed. Above it is said that there was burning of the third part of the earth at the sounding of the trumpet of the first angel, that the third part of the sea was changed to blood at the sounding of the trumpet of the second angel, that no less than a third part of the waters became as wormwood at the sounding of the trumpet of the third angel. We have shown that these things have to be interpreted as relating to the elect. Consequently the striking of the sun, moon and stars has to be interpreted in a good sense. By the third part of the sun that is struck, that is darkened, is signified those of the Jewish people who believed in Christ. These are considered darkened by the Jews who do not believe, but they shine out in the sight of God. In the same way the third part of the moon and the stars that is darkened signifies those among the heads of the synagogues, the priests, and those out of the pharisees who believed in Christ. For as a result of the true light, that is Christ, which these people have received, they become darkened to those whose eyes of the spirit the Devil has blinded, so that they did not believe in Christ.

Folio 13 recto

The Eagle flies across the Heavens crying 'Woe'

John leans on his staff, looking anxiously up as the eagle flies through the clouds bearing a scroll with the words: 'Woe, woe, woe to the inhabitants of the earth'. Below is written a passage from the commentary: 'By the eagle Christ and the apostles are signified, and the first woe relates to the heretics fighting against the Church of God.' The historiated initial shows two men wrestling and pulling hair on the bar of the initial E.

TEXT: *Revelation 8 v. 13*. And I beheld, and heard the voice of an eagle flying through the midst of heaven, saying with a loud voice: Woe, woe, woe to the inhabitants of the earth: from the voices of the three angels, who are yet to sound the trumpet.

COMMENTARY: By heaven in this case the Church is signified: the eagle is Christ and the apostles. The eagle flies through the middle of heaven and cries out, because Christ first preached the Gospel in Judaea, and his apostles then to all peoples: they foretold that the Church would suffer persecutions from its adversaries in many forms. And for that reason it was afflicted by three woes, of which the first concerns the heretics, who attempted to attack the Church of God in many ways; the second applies to the pagans who similarly persecuted the Church of God, and have put to death a great multitude of the faithful. The third applies to Antichrist who will wage war against the people of God at the end of the world. We have to consider whether the three woes relate to the elect who endure to the end many calamities caused by the unbelievers, or whether they apply to those unbelievers who have caused these calamities. For the Lord says: *Woe, woe, woe to the inhabitants of the earth*. For the unbelievers, who seek for nothing other than the earth, are rightly called inhabitants of the earth. Whereas the just, who always desire heavenly things, are rightly called inhabitants of heaven, as the apostle Paul says: *But our conversation is in heaven* (Philippians 3 v. 20).

Folio 13 verso

The Fifth Trumpet: The Star and the Key fall from Heaven and the Locusts come up from the Bottomless Pit led by their King, Abaddon

John looks through a small window as the angel blows the fifth trumpet. The star and the key to the bottomless pit fall from heaven, and at its opening smoke rises and the locusts, led by their king Abaddon, come up out of it. Abaddon is a winged human figure riding on one of the locusts, in the form of a horse clad in chain mail with the face of a man and hair of a woman. The historiated initial below shows a man shooting a crossbow at the text.

TEXT: *Revelation 9 vv. 1–11*. And the fifth angel sounded the trumpet, and I saw a star fall from heaven upon the earth. And there was given to him the key of the bottomless pit. And he opened the bottomless pit: and the smoke of the pit arose, as the smoke of a great furnace; and the sun and the air were darkened by the smoke of the pit. And from the smoke of the pit there came out locusts upon the earth. And power was given to them, as the scorpions of the earth have power: and it was commanded them that they should not hurt the grass of the earth, nor any green thing, nor any tree, but only the men who have not the sign of God upon their foreheads. And it was said unto them that they should not kill them; but that they should torment them five months: and their torment was as the torment of a scorpion when he striketh a man. And in those days men shall seek death and shall not find it; and they shall desire to die, and death shall fly from them. And the shapes of the locusts were like unto horses prepared unto battle, and on their heads were, as it were, crowns like gold, and their faces were as the faces of men. And they had hair as the hair of women; and they had breastplates as breastplates of iron, and the noise of

their wings was as the noise of chariots of many horses running to battle. And they had tails like to scorpions, and there were stings in their tails. And they had over them a king, the angel of the bottomless pit, whose name in Hebrew is Abaddon, and in Greek Apollyon, and in Latin Exterminans.

COMMENTARY: The star that fell from heaven opened the bottomless pit because the heretics shall open their mouths to reveal the malice which they hide in their hearts.

Folio 14 recto

The Sixth Trumpet: The Four Angels in the Euphrates

John looks through a small circular hole in the frame as the angel blows the trumpet. An angel comes out of the clouds surrounding the altar in heaven, commanding that the four angels in the Euphrates should be freed. These angels, holding swords, an axe and a spear, stand on the right in the river, already freed. The historiated initial below contains a standing man with his hands to his ears, probably a comment on the blowing of the trumpet above.

TEXT: *Revelation 9 vv. 12–16.* One woe is past, and behold there come two woes hereafter. And the sixth angel sounded the trumpet: and I heard a voice from the horns of the golden altar, which is before the eyes of God, saying to the sixth angel, who had the trumpet: Loose the four angels who are bound in the great river Euphrates. And the four angels were loosed, who were prepared for an hour, and a day, and a month, and a year: for to kill the third part of men. And the number of the army of horsemen was twenty thousand times ten thousand.

COMMENTARY: By the sixth angel are signified the martyrs: the sixth angel sounds the trumpet because the martyrs of Christ have given the drink of the doctrine of the faith to unbelievers. By the golden altar is signified the Church. The four horns of the altar surely indicate the four evangelists: thus he says he heard one voice speaking forth from the four horns of the golden altar; because there is one faith and one doctrine that the four Gospels teach. The four angels signify the four kingdoms, which are clearly those of the Assyrians, the Persians, the Macedonians and the Romans. By the Euphrates the world is to be understood. The chains of the four angels are the words of the Lord, not because God ordered the persecutors to end the persecution while the seeds of the faith were spreading through all nations, but because that which he instructed in words was established through his power. For the Romans before the coming of Christ could not have enough of killing, rape and shedding the blood of the human race. The four angels are released because wicked men persecuted the people of God once peace was broken, and untied the hands which had bound the peace. That it says *they were prepared* shows the free will of the wicked.

Folio 14 verso

The Horsemen destroy the People

John stands behind a hillock as the horsemen as armed knights in chain mail ride on horses which trample on the people. The 'horses' have lions' heads and tails of serpents, and they breathe out fire, smoke and brimstone on the people, so as to destroy them. The historiated initial below contains a man holding a stick leaning on the bar of the initial.

TEXT: *Revelation 9 vv. 17–21.* And I saw the horses in the vision: and they that sat on them had breastplates of fire and of hyacinth and of brimstone, and the heads of the horses were as the heads of lions: and from their mouths proceeded fire, and smoke, and brimstone. And by these three plagues was slain the third part of men, by the fire and by the smoke and by the brimstone, which issued out of their mouths. For the power of the horses is in their mouths, and in their tails. For their tails are like to serpents, and have heads: and with them they hurt. And the rest of the men, who were not slain by these plagues, did not do penance from the works of their hands, that they should not adore devils, and idols of gold, and stone, and wood, which neither can see, nor hear, nor walk: neither did they penance from their murders, nor from their sorceries, nor from their fornication, nor from their thefts.

COMMENTARY: In this instance the horses signify senseless people, the riders of the horses the princes of the earth: the breastplates that repel the blow of a sword signify the hardness of the hearts of the reprobates that does not allow the sword of the spirit, that is the word of God, to come near their hearts. The breastplates are said to be of fire, hyacinth and brimstone. By the fire is clearly signified the cruelty of mind of the persecutors: by the hyacinth, which has the quality of heaven, (is signified) the honour of the godhead which they pay to their deities. By the brimstone, which smells bad, those who blaspheme Christ are signified. By the heads of the horses are signified the Roman emperors who are seen to be at the head of all the persecutors, and whose insatiable rage resembles that of lions. The fire symbolises their wicked commands, the smoke the falsehood of their idolatry, and the brimstone their blasphemy.

Folio 15 recto

The Great Angel and the Seven Thunders; John is told not to write

John looks on at the great angel in a cloud with a rainbow at his head, holding an open book, and having one foot in the sea and the other on the land, his feet being as pillars of fire. At his cry the seven thunders at the top right-hand corner give out their voices. John appears again at the right at a writing desk, holding in his left hand a knife for sharpening his quill, whereas the quill in his right hand is held back by an angel who tells him not to write. The angel holds a scroll on which is written: 'Seal up the things which the seven thunders have spoken; and write them not.' The ornamental initial below contains foliage coils.

TEXT: *Revelation 10 vv. 1–7.* And I saw another mighty angel come down from heaven, clothed with a cloud, and a rainbow was on his head, and his face was as the sun, and his feet as pillars of fire. And he had in his hand a little book open: and he set

his right foot upon the sea, and his left foot upon the earth. And he cried with a loud voice as when the lion roareth. And when he had cried, and the seven thunders had uttered their voices, I was about to write. (And I heard a voice from heaven saying to me): Seal up the things which the seven thunders have spoken; and write them not. And the angel, whom I saw standing upon the sea and upon the earth, lifted up his hand to heaven, and he swore by Him that liveth for ever and ever, who created heaven, and the things which are therein; and the earth, and the things which are in it; and the sea, and the things which are therein: That time shall be no longer, but in the days of the voice of the seventh angel, when he shall begin to sound the trumpet, the mystery of God shall be finished, as he hath declared by his servants the prophets.

COMMENTARY: The strong angel signifies our Lord Jesus Christ, of whom the psalmist says: *The Lord who is strong and mighty, the Lord mighty in battle* (Psalm 23 v. 8). He who descends from heaven is said to be clothed with a cloud because our Lord coming into the world took flesh, which is signified by the cloud, and that through taking on flesh takes the form of men whom he came to redeem. By the rainbow is signified his mercy, as we have said earlier. By the head is to be understood his divinity in this case. He has a rainbow on his head because his divinity that he had before his incarnation assumes such great mercy that he does not consider himself unworthy to become man for the sake of men, and at the end to be condemned to the worst of deaths. By the sun the Lord is signified, as we have said above.

Folio 15 verso

The Great Angel gives John the Book to eat; John eats the Book

John on the left is instructed by a voice from heaven to take the book from the hand of the great angel. The great angel gives John the book, and instructs him to eat it. On the right John is shown about to eat the book. The ornamental initial below contains foliage coils and a dragon.

TEXT: *Revelation 10 vv. 8–11.* And the voice that I heard from heaven again speaking to me, and saying: Go and take the book that is open from the hand of the angel who standeth upon the sea and upon the earth. And I went to the angel, saying unto him, that he should give me the book, and he said to me: Take the book and eat it up: and it shall make thy belly bitter, but in thy mouth it shall be as sweet as honey. And I took the book from the hand of the angel and ate it up, and it was in my mouth sweet as honey. And when I had eaten it my belly was bitter. And he said to me: Thou must prophesy again to many nations, and peoples, and tongues and kings.

COMMENTARY: By John in this case we can understand all the apostles. The voice from heaven tells John to go to the angel and take from him the book, because the grace of the Holy Spirit inspired the apostles to give up everything and follow Christ, in order to receive the teaching of the Gospel. *And I*

went to the angel, saying unto him etc. The apostles went to Christ such that they could be instructed by him on the teaching of divine scripture. *Take the book etc.* By the mouth, in which tastes are distinguished, we are able to understand the hearts of the apostles. By the stomach, in which all filth of the body is contained, we have to understand the remembrance of sins. The book that is to be eaten is said to be sweet as honey because divine scripture unfolds in the mind, making the heart sweet as honey, and promising life eternal to those who observe the commandments of God. When the mind is led from things on high to inferior things, that is from contemplation of the celestial land to that of sin, wicked people suffer penalties for their sins. This shows that which formerly was sweet, showing celestial glory, becomes bitter when sins are revealed.

Folio 16 recto

The Angel gives John the Rod to measure the Temple of God

John appears to stagger back as the angel gives him a rod to measure the temple. Those who worship there are shown kneeling before an altar on which is a chalice. The ornamental initial below contains foliage coils.

TEXT: *Revelation 11 vv. 1–2.* And there was given to me a reed like unto a rod, saying: Arise, and measure the temple of God, and the altar and them that adore therein. But the court, which is without the temple, cast out, and measure it not: because it is given to the Gentiles, and the holy city they shall tread under foot two and forty months.

COMMENTARY: By the reed, with which the ancients were accustomed to write, is meant the Gospel which was given to him by the Lord, and which he afterwards wrote; by the rod certainly often is signified discipline that is received. The reed therefore that is given to John had the likeness of a rod, for the discipline of Christians is the Gospel. It is instructed that the temple and altar be measured. The temple symbolises the Church, and the altar the holy and perfect men who are in the Church. By the worshippers is signified the multitude who are instructed by their teaching. The temple of God certainly represents the altar and worshippers in it. Every preacher has to measure them when he dispenses the doctrine of spiritual grace to each according to their capacity. *The court that is without cast out.* By the court the Jews are signified, for the Jews were without because of their unbelief. But John and the other apostles hold together always through the love they have in their hearts, just as the apostle Paul says: *For I wished myself to be an anathema for the cause of Christ, for my brethren, who are my kinsmen according to the flesh, who are Israelites* (Romans 9 v. 3). That is why it is ordered not to measure the court, that is to say not to dispense the words of preaching to them, just as the Gospel says: *Do not cast your pearls before swine lest they trample them under their feet, and turning upon you they tear you* (Matthew 7 v. 6). *And the holy city etc.* The holy city, which is the Church, will be trampled upon by Antichrist and his ministers, when they persecute it for three years and a half.

Folio 16 verso

The Witnesses appear preaching and breathing out Fire against their Enemies

The two witnesses are clad in cloak-like garments, whereas in some contemporary English Apocalypses their clothes resemble habits of the mendicant orders. The one on the right is preaching, whereas the one on the left breathes out fire to destroy their enemies. They are labelled as Elijah and Enoch because the commentary says that is what they are called. The ornamental initial below contains foliage palmettes.

TEXT: *Revelation 11 vv. 3–6*. And I will give unto my two witnesses, and they shall prophesy a thousand two hundred sixty days, clothed in sackcloth. These are the two olive trees, and the two candlesticks, that stand before the Lord of the earth. And if any man will hurt them, fire shall come out of their mouths, and shall devour their enemies. And if any man will hurt them, in this manner must he be slain. These have power to shut heaven, that it rain not in the days of their prophecy: and they have power over waters to turn them into blood, and to strike the earth with all plagues as often as they will.

COMMENTARY: The Lord calls his witnesses Elijah and Enoch, who are to precede his second coming, just as John preceded the first. *These are as two olive trees etc.* Olives produce oil, that afterwards is placed on the candlestick, that it should give light to all who are in the house. By the oil in this case we are able to receive spiritual understanding; each one of us is thus an olive, when coming to rest in himself, he loves to serve God by the grace of contemplation; when he fulfils what the Lord says in the Gospel: *Let not thy left hand know what thy right hand doeth* (Matthew 6 vv. 3–4). Then he becomes a candlestick when he fulfils what the Lord says in the Gospel: *That they may see your good works and glorify your Father who is in heaven* (Matthew 5 v. 16). For these saints are as two olive trees when, in some place on earth where the divine Majesty instructs that they should remain, they serve God by grace of contemplation. They became candlesticks when they came to accomplish their preaching to all, both the faithful and the reprobates, announcing the word of God. Of this candlestick the Lord says in the Gospel: *Men do not light a candle and put it under a bushel, but put it on a candlestick that it may shine to all that are in the house* (Matthew 5 v. 15).

Folio 17 recto

The Beast comes up to oppose the Witnesses; The Witnesses are killed by the Beast

The Beast comes up out of a hole in the ground brandishing a scimitar at the two witnesses, labelled as Elijah and Enoch. They hold a scroll which bears the words: 'The Lord Jesus Christ shall kill you with the spirit of his mouth, and shall destroy you with the brightness of his coming' (II Thessalonians 2 v. 8). On the right the Beast kills the witnesses with his scimitar. In both cases the Beast is labelled as Antichrist

because the commentary designates him as such. The ornamental initial below contains foliage coils.

TEXT: *Revelation 11 vv. 7–8*. And when they shall have finished their testimony, the beast, that ascendeth out of the abyss, shall make war against them, and shall overcome them and kill them. And their bodies shall lie in the streets of the great city, which is called spiritually, Sodom and Egypt, where their Lord also was crucified.

COMMENTARY: This beast signifies Antichrist. *He shall make war against them* when he shall persecute them: he shall certainly conquer them, not overcoming them in words but by killing them. Thus it goes on: *And he shall kill them etc.* If by the great city we should wish to understand the terrestrial Jerusalem, as it says, 'Where the Lord was crucified', we should certainly wander from the truth; because that Jerusalem was razed to the ground, and this that is built to replace it is said not to be in that place but elsewhere. It cannot be said to be Sodom and Egypt because it is inhabited by Christians. And at the same time, considering that wherever the great city is referred to in this book, it signifies Babylon which is the city of the Devil, consisting of reprobates. For as the bodies of the saints are said to be exposed in the streets of the great city, we can understand simply that they are thrown into some street, and that it refers to some law of these reprobates. But it seems to me better that, just as we have said, by the great city all the reprobates are to be understood. Thus we understand by the street the hearts of the reprobates. For the bodies of the saints lie in the street of the great city, and the saints are lying for those to whom they are considered to be of no importance. On the contrary they are standing for the faithful, who look at their virtue and glory with the eyes of the heart. Certainly the city of the Devil is not inappropriately called here Sodom and Egypt, because Sodom is interpreted as blind and Egypt as dark.

Folio 17 verso

The People rejoice at the Death of the Witnesses as they lie in the Streets

John stands outside the frame looking in through a small slit at the people dancing and playing music as they rejoice over the death of the witnesses who are lying in the street in the foreground. The ornamental initial below contains foliage coils.

TEXT: *Revelation 11 vv. 9–10*. And they of the peoples, and tribes, and tongues, and nations, shall see their bodies for three days and a half: and they shall not suffer their bodies to be laid in sepulchres. And they that dwell upon the earth shall rejoice over them, and make merry: and shall send gifts one to another, because these two prophets tormented them that dwelt upon the earth.

COMMENTARY: The bodies of the saints are described as thrown down in the street of the great city where the Lord was crucified, for just as Christ was crucified by the attainments of

the Devil, so in the same way are these two prophets killed. By the three and a half days we are able to understand the three and a half years during which these prophets preached. By the tombs we are able to understand the minds of the reprobates, and of these tombs the Lord spoke: *Woe to you scribes and pharisees, because you are like to whitened sepulchres, which outwardly appear to men beautiful, but within are full of dead men's bones, and of all filthiness* (Matthew 23 v. 27). However, the reprobates did not allow the bodies of the saints to be placed in tombs, because they had put them and their teaching out of their minds. But it is said that after three and a half days the spirit of life from God entered into them and they stood up on their feet, and so their virtue and splendour became apparent to all the wicked after the time of their resurrection. And great fear fell upon their enemies when they saw them, and when they shall see them in the day of judgement in their glory they will be disturbed with dreadful fear saying: *These are they whom we had some time in derision, and for a parable of reproach* (Wisdom 5 v. 3).

Folio 18 recto
The Ascension of the Witnesses; The Great Earthquake

John with his hand to his face looks on as at the left the spirit of life enters into the dead witnesses in the form of doves, and they rise up into the clouds. The angel flying down represents the voice from heaven saying: 'Come up hither.' Their ascension is followed by a great earthquake destroying the city and many people, which is seen on the right. The historiated initial below contains two men wrestling.

TEXT: *Revelation 11 vv. 11–13.* After three days and a half, the spirit of life from God entered into them. And they stood upon their feet, and great fear fell upon them that saw them. And they heard a great voice from heaven, saying to them: Come up hither. And they went up to heaven in a cloud: and their enemies saw them. And at that hour there was made a great earthquake, and the tenth part of the city fell: and there were slain in the earthquake names of men seven thousand: and the rest were cast into a fear, and gave glory to the God of heaven.

COMMENTARY: By the two witnesses we are able to understand the preachers to two peoples, the Jews and the Gentiles. It is said that they will preach for one thousand two hundred and sixty days, for all the time when the persecution and deception of Antichrist shall prevail throughout the whole world they will strive to bring all those they can to the way of truth. *And at that hour there was made a great earthquake.* Now at the beginning it goes back to the preaching of Elijah and Enoch, for the earth was moved when the preaching of Elijah and Enoch brought many to penitence and to faith. The earthquake, as we have just said, signifies the motion of hearts. *And the tenth part of the city fell.* It says here that a tenth part shall fall to the ground of that great city which earlier was called Sodom and Egypt, in whose street the bodies of the saints are said to lie for three and a half days without burial. And because the number

ten often signifies the Law, because the Law was received through the Ten Commandments, we are able to understand by the tenth part which fell down the Jews who observe the Law, who, through the preaching of Elijah and the faith of Christ, will fall down and will be cut into pieces by means of the city of the Devil.

Folio 18 verso
The Seventh Trumpet: God is praised by the Twenty-Four Ancients

John sits on a hillock as the angel behind him blows the seventh trumpet. This heralds a vision of heaven in which the ancients kneel down praising God, and the angels in the clouds join in the praise. The historiated initial below shows the fable of the stork and the fox (or wolf).

TEXT: *Revelation 11 vv. 15–18.* And the seventh angel sounded the trumpet: and there were great voices in heaven, saying: The kingdom of this world is become our Lord's and his Christ's, and he shall reign for ever and ever. And the four and twenty ancients, sitting in their seats in the sight of God, fell on their faces and adored God, saying: We give thee thanks, O Lord God Almighty, who art, and who wast: because thou hast taken to thee great power, and thou hast reigned. And the nations were angry, and thy wrath is come, and the time of the dead, that they should be judged, and that thou shouldest render reward to thy servants the prophets and the saints, and to them that fear thy name, little and great, and shouldest destroy them who have corrupted the earth.

COMMENTARY: By the seventh angel are signified the holy preachers that are to be born at the end of the world. The trumpets will sound as they announce the word of God. *And there were great voices saying.* We are able to understand by heaven the Church, by the great voices the words of the saints that rejoice at the coming of the Lord to the judgement, just as the Lord says in the Gospel: *Look up and lift up your heads, because your redemption is at hand* (Luke 21 v. 28). The kingdom of this world signifies men in whose minds reign either God or the Devil, who is king over all the sons of pride. The kingdom of this world of the Lord Jesus Christ will be achieved when the Devil with all those he has deceived will be plunged into Hell. By the twenty-four ancients here we are able to understand the souls of the saints who live with the Lord in celestial bliss, and the seats signify their eternal rest. The twenty-four ancients sit in their seats in the sight of God because the souls of the saints, but not their bodies, rest now in celestial bliss without end.

Folio 19 recto
The Temple in Heaven appears

John stands, looking up with his hand to his head, as the temple appears in heaven. The ark of the testament appears on an altar between two candlesticks, and from the clouds surrounding it heads emerge, blowing down, and these represent the voices, lightning and hail, and, below, the agitated contours of the

earth represent the earthquake. The historiated initial below shows a tonsured cleric ringing bells hung in a belfry above.

TEXT: *Revelation 11 v. 19.* And the temple of God was opened in heaven: and the ark of his testament was seen in his temple, and there were voices, and lightnings, and an earthquake, and great hail.

COMMENTARY: We are able to understand blessed Mary by the temple of God, and by the ark of the covenant, Christ, who has received from it his flesh. The temple of God is not said to be open as the womb of the blessed Virgin in bearing Christ, because she was a virgin before and after giving birth, but is said to be open because through her our Lord Jesus Christ was made visible to us. Also we are able to understand the Old Testament by the temple, and the ark and the sacraments, which for Christ are kept in the Old Testament. When Christ comes in the flesh, the Old Testament is opened, and the spiritual understanding that lay hidden in it is revealed to the faithful. *And there were (voices) etc.* By the lightnings are signified the miracles done by Christ, and by the voices his preaching. The earthquake signifies the motion of the heart, for many people are moved to penance for their sins through the preaching of Christ, and are moved from infidelity to fidelity, from bad to good. And because hail hits the earth we are able to understand through the hail the threats of eternal fire which often are found in the Gospels, threats by which the hearts of the depraved are hit, that they should repent of their iniquities.

Folio 19 verso
The Woman in the Sun appears in Heaven

John beholds the vision of the appearance in heaven of the woman seated in the sun with the moon at her feet and twelve stars incorporated in her halo. The ornamental initial below contains two intertwined birds or dragons.

TEXT: *Revelation 12 vv. 1–2.* And a great sign appeared in heaven: A woman clothed with the sun, and the moon under her feet, and on her head a crown of twelve stars: and being with child, she cried travailing in birth, and was in pain to be delivered.

COMMENTARY: This woman signifies the Church, and as a result of the preaching of Christ, its image was created, born from his preaching. Here we are able to understand this world by the sky, and by the great sign the great salvation that the coming and preaching of Christ brought to the world. By the sun Christ is signified, as the prophet says: *But unto you that fear my name, the sun of justice shall arise and health in his wings* (Malachi 4 v. 2). The woman, however, is clothed with the sun because the faithful which make up the Church become clothed with Christ in their baptism, just as the apostle says: *For as many of you as have been baptised in Christ, have put on Christ* (Galatians 3 v. 27). By the moon which appeared under her feet, that is seen to wax and wane, we are able to understand this world, on

which the Church tramples in scorn in order to make the way free to heaven. But because the moon lights up the night, it may be better that it is seen to be Holy Scripture, without whose light we would be unable in the darkness of this time to walk in the way of righteousness. Of this light the psalmist says: *Thy word is a lamp to my feet, and a light to my paths* (Psalm 118 v. 105). The woman is seen to have the moon under her feet because the Church, basing its spiritual journey on the precepts of Holy Scripture, knows that every day should be directed towards the consideration of spiritual things. A crown of twelve stars is seen on her head, for the head of the Church is Christ, and the twelve stars are the twelve apostles. By the head we are also able to understand the minds of the faithful.

Folio 20 recto
The Great Dragon appears; The Child of the Woman in the Sun is taken up to Heaven; The Woman departs to the Wilderness

The second sign that appears in heaven is the great red dragon with seven heads, whose tail draws a third of the stars from heaven and casts them on the earth, as can be seen at the bottom of the picture. The woman in the sun has given birth to a child who is being taken up to heaven by an angel. In order to escape from the Dragon the woman retreats to the wilderness and can be seen on the right disappearing out of the frame into a cloud. John crouches outside the frame on the right, looking up as the woman disappears into the wilderness. The historiated initial below shows a man leaning on a stick looking upwards.

TEXT: *Revelation 12 vv. 3–6.* And there was seen another sign in heaven: and behold a great red dragon, having seven heads, and ten horns: and on his head seven diadems: and his tail drew the third part of the stars of heaven, and cast them upon the earth: and the dragon stood before the woman who was ready to be delivered; that, when she should be delivered, he might devour her son. And she brought forth a man child, who was to rule the nations with an iron rod: and her son was taken up to God, and to his throne. And the woman fled into the wilderness, where she had a place prepared by God, that there they should feed her a thousand two hundred sixty days.

COMMENTARY: The Dragon signifies the Devil. Red is a colour, just as if the colour of saffron is mixed with blood. The pale colour, that is to say of the saffron, is in harmony with blood because blood, when it flows out, leads to death, and the whole body becomes pale in death. Thus it is rightly said that the Devil has the colour of death, because through his ill will death entered into the world of the earth. By the seven heads are signified the reprobates whom the Devil makes use of to deceive the human race. The diadems symbolise royal power, for *he is king* as scripture says *over all the children of pride* (Job 41 v. 25). For just as the seven horns of the Lamb signified the elect, so the seven horns of the Dragon signify the reprobates that are opposed to the way of God. The first head of the Dragon signifies the reprobates that were before the Flood, the second those after

the Flood, the third after the Law was given, the fourth the false prophets and wicked kings, the fifth those wicked men among the Jews, the sixth the persecutors of the Church, and the seventh head of the Devil signifies Antichrist.

Folio 20 verso

The War in Heaven

St Michael in the centre of the picture spears one of the heads of the Dragon, while one smaller angel on the left brandishes his sword at a smaller dragon, and on the right a third angel forces the Dragon down into a pit with a pitchfork. The ornamental initial below contains a foliage palmette.

TEXT: *Revelation 12 vv. 7–10.* And there was a battle in heaven, Michael and his angels fought with the dragon, and the dragon fought with his angels; and they prevailed not, neither was their place found any more in heaven. And that great dragon was cast out, that old serpent, who is called the devil and Satan, who seduceth the whole world; and he was cast into the earth, and his angels were thrown down with him. And I heard a loud voice in heaven, saying: Now is come salvation, and strength, and the kingdom of our God, and the power of his Christ: because the accuser of our brethren is cast forth, who accused them before our God, day and night.

COMMENTARY: Because what went before is associated with the nativity and preaching of Christ, consequently this is linked to his conquest of the Devil through his passion. Michael, who in one sense is understood as God, signifies Christ. There was a great battle in heaven, that is for heaven, for clearly Michael's battle with the Dragon is for all the elect; for Christ in his preaching, suffering and dying fought for the salvation of the human race. The angels of Michael, that is to say the apostles of Christ, fight against the Dragon by their preaching, the miracles they perform, and eventually in their dying for the name of Christ. The Dragon and his angels fight against Michael and his angels when the Devil and all the multitude of devils stir up the Jews against Christ that they should kill him. He also fought against the angels of Michael when he instigated the persecution of the apostles of Christ, both by the Jews and by the pagans, such that he has them killed. But the Devil and his followers were not successful in conquering Christ and his apostles, because they have been conquered by those whom they thought that they had conquered. They thought they had conquered Christ by his death, but it is by his death that he shines out in the world.

Folio 21 recto

'Woe to the Earth because the Devil has come'

An angel coming from a cloud speaks to John, whereas another flies down holding a placard with the words: 'Woe to the earth, and to the sea, because he is come down unto you, having great wrath'. The Devil, holding a scimitar and pitchfork, sits on the ground on the right. The ornamental initial below contains foliage coils.

TEXT: *Revelation 12 v. 12.* Woe to the earth, and to the sea, because he (the Devil) is come down unto you, having great wrath, knowing that he hath but a short time.

COMMENTARY: We are able to understand by the earth the Jews, and by the sea the pagans and other reprobates. Woe to the Jews and unbelievers, for as a result of the rage of the Devil in losing a great multitude of his followers, the reprobates are ruled over with cruelty, and he casts them into such a life of crime that they become completely unworthy to return to the right paths and be healed. It is also said that the Devil knows that he has but a short time, because as he sees the day of judgement approaching he becomes ever more cunning in deceiving men. This Devil reproaches our brothers before the face of God by day and night. Evil-doing men are accused by their judges when their crimes are revealed. In the sight of God, who knows not only what is done, but also our thoughts, how can the Devil find fault with anyone? But he is able to find fault in the sight of God when we sin, and those are the people who plunge into sin as a result of his wicked persuasion.

Folio 21 verso

The Dragon persecutes the Woman who is given Wings of an Eagle

John peeps through a hole in the frame as the Dragon comes up out of a pit to pursue the woman who is being given eagle's wings by an angel. The historiated initial shows either a man warming himself before a fire, an image deriving from the January or February labour of the month in calendars, or possibly a personification of *luxuria*.

TEXT: *Revelation 12 vv. 13–14.* And when the dragon saw that he was cast into the earth, he persecuted the woman, who brought forth the man child: and there were given to the woman two great wings of an eagle, that she might fly into the desert unto her place, where she is nourished for a time and times, and half of a time, from the face of the serpent.

COMMENTARY: The Devil, seeing that he had lost a great multitude of the elect, and that he was confined within the hearts of the reprobates, persecuted the woman, that is the Church; for he incited the emperors of the Romans and all the multitude of the wicked to persecute the people of God. *And there were given unto the woman two great wings of an eagle etc.* By the eagle we are able to understand Christ: the two wings are certainly the two Testaments. Therefore two wings are given to the woman, because the Church receives both Testaments; for through their teaching it escapes from the Devil, and daily ascends to the celestial land. For this country is called the desert, in the manner of the Lord in the Gospel, when he said that he let ninety-nine sheep go into the desert, and went away to seek the one that had strayed. This land is called the place of the Church, just as it shall be said in the judgement: *Come, ye blessed of my Father, possess you the kingdom prepared for you from the foundation of the world* (Matthew 25 v. 34). *For a time and times, and half of a time is*

signified as the time from the passion of Christ until the end of the world. In this space of time the souls of the saints, that is the Church, are nourished at the banquets of glory of the celestial land in the bliss of heaven.

Folio 22 recto

The Dragon casts out a Flood at the Woman

The Dragon casts out a flood of water from his mouth, and the woman flies away up into some trees, with John outside the frame looking up at her as she disappears. The historiated initial shows an acrobat seated on the bar of the initial E.

TEXT: *Revelation 12 vv. 15–16*. And the serpent cast out of his mouth after the woman, water as it were a river; that he might cause her to be carried away by the river. And the earth helped the woman, and opened its mouth, and swallowed up the river, which the dragon cast out of his mouth.

COMMENTARY: Carnal desires are the river of water; indeed the Devil, seeing that the Church could not be cast down by persecutions, but rather that it increased and grew in strength, wished to send into it a host of carnal desires, deceived by which it might be drawn back to evil works. *And the earth helped etc.* We are able by the earth to understand the reprobates who take up the carnal desires, by which the Devil wished (to ensnare) the faithful and to entice them to himself. We are also able to understand Christ by this earth, for there is great power in the words of the Lord: *For he spoke, and they were made: he commanded and they were created* (Psalm 148 v. 5); it is by no means unreasonable to understand his power by the mouth of the earth. *For the earth helped the woman*, that is Christ helped the Church *in opening his mouth and swallowing up the river that the serpent cast out of his mouth*; that is he opened the bosom of his mercy, and his power extinguished completely the river of vices.

Folio 22 verso

The Seed of the Woman fight the Dragon

The seed of the woman, in chain mail and armed with battle-axe, sword, spear and shields, fight the Dragon. Outside the frame, on the left, John turns away in horror from the scene, raising up his hand in a gesture of despair. The historiated initial contains two grimacing male heads.

TEXT: *Revelation 12 vv. 17–18*. And the dragon was angry against the woman, and went to make war with the rest of her seed, who keep the commandments of God, and have the testimony of Jesus. And he stood upon the sand of the sea.

COMMENTARY: The rest of the seed are the elect of the Church, who at the end of the world are to be born. In what manner the Devil accomplishes this battle is made clear in the following. By the sand of the sea is signified the multitude of reprobates that there shall be at that time.

Folio 23 recto

The Beast rises from the Sea

John within the frame looks on as the seven-headed Beast rises up out of the sea, placing its front paws on the land. The historiated initial below shows a man looking up and pointing to the scene above.

TEXT: *Revelation 13 vv. 1–2*. And I saw a beast coming up out of the sea, having seven heads and ten horns, and upon his horns ten diadems, and upon his heads names of blasphemy. And the beast which I saw, was like to a leopard, and his feet were as the feet of a bear, and his mouth as the mouth of a lion.

COMMENTARY: This beast signifies Antichrist. Those signified by the sand are those who are also signified by the sea, namely the multitude of reprobates. The Beast is seen to come up out of the sea, because Antichrist rises out of the society of the wicked. The Beast is described as having seven heads and ten horns. Similarly, earlier the Dragon was said to have seven heads and on the heads seven diadems; by these we say are signified all the reprobates whom the Devil uses to deceive the human race. This beast however is not described as having ten crowns on its heads but on ten horns; and therefore by the ten horns are signified the people that Antichrist would subjugate to himself. The seven heads signify the seven principal vices: (the first) is the cult of idols, the second debauchery, the third anger, the fourth pride, the fifth lust, the sixth avarice, the seventh blasphemy or discord. *And the beast which I saw, was like to a leopard*. By the leopard, who is of various colours, are signified the hypocrisies of Antichrist, who shall be the worst of men and will change his colours through various powers in order to deceive more easily foolish men. By the bear, which is a very cunning animal, can be understood his cleverness in deceiving men. By the lion is signified his cruelty in tearing to pieces the people of God.

Folio 23 verso

The Dragon delegates Power to the Beast

As John and two groups of people on either side look on, the Dragon hands over a sceptre of power to the Beast. The historiated initial below shows a fool holding a bauble and disc, taken from the illustration to psalm 52 in Psalters, 'The fool hath said in his heart: there is no God.'

TEXT: *Revelation 13 vv. 2–3*. And the dragon gave him his own strength, and great power. And I saw one of his heads as it were slain to death: and his death's wound was healed. And all the earth was in admiration after the beast.

COMMENTARY: The Devil shall give his power, which is completely evil, to Antichrist, for he shall dwell in him and through him he will carry out all the wickedness of the Devil that can be thought up. But when scripture says *There is no power but from God* (Romans 13 v. 1), how will the Devil give power to Anti-

christ? God will give the power to Antichrist but that power will change to being so bad that it will be understood to be completely of the Devil. *And I saw one of the heads.* I have said above by the seven heads of Antichrist the seven principal vices are signified. By the head that is not slain to death, but appears to be so, blasphemy is signified, and it has to be asked in what way blasphemy is said to be as if slain.[14]

Folio 24 recto

The Worship of the Dragon

John looks anxiously on through a small slit in the frame as the people are falling down to worship the Dragon. The historiated initial shows a musician and a miser holding a bag of money, personifying avarice.

TEXT: *Revelation 13 v. 4.* And they adored the dragon, which gave power to the beast.

COMMENTARY: In what manner will they adore the Dragon that is the Devil whom they do not see? But they will adore Antichrist, those who are signified by the earth, and in Antichrist the Devil, in saying that nobody is like unto Antichrist, nor is anybody equal to him in strength.

Folio 24 verso

The Worship of the Beast; The Beast blasphemes

On the left a group of people are being encouraged to worship the Beast, who is enthroned holding a sword and shield. He holds out his paw to the right, gesturing up to a part-mandorla in the clouds, representing his blasphemy against heaven. At the far right a group of men are running away in terror. The historiated initial below contains a standing man holding an ape and a bird.

TEXT: *Revelation 13 vv. 4–10.* And they adored the beast, saying: Who is like to the beast and who shall be able to fight with him? And there was given to him a mouth speaking great things, and blasphemies: and power was given him to do two and forty months. And he opened his mouth unto blasphemies against God, to blaspheme his name, and his tabernacle, and them that dwell in heaven. And it was given him to make war with the saints, and to overcome them. And power was given him over every tribe, and people, and tongue, and nation. And all that dwell on the earth shall adore him, whose names are not written in the book of life of the Lamb, which was slain from the beginning of the world. If any man have an ear, let him hear. He that shall lead into captivity, shall go into captivity: he that shall kill with the sword, must be killed with the sword.

COMMENTARY: And there was given to him a mouth speaking great things and blasphemies, that is allowed by God to

[14] The full commentary of Berengaudus, col. 883, goes into a lengthy explanation of why blasphemy is said to be 'as if slain'. Doubtless the thirteenth-century compiler of the Berengaudus extracts for the Getty Apocalypse found it difficult to summarise this verbose explanation, and so leaves it as an unresolved question.

speak great things of himself, saying that he was the son of God, and to speak blasphemies about God. *And it was given to him to do forty-two months.* It is difficult to see that in so very short a time, that is in three years and a half, all people could be subjected to him, and the human race could succumb to his cult, excepting the few elect, for there would be many of the elect but they would be very few in comparison with the unbelievers. However, he inflicted diverse and unheard-of torments on those who contradicted him, forcing them to do what they would refuse voluntarily. His mouth will open to blaspheme God the Father, and the Son, and the Holy Spirit: he will blaspheme the name of God saying that Christ is not God. He will make war on the saints by flattering some, frightening others, and in the end by inflicting upon them the worst torments.

Folio 25 recto

The False Prophet rises from the Earth; The False Prophet brings down Fire from Heaven and orders the Worship of the Beast

John stands closely behind the False Prophet rising from the earth, holding a scimitar, and with one of his paws on the shoulder of a man. Fire comes down from heaven as men worship the Beast on the right. The historiated initial below contains a musician playing before a man and woman dancing.

TEXT: *Revelation 13 vv. 11–14.* And after these things I saw another beast coming up out of the earth, and he had two horns like a lamb, and he spoke as a dragon. And he executed all the power of the former beast in his sight; and he caused the earth, and them that dwell therein, to adore the first beast, whose wound to death was healed. And he did great signs, so that he made also fire to come down from heaven unto the earth in the sight of men. And he seduced them that dwell on the earth by the signs which were given him to do in the sight of the beast, saying to them that dwell on the earth, that they should make the image of the beast, which had the wound by the sword, and lived.

COMMENTARY: *And I saw another beast etc.* The Beast having two horns similar to a lamb and speaking like the Dragon signifies one of the disciples of Antichrist, or the many who shall preach him. He is seen coming out of the earth, for he arises from the society of reprobates: and he is seen to have two horns like the Lamb. Earlier we have said that all the elect are signified by the seven horns of the Lamb, that are divided into seven parts: by the fifth horn we said was signified the Jews who believed in Christ: by the sixth the Gentiles who similarly believed in Christ. The Beast however shall have two horns similar to the Lamb, because he shall possess both Jews and Gentiles by deceiving them. For although many of the Jews believed in Christ through the preaching of Elijah, the greatest part of them shall follow Antichrist, just as the Lord said in the Gospel: *I am come in the name of my Father and you receive me not: if another shall come in his own name, him you will receive* (John 5 v. 43). (*He made also fire*) *to come down from heaven.* We read in the book of Job that by permission from God (to the

Devil) fire was made to descend from heaven, and the flocks and children of Job were consumed.

Folio 25 verso

The False Prophet kills those who refuse to worship the Image of the Beast and orders that All Men should be marked

The False Prophet, represented twice in the centre of the picture, threatens people on the left such that they worship the image of the Beast, and on the right he is marking a man on his forehead, with others lining up to be marked. The historiated initial shows an acrobat exercising on the bar of the initial E.

TEXT: *Revelation 13 vv. 15–18.* And it was given him to give life to the image of the beast, and that the image of the beast might speak; and should cause, that whosoever will not adore the image of the beast, should be slain. And he shall make all the little and great, rich and poor, freemen and bondmen, to have a character in the right hand, or on their foreheads. And that no man might buy or sell, unless he has the character, and the name of the beast, or the number of his name. Here is wisdom: he that hath understanding, let him count the number of the beast. For it is the number of a man, and the number of him is six hundred sixty-six.

COMMENTARY: *And it was given him to give life to the image of the beast, and that the image of the beast might speak.* We have heard that some magicians have done this, for indeed through their magic art they can make a statue move and speak. We could understand this in another way. An image has the appearance of a man, but it is not a man; similarly Antichrist through the working of miracles and signs shall be considered as God, but this will be a complete falsehood, for an evil man is not able to have deity in himself. Thus those who think Antichrist is God will make an image of him. The followers of Antichrist will give life to the image when they force those people that would come to believe in Antichrist to blaspheme Christ. *And should cause, that whosoever etc.* The faithful that would not adore Antichrist, tormented by various punishments, will be killed. *For there shall then be tribulation* (Matthew 24 v. 21), as the Lord said in the Gospel, such that there was not since the beginning and there would never be, unless the elect are judged to be in error, if that were possible. Just as we have the mark of Christ, that is the cross, that we are signed with, so Antichrist has his own character that is marked on those who believe in him.

Folio 26 recto

The Lamb is adored on Mount Sion

John views the Lamb standing holding his banner on the summit of Mount Sion as a procession of lambs comes up the slopes of the mountain to join him. The historiated initial below shows two shepherds gazing up at the star of Bethlehem.

TEXT: *Revelation 14 v. 1.* And I beheld, and lo a Lamb stood upon mount Sion, and with him an hundred forty-four thou-

sand, having his name, and the name of his Father, written on their foreheads.

COMMENTARY: If we look carefully into the text of the following statement, we shall see that the things said about the one hundred and forty-four thousand refer rather to the elect, whose souls rejoice with the Lord in celestial bliss, than to those who labour in this life. And so the Lamb is shown as Christ. It is a matter of speculation as to how Sion is interpreted; by Mount Sion we should understand the celestial land. The Lamb is seen on Mount Sion because Christ is in celestial bliss among his saints. *And with him an hundred forty-four thousand etc.* In the third vision, which preceded this one, it was said that forty-four thousand elect out of the twelve tribes were marked with the sign of faith. Those elect signify those who toil in this life, but these hundred and forty-four thousand elect signify those rejoicing with the Lord in celestial glory, just as the text makes clear in this reading at this moment. But why does it say that they have the names of the Father and Son written on their foreheads and yet keeps silent concerning the Holy Spirit? That is because whenever we read the Father and the Son we have also to understand the Holy Spirit. For, by their foreheads, we are able to understand the hearts of the saints. They have the name of the Father and the Son and of the Holy Spirit written on their foreheads because the love of God will never be able to be torn away from their minds, in the way that it was torn from the hearts of certain angels who on account of their pride fell from heaven.

Folio 26 verso

The New Canticle sung by the Voices before the Lamb and the Throne of God

John kneels to look through a hole in the frame at the vision of God holding an open book and blessing, surrounded by the four living creatures, with the Lamb holding a sceptre-like staff below, being praised by the singing of the new canticle by voices with open books coming from the cloud. The twenty-four ancients sit and stand on either side. The ornamental initial below contains foliage coils.

TEXT: *Revelation 14 vv. 2–5.* And I heard a voice from heaven, as the noise of many waters, and as the voice of great thunder; and the voice which I heard, was as the voice of harpers, harping on their harps. And they sung a new canticle, before the throne, and before the four living creatures, and the ancients; and no man could say the canticle, but those hundred forty-four thousand, who were purchased from the earth. These are they who were not defiled with women: for they are virgins. These follow the Lamb whithersoever he goeth. These were purchased from among men, the first fruits to God and to the Lamb, and in their mouth there was found no lie, for they are without spot.

COMMENTARY: Often the faithful in this present life are shown by John; by the waters surely the people are signified.

And because from all the nations holy ones of God established on earth are daily brought together, who are signified by John, they continually hear the voices of many waters; because they constantly feel present in their hearts and ears the teaching of the saints in heaven, and imitate it in their deeds with what virtue they can. From the same place a voice is said to be as if of thunder, that usually terrifies the hearts of those who hear it; for they are terrified when they are trying to reach it, that they are unable to ascend to perfection. *And the voice that I heard etc.* The sound of the players of the harp is sweet to the ear of the hearers. And what is sweeter for the faithful than the memory of the saints dwelling in heaven, for although they are in spirit, how great is their glory as they offer prayers of supplication when they have reached there. *And they sang a new canticle.* The canticle that is new signifies the New Testament, because the Old Testament that preceded it begets for it a new people.

Folio 27 recto

The First Angel saying 'Fear the Lord'

John stands watching an angel flying down from the clouds between two seated groups of men, bearing a scroll with the words: 'Fear the Lord, and give him honour, because the hour of his judgement is come, Amen.' The historiated initial below contains a sower.

TEXT: *Revelation 14 vv. 6–7.* And I saw another angel flying through the midst of heaven, having the eternal gospel, to preach unto the inhabitants upon the earth, and over every tribe, and tongue, and people: saying with a loud voice: Fear the Lord, and give him honour, because the hour of his judgment is come, and adore ye him, that made heaven and earth, and the sea and the fountains of waters.

COMMENTARY: This angel signifies Christ and the apostles, and the other preachers of Christ. It is said that they had the eternal gospel because the teaching of the Gospel was given by Christ, the apostles and the other preachers in order to preach to the nations. The Gospel is said to be eternal because it brings eternity to those who practise it. Also it is said that it is to be preached to those upon the earth. The nations to whom the Gospel is preached looked for nothing other than the earth, and established their final rest on the earth. What this angel preaches we should listen to. *Fear the Lord etc.* It is appropriate to put the fear of the Lord first and after it his honour. For fear of the Lord indeed urges men to penance, because it rouses them to do good works. That is because we give honour to God whenever we do good works, as he himself says: *They may see your good works and glorify your Father who is in heaven* (Matthew 5 v. 16). Those people will be severely judged at the day of judgement who, on hearing the word of the Gospel, disregard it and do not wish to receive the faith of Christ. Similarly those who, having received the faith of Christ, do not want to carry out his works. For from those to whom more has been committed more is required.

Folio 27 verso

The Second Angel: The Fall of Babylon

John stands, half turning away, as an angel flies down from the clouds over the collapsing buildings of the city of Babylon. The historiated initial below contains two musicians standing in turrets, both having wind instruments.

TEXT: *Revelation 14 v. 8.* And another angel followed, saying: That great Babylon is fallen, is fallen, which made all nations to drink of the wine of the wrath of her fornication.

COMMENTARY: The other angel signifies the Doctors of the Church, who, at the end of the time of persecutions, governed the Church of God. *That great Babylon is fallen, is fallen.* By Babylon, just as we have said above, is signified the city of the Devil, that is composed of all the wicked. It had fallen, however, because all their practices were driven away by the faith of Christ. And it is said twice to have fallen down; because it had fallen as a result of the persecutors, and as a result of devilish cults, *which made all nations to drink of the wine of her wrath.* The errors of the Gentiles are the wine of wrath, that provoke God to rage; but since Babylon is nothing other than all nations, that is all the reprobates, in what way did she make all nations drink of the wine of her wrath? But surely one taught another, and he the third, and the third the fourth, and so the devilish error passed into all men, and so certainly Babylon made all nations drink of the wine of the wrath of God.

Folio 28 recto

The Third Angel: The Judgement of those who worship the Beast

An angel flies down from the clouds towards John, indicating to him a group of seated men beside the Lamb and the cup of the wrath of God on a hillock, with smoke rising up from it to four angels in the clouds above. The ornamental initial below contains foliage coils and a dragon.

TEXT: *Revelation 14 vv. 9–12.* And the third angel followed them, saying with a loud voice: If any man shall adore the beast and his image, and receive his character in his hand, or on his forehead, he also shall drink of the wine of the wrath of God, which is mingled with pure wine in the cup of his wrath, and shall be tormented with fire and brimstone in the sight of the Lamb. And the smoke of their torments shall ascend up for ever and ever: neither have they rest day or night, who have adored the beast, and his image, and whoever receiveth the character of his name. Here is the patience of the saints, who keep the commandments of God, and the faith of Jesus.

COMMENTARY: The third angel represents the preachers that there will be in the time of Antichrist; for they shall preach that Antichrist should not be adored, neither should the ears make the heart susceptible to his very bad doctrine, neither should his works be imitated. For if anyone shall do these things they shall bear witness that he is to be condemned to perpetual

punishment. By the wine of the wrath of God is signified the final condemnation that will be imposed on the wicked in the day of judgement. But we say it is pure undiluted wine; by the pure wine the justice of God is signified, for certainly by the chalice we are able to receive the judgement of God. And thus the wine is mixed in the chalice of God, because the final condemnation, in which the wicked shall be condemned, shall be mixed with justice in the chalice of God, that is in the judgement; because it will be fulfilled in the most just judgement of God. The wicked shall drink of the wine of the wrath of God when it is said: *Depart from me you cursed into everlasting fire which was prepared for the Devil and his angels* (Matthew 25 v. 41). The fire consumes, and the brimstone gives out the most foul stench. By the fire shall be tormented in their bodies those who did not wish to extinguish in themselves the fire of their vices. By the foul stench of the brimstone shall be tormented those who found delightful the stench of lust.

Folio 28 verso
'Blessed are the Dead who die in the Lord'

An angel flies out of a cloud to give what may be a pot of ink to the seated John holding quill and knife, instructing him to write. On the right two angels carry up souls from dead men below, with a woman lamenting at the side of the bed. The ornamental initial below contains foliage palmettes.

T E X T: *Revelation 14 v. 13*. And I heard a voice from heaven, saying to me: Write: Blessed are the dead who die in the Lord. From henceforth now, saith the Spirit, that they may rest from their labours; for their works follow them.

C O M M E N T A R Y: *Blessed are the dead who die in the Lord*. Such is the suffering of the saints that keep the commandments of God and faith in Jesus, that they are blessed for ever. But why does it say: Blessed are the dead who die in the Lord? What dead person can die? Without doubt no dead person can die unless he first gets back his soul so that he can die again. But those are blessed, and they die in the Lord, who first die to the world, and afterwards in the flesh: who first extinguish in themselves the old man, that is, all spiritual and carnal iniquity, so that they can say with the Apostle: *The world is crucified to me, and I to the world* (Galatians 6 v. 14). For these die in the Lord, of whom the Lord says: *Whosoever shall persevere to the end, shall be saved* (Matthew 24 v. 13). *From now on* it is the souls, *that they may rest from their labours*. From now on, that is, from the time of their death, the saints rest from their labours. *For their works follow them*. In what way do their works follow them? The reward for their works accompanies them for eternity. We are able to understand spiritually from this that those who are killed at the time of Antichrist for the name of the Lord Jesus Christ shall be blessed, for they die in the Lord. The punishment of those who shall believe in Antichrist is described, and the bliss of those who shall persevere to the end in the faith of Christ, and that in the day of judgement all shall be accomplished.

Folio 29 recto
The Harvest of the Earth

John looks at the king, coming in the clouds holding a sickle, who on earth reaps the harvest at the instruction of an angel coming out from the temple. The historiated initial below contains a standing man leaning on a stick and pointing to his eye.

T E X T: *Revelation 14 vv. 14–16*. And I saw, and behold a white cloud, and upon the cloud one sitting like to the Son of Man, having on his head a crown of gold, and in his hand a sharp sickle. And another angel came out from the temple crying with a loud voice to him that sat upon the throne: Thrust in thy sickle, and reap, because the hour is come to reap, for the harvest of the earth is ripe. And he that sat on the cloud thrust his sickle into the earth, and the earth was reaped.

C O M M E N T A R Y: I would suggest that these things looked at from all aspects are seen more clearly. For in both cases this angel signifies Christ. Similarly, the two sickles have one meaning; for they signify that fire which is to destroy the world at the end, because just as at the beginning the world was destroyed by the Flood, so at the end of time it shall be destroyed by fire. But we should question why the one Christ is figured by two angels, and the one destruction by two sickles. Indeed the first angel is seated on a white cloud, and is seen to have a crown of gold: the second has no golden crown, neither is he seated on a white cloud. And the first harvests the earth, whereas the second is said to go before the clusters of the vineyards of the earth. But it is not said where the first put the harvest of the earth: the second is said to have sent the clusters of the vineyards of the earth into the great winepress of the wrath of God. That is why it seems to me that the harvest of the earth signifies the elect, and by the clusters of grapes from which wine comes, that clouds men's minds, the reprobates are signified. This is that harvest of which the Lord speaks in the Gospel: *Gather up first the cockle, and bind it in bundles to burn, but the wheat gather ye into my barn* (Matthew 13 v. 30). For those who are signified there by the wheat are here signified by the harvest. And those who are signified there by the cockle are signified here by the vineyards of the earth.

Folio 29 verso
The Vintage; The Blood from the Winepress of God's Wrath

John, from the outside of the frame, views an angel coming out of the temple holding a sickle above an altar from which flames arise, while another angel, standing by the altar, instructs a third angel to gather the clusters of grapes from the vineyard. At the far right are two horses, with the river of blood from the winepress – in which are two small devils – coming up to their bridles. The ornamental initial below contains foliage coils incorporating heads of a man and a woman.

T E X T: *Revelation 14 vv. 17–20*. And another angel came out of the temple which is in heaven, he also having a sharp sickle.

And another angel from the altar, who had power over fire, cried with a loud voice to him that had the sharp sickle, saying: Thrust in the sickle, and gather the clusters of the vineyard of the earth, because the grapes thereof are ripe. And the angel thrust in his sickle into the earth, and gathered the vineyard of the earth, and cast it into the great press of the wrath of God: and the press was trodden without the city, and blood came out of the press, up to the horses' bridles, for a thousand and six hundred furlongs.

COMMENTARY: This angel signifies Christ. In a similar way the two sickles have a single meaning. They signify the fire that shall destroy the whole earth. For just as at the beginning of time the world was destroyed by the waters of the Flood, so at the end of time it will be destroyed by fire. But we should ask why.[15]

Folio 30 recto
The Seven Angels holding the Vials

John, holding his hand to his head, sees the vision in heaven of seven angels holding vials which represent the seven last plagues. The historiated initial below shows a jug on a table, with another hanging from a bar on which a cloth hangs.

TEXT: *Revelation 15 v. 1*. And I saw another sign in heaven, great and wonderful: seven angels having the seven last plagues. For in them is filled up the wrath of God.

COMMENTARY: Just as above, before he came to the story of the seven angels that sounded the trumpets, he made mention of them; so, here, before he comes to the story of the seven angels having the vials, he mentions them so as to indicate the great mysteries contained in their vision.

Folio 30 verso
The Harpers on the Sea of Glass mingled with Fire

John looks at the harpers on the sea of glass mingled with fire, surrounding a hill on which the Lamb stands. A man kneels before the Lamb, holding a scroll on which is written: 'Great and wonderful are thy works, O Lord God Almighty; just and true are thy ways, O King of ages.' The historiated initial below shows David harping with a musician, relating to the subject of the picture above.

TEXT: *Revelation 15 vv. 2–4*. And I saw as it were a sea of glass mingled with fire, and them that had overcome the beast, and his image, and the number of his name, standing on the sea of glass, having the harps of God: and singing the canticle of Moses, the servant of God, and the canticle of the Lamb, saying: Great and wonderful are thy works, O Lord God Almighty; just and true are thy ways, O King of ages. Who shall not fear thee, O Lord, and magnify thy name? For thou only art holy:

[15] For some reason this question is not answered. It is also surprising that the commentary from this text repeats a section from the commentary on the preceding page, and there may have been some confusion about what was to be included in this section of the text.

for all nations shall come, and shall adore in thy sight, because thy judgments are manifest.

COMMENTARY: What the sea of glass signifies we have said earlier in the second vision; but there it was as of crystal, here it is mingled with fire, but because crystal is distinguished by its brightness, and is accustomed to give out fire from itself when it receives the heat of the sun, so crystal has the same meaning there as fire does here. They symbolise spiritual understanding as it is found in Holy Scripture. The sea of glass is mingled with fire because Holy Scripture is mixed with spiritual thoughts. Those who have conquered the Beast are seen standing on the sea of glass because the saints of God who shall fight against Antichrist direct their steps according to the precepts of Holy Scripture, and no blast of wind can shake their faith. The harps, which they have, signify the mortification of the flesh. The canticle of Moses represents the Old Testament, and the canticle of the Lamb the New. They sing the canticle of Moses and the canticle of the Lamb because the saints shall preach both the Old and the New. Let us listen to what is sung: *Great and wonderful are thy works, O Lord God Almighty; just and true are thy ways, O King of ages*. This canticle accords with both the Old and the New Testaments.

Folio 31 recto
The Temple of the Tabernacle in Heaven is opened; The Angels are given their Vials by the Eagle

The eagle, one of the living creatures, perches on the edge of a rock distributing the golden vials to the angels, who are clad in white garments with golden girdles around their shoulders. At the right God sits within the temple of the tabernacle of the testimony, which below is filled with smoke. The ornamental initial below contains foliage sprays.

TEXT: *Revelation 15 vv. 5–8*. And after these things I looked; and behold, the temple of the tabernacle of the testimony in heaven was opened: and the seven angels came out of the temple, having the seven plagues, clothed with clean and white linen, and girt about the breasts with golden girdles. And one of the four living creatures gave to the seven angels seven golden vials, full of the wrath of God, who liveth for ever and ever. And the temple was filled with smoke from the majesty of God, and from his power; and no man was able to enter into the temple, till the seven plagues of the seven angels were fulfilled.

COMMENTARY: The four creatures, as always, signify the four evangelists, but also all of them together and individually signify Christ. By this particular creature we understand Christ. The vials are certainly the hearts of the saints who are rightly called golden on account of their wisdom. One of the four creatures gives to the seven angels the seven golden vials because Christ has filled their hearts with wisdom. But if they have been filled with wisdom why are they said to be full of wrath of God? The Lord says in the Gospel of the sin of the Jews: *If I had not come and had not spoken to them they would*

not have sin (John 15 v. 22). Was it that the Jews did not sin before the coming of Christ? They were indeed previously sinners, but they did not commit the sin of unbelief, nor the sin of blasphemy for which they called him Beelzebub, nor the sin of murder which they committed when they crucified him, nor other crimes which they committed at his coming. But in the vial of Christ in which the world is contained, the Jews discovered the death that would drive away their faults. The vials of the seven angels were full of the wrath of God because in its reference to the reprobates the preaching of the saints contained in it the wrath of God, and because they scorned their preaching they incurred the wrath of God. *And the temple was filled with smoke from the majesty of God, and from his power.* By the temple is signified the celestial land.

Folio 31 verso
The First Vial poured upon the Earth

John looks through a hole in the frame as the angel pours the first vial on the earth, while a group of men look anxiously on. The ornamental initial below contains foliage coils.

T E X T : *Revelation 16 vv. 1–2.* And the first angel went, and poured out his vial upon the earth, and there fell a sore and grievous wound upon men, who had the mark of the beast; and upon them that adored the image thereof.

C O M M E N T A R Y : The first angel signifies the preachers that were before the Law, just as the first to sound the trumpet in the former vision was seen to be. But there the elect were signified by the third part of the earth that was burnt up; here, however, those who suffered a sore and grievous wound are those made even worse by the preaching of the saints, reprobates who scorned the commands of God. But if the sore and grievous wound refers to the reprobates, and if only those who had the mark of the Beast suffered, it has to be asked what the mark of the Beast is. If by the mark of the Beast we wish to understand pride, for it was on account of that the Devil fell from heaven, we have to note that many of the elect have been wounded by pride, but were cured through the medicine of humility. But there is another worse vice that the medicine of penance always prevents. We know that the Devil is irrevocably (damned) and in no way can be corrected from his iniquities, therefore the medicine of penance is not required by him, and the Devil is completely excluded from this remedy. Thus, those who have the mark of the Devil have not been able to revoke their crimes through the teaching of the holy fathers, for they shall persist incorrigible and impenitent. But because in our time many people suffer from this vice, it is necessary that we say some things about its great extent. For certain people are so irrevocably determined that, knowing that they are depraved, in no way are they able to revoke this behaviour, fearing to be overcome by other men.[16]

[16] The sense of the passage is not clear, but the general point being made is that some people fall into bad ways, and they just cannot change, and therefore they come to neglect the sacrament of penance completely, which could cure them if they availed themselves of it.

Folio 32 recto
The Second Vial poured upon the Sea

The angel looks at John as he pours the second vial upon the sea, which becomes blood, and many dead men are seen submerged in its waters. The historiated initial below contains a bird perched on the bar with small dogs or sheep below.

T E X T : *Revelation 16 v. 3.* And the angel poured out his vial upon the sea, and there came blood as it were of a dead man; and every living soul died in the sea.

C O M M E N T A R Y : This angel signifies the Doctors of the Law, just as in the previous vision was the case for the second sounding of the trumpet: but there the third part of the sea was said to be turned to blood, that we said was to signify the elect; here, however, all the sea is described as being turned to blood. The pouring out of blood was punishment for the deadly sins of wicked people under the Law. By the sea therefore are signified those who committed errors of the Law, and it is turned into blood because they received perpetual punishment for contempt of the commandments of God. Every living soul is dead in the sea because many of those who were in the sea, that is the number of the reprobates who are signified by the sea, were alive before the understanding (of the Law) was received, and seemed to be just; but when the Law had been received were proved to be unjust by their transgression of the Law. There are even many people in the Church who have attained ecclesiastic or civic honour that are seen as saintly and just, but having accepted these honours they turn into evil the gift of God, and to all it is evident that they were as dead and not living.

Folio 32 verso
The Third Vial poured upon the Fountains and the Rivers; The Fourth Angel proclaims the Justice of the Lord

The angel pours the third vial on the fountains and rivers, which become blood. The fourth angel holding a vial stands by an altar announcing: 'Thou art just, who art, who wast, the Holy One, because thou hast judged these things.' The ornamental initial below contains foliage coils.

T E X T : *Revelation 16 vv. 4–7.* And the third angel poured out his vial upon the rivers and the fountains of the waters; and there was made blood. And I heard the fourth angel saying: Thou art just, who art, who wast, the Holy One, because thou hast judged these things: for they have shed the blood of the saints and prophets, and thou hast given them blood to drink; for they are worthy. And I heard another, from the altar, saying: O Lord God Almighty, true and just are thy judgments.

C O M M E N T A R Y : By the rivers and the fountains of the waters are signified the twelve tribes with their families. For in the preceding vision of the third angel blowing the trumpet we have said that the prophets have been signified. But there the third part of the rivers and of the fountains is said to be changed into

wormwood, and we have said that signified those who through the teaching of the prophets had taken up the bitterness of penance and through that they deserved to be saved. Here, however, in the pouring out of the vial of the third angel the rivers and the fountains of waters become blood. The angel pours out his vial on the rivers and fountains of waters when the holy prophets announce the word of God to wicked people, but these people, made worse by the preaching of the saints, not only despised the commandments of God, but they killed the ministers of the word of God. They have been changed to blood because they themselves came to eternal death. By the fourth angel we are able to understand the angel of those people who, seeing iniquitous people condemned by the just justice of God, praises the most just sentence of Almighty God. And because of the blood the saints and prophets have shed, they have drunk of the blood, and for the temporary death that they have brought to the just, they have received eternal death.

Folio 33 recto
The Fourth Vial poured upon the Sun

John shelters his head and face with his cloak to protect himself from the sun as the angel flies out of a cloud to pour the fourth vial on it. Below, men collapse and gesticulate in agony as they are scorched by the great heat. The historiated initial below shows three men shielding their eyes and bodies, intended to refer to the gesture of John in protecting himself from the sun.

TEXT: *Revelation 16 vv. 8–9*. And the fourth angel poured out his vial upon the sun, and it was given unto him to afflict men with heat and fire: and men were scorched with great heat, and they blasphemed the name of God, who hath power over these plagues, neither did they penance to give him glory.

COMMENTARY: The fourth angel signifies Christ and his apostles, and other preachers that we have said the fourth angel signified in the earlier vision; but by the sun was signified the people of the Jews, by the third part of the sun, moon and stars the faithful out of that people who believed in Christ. The fourth angel therefore pours out his vial upon the sun, because Christ and his apostles preached clearly that the unbelieving Jews would be destroyed by the Romans. For just as any slave receives a sword from his lord, not that his own throat should be cut with it, but that he should behead a guilty person, so the Romans poured out the vial that contained the wrath of God on the Jews, so that they perished, not for their own account, but in avenging the blood of Christ. And so it continues: *For it was given unto him to afflict men with heat and fire.* We can understand by the heat, the siege, by the fire, the famine and the sword by which the Jews were almost all destroyed. It is given thus to the sun to afflict men with heat and fire, so it was given to the Romans, by God, to afflict the wicked among the Jews with various calamities, killing some of them and expelling some of them from their land. *And men were scorched with great heat.* Whoever wishes to know the extent to which the Romans inflicted great heat upon the Jews has to read Josephus

where he will find that no nation among all the kingdoms of the earth ever perished with such cruelty.[17] And they blasphemed the name of the Lord who has power over these afflictions, and made no penance to give him glory.

Folio 33 verso
The Fifth Vial poured upon the Seat of the Beast

John sits with his hand to his head as he looks at the angel pouring the fifth vial on the draped seat of the Beast from which a great black cloud arises, making his kingdom dark. A group of men in contorted poses gnaw their tongues for pain and blaspheme God who is blessing above, and holding a book inscribed with Alpha and Omega. The historiated initial shows an acrobat exercising on the bar of the letter E.

TEXT: *Revelation 16 vv. 10–11*. And the fifth angel poured out his vial upon the seat of the beast; and his kingdom became dark, and they gnawed their tongues for pain: and they blasphemed the God of heaven, because of their pains and wounds, and did not penance for their works.

COMMENTARY: The fifth angel signifies the orthodox fathers who struggled against the heretics, in such a way as we have said in the former vision when the fifth trumpet sounded. And just as there the heretics are signified by the locusts, here they are signified by the seat of the Beast; the Beast however signifies the Devil. Rightly therefore the heretics are called the seat of the Beast, because the Devil lives in their hearts. The fifth angel therefore pours his vial on the seat, because the holy men, detecting the errors of heretics, were eager to show what punishment would befall them. Certainly *his kingdom becomes dark*, because it was demonstrated by the teaching of the holy fathers to those to whom the doctrine of the heretics seemed bright, that it was wretched and dark. *And they gnawed their tongues for pain*, because they were all reproved of every one of their errors. For Arius did not follow Eunomius or Sabellus, nor any of the other (heretics).[18] None of them followed each other, but each one, wishing to establish his own heresy, condemned the errors of the others. They are said to have blasphemed God for causing their sorrows and their wounds. For the heretics suffered pain because they were always refuted by the Catholics, and their wounds were in the errors of each of them. The heretics blasphemed God on account of their sorrows, for the more the Catholics overcame them the greater were the blasphemies they devised to refute them. Also, they are said to have been without penance.

Folio 34 recto
The Sixth Vial poured upon the Euphrates

John, seated on a hillock, lowers his head as the angel pours the

[17] This refers to *The Jewish War* by Flavius Josephus (*c*.37–*c*.100), an account of the suppression of the Jewish rebellion by the Romans AD 66–70, in which the sack of Jerusalem by the Roman emperor Titus at the end of the campaign is described.
[18] This refers to three of the most important heretics of the early Church: Arius (*c*.250–*c*.336), Eunomius (d.394) and Sabellus (third century).

sixth vial on the river Euphrates, whose water is drying up. The ornamental initial below contains a foliage palmette.

TEXT: *Revelation 16 v. 12.* And the sixth angel poured out his vial on the great river Euphrates; and dried up the water thereof, that a way might be prepared for the kings from the rising of the sun.

COMMENTARY: This sixth angel signifies the same thing as that one who was seen to blow the sixth trumpet, for he represents the holy martyrs. And those things, signified there by the horsemen who killed a third part of men, are as those represented here by the great river Euphrates, that is to say the persecutors of the Church of God. Thus, the angel pours his vial on the river Euphrates because they are foretold, without disturbing these persecutors themselves, that the damnation of the persecutors of the Church will soon take place. By the water is signified the persecution itself, for the waters have dried up because the holy martyrs have persisted in preaching the word of God until all the persecution comes to an end. Some of the persecutors were plunged into Hell, but some submitted themselves to the Christian faith. By the kings we are able to understand the multitude of the nations that were brought together to faith in Christ. That is why the way for the kings is prepared by the dried-up water, because at the end of the persecutions freedom was given to all peoples to come to faith in Christ. But why is it said that they came from the rising of the sun, that is from Christ, for they came not from Christ but to Christ, in their forsaking the Devil? Here, but not for strong reason, we have to understand by the sun, the Devil, for from him they came to Christ. But it is better that we understand Christ by the sun on account of the prophecy: *But unto you that fear my name, the sun of justice shall arise, and health in his wings* (Malachi 4 v. 2). For from the place of the sun they come, that is from Christ, they come to him through his inspiration and impulsion.

Folio 34 verso
Frogs come out of the Mouths of the Dragon, the Beast and the False Prophet
John gesticulates in horror as frogs signifying their unclean spirits emerge from the mouths of the seated False Prophet, Dragon and Beast. The ornamental initial below contains foliage stems incorporating four male heads wearing caps.

TEXT: *Revelation 16 vv. 13–16.* And I saw from the mouth of the dragon, and from the mouth of the beast, and from the mouth of the false prophet, three unclean spirits like frogs. For they are the spirits of devils working signs, and they go forth unto the kings of the whole earth, to gather them to battle against the great day of Almighty God. Behold I come as a thief. Blessed is he that watcheth, and who keepeth his garments, lest he walk naked, and they see his shame. And he shall gather them together into a place, which in Hebrew is called Armageddon.

COMMENTARY: *They are the spirits of devils working signs.* Having described the calling of the Gentiles, how they came to faith in Christ, it makes mention of Antichrist who shall come just before the end of the world. The three unclean spirits signify the disciples of Antichrist who shall preach concerning him throughout the world. Although they are to come as men, they are called unclean spirits and the spirits of devils, because devils shall dwell in them, and speak through their mouths; just as they are seen coming out of the mouth of Antichrist and of the mouth of the False Prophet, for it is the Devil who speaks through the mouth of Antichrist. Nevertheless they are rightly likened to frogs, that are unclean reptiles living in the mud, because just as the frog dwells in dirty waters, so the disciples of Antichrist will easily deceive those who are not afraid to be dirtied by diverse vices and sordid ways. For the harsh and ugly voice of frogs signifies their wicked preaching full of blasphemies. *And they go forth unto the kings of the earth etc.* By the kings of the earth are signified not only the kings but also the peoples. For the day of the Lord shall *come as a thief* in the night. When they shall say there is peace and security, then suddenly destruction shall come upon them.

Folio 35 recto
The Seventh Vial poured on the Air; The Earthquake destroys the Cities of the Earth
John is walking away as the angel pours the seventh vial on the air, causing an earthquake in which buildings collapse and men are killed, while above is God in a mandorla in heaven, with, at the left below, a head representing the great voice out of the temple from the throne. Five animal heads coming out of the clouds, with lines emerging from their mouths, represent the lightnings and voices and thunders. The ornamental initial below contains foliage coils.

TEXT: *Revelation 16 vv. 17–21.* And the seventh angel poured out his vial upon the air, and there came a great voice out of the temple from the throne, saying: It is done. And there were lightnings, and voices, and thunders, and there was a great earthquake, such a one as never had been since men were upon the earth, such an earthquake, so great. And the great city was divided into three parts; and the cities of the Gentiles fell. And great Babylon came in remembrance before God, to give her the cup of the wine of the indignation of his wrath. And every island fled away, and the mountains were not found. And great hail, like a talent, came down from heaven upon men: and men blasphemed God for the plague of hail: because it was exceeding great.

COMMENTARY: By this seventh angel are signified the holy preachers that shall come in the time of Antichrist. The angel therefore pours out his vial upon the air, for the holy preachers shall announce that vain and wicked men are to be condemned to eternal punishment. *And a great voice came out.* The great voice is the voice of the holy preachers. By the temple the Church is understood. From the temple a voice thus comes out,

[62]

because from the Church proceeds the voice of holy preachers; it is also said to come out from the throne, because the Church is the throne of God, and he sits upon it. For what this voice says is revealed in adding, *It is done*, that is to say the end of the world is soon to follow, when all things that are prophesied by God and by his saints shall be accomplished. By the lightnings are signified the miracles which God has done through his saints, and we have read above that Elijah and Enoch have also performed many miracles. By the voices is expressed the preaching of the saints, and by the thunders the fear of (eternal) fire.

Folio 35 verso
The Great Harlot seated on the Waters

The angel draws John by his cloak towards the Great Harlot seated on the waters, who is admiring herself in a mirror. The historiated initial below shows a back-turned man pointing upward towards the Harlot in the picture.

TEXT: *Revelation 17 vv. 1–2.* And there came one of the seven angels, who had the seven vials, and spoke with me, saying: Come, I will shew thee the condemnation of the great harlot, who sitteth upon many waters, with whom all the kings of the earth have committed fornication; and they who inhabit the earth, have been made drunk with the wine of her whoredom.

COMMENTARY: Just as above at the sounding of the trumpet of the seventh angel, the day of judgement is briefly understood, he returns to what he had passed over; and describing the Holy Church in the form of the woman that was clothed with the sun, and with the moon at her feet, he adds what sufferings she bore from the Devil, and what she is to suffer from Antichrist at the end of the world. So here, at the pouring out of the vial of the seventh angel, in briefly referring to the day of judgement, he returns to that which he omitted, describing under the form of a harlot the city of the Devil, and makes clear in what follows the punishments that she will suffer for her crimes. The angel that had one of the vials signifies the holy preachers, and John is the prototype of all the faithful. This harlot in some places particularly represents Rome who at that time persecuted the Church of God. In other places it more generally represents the city of the Devil, that is to say the whole body of the reprobates. The angel shows John the condemnation of the Great Harlot because the holy preachers by their words and writings show to the faithful what punishments the wicked suffer for their crimes, in order that their punishments terrify them, such that they abstain from sin. It is said that she sits upon many waters because the city of the Devil is constituted out of many nations that are signified by the waters. The kings of the earth are said to have committed fornication because they have increased the crimes of Babylon which they have destroyed. *And they who inhabit the earth, have been made drunk with the wine of her whoredom.* The wine of whoredom signifies the many errors and crimes of the wicked city.

Folio 36 recto
The Great Harlot seated on the Beast

John withdraws in fear as the angel shows him the Great Harlot seated on the Beast. In a coquettish pose, seated side-saddle, she holds up a golden cup. The ornamental initial below contains foliage coils.

TEXT: *Revelation 17 vv. 3–5.* And he took me away in spirit into the desert. And I saw a woman sitting upon a scarlet coloured beast, full of names of blasphemy, having seven heads and ten horns. And the woman was clothed round about with purple and scarlet, and gilt with gold, and precious stones and pearls, having a golden cup in her hand, full of the abomination and filthiness of her fornication. And on her forehead[19] a name was written: A mystery; Babylon the great, the mother of the fornications and the abominations of the earth.

COMMENTARY: By the desert is signified the multitude of the wicked, for they have deserted God, and therefore have been abandoned by him. The Harlot is found in the desert because the city of the Devil consists of the multitude of the wicked. The Beast, who appears, signifies the Devil himself, coloured scarlet, the colour of blood, and by blood death is often signified. The Devil is the colour of blood because he is the author of death and all perdition. It is said that the Beast is full of the names of blasphemy because the Devil is the source of all blasphemers. What the seven heads and ten horns are, the angel explains as follows. *And the woman was clothed round about with purple etc.* Purple is tinged with blood and scarlet has the colour of blood. It also is the colour of royal garments which signify secular power. Purple and scarlet have the appearance of blood because secular power is the instrument of death, and a constant danger to those who put more value on the glory of heaven. We are able to understand by the garments of the colour of blood the deeds of the wicked who shall be condemned to eternal death. And it continues: *And gilt with gold.* By gold often worldly wisdom is signified, and by gems and pearls the eloquence of the world. By the golden cup the teaching of the philosophers (of the world is signified).

Folio 36 verso
The Great Harlot drunk with the Blood of the Saints

The Harlot, scantily and sloppily clad, with a jug in one hand and a cup in the other, staggers in her state of drunkenness with the blood of the saints. A cup, jug and two books are on the ground, with another jug and cup on a wooden structure at the right. John, in conversation with the angel, raises his hands in amazement at the sight of her depravity. The historiated initial shows a woman pouring wine from a drinking horn into a cup, related to the imagery of the scene above.

TEXT: *Revelation 17 vv. 6–7.* And I saw the woman drunk with

[19] These four words were omitted by the scribe and have been added later in the margin.

the blood of the saints, and with the blood of the martyrs of Jesus. And I wondered when I had seen her, with great admiration. And the angel said to me: Why dost thou wonder? I will tell thee the mystery of the woman, and of the beast which carrieth her, which hath the seven heads and ten horns.

COMMENTARY: By the woman Babylon is signified, who drank the blood of the saints. She was drunk, that is alienated from all spiritual reasoning. She was drunk because the vengeance of the blood of the saints condemned her, and as she was alienated from the mercy of God, was not worthy in any way to be availed of his salvation. *And I wondered when I had seen her etc.* The faithful are astonished when they see the reprobates so alienated from the fear of God, that, without worrying at all they do many bad things to the innocent and plunge themselves into shameful crimes, knowing that God leaves no crime unpunished, only if it is first effaced by penance and the other medicines by which sins are healed. *And the angel said to me: Why dost thou wonder?* The Beast has the same signification here as above we have said that the Dragon has, for he signifies the Devil. The signification of the seven heads and ten horns is explained in what follows. The Beast, that is the Devil, existed before the coming of Christ, and possessed the human race. But now, no more does he possess the human race as he did formerly, for through Christ he has been cast out of the hearts of the elect. *And he comes out of the abyss* because at the time of Antichrist Satan shall be released from his prison and shall go out and seduce the nations, as what follows well shows. *And she will go to her ruin*, for she will be condemned to eternal punishment with all the other reprobates and with their associates, that he will deceive.

Folio 37 recto
The Fall of Babylon

John starts back in horror as the angel announcing its fall hovers over the collapsing city of Babylon, in which there are unclean birds and the heads of devils. The historiated initial below contains a king's head.

TEXT: *Revelation 18 vv. 1–3.* After these things, I saw another angel come down from heaven, having great power: and the earth was enlightened with his glory. And he cried out with a loud voice, saying: Babylon the great city is fallen, is fallen; and is become the habitation of devils, and the hold of every unclean spirit, and the hold of every unclean bird: because all nations have drunk of (the wine of) the wrath of her fornication; and the kings of the earth have committed fornication with her; and the merchants of the earth have been made rich by the power of her delicacies.

COMMENTARY: This angel signifies Christ who deigned to come down from heaven to earth, such that men could be brought up to heaven. It is said that he has great power, because he has the same power as the Father, for he is equal in all things. *And the earth was enlightened with his glory*, because

through the teaching of the faith he has enlightened the human race from the darkness of ignorance and unbelief. *And he cried out with a loud voice, saying.* The voice of Christ is the teaching of the Gospel. What the voice cries out is explained in what follows. *Babylon the great city is fallen, is fallen.* For God, that is to say, it is done. He said that Babylon is fallen because he himself has made it fall. It is said twice that it is fallen, for it fell firstly when by the teaching of the Gospel it lost a great multitude of the elect, who became separated from it by faith in Christ, and became citizens of the holy city, that is to say the Church. It shall fall for the second time when in the final days it will be punished by eternal death, which is called in this book, the second death. *And is become the habitation of devils.* Did not devils inhabit Babylon before the coming of Christ? They did inhabit it, but their dwelling there was not known. When the multitude of the elect were converted to the faith, Babylon became the habitation of devils, because those who had received the faith of Christ knew that Babylon was the dwelling place of devils.

Folio 37 verso
The People go out of Babylon; The Lament of the Merchants over the Sins of Babylon

John bends his head to look through a window in the frame at the people leaving the burning city of Babylon. In the centre an angel comes from the clouds telling them to leave the city. On the right a group of men represent the lament of the merchants over the fall of the city, and the man in front holds a scroll bearing the words: 'Alas! that great city Babylon, that strong city, for in one hour is thy judgement come, and the merchants of the earth shall weep and mourn over her.' The historiated initial below contains a crouching man or woman holding a stick and pointing to their head.

TEXT: *Revelation 18 vv. 4–11.* And I heard another voice from heaven, saying: Go out from her, my people; and you be not partakers of her sins, and that you receive not of her plagues. For her sins have reached unto heaven, and the Lord hath remembered her iniquities. Render to her as she has also rendered to you; and double unto her double according to her works: in the cup wherein she hath mingled, mingle ye double unto her. As much as she hath glorified herself, and lived in delicacies, so much torment and sorrow give ye unto her; because she saith in her heart: I sit a queen, and am no widow, and sorrow I shall not see. Therefore shall her plagues come in one day, death, and mourning, and famine, and she shall be burnt with the fire; because God is strong, who shall judge her. And the kings of the earth, who have committed fornication, and lived in delicacies with her, shall weep, and bewail themselves over her, when they shall see the smoke of her burning, standing afar off for fear of her torments, saying: Alas! that great city Babylon, that strong city, for in one hour is thy judgment come. And the merchants shall weep and mourn over her, for no man shall buy their merchandise any more.

COMMENTARY: By heaven the Church is here signified, and the voice from heaven is the voice of the preachers who come out of the Church. But what does this voice say? *Go out from her, my people.* The Lord, by the preachers, persuades the elect to leave Babylon, not in their bodies, but in spirit. The way in which they have to leave Babylon he teaches them in saying what follows. For they go out from Babylon as is appropriate, for they become alien to its bad deeds, just as the psalmist says: *I have not sat with the council of vanity, neither will I go in with doers of unjust things* (Psalm 25 v. 4). *And that you receive not of her plagues.*

Folio 38 recto
The Angel casts the Millstone into the Sea

John, with an open book on his lap, sits on a hillock as the angel casts the millstone into the sea. The historiated initial below shows a baker kneading dough in a bowl.

TEXT: *Revelation 18 vv. 21–4.* And a mighty angel took up a stone, as it were a great millstone, and cast it into the sea, saying: With such violence as this shall Babylon, that great city, be thrown down, and shall be found no more at all. And the voice of the harpers, and of musicians, and of them that play on the pipe, and on the trumpet, shall no more be heard at all in her; and the sound of the mill shall be heard no more at all in her; and the light of the lamp shall shine there no more; and the voice of the bridegroom and the bride shall be heard no more at all in thee: for thy merchants were the great men of the earth, for all the nations have been deceived by thy enchantments. And in her was found the blood of prophets and of saints, and of all that were slain upon the earth.

COMMENTARY: This angel signifies Christ, who is said to be mighty, for the human mind cannot comprehend how great is the strength of Christ. By the millstone certainly the great multitude of the wicked is signified, and the sea signifies Hell, in which all wicked people are plunged. The angel puts the millstone into the sea, for our Lord Jesus Christ in the day of judgement in his just judgement plunges all the multitude of the wicked into Hell. *And the voice of the harpers etc.* It has to be asked why among the crimes of Babylon are considered to be ordinary human activities, the sound of the mill, the light of the lamp, and the voice of the bridegroom and the bride, for all these things can be done without fault, and without them human life cannot go on. All these things have to be understood spiritually. We are able to understand by ordinary human activities that *the wisdom of this world is foolishness with God* (I Corinthians 3 v. 19), for the bad artisans and the sons of Babylon are able to gain advantage from their activities, for *they are wise to do evil, but they have no knowledge to do good* (Jeremiah 4 v. 22). The mill, however, will grind and crush whatever it receives, and we are able to understand wicked judges by the mill.

Destruction of the Great Harlot in Flames; The Triumph in Heaven

At the bottom of the picture lies the Great Harlot with flames and smoke arising from her body, with men, probably representing the servants of God, kneeling on either side of her. Above is God in a mandorla with figures blowing trumpets above him and the four living creatures below him. Out of the bottom of the mandorla flies an angel who represents the voice from the throne who says to the kneeling men: 'Give praise to our God, all ye his servants; and you that fear him, little and great.' The historiated initial below contains a standing man holding a stick with his hand to his head.

TEXT: *Revelation 19 vv. 1–5.* After these things I heard as it were the voice of many great trumpets[20] in heaven, saying: Alleluia. Praise, and power and glory is to our God. For true and just are his judgments, who hath judged the great harlot which corrupted the earth through fornication, and hath revenged the blood of his servants, at her hands. And again they said: Alleluia. And the four and twenty ancients, and the four living creatures fell down and adored the Lord that sitteth upon the throne, saying: Amen; Alleluia. And a voice came out from the throne, saying: Give praise to our God, all ye his servants; and you that fear him, little and great.

COMMENTARY: For from the seven voices alleluia is sung five times: the first and the second from the voice of many trumpets; the third from the twenty-four ancients, and the four living creatures; the fourth from the voice that comes out of the throne; not now alleluia but its equivalent is sung, that is: *Give praise to our God all ye his saints.* Alleluia to be sure resounds in praising the Lord. The fifth is sung all at once by three voices together, from the voice of the great trumpet, from the voice of many waters, and from the voice of the great thunders. The writings of this book often show the whole multitude of the elect divided into seven parts, if the meaning is examined subtly. The just that were before the Flood, as the first part, those that lived after the Flood until the Law was given, relate to the second part, just as we have often shown. By the many trumpets are signified the elect of the time before the Flood, and after the Flood, until the time when the Law was given. They give out a sound, because through the doctrine of their preaching, insofar as they were able, they recalled them from their errors. They sing alleluia because they have taken pains to please God through good works.

Folio 39 recto
The Marriage Feast of the Lamb

John leans back as one head from the clouds blows a great trumpet towards him, another head causes the voice of many

[20] The word in the Vulgate is 'turbarum', that is 'of a crowd of people', but in the Berengaudus commentary it is 'tubarum'. The artist clearly interpreted it as such by showing the blowing of many trumpets.

waters to come from the clouds, and five animal heads represent the great thunders. These are all set above a marriage feast at which the Lamb and his bride have the marriage veil held over them by a hand above, and guests sit eating and drinking either side. The veil represents the part of the marriage ceremony in the medieval church in which it is held over the bridal pair when they are blessed by the priest before receiving communion. The ornamental initial below contains foliage coils.

TEXT: *Revelation 19 vv. 6–8*. And I heard as it were the voice of a great trumpet,[21] and as the voice of many waters, and as the voice of great thunders, saying, Alleluia: for our God the Almighty hath reigned. Let us be glad and rejoice, and give glory to him; for the marriage of the Lamb is come, and his wife hath prepared herself. And it is granted to her that she should clothe herself with fine linen, glittering white. For the fine linen are the justifications of the saints.

COMMENTARY: The great trumpet signifies Christ. The voice of the trumpet is the preaching of the Gospel. By the voice of the many waters is signified the multitude of nations who acknowledge Christ. By the voice of the great thunders are understood the elect who shall be born at the end of the world. And also justice by the thunders because they shall announce the terror of the day of judgement. Three voices sing alleluia at one time because they have observed faith in the Holy Trinity, and the teaching of the Gospel which comes from the great trumpet that is Christ, and they shall serve him until the end of time. Two categories, that is the first and the second, relate to the law that we have said to be natural. Two that follow, that is the third and the fourth, to the Law that was given by Moses. The three that remain, that is the fifth, sixth and seventh, to the law of the Gospel, in order to show those that have to keep faith in the Holy Trinity until the end of the world. Let us hear what they sing in the other three categories: *Alleluia: for our God the Almighty hath reigned*, that is to say we praise the Lord, that is in having destroyed the reign of the Devil, our destroyer, it is worthy that the Lord who is our Saviour rules us. We praise, exult and give glory to him, because they have come to the wedding feast that is prepared for the Lamb and his bride. We praise and exult because, in the mercy of the founder of our Church, we are united as the bride is united with the bridegroom, in order that we are as one body with him.

Folio 39 verso
John bidden by the Angel to write; He falls down before the Angel
On the left an angel holding a scroll instructs John to write. On the right John falls down in adoration at the feet of the angel, who points up to God above, telling John that it is God whom he should adore. The historiated initial below contains a tonsured man writing at a lectern.

TEXT: *Revelation 19 vv. 9–10*. And he said to me: Write: Blessed are they who are called to the marriage supper of the Lamb.

21 The Vulgate reading is 'turbe', that is 'of a crowd of people'.

And he saith to me: These words of God are true. And I fell down before his feet to adore him. And he saith to me: See thou do it not: I am thy fellow servant, and of thy brethren, who have the testimony of Jesus. Adore God. For the testimony of Jesus is the spirit of prophecy.

COMMENTARY: Now is the meal of the elect, when they are fed with feasts of the Gospel in the Church. Their banquet will certainly be when, after the resurrection, they enjoy to the full eternal glory in celestial bliss. And as a meal that takes place in our time includes both good and bad, not all are blessed that are received in that banquet which shall take place after the end of the world. *And he saith to me: these words of God are true etc.* The redemption of the blood of Christ was conferred on the faithful so that they were made sons of God and companions of the angels; and for that reason that angel that was adoring God as man is afraid to be adored by a man, and on that account he calls himself the fellow servant of John and of the other faithful. *The testimony of Jesus is the spirit of prophecy*; the fathers of the Old Testament who predicted the coming of Christ, his passion and resurrection, most certainly had the spirit of prophecy, and thus are called prophets. Whosoever thus bears witness to Christ has the spirit of prophecy.

Folio 40 recto
The Armies of Heaven; The Treading of the Winepress of the Wrath of God
Christ on a white horse, holding a sceptre and with a sword in his mouth, leads the armies of heaven across the sky. On his garment is written: 'King of Kings, and Lord of Lords'. At the bottom right Christ, with the same inscription on his garment, treads the winepress of the wrath of God. The historiated initial below shows an acrobat performing on the bar of the initial E.

TEXT: *Revelation 19 vv. 11–16*. And I saw heaven opened, and behold a white horse; and he that sat upon him was called Faithful and True, and with justice does he judge and fight. And his eyes were as a flame of fire, and on his head were many diadems, and he had a name written, which no man knoweth but himself. And he was clothed with a garment sprinkled with blood; and his name is called the Word of God. And the armies that are in heaven followed him on white horses, clothed in fine linen, white and clean. And out of his mouth proceedeth a sharp sword; that with it he may strike the nations. And he shall rule them with a rod of iron, and he treadeth the winepress of the fierceness of the wrath of God the Almighty. And he hath on the garment, and on the thigh written: King of Kings, and Lord of Lords.

COMMENTARY: In no way should we think that this chapter relates to the coming of Christ, in which he is coming to the judgement, but rather to the elect that shall be born at the end of the world; for indeed at the time of the end of the world, the Lord shall come among his saints, that he should fight through

them against Antichrist and his followers. And in that form he will be preached by his saints, and so is he described here; for by heaven the Church is signified, and by the white horse the man, that the Son of God took upon himself, and on which he is seen to sit. For also it is said that he is called Faithful and True. These two words, Faithful and True, have here the same meaning. Rightly, the Son of God is called Faithful, as the psalmist says: *The Lord is faithful in all his words, and holy in all his works* (Psalm 144 v. 13). And rightly he calls himself True, saying in the Gospel: *I am the way, the truth and the life* (John 14 v. 6). *And with justice does he judge and fight.* It is not with weapons that God fights against the wicked at the day of judgement, but the justice of God overthrows them and they are crushed. For God brings to light all the sins and all the crimes of the wicked such that they know that they are to be condemned by the judgement of the most just God. Through the eyes of the Lord the Holy Spirit is signified. By the many diadems the multitude of the saints are expressed.

Folio 40 verso
The Birds summoned by the Angel standing in the Sun

John raises his arms in amazement as, at the right, the angel standing in the sun commands the birds to fly down from heaven to eat the flesh of kings and tribunes. The historiated initial below contains a dancing man holding a trumpet and pointing upward at the picture.

TEXT: *Revelation 19 vv. 17–18.* And I saw an angel standing in the sun, and he cried out with a loud voice, saying to all the birds that did fly through the midst of heaven: Come, gather yourselves together to the great supper of God: that you may eat of the flesh of kings, and the flesh of tribunes.

COMMENTARY: This angel represents the preachers that shall be at the end of the world, that also were signified formerly in a small way by the horsemen. By the sun we certainly have to understand Christ. The angel however stands in the sun, because the holy preachers shall be so firmly set in Christ, that no power of persecutions can tear them away from faith in him. By the birds are signified all the faithful that shall be at that time; they shall fly in heaven, for though placed in the earth, in their minds they shall dwell in the heavens. Nevertheless we can understand the Church by heaven. The saints fly around heaven, for having two wings, that is the two precepts of charity, they fly on every side, to some bestowing mercy, and withdrawing others from wickedness. *Come gather yourselves together to the great supper of almighty God: That you may eat the flesh of kings, and the flesh of tribunes, and the flesh of mighty men, and the flesh of horses, and of them that sit upon them, and the flesh of all freemen and bondmen, and of little and of great.* Those who are signified by the kings and princes, freemen and bondmen, and the others, these are signified by the horses and their riders, namely the princes of the earth and the people who will be subjected to them. What other is the supper of God but the expulsion of the wicked? The just shall eat the flesh

of the wicked when they receive the punishment according to the bad things which they have done. For the just, in seeing the punishment of the wicked, profit from their good works, as the psalmist says: *The just shall rejoice when he shall see the revenge: he shall wash his hands in the blood of the sinner* (Psalm 57 v. 11).

Folio 41 recto
The Battle with the Army of the Beast

Christ, on the white horse, with the army of heaven, attacks the Beast and his army. The shield of Christ bears a cross, and the shields of the Beast and one of his followers bear a demonic head. The historiated initial below contains a fallen eagle.

TEXT: *Revelation 19 v. 19.* And I saw the beast, and the kings of the earth, and their armies gathered together to make war with him that sat upon the horse, and with his army.

COMMENTARY: Thus he shows that this does not relate to the coming of the Lord according to that which has been said above, but rather to that time in which, through his saints, war shall be made on Antichrist, just as we have already said. For the beasts and the kings of the earth, and their armies, will be gathered together to fight against Christ and his saints; when Antichrist and the innumerable multitude of people that will be brought down by him will rise up to persecute the Church of God, that they might completely extinguish the name of Christ from the world.

Folio 41 verso
The Beast and the False Prophet cast into the Pool of Fire

John, seated on a mound outside the frame, looks through an opening to view Christ on the white horse, with the army of heaven behind, directing two men to force the Beast and the False Prophet down into a pit which contains the pool of fire. The birds which were filled with flesh perch around the entrance to the pit. The ornamental initial below contains a palmette inhabited by two birds.

TEXT: *Revelation 19 vv. 20–1.* And the beast was taken, and with him the false prophet, who wrought signs before him, wherewith he seduced them who received the character of the beast, who adored his image; these two were cast alive into the pool of fire, burning with brimstone. And the rest were slain by the sword of him that sitteth upon the horse, which proceedeth out of his mouth; and all the birds were filled with their flesh.

COMMENTARY: The Beast and his False Prophet are taken when that shall be fulfilled of which the apostle Paul speaks: *Whom the Lord Jesus shall kill with the spirit of his mouth, and shall destroy with the brightness of his coming* (II Thessalonians 2 v. 8). If Antichrist is to be killed with the spirit of the mouth of the Lord, in what manner are he and his False Prophet to be thrown alive into the pool? There is the life of the just and the life of the wicked. Thus Antichrist and his False Prophet are sent alive into the pool of fire, that is alive in their wickedness,

in persevering in it to be sure until the end of life. But it says that others were slain by the sword of him who sat on the horse; for their ruin he ordained their destruction. For the saints, whose doctrine is signified by the sword which comes out of the mouth of the Lord, once Antichrist is exterminated by Christ, they shall overcome the wicked, who will have considered that this evil man, Antichrist, the worst of all men, was immortal and a god, and it shall be obvious to them that he has been destroyed by the very worst death. Those whom he has deceived shall be confounded and consumed in their wickedness.

The following pages are taken from the British Library Apocalypse, MS Add. 35166, and are reproduced on pages 73–82.

Folio 26 recto BL Add. 35166
The Dragon chained and led to Prison

John turns away in fear as the angel coming down from the clouds with a key holds the Dragon on a chain. At the right the angel is putting the Dragon in a prison and is about to lock the door with the key. The ornamental initial below contains foliage coils.

T E X T: *Revelation 20 vv. 1–3.* And I saw an angel coming down from heaven, having the key of the bottomless pit, and a great chain in his hand. And he laid hold on the dragon the old serpent, which is the Devil and Satan, and bound him for a thousand years. And he cast him into the bottomless pit, and shut him up, and set a seal upon him, that he should no more seduce the nations, till the thousand years be finished. And after that he must be loosed a little time.

C O M M E N T A R Y: Wishing to tell of the damnation of the Devil it returns to the coming of Christ. For there are three damnations of the Devil: the first damnation is when he is thrown out from celestial bliss on account of his iniquity: the second damnation was the one the author of this book now begins to narrate, when through the death of Christ the human race is rescued from his power, and he, as the present text shows, is tied up in the abyss: the third damnation shall be when he is cast into eternal torment in Hell with all wicked people. The angel therefore signifies Christ; his coming down from heaven is the incarnation. He possesses the key of Hell, that is the abyss, for he holds back from its entrance those he wishes, and those he wishes he rightly allows to fall into damnation. By the great chain surely is signified his power. Christ lays hold of the great serpent that is the Devil when through his death he destroys his empire. By the thousand years we have to understand the time that extends from the coming of Christ until the end of the world. For Christ has chained the Devil not with material chains, but with the chains of his boundless power, because in driving him out of the hearts of the elect, by his divine power he holds him away from deceiving them. We are thus able to understand the binding of the Devil in three ways. For we are able to understand this in a simple way, that the

power of almighty God has him held bound in the abyss until the appointed time.

Folio 26 verso BL Add. 35166
The First Resurrection

John looks through a window in the frame at three men holding swords and sitting on thrones in judgement. Below them, seeming as if dead, are souls to be judged. The ornamental initial below contains foliage coils.

T E X T: *Revelation 20 vv. 4–5.* And I saw seats, and they sat upon them; and judgment was given unto them; and the souls of them that were beheaded for the testimony of Jesus, and for the word of God, and who had not adored the beast nor his image, nor received his mark on their foreheads, or in their hands; and they lived and reigned with Christ a thousand years. The rest of the dead lived not, till the thousand years were finished. This is the first resurrection.

C O M M E N T A R Y: Since it is narrated above in what manner the divine mercy daily frees his elect from the most monstrous enemy the Devil, consequently the glory to which their souls are brought daily is described; for the seats signify the celestial land and they that are sitting on them the souls of the saints. For judgement is given to the saints whose souls rest in celestial bliss; this we are able to perceive, when the evil spirits gathered around their bodies are driven away at their burial, their falsehood revealed, and we shall see many miracles performed. For we can take *the souls of those slain on account of the word of God and the testimony of Jesus* for the martyrs, who have been slain at various times. Those who have not adored the Beast or his image, I think are to be understood as those who are killed by Antichrist. For these *lived and reigned with Christ a thousand years*, because although in their bodies they are said to have been killed, they are living after this in the soul reigning with Christ for a thousand years. For the time of a thousand years does not relate to future time, that is without end, but it relates rather to the present, because at the end of the world, when faith in the Gospel flourishes throughout the world, and daily he (Christ) directs the elect to take possession of eternal life, it shall be accomplished. For I think it is explained thus. The time from the ascension of Christ until the end of the world shall be accomplished is signified by the thousand years.[22]

Folio 27 recto BL Add. 35166
The Dragon comes up again to attack the Holy City

On the left the Dragon, who is Satan, comes up out of his prison, and is followed by his army coming towards the holy city, surmounted by a cross and a banner bearing a cross. On

[22] It should be noted that it is carefully worded that this time span is 'signified' by the thousand years, and does not say that it will be a thousand years. Theologians at all times, who have written and compiled commentaries on the Apocalypse, have always been sensitive on this issue, to avoid giving support to those who literally interpret the thousand-year span before the end of the world.

the right fire comes down to destroy them from God in heaven. The army falls down and the Dragon re-enters his prison. The ornamental initial below contains foliage coils.

TEXT: *Revelation 20 vv. 7–9.* And when the thousand years shall be finished, Satan shall be loosed out of his prison, and shall go forth, and seduce the nations, which are over the four quarters of the earth, Gog, and Magog, and shall gather them together to battle, the number of whom is as the sand of the sea. And they came upon the breadth of the earth, and encompassed the camp of the saints, and the beloved city. And there came down fire from God out of heaven, and devoured them. And the Devil, who seduced them, was cast into the pool of fire.

COMMENTARY: What is here called a prison is called above the abyss. But for the time being a question arises; following indeed the opinion of some, I have said above that the abyss could signify the hearts of the wicked, in whom the Devil, driven out from the hearts of the faithful, is held bound. If therefore by the abyss the hearts of the reprobates are signified, how is it said to go forth from the abyss, that is from the hearts of the reprobates, whom he never leaves unattended? Surely he will not abandon the reprobates and attack the elect. In no way. Therefore I think that the binding of the Devil must be taken in the literal sense, that he is held bound in some way by divine power in some bad place of the abyss, or certainly in Hell until the day of his delivery. *He shall seduce the nations that are at the four corners of the earth*; for they are all the nations that are included within the four regions of the world. The wicked teaching of Antichrist shall come there and seduce no other nations except those called spiritually Gog and Magog, coming from a dwelling place. By Gog, interpreted as a dwelling place, those people are signified who, covering [the scribe has written 'uncovering' in error] their malice in their hearts, shall be seen as righteous by men, although in spirit they shall be reprobates in the future. Magog, who signifies from a dwelling place, signifies those who, in breaking out of the dwelling place of their hearts and exposing their wretchedness, will clearly indicate all those wicked people. Such people the Devil through Antichrist easily deceives. He shall gather them together in battle for he will provide them with arms pursuing to the end the Church of God.

Folio 27 verso BL Add. 35166
The Dragon cast into Hell

John watches as three men force the Dragon and the Beast with pitchforks into the pool of fire and brimstone. The ornamental initial below contains foliage coils.

TEXT: *Revelation 20 vv. 9–10.* And the Devil, who seduced them, was cast into the pool of fire and brimstone, where both the beast and the false prophet shall be tormented day and night for ever and ever.

COMMENTARY: Then this shall be fulfilled when the Lord shall say: *Depart from me, you cursed, into everlasting fire which was prepared for the Devil and his angels* (Matthew 25 v. 41). *And they shall be tormented day and night for ever and ever.* From that torment may the mercy of our Redeemer deign to free us, who with the Father and the Holy Spirit lives and reigns for ever and ever. Amen.

Folio 28 recto BL Add. 35166
The Judgement

Christ sits in a mandorla in judgement, holding an open book. On either side stand those to be judged, holding open books. On the left, below the men, are land and sea, for the sea also gave up its dead. On the right they stand above the mouth of Hell, because Hell too gave up its dead. The ornamental initial below contains foliage coils.

TEXT: *Revelation 20 v. 11–21 v. 1.* And I saw a great white throne, and one sitting upon it, from whose face the earth and heaven fled away, and there was no place found for them. And I saw the dead, great and small, standing in the presence of the throne, and the books were opened; and another book was opened, which is the book of life; and the dead were judged by those things which were written in the books, according to their works. And the sea gave up the dead that were in it, and death and Hell gave up the dead that were in them; and they were judged every one according to their works. And Hell and death were cast into the pool of fire. This is the second death, the pool of fire. And I saw a new heaven and a new earth. For the first heaven and the first earth was gone, and the sea is now no more.

COMMENTARY: That throne of God shall not be decorated with gold and gems, but with righteous men, for that is the throne of which the psalmist spoke: *Thy throne, O God, is for ever and ever: the sceptre of thy kingdom is a sceptre upholding justice* (Psalm 44 v. 7). Therefore the throne of God is the whole multitude of angels and saints. *From whose face etc.* In what manner heaven and earth pass away from the sight of him sitting on the throne the psalmist reveals, as we have said above: *It (a fire) shall burn before him* (Psalm 49 v. 3); and again: *A fire shall go before him* (Psalm 96 v. 3). *For earth and heaven fled away*, that is the appearance of earth and heaven, because they will be changed in their appearance by the fire, in order that they shall reappear better and more beautiful. For it says: *There was no place found for them.* It does not say that they lost their former place, but their appearance. By the dead, great and small, are signified only the reprobates, who in the day of resurrection of the dead shall be standing in the face of God. We have said that certainly they had a first death, but after a short time they shall be cast into the second death. By the dead who are great I think are signified those who were either great in their crimes, or of higher rank in the world.

Folio 28 verso BL Add. 35166

The Holy City comes down from Heaven

John sits on a mound viewing the holy city coming down from heaven. God in a mandorla blesses at the right, and coming from the mandorla Christ seems to represent the great voice from the throne which says: 'Behold the tabernacle of God with men.' The ornamental initial below contains foliage coils.

TEXT: *Revelation 21 vv. 2–8*. And I John saw the holy city, the new Jerusalem, coming down out of heaven from God, prepared as a bride adorned for her husband. And I heard a great voice from the throne, saying: Behold the tabernacle of God with men, and he will dwell with them. And they shall be his people; and God himself with them shall be their God. And God shall wipe away all tears from their eyes: and death shall be no more, nor mourning, nor crying, nor sorrow shall be any more, for the former things are passed away. And he that sat on the throne, said: Behold, I make all things new. And he said to me: Write, for these words are most faithful and true. And he said to me: It is done. I am Alpha and Omega; the beginning and the end. To him that thirsteth, I will give of the fountain of the living water, freely. He that shall overcome shall possess these things, and I will be his God; and he shall be my son. But the fearful, and unbelieving, and the abominable, and murderers, and whoremongers, and sorcerers, and idolaters, and all liars, they shall have their portion in the pool burning with fire and brimstone, which is the second death.

COMMENTARY: The city of Jerusalem is the Church, built up of all the righteous; it comes down from heaven because when the Lord comes to the judgement, all the multitude of the saints come with him, just as Isaiah the prophet says: *The Lord will enter into judgement with the ancients of his people, and their princes* (Isaiah 3 v. 14). And the most wise Solomon in Proverbs: *Her husband is honourable in the gates, when he sitteth among the senators of the land* (Proverbs 31 v. 23). It is said that she is to appear as a bride adorned, for just as a bride adorns herself with various necklaces and ornaments to please her husband, so is the Church decorated with various virtues to please its creator who is its husband. By the city of Jerusalem and by the tabernacle of the Lord, the Church is signified.

Folio 29 recto BL Add. 35166

The Angel shows John the Heavenly Jerusalem

John is led by the angel to view the heavenly Jerusalem on a hill, whose slopes are populated by birds and animals. The city has two sections on each side flanking the central gate, and these sections are labelled: 'On the east, on the south, on the north, on the west'. The ornamental initial below contains foliage coils.

TEXT: *Revelation 21 vv. 9–21*. And there came one of the seven angels, who had the vials full of the seven last plagues, and spoke with me, saying: Come, and I will show thee the bride,

the wife of the Lamb. And he took me up in the spirit to a great and high mountain: and he shewed me the holy city of Jerusalem coming down out of heaven from God, having the glory of God, and the light thereof was like to a precious stone, as to the jasper stone, even as crystal. And it had a wall great and high, having twelve gates, and in the gates twelve niches,[23] and names written thereon, which are the names of the twelve tribes of the children of Israel. On the east, three gates: on the south, three gates: and on the north, three gates: and on the west, three gates. And the wall of the city had twelve foundations, and in them, the twelve names of the twelve apostles and of the Lamb. And he that spoke with me, had a measure of a reed of gold, to measure the city and the gates thereof, and the wall. And the city lieth in a four square, and the length thereof is as great as the breadth: and he measured the city with the golden reed for twelve furlongs, and the length and the breadth and the height thereof are equal. And he measured the wall thereof an hundred forty-four cubits, the measure of a man, which is of an angel. And the building of the wall thereof was of jasper stone: but the city itself pure gold, like to clear glass. The foundations of the wall of the city were adorned with all manner of precious stones. The first foundation was jasper, the second sapphire, the third, a chalcedony, the fourth, an emerald, the fifth, sardonyx, the sixth, sardius, the seventh, chrysolite, the eighth, beryl, the ninth a topaz, the tenth a chrysoprasus, the eleventh a jacinth, the twelfth an amethyst. And the twelve gates are twelve pearls, one to each.

COMMENTARY: There is no commentary in the original manuscript, but a later, perhaps Italian, hand has added a short text. As this is extraneous to the original text it has not been translated.

Folio 29 verso BL Add. 35166

The River of Living Water flows from the Throne of God and the Lamb

John on the left side, and a group of men on the right, flank the river flowing from the throne of God and the Lamb. The river flows down, and on both sides of the river are trees representing the tree of life. From the side of the mandorla it is perhaps intended to be Christ coming to John to say: 'These words are most faithful and true.' The ornamental initial below contains foliage coils.

TEXT: *Revelation 22 vv. 1–7*. And he showed me a river of living water, clear as crystal, proceeding from the throne of God and of the Lamb. In the midst of the street thereof, and on both sides of the river, was the tree of life, bearing twelve fruits, yielding its fruits every month, and the leaves of the tree were for the healing of the nations. And there shall be no curse any more; and the throne of God and of the Lamb shall be in it, and his servants shall serve him. And they shall see his face: and his name shall be on their foreheads. And night shall be no more: and they shall not need the light of the lamp, nor of the sun,

[23] The word in the Vulgate is 'angelos', that is 'angels'.

because the Lord God shall enlighten them, and they shall reign for ever and ever. And he said to me: These words are most faithful and true. And the Lord God of the spirits of the prophets sent his angel to shew his servants the things which must be done shortly. Blessed is he that keepeth the words of the prophecy of this book.

COMMENTARY: By the river the eternal glory of the saints is understood, for it is said to proceed from the throne of God and the Lamb, because from that the river of the glory of the saints proceeds, for those in the flesh the stream from which proceed all good things. The river is said to be as clear as crystal, but because this book often mentions this stone, it is good to say a few things about its nature and meaning. This stone is brighter than all stones. It is found in the coldest regions in which the cold never goes away. For it is cleft out of the lower part of a rather softer stone, fixing its root in it for a short while. It increases in size, having six corners, and is very sharp at its tip, extending the form of six corners even to the tip. It signifies every perfect man, for the stone that is so formed signifies Christ. The clarity of crystal signifies the pure minds of the saints, and the six corners show the perfection of their good works.

Folio 30 recto BL Add. 35166
John hears and sees; John kneels before the Angel

John is seated on the left, and this is probably intending to represent the words 'I, John, who have heard and seen these things', which is his testimony that he has witnessed these visions. In the centre he kneels down before the angel, but the angel tells him that he should not do this, and points up to God in a half mandorla in the clouds, who must be the object of his adoration. The ornamental initial below contains foliage coils.

TEXT: *Revelation 22 vv. 8–15.* I, John, who have heard and seen these things. And after I had heard, I fell down to adore before the feet of the angel, who shewed me these things. And he said to me: See thou do it not: for I am thy fellow servant, and of thy brethren the prophets, and of them that keep the words of this book. For the time is at hand. He that hurteth, let him hurt still: and he that is filthy, let him be filthy still: and he that is just, let him make justice still: and he that is holy, let him be sanctified still. Behold I come quickly; and my reward is with me, to render to every man according to his works. I am Alpha and Omega, the first and the last, the beginning and the end. Blessed are they that wash their robes (in the blood of the Lamb): that they may have a right to the tree of life, and may enter in by the gates into the city. Without are dogs, and sorcerers, and unchaste, and murderers, and servers of idols, and every one that loveth [justice erased by underlining with dots] and maketh a lie.

COMMENTARY: Why the angel does not wish John to worship him blessed Gregory adequately explains, but we have to ask why he repeated that which had been forbidden to him

before. Here the angel shows him that the bride of Christ, that is the Church, is united with Christ, and he then wishes to adore the angel. For when at the end of this vision he has been shown how the Church after the glory of the resurrection shall be united to Christ for ever to reign continuously with him, he wished to adore the angel.[24] The Church is united daily with Christ through faith and other good works that are symbolised by fine linen. It shall be united to him after the resurrection in a much higher and more excellent way, no longer in a partial way but all staying with him for eternity, and reigning with him for ever. So John wished to adore the angel for a second time, to show the double union of the Church with Christ. *And he saith to me: Seal not etc.*[25] It is not known exactly what these things are that are not to be sealed as scripture. However, John is advised that he should not seal the words of the prophecy of this book, that is that he is not to silently conceal its obscurities.

Folio 30 verso BL Add. 35166
John's Vision of Christ

John kneels before Christ enthroned, holding an open book inscribed with Alpha and Omega, and flanked by two angels holding candlesticks. The ornamental initial below contains foliage coils.

TEXT: *Revelation 22 vv. 16–21.* I Jesus have sent my angel, to testify to you these things in the churches. I am the root and stock of David, the bright and morning star. And the bridegroom and the bride say: Come. And he that heareth let him say: Come. And he that thirsteth, let him come: and he that will, let him take of the water of life, freely. For I testify to every one that heareth the words of the prophecy of this book: If any man shall add to these things, God shall add unto him the plagues written in this book. And if any man shall take away from the words of this prophecy, God shall take away his part out of the book of life, and out of the holy city, and from these things that are written in this book. He that giveth testimony of these things, saith: Surely I come quickly: Amen. Come, Lord Jesus. The grace of our Lord Jesus Christ be with you all.

COMMENTARY: David is the root of his whole race, for just as from a root many branches spring, so out of David comes a great progeny. For David was the root of Christ, as Christ was born of his stem, but how is it that Christ is said to be the root of David? Christ, however, is both root and son of David. He is root of David because by him David was created, just as other men. He is son of David because he comes out of David's stem in the flesh. He is called the morning star. The morning star that we call the bringer of light is rightly said to be Christ, because just as in its morning rising it pours forth its brilliance throughout the whole world, so Christ in coming into the world illuminates the whole earth. For he is not inappropriately called bearer

[24] The resurrection referred to here is that of the dead at the Last Judgement at the end of time.

[25] This passage, the beginning of verse 10, has been omitted from the Apocalypse text above the commentary.

of light, because coming into the world he brought with him the light that extinguished the darkness of this world. Of this bearer of light Job wrote, saying: *Canst thou bring forth the day star in its time?* (Job 38 v. 32). God the Father made the bearer of light appear at the time he established when he sent his Son at the appointed time to redeem the human race. *And the bridegroom and the bride say: Come.* The bridegroom and the bride, that is Christ and the Church, daily invite all men, through the Holy Scriptures and through the preachers, to receive eternal rewards, that he grants to us through his grace.

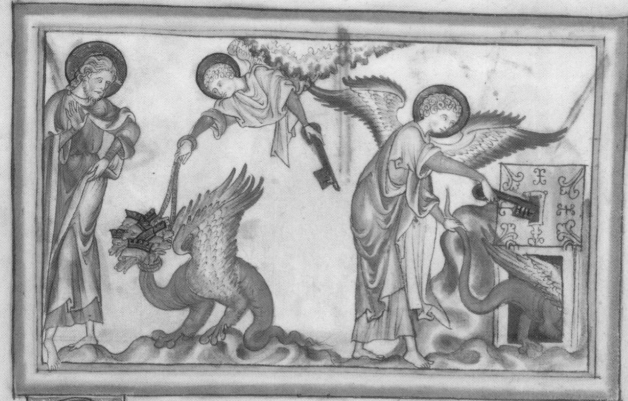

Et vidi angelum descenden
tem de celo habentem claue
abyssi z chatenam magna
in manu sua· Et apprehendit draconem
serpentem antiquum qui est diabolus z
sathanas z ligauit eum p annos mille
z misit eum in abyssum· z clausit z sig
nauit super illum ut non seducat ampli
gentes· donec consūmentur mille anni· Et p
hec oportet eum solui modico tempe·

Dampnacōnem diaboli narrare uolens ad
aduentum xpi resuit· Tres namq sunt
dampnaciones diaboli· Dampnat primo cum de
celesti beatitudine pp iniquitate sua z deicitur
Secunda dampnacio eius sunt de qua auctor huius
libri loqui modo incipit cum p mortem xpi ge
nus humanum de potestate eius est ereptum

z ipse sicut presens scriptura demonstrat in aby
ssum est religatus· Tertia est dampnacio eius
cum in infernum cum omnibus impiis in etnū crucian
dus demergetur· Angelus itaq iste xpm significat
Descensio eius de celo est incarnatio eius· Clauem z
ferrum z abyssi ipse possidet qm ab ingressu eius qs
uult rethit z quos uult in eius dampnacōm eade
uiste punit· P chatenam uero magna eius potes
tas designatur· Apprehendit xpe serpentem antiquū
z diabolum qm p mortem suam eum destruere
incipimus· P annos aūt mille omne tempus ab aduen
tu xpi usq ad finem mundi debemus accipe· Reli
gauit qm xpe diabolum non uinculis corporis sz
uinculis potestatis sue iniense· quia eum a cordibus
electorum suorum expellens ab eorū decepcōe diuina
sua uirtute exclusum tenet· Alligacione aūt
diaboli tribus modis possumus intelligere· Possumus
nanque hanc simpliciter intelligere ut scire debeamus oportere
in abyssum religatus teneatur usq ad tempus psimū

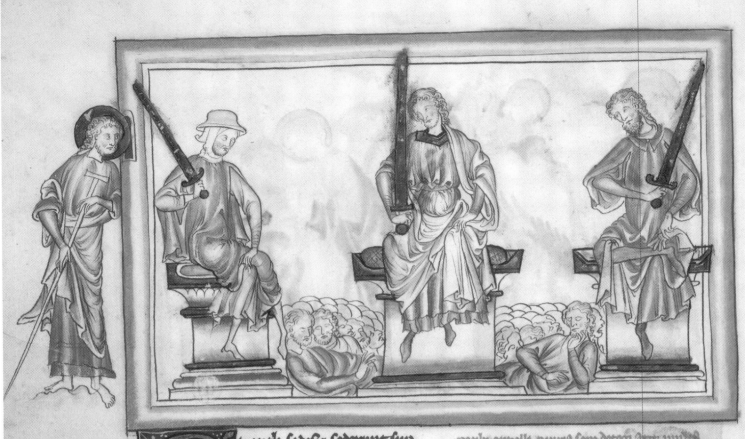

et uidi sedes z sederunt sup
eas z iudiciu datum est illis
z animae decollator̃ ꝓ testi
monium ihu z ꝓ uerbum di
z qui nõ adorauerũt bestiam neʒ ymagi
nē ei nec acceperunt characterem ei i frontiꝰ
buʒ suis z manibꝰ suis z uixerunt z regnauerũt
cũ xp̃o mille annis ceti mortuoꝝ nõ uixerũt
donec ꝯsumenl̃ mille anni. Hec est resur
rectio prima.

Quia supius narratur quo ordine christiana
uia cotidie electos suos ab imanissimo
hoste diabolo liberet consequens est ut ecclia ad quã
eoꝝ aie cotidie pducuntur describatur. P sedes ũapꝰ
celestis pria ꝓ sedentes il super eas sctoꝝ aie design
nant. Quod aũ iudiciu datum sit stñs quoꝝ aie
ĩ celesti beatudine requiescunt i hoc aduertie
possunt cũ ad eoꝝ sepulchꝰ demones obsessis coꝛ

poribꝰ expelli plurica sepe deteri atꝗ multa
miracula fieri uidemus. P animae interfector̃ ꝗ
uerbum di z testimoniũ ihu martires ꝗ diuſ
tꝑibus interfecti sunt ꝓ solum accipe. p̃ eos ũ qui
nõ adorauerũt bestiam z ymaginē ei z eos qui ab
antixp̃o interfitiendi st̃ puto ĕe intelligendos.
Isti g uixerũt z regnauerũt cũ xp̃o mille annis
qꝛ quamuis corpore sint interfecti secũdũ animã
tñ uiuũt cũ xp̃o in celesti beatudine. Sꝗ que
rendũ nobꝝ quoniã electi qui uiuantur siue inter
nestruntur sunt cũ xp̃o mille annos regnare di
cuntur. cũ tñ mille annoꝛ nõ ad futurũ tempꝰ
qd sine fine est sꝑ ad presens ꝑtineat ꝗd
i fine mundi ꝯsumabitur z in quo fides euan
gelii ꝑ uniuersum orbem florens electos cotidie
ad uitam eternam pcipiendã dirigit. Quod
uel soluendum puto. Tempꝰ ab ascencione
x usꝗ ad finem mundi ꝯsumabit qd ꝓ mille
annos designatur.

f. 26v. The First Resurrection

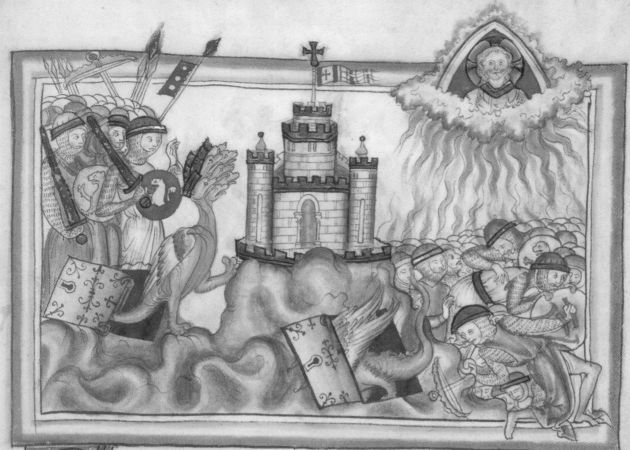

C.20.

et tñ cõsūmati fuerint mille
anni soluetur sathanas de car
cere suo ⁊ exibit ⁊ seducet gs
que sunt sup̄ iiii angulos tre. Gog ⁊ magog
et congregabit eos in prelium quop̄ numꝰ
est sicut harena maris. ⁊ ascendunt sup̄
altitudinē tre ⁊ circuierunt castra sctoz ⁊
ciuitatem dilectam. ⁊ descendit ignis a dō
de celo ⁊ deuorauit eos ⁊ diabolus qui se
ducebat eos missus ē in stagnū ignis.

Quod hic carcer. supius abyssus uocat.
Et uiriu questio onē. Supius ꝗpe
quoydam opinionē secquēs dixi p̄ abyssum cor
da impior̄ posse designari in quibz diabolus a
cordibz fidelium expulsus religatus teneatur
Sic ⁊ p̄ abyssum corda reploz designant̄ cūm
de abysso .r. de cordibz reploz exisse dicitur.

et omnium derelinquet. Numeꝗ reꝑbos deliciis
ē ⁊ wualuit electos ꝗ nullo ū. Alligationem ꝗ
diaboli sīn lram intelligenda. puto. ut̄ ī aliꝗ
abyssi loco iuture diuina religat̄ teneat̄. ut̄ ē
tā ī inferno ustꝗ ad diem absolucōnis sue. se
ducet ā gentes que sup̄ iiii angulos tre st
ꝗ uniusas gs que infra .iiii. plagas mundi
ornent. Antixp̄i impissima doctrina pluskue
sitialsꝗ alias gs seducet nisi que spiritualit̄
gog ⁊ magog detecto. ꝗ gog qui mꝗp̄ tectum
uel designantur qui malitia sua ī corde dete
gentes. uerst ab hominibz. uidebit cū future
sint mente reꝑbi. oꝗlsgꝗ sū ad mꝗp̄ detecto
eos designat qui detecto cordis sui ī aperta
miserias prumpentes omnibz se impios ēe
demonstrabunt. Tales itaꝗ diabolus p̄ antī
xp̄i sfacile decipiet. In prelio eos congregabit
qꝗ ad ecciam dī ꝑsequendi eos armabit.

f. 27r. The Dragon comes up again to attack the Holy City

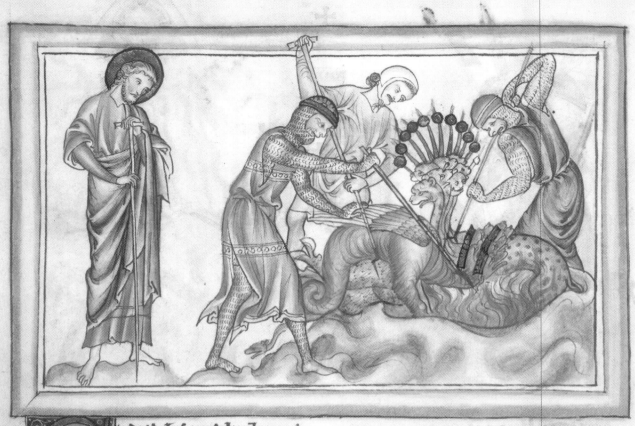

et diabolus qui seducebat eos?
missus est in stagnum ignis ⁊
sulphuris ubi bestia ⁊ pseudo
apphe cruciabuntur die ac nocte i secula se
culo꜠.

hoc tunc implebitur quando dommus di
cet ite maledicti in ignem eternum
qui apparatus est diabolo ⁊ angelis eius. ⁊
cruciabunt die ac nocte. in secula seculo꜠
A quo cruciatu misericordia redemptoris nostri nos
liberare dignetur qui ui tim pater ⁊ spiritu sancto
uuint ⁊ regnat i secula seculo꜠ amen.

f. 27v. The Dragon cast into Hell

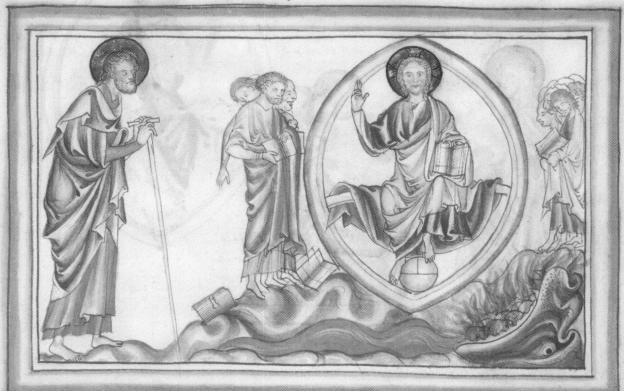

Et uidi tronum magnum candidum ʒ sedentem sup eum
a cuius conspectu fugit tra ʒ celum ʒ locus non est inuentus ab eis. Et uidi mortuos magnos ʒ pusillos stantes i ospectu throni ʒ libri aperti sunt. ʒ alius liber apertus est qui est liber uite. Et iudicati sunt mortui ex hiis que scripta erant in libris secm opa ipoʒ. Et dedit mare mortuos qui in eo erant ʒ mors ʒ infernus dederunt mortuos qui in ipsis erant ʒ iudicatum est de singulis secundu opa ipoʒ ʒ infernus ʒ mors missi sunt in stagnum ignis. hec mors secunda est stagnum ignis. Et uidi celum nouum ʒ terram nouam. P mum enim celum ʒ prima terra abiit ʒ mare iam non est.

Thronus iste dei no auro ʒ gemmis ornabit

sz hominibz ustus. Iste namq ē thinus de q scm ista dicitur. Thinus tuus ds in seculum seculi ir ʒ equitatis urga regni tui. Thinus ds dei ʒ omnis misericordie angelor atq scoʒ. A tui gschtu ʒ ʒ. Queadmod a ospectu sedentis sup thinum celu ʒ tra fugiat psalmista ostendit ut sup iam dixi qui dicit. In conspectu ei exardescet. Et iiii. Ignis ante ipm precedet. fugit au terra ʒ celum idʒ spes terre ʒ celi quia pigue a sua spe comutabuntur ut possint in aliam reformari meliori ʒ pulchriose. Quod si dicit locus no ē inuentus eis no ideo dicit ut locum ipstrum amuttant sed spem. P mortuos magnos ʒ pusillos soli repbi designantur qui in die resurrecōe morti astabunt i conspectu di ea uidelicz morte his imam ē dicimus post pauliulii ʒ morte secundam deinceti. P mortuos uero eos magnos designari puto qui aut maiore fuerut i scelibz sui aut altiores i scli dignitatibz

f. 28r. The Judgement

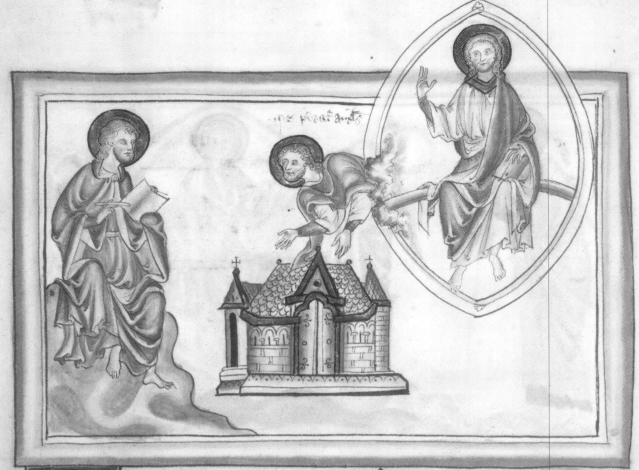

t ego Johannes uidi ciuitatem
sanctam ierlm nouam descen
dentem de celo a deo paratam
sicut sponsam ornatam uiro
suo. Et audiui uocem magnam de thno
dicente. Ecce tabnaculum dei cum hoibz
z habitabit cum eis. z ipsi populius er
erunt z ipe ds cum eis erit eoy ds. Et absf
get ds omnem lacrmam ab oculis eoy. Et
mors ultra no erit nec luctus nec clamor
nec dolor erit ultra que prima abierūt
Et dixit qui sedebat in thno. Ecce noua
facio omnia. Et dixit m. Scribe quia hec
uba fidelissima sunt z uera. Et dixit m
factum est z ego sū A. z w. initium z
finis. Ego sitienti dabo de fonte uite
atque uiue gratis qui uicerit possideb

hec. Et ero illi deus z ille michi filius.
Timidis aut z incredulus z execratis z ho
micidis. z fornicatoribz z uenefitis z y
dolatris z omnibz mendacibz pars illoy
erit in stagno ardenti igne z sulphure
quod est mors secunda.

Qiuitas ierlm ecta est ex omnibz itis
construcia. De celo descendet quia do
mino fecto iudicium ueniente tum illoy ois
multitudo scoy ueniet sicut dicit ysayas ppha
Dominus ad iudicium ueniet cū senibz populi
sui z principibz eis. Et sapientissimus salomon
in puubis. Stabilit in porcis uir ei quado sedit
cum senatoribz terre Que sicut sponsa para
ta z ornata ee dr. qz sicut sponsa diuersis mo
nilibz acz ornamentis semetipsam ornat
ut sponso placeat ita z ecta diuersis uirtu
tibz decoratur ut creatori suo qui z spons
eius placere ualeat. P tumultum ierlm z
p tabnaculū dm sepe eccta designat.

f. 28v. The Holy City comes down from Heaven

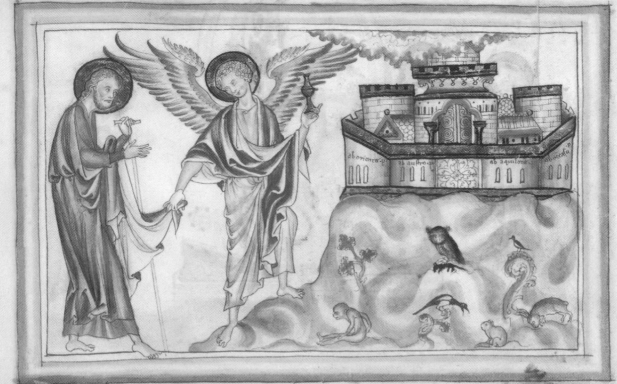

Et uenit unus de septem angel
habentibz plenas phialas
septem plagis nouissimis
z locutus est mecum dicens. Veni osten
dam tibi sponsam uxorem agni. Et sus
tulit me in spiritu in monte magnū
z altuin. Et ostendit michi ciuitatem
sanctam ierlm descendentem de celo a
deo habentem claritatem dei. Lumen
et simile lapidi precioso tanqz lapidi
iaspidis sicut cristallum. Et habebat mu
rum magnū z altuin habens portas
xij z in portis angulos xij z noia scrip
ta que sunt noia xij tribuum filioz irl
Ab oriente porte tres z ab austro porte
tres z ab aquilone porte tres z ab occasu
porte tres. Et murus ciuitatis habens fu

damenta xij z in ipsis xij noia xij aploz
z agni. Et qui loquebat mecū habebat men
suram harundineā auream ut metiret ciuitate
z portas ei z muru. z ciuitas in quadro posita;
Longitudo eius tanta; qnta z latitudo. Et
mensus est ciuitatem de harundine p stadia
xij. Longitudo z latitudo z altitudo eius equalia
Et mensus est muros eius centū xl iiij cubitoz
mensura hominis que est angeli z erat struc
tura muri eius ex lapide iaspide. Ipsa ū ciui
tas auro mūdo simile uitro mūdo. Funda
menta muri ciuitatis oi lapide pcioso ornata
fundamentū primū iaspis. secds saphir. ter
cius calcedonius. qrtus smaragd. quintus sardo
nyx. sextus sardius. septim crisolitus. octauus
berillus. nonus topazius. decim crisoprassus
undecim iacinctus. Duodecim amatistus
Et xij porte. xij margarite sunt p siglas

De un angelis .i. xpi qui uenit p incarnacōis misteriū. Ostendam e sponsam.
id est ecctam que modo sponsa est p fidem. uxorem agni .i. ecctam que in futuro
traducpetetur in domo sponsi p glam. Ideo ostidit ru ciuitatem .i. ecctam habite
deū hitatorem. Ccam. p gie infusione. ierlm. quia ad hoc laborat ut p uenat
ad pris uisione. Descendentē de celo .c. quo ad bonoz oim recepcōem. habitem
claritatē dei. i. claratā ognicionem de deo qm isto hemus obscuram. Duodecim
porte. significant .xij. aptos et doctores universos p quoz ministiū et doctrinā
intramus in ecctam. Ideo p .xij. angulos in portis significantur omes plate et doctores
sub aptis qui dicuntur anguli. qz sicut angulus coniigit duos pietes. sic isti ipm
pntem adiuuare doctrina et pdicacione in una fide.

f. 29r. The Angel shows John the Heavenly Jerusalem

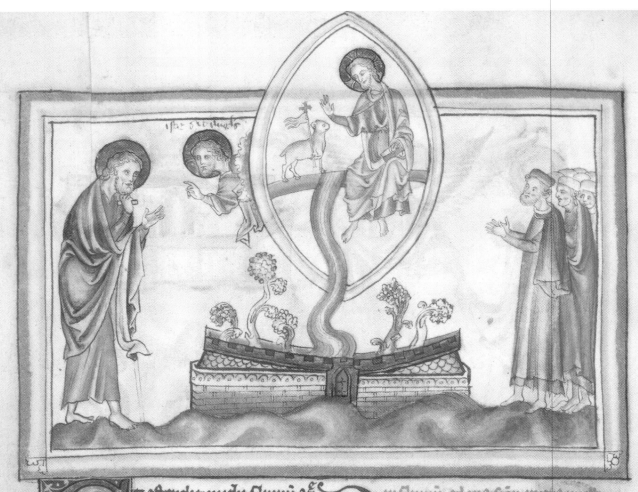

ostendit nuchi fluuiu̅ aq̅
uiue splendidu̅ tanq̅m crf
tallu̅ pcedentem de sede dei
ƺ agni i̅ medio platee eᵗ. ƺ ex utraꝗ pte
fluminis lignu̅ uire afferent fructuf xij
ꝑ menses singulos reddens fructum suu̅
ƺ folia ligni ad sanitate̅ gentium ƺ om̅e
maledictum n̅o erit amplᵉ ƺ sedes dei ƺ
agni i̅ illa erunt. ƺ serui eᵗ seruient illi
ƺ uidebunt faciem eᵗ ƺ nom̅e eᵗ i̅ fron
tib̅ eoᵖ̅ ƺ nox ultra n̅o erit. Et n̅o egreb̅t
lumine lucerne neꝗ solif qu̅ dominus
deuf illuminabit illos ƺ regnabunt i̅
secula seculoᵖ̅. Et dixit michi · Hec u̅ba
fidelissima ƺ uera sunt ƺ dominus d̅s spiri
tuu̅ ꝓ ꝑh̅aꝝ misit angelum suu̅ ostende
seruif suif que oportet fieri tito. Beatuf
qui custodit u̅ba ꝓ ꝑh̅ie huius libri

P er fluuiu̅ gloria scoᵖ̅ ꝓpria mᵗa
gnitur. Qui a sede d̅i ƺ agni ꝓcedit
d̅i quia ab illo fluuif g̅tie scoᵖ̅ ꝓcedit A
quo illuf i̅ carne h̅o̅if ꝓstit riuuf om̅
bonoᵖ̅ Qui fluuiuf splendidul tanꝗ cristalluf
ee̅ d̅i. Veru̅ q̅ huif lapidif i̅ hoc libro sepe fit
mentio: platuit ut de natura ƺ significat̅o̅e
eᵗ pauca dicam̅? Hic lapis clarioᵖ est om̅ib̅ la
pidib̅ Flastric au̅ i̅ frigidissimif locif A quib̅
frigus nunꝗ recedit. Qui eᵖ̅ urioᵖ pte sco
mberet Aliquantulu̅ mollioᵖ radice̅ i̅ eo pa
riu̅ꝑ defigens sursunꝗ crescens erigit.
sex angulof huf. In summitate cu̅ scrutur
eunde tn̅ ordine sex anguloᵖ̅ uſꝗ ad summet
te̅ seruans Significat au̅ uniuſquiſꝗ ꝑfciu̅
uiru̅ Lapis si cui mberet xp̅m designat. Cla
ritaf cristalle puritate̅ mentiu̅ scᵗꝝ. Sex
angult ꝑfecom̅ demonstrat bonoᵖ̅ opm̅

f. 29v. The River of Living Water flows from the Throne of God and the Lamb

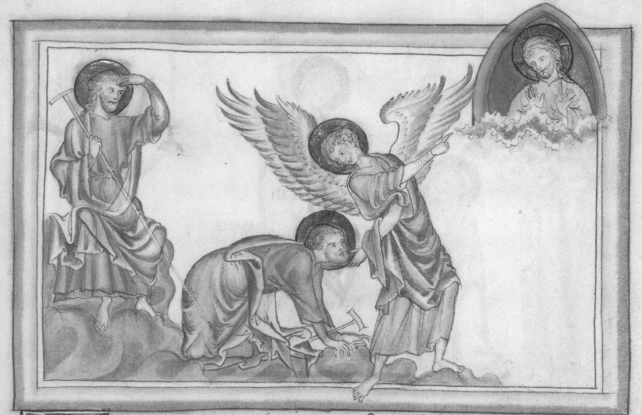

C. 22

Ego Johannes qui audiui ⁊ uidi hec · et postquam audissem cecidi ut adorarem pedes angeli qui michi hec ostendebat · ⁊ dixit michi · Vide ne feceris · conseruus tuus sū ⁊ fratrum tuoꝝ ꝓphaꝝ ⁊ eoꝝ qui seruant uꝪba libri huius · ⁊ templum eū Ꝫpe est · Qui nocet noceat adhuc · et in sordibus ⁊ sordescat adhuc ⁊ iustus iustitiam faciat adhꝰ ⁊ sꝇs sꝛtificetur adhꝰ · Ecce uenio cito ⁊ merces mea mecū ⁊ reddere unicuiꝙ secundū opa sua · Ego sum alpha ⁊ ω · primꝰ ⁊ nouissimꝰ · principiū ⁊ finis · Beati qui lauant stolas suas ut sit potestas eoꝝ in ligno uite ⁊ ꝑ portas intrent in ciuitatem · Foris canes ⁊ uenefici ⁊ inpudici · homicide · ⁊ ydolis seruientes · ⁊ omnis qui amat iniustitiam ⁊ facit mendacium ·

Cur angꝰs a Johanne adorari noluit · beatus Gregorius sufficient exponit · ostendendum ū nobꝪ cur repetit qd antea ei ꝓstiterat i loco quū angꝰs sibi monstrauit qualꝪ sponsa idꝪ ecᶜa iuncta est ꝯpo tunc angm̄ nō luit adorare · Hic aū cū infine huꝰ uisionꝪ demonstratum eēt ei qualꝪ ecᶜa post resurrectionem stetiat ꝯpo in eternum cū illo regnatura seruabit · eremio angm̄ adorare noluit · Coniungꝛ namꝙ ecᶜa totaliter ꝯpo p suam decꝪ bona opa que ꝑ ꝯp̄istum designans colligꝛ ꝙ ei ꝑ resurrectionem multo excelsiꝰ atꝙ no bilius · sꝇo iam ꝑ ptes sunt mediꝪ si corda sunt in eternum cū illo mansura ⁊ sine fine cū illo regnatura · Ideirco johs bis angm̄ adorare noluit qui binas quietudes ecᶜe cū ꝯpo et deuo struit et dixit ih · iste signauit ⁊ c · Signata ē septima aꝪa quibꝪ nō intelligꝛ · Precipꝛ gō Jo hanni ne signet uꝪba ꝓphie huꝰ libri · idest ue tando obscuritates ei absconat

f. 30r. John hears and sees; John kneels before the Angel

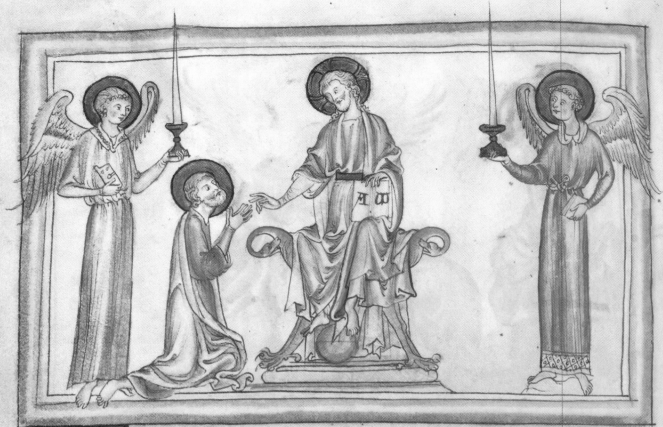

E go ihc mist angelum mcum
tettificari uobis hec in eccliis
ego sum radix z genur dauid
ftella splendida z matutina.
z sponsul z sponsa dicunt vem lt qui au
dit dicat vem. Qui sitit ueutat. Qui uult
accipiat Aquia uite gratis. Contestor ego
audienti omnu homine ubi pphie libri
huts. Si quis apposuerit ad hec apponet ds
sup illum plagas striptas in libro isto.
et si quis dimmmuit de ubis libri pphie
huts auferet deus prte euis de lib ute
z de ciuitate sca z de hus que stripta st
m libro isto. dicit qui testimonum phib;
ttoz. Eua uenio cito ame. Veni dne ihu
gritia dui nri ihu xpi cum oibz uobis.

D auid radix est uniuse stirpis sue. Qr a
situt ex uria radice multi ramu oriunt

ira z eximo dauid magna premies e excr
ta. Cum gr ds siut radix xpi eo qd de stirpe
ei xpe siutgortus quo in xpc radicem se di
tit ee ds. xpe gr z radix z filius est dauid. Ra
dix est ds qr ab ipo est dauid creatus situt z
teti homines. Filius e ds qr ex eius pgemie p
cestir secundu carne. Qu stellam uadmu
nam se uocat. stella matutina qii uusii
uocam recte xpe di qua situt illa mane ori
ens splendore suu p uniusu mundu sparge
ira z xpe ueniis i mundu uniusam undi
fatem illummare. Qu no lgstucimer
lutifer uocat qr uemes i mudim lucem
secum detulir qua uerelgs hui mudi exti
xit. De hac lutifero iob loquie dicens Qu
pellunt uirisium in tpe suo. Lucifium i tpe
suo ds dr pduxir cu filium suu tpo costi
tuto ad redimendu gris humanu dicit.
Et sponsus z sponsa dicunt veni. Sponsus e
sponsa a i x z etia omis bocs z p stirpis z
p predicatores ad percipienda premia eterna
tottue iuitaur. Que nob sua gra pcedat.

f. 30v. John's Vision of Christ

BIBLIOGRAPHY

J. J. G. Alexander, *Insular Manuscripts from the 6th to the 9th Century. A Survey of Manuscripts Illuminated in the British Isles*, I, London, 1978

Apokalypse (*Ms Douce 180 der Bodleian Library, Oxford*), Codices Selecti LXXII, facs. edn., Graz, 1982 (with a commentary volume by P. Klein published separately in 1983 as *Endzeiterwartung und Ritterideologie. Die englische Apokalypsen der Frühgotik und MS Douce 180*)

F. Avril and P. Stirnemann, *Manuscrits enluminés d'origine insulaire VIIe–XXe siècle*, Bibliothèque nationale, Paris, 1987

J. Baltrusaitis, *Réveils et Prodiges, le gothique fantastique*, Paris, 1960

S. Berger, 'Les préfaces jointes aux livres de la Bible dans les manuscrits de la Vulgate', *Mémoires présentés par divers savants à l'Académie des Inscriptions et Belles-Lettres*, 11 pt. 2, 1904, 1–78

P. Binski, *The Painted Chamber at Westminster*, London, 1986

P. Binski, 'Reflections on *La estoire de Seint Aedward le Rei*: hagiography and kingship in thirteenth-century England', *Journal of Medieval History*, 16, 1990, 335–50

P. Binski, 'Abbot Barking's tapestries and Matthew Paris' Life of St Edward the Confessor', *Archaeologia*, 109, 1991, 85–100

P. Binski, *Westminster Abbey and the Plantagenets. Kingship and Representation of Power 1200–1400*, New Haven, 1995

P. Binski, *Becket's Crown. Art and Imagination in Gothic England 1170–1300*, New Haven, 2004

P. Binski, A. Massing and M. L. Sauerberg (eds), *The Westminster Retable. History, Technique and Conservation*, London/Turnhout, 2009

T. Borenius, 'The cycle of images in the palaces and castles of Henry III', *Journal of the Warburg and Courtauld Institutes*, 6, 1943, 40–50

J. W. Bradley, *The Apocalypse, its Commentators and Illustrators, with Special Reference to the Morgan Manuscript*, London, 1906

A. Bräm, *Neapolitanische Bilderbibeln des Trecento. Anjou-Buchmalerei von Robert dem Weisen bis zu Johanna I*, 2 vols, Wiesbaden, 2007

G. Breder, *Die lateinische Vorlage des altfranzösischen Apokalypsenkommentars des 13 Jahrhunderts (Paris, B.N. MS fr. 403)*, Münster, 1960

P. Brieger, *The Trinity College Apocalypse*, London, 1967

M. Camille, 'Visionary Perception and Images of the Apocalypse in the Later Middle Ages', in (eds) R. K. Emmerson and B. McGinn, *The Apocalypse in the Middle Ages*, Ithaca, 1992, 276–89

S. Castronovo, *La biblioteca dei conti di Savoia e la pittura in area savoiarda (1285–1343)*, Turin, 2002

Y. Christe, 'L'Apocalypse dans les Bibles moralisées de la première moitié du XIIIe siècle', *Bulletin archéologique du Comité des Travaux Historiques et Scientifiques*, 25, 1997, 7–46

H. O. Coxe, *The Apocalypse of St John the Divine*, Roxburghe Club, 1876

R. J. Dean and M. B. M. Boulton, *Anglo-Norman Literature. A Guide to Texts and Manuscripts*, Anglo-Norman Text Society, Occasional Publications Series, 3, London, 1999

L. Delisle and P. Meyer, *L'Apocalypse en français au XIIIe siècle*, 2 vols, Paris, 1900–1

P. M. de Winter, 'Visions of the Apocalypse in Medieval England and France', *Bulletin of the Cleveland Museum of Art*, 70, 1983, 396–417

S. Edmunds, 'The Missals of Felix V and Early Savoyard Illumination', *Art Bulletin*, 46, 1964, 127–41

S. Edmunds, 'Jean Bapteur et l'Apocalypse de l'Escorial', in (ed.) A. Paravicini Bagliani, *Les manuscrits enluminés des comtes et ducs de Savoie*, Turin, 1991, 92–104

R. K. Emmerson, *Antichrist in the Middle Ages. A Study of Medieval Apocalypticism*, Manchester, 1981

R. K. Emmerson and S. Lewis, 'Census and Bibliography of Medieval Manuscripts containing Apocalypse Illustrations ca. 800–1500 pt. II', *Traditio*, 41, 1985, 367–409

L. Fisher, *Iconography and Narrative in the 'St Albans' Apocalypses*, PhD Dissertation, Ohio State University, 1984

J. Fox, 'The earliest French Apocalypse and Commentary', *Modern Language Review*, 7, 1912, 447–68

R. Freyhan, 'Joachism and the English Apocalypse', *Journal of the Warburg and Courtauld Institutes*, 18, 1955, 211–44

C. Gardet, 'Un manuscrit savoyard de l'Apocalypse à la Bibliothèque nationale', *Revue Savoisienne*, 1967, 1–6

C. Gardet, *L'Apocalypse figurée des ducs de Savoie*, Annecy, 1969

G. B. Guest, *Bible Moralisée, Codex Vindobonensis 2554, Vienna Österreichische Nationalbibliothek*, London, 1995

F. X. Gumerlock, *The Seven Seals of the Apocalypse*, Kalamazoo, 2009

C. Hahn, *Portrayed on the Heart. Narrative Effect in Pictorial Lives of Saints from the Tenth through the Thirteenth Century*, Berkeley, 2001

C. Hansen, *Die Wandmalereien des Kapitelhauses der Westminsterabtei in London*, Würzburg, 1939

E. Harnischfeger, *Die Bamberger Apokalypse*, Stuttgart, 1981

R. Haussherr, 'Eine verspätete Apokalypsen-Handschrift und ihre Vorlage', in *Studies in Late Medieval and Renaissance Painting in Honor of Millard Meiss*, New York, 1978, 219–40

G. Henderson, 'Studies in English manuscript illumination II, III', *Journal of the Warburg and Courtauld Institutes*, 30, 1967, 104–37; 31, 1968, 103–47

G. Henderson, 'An Apocalypse manuscript in Paris: BN lat. 10474', *Art Bulletin*, 52, 1970, 22–31

O. Ivanchenko and G. Henderson, 'Four Miniatures from a Thirteenth Century Apocalypse', *Burlington Magazine*, 122, 1980, 97–106

M. R. James, *The Trinity Apocalypse*, Roxburghe Club, 1909

M. R. James, *La Estoire de Seint Aedward le Rei*, Roxburghe Club, 1920

M. R. James, *The Apocalypse in Latin and French (Bodleian MS Douce 180)*, Roxburghe Club, 1922

M. R. James, *The Apocalypse in Latin, MS 10 in the Collection of C. W. Dyson Perrins*, Oxford, 1927

R. Kent Lancaster, 'Henry III, Westminster Abbey and the Court School of Illumination', *Seven Studies in Medieval English History and other Historical Essays presented to Harold S. Snellgrove*, Jackson, 1983, 85–95

P. K. Klein, 'Les cycles de l'Apocalypse du haut Moyen Âge (IX–XIIIe siècles)', in (eds) R. Petraglio *et al.*, *L'Apocalypse de Jean. Traditions exégetiques et iconographiques IIIe–XIIIe siècles*, Geneva, 1979, 135–86

P. K. Klein, *Endzeiterwartung und Ritterideologie. Die englische Apokalypsen der Frühgotik und MS Douce 180*, Graz, 1983

P. K. Klein, 'The Apocalypse in Medieval Art', in (eds) R. K. Emmerson and B. McGinn, *The Apocalypse in the Middle Ages*, Ithaca, 1992, 159–99

P. K. Klein, 'From the Heavenly to the Trivial: Vision and Visual Perception in Early and High Medieval Apocalypse Illustration', in (eds) H. L. Kessler and G. Wolf, *The Holy Face and the Paradox of Representation*, Bologna, 1998, 247–78

P. K. Klein, 'Initialen als "Marginal Images": Die Figureninitialen der Getty-Apokalypse', *Cahiers Archéologiques*, 48, 2000, 105–23

P. K. Klein, *Die Trierer Apokalypse*, Graz, 2001

P. K. Klein, 'Visionary Experience and Corporeal Seeing in Thirteenth-Century English Apocalypses: John as External Witness and the Rise of Gothic Marginal Images', in (ed.) C. Hourihane, *Looking Beyond. Visions, Dreams and Insights in Medieval Art and History*, Princeton, 2010, 177–201 (cited as Klein 2010a)

P. K. Klein, *Apocalipsis de Valenciennes – The Apocalypse of Valenciennes*, Madrid, 2010 (cited as Klein 2010b)

P. K. Klein and R. Laufner, *Trierer Apokalypse, Codices Selecti*, XLVIII, Graz, 1975

H. P. Kraus, *Monumenta Codicum Manu Scriptorum. An Exhibition Catalogue of Manuscripts from the 6th to the 17th Centuries*, New York, 1974

H. P. Kraus, *In Retrospect. A Catalogue of 100 Outstanding Manuscripts sold in the last Four Decades by H. P. Kraus*, New York, 1978

S. Lewis, 'The Enigma of Fr. 403 and the Compilation of a Thirteenth-Century English Illustrated Apocalypse', *Gesta*, 29, 1990, 31–43

S. Lewis, 'The English Gothic illuminated Apocalypse, *lectio divina*, and the art of memory', *Word and Image*, 7, 1991, 1–32

S. Lewis, 'Exegesis and Illustration in Thirteenth-Century English Apocalypses', in (eds) R. K. Emmerson and B. McGinn, *The Apocalypse in the Middle Ages*, Ithaca, 1992, 259–75 (cited as 1992a)

S. Lewis, 'Beyond the Frame: Marginal Figures and Historiated Initials in the Getty Apocalypse', *The J. Paul Getty Museum Journal*, 20, 1992, 53–76 (cited as 1992b)

S. Lewis, *Reading Images. Narrative Discourse and Reception of the Thirteenth-Century Illuminated Apocalypse*, Cambridge, 1995

S. Lewis, Review of Muir Wright, *Art and Antichrist, Speculum*, 72, 1997, 902–7

M. Liversidge and P. Binski, 'Two Ceiling Fragments from the Painted Chamber of Westminster Palace', *Burlington Magazine*, 137, 1995, 491–501

G. Lobrichon, 'Une nouveauté: Les gloses de la Bible', in (eds) P. Riché and G. Lobrichon, *Le Moyen Âge et la Bible*, Paris, 1984, 95–114

G. Lobrichon, 'Conserver, réformer, transformer le monde: les manipulations de l'Apocalypse au moyen âge central', in *The Role of the Book in Medieval Culture, Bibliologia*, 4, 1986, 75–94

G. Lobrichon, *La Bible au Moyen Âge*, Paris, 2003

J. Lowden, *The Making of the Bibles Moralisées*, 2 vols, University Park, 2000

J. Lowden, 'The Apocalypse in the Early Thirteenth-Century Bibles Moralisées: a Re-Assessment', in (ed.) N. J. Morgan, *Prophecy, Apocalypse and the Day of Doom, Proceedings of the 2000 Harlaxton Symposium*, Harlaxton Medieval Studies, 12, Donington, 2004, 195–219

W. R. L. Lowe, E. F. Jacob and M. R. James, *Illustrations to the Life of St Alban in Trin. Coll. Dublin MS E.i.40*, Oxford, 1924

B. McGinn, *Visions of the End*, New York, 1979

B. McGinn (ed.), *The Encyclopaedia of Apocalypticism, 2: Apocalypticism in Western History and Culture*, New York, 2000 (cited as McGinn 2000a)

B. McGinn, *Antichrist. Two Thousand Years of the Human Fascination with Evil*, New York, 2000 (cited as McGinn 2000b)

D. McKitterick, N. J. Morgan, I. Short and T. Webber, *The Trinity Apocalypse*, London and Luzern, 2005 (the facsimile edition with commentary text in German was published in 2004)

M. A. Michael, 'An illustrated "Apocalypse" Manuscript at Longleat House', *Burlington Magazine*, 126, 1984, 340–3

E. G. Millar, *The Rutland Psalter, a Manuscript in the Library of Belvoir Castle*, Roxburghe Club, 1937

N. J. Morgan, *Early Gothic Manuscripts I, 1190–1250. A Survey of Manuscripts Illuminated in the British Isles*, IV.1, London, 1982

N. J. Morgan, 'The Burckhardt-Wildt Apocalypse', *Art at Auction: The Year at Sotheby's 1982–83*, London, 1983, 162–9

N. J. Morgan, 'The Artists of the Rutland Psalter', *The British Library Journal*, 13, 1987, 159–85

N. J. Morgan, *Early Gothic Manuscripts II, 1250–85. A Survey of Manuscripts Illuminated in the British Isles*, IV.2, London, 1988 (cited as Morgan 1988a)

N. J. Morgan, 'Matthew Paris, St Albans, London and the leaves of the Life of St Thomas Becket', *Burlington Magazine*, 130, 1988, 85–96 (cited as Morgan 1988b)

N. J. Morgan, 'Some French Interpretations of English Illustrated Apocalypses c.1290–1330', in (ed.) J. Mitchell, *England and Europe. Essays in Memory of Andrew Martindale*, Harlaxton Medieval Studies, 7, Stamford, 2000, 137–56

N. J. Morgan, *The Douce Apocalypse. Picturing the end of the world in the Middle Ages*, Oxford, 2007

N. J. Morgan and M. Brown, *The Lambeth Apocalypse. Manuscript 209 in Lambeth Palace Library*, London, 1990

N. J. Morgan, P. Kidd and D. Burrows, *Apocalypse Yates Thompson*, Madrid, 2010

N. J. Morgan, S. Lewis, M. Brown and A. Nascimento, *Apocalipsis Gulbenkian*, Barcelona, 2002

H. Omont, 'Manuscrits illustrés de l'Apocalypse aux IXe et Xe siècles', *Bulletin de la Société française pour réproduction des manuscrits à peintures*, 6, 1922, 62–84

Y. Otaka and H. Fukui, *Apocalypse Anglo-Normande (Cambridge, Trinity College MS R.16.2)*, Osaka, 1977

Y. Otaka and H. Fukui, *Apocalypse (Bibliothèque Nationale Fonds Français 403)*, Osaka, 1981

A. Paravicini Bagliani, *Les manuscrits enluminés des comtes et ducs de Savoie*, Turin, 1991

J. Poesch, *Antichrist Imagery in Anglo-French Apocalypse Manuscripts*, PhD Dissertation, University of Pennsylvania, 1966

J. Poesch, 'Revelation 11:7 and Revelation 13:1–10, Interrelated Antichrist Imagery in some English Apocalypse Manuscripts', in (ed.) M. Barasch, L. Freeman Sandler, *Art the Ape of Nature. Studies in Honor of H. W. Janson*, New York, 1981, 15–33

P. Prigent, *Apocalypse 12: Histoire de l'exégèse*, Tübingen, 1959

P. Prigent, *Commentary on the Apocalypse of John*, Tübingen, 2001

L. M. C. Randall, 'Exempla as a Source of Gothic Marginal Illumination', *Art Bulletin*, 39, 1957, 97–107

L. M. C. Randall, *Images in the Margins of Gothic Manuscripts*, Berkeley, 1966

L. Rivière-Ciavaldini, 'L'Apocalypse de Galois de Viry et la "croisade" de 1366 (Paris, BnF MS. lat. 688)', in *Art et artistes de Savoie, Actes du XXXVIIe congrès des sociétés savantes de Savoie*, Chambéry, 2000, 69–82 (cited as Rivière-Ciavaldini 2000a)

L. Rivière-Ciavaldini, 'Jean Colombe entre Naples et la Savoie. À propos de l'Apocalypse des ducs de Savoie', *Arte Cristiana*, 88 (nos 798–9), 2000, 181–200, 259–68 (cited as Rivière-Ciavaldini 2000b)

L. Rivière-Ciavaldini, *Imaginaires de l'Apocalypse. Pouvoir et spiritualité dans l'art gothique européen*, Paris, 2007

L. F. Sandler, 'Marginal Illustration in the Rutland Psalter', *Marsyas*, 8, 1959, 70–4

L. F. Sandler, *The Peterborough Psalter in Brussels and other Fenland Manuscripts*, London, 1974

L. F. Sandler, *Gothic Manuscripts 1285–1385*, A Survey of Manuscripts Illuminated in the British Isles, V, 2 vols, London, 1986

C. Santiago Agut, *Apocalipsis figurado de los Duques de Saboya. Cod. MS Vitrina I de la Biblioteca de El Escorial*, 2 vols, Madrid, 1980

G. Saroni, *La Biblioteca di Amedeo VIII di Savoia (1391–1451)*, Turin, 2004

M. Schapiro, 'On the Aesthetic Attitude in Romanesque Art', in (ed.) K. Bharatha Iyer, *Art and Thought*, London, 1947, 130–50

R. W. Scheller, 'Wreath and Crown: Variations and Changes in Apocalyptic Headgear', in (ed.) S. Panayotova, *The Cambridge Illuminations. The Conference Papers*, London/Turnhout, 2007, 87–96

Sotheby's Sale 25 April 1983, *Catalogue of Single Leaves and Miniatures from Western Illuminated Manuscripts*, London, 1983

F. Stegmüller, *Repertorium Biblicum Medii Aevi*, VI, Madrid, 1958

P. Stirnemann, 'Note sur la Bible moralisée en trois volumes conservée à Oxford, Paris et Londres', *Scriptorium*, 53, 1998, 120–4

B. Stocks and N. J. Morgan (eds), *The Medieval Imagination. Illuminated Manuscripts from Cambridge, Australia and New Zealand*, exhibition catalogue, State Library of Victoria, Melbourne, 2008

H.-W. Stork, *The Bible of St Louis. Commentary*, Graz, 1996

E. W. Tristram, *English Medieval Wall Painting, II, The Thirteenth Century*, 2 vols, Oxford, 1950

D. Visser, *Apocalypse as Utopian Expectation (800–1500)*, Leiden, 1996

A. von Euw and J. M. Plotzek, *Die Handschriften der Sammlung Ludwig*, I, Cologne, 1979

F. von Juraschek, *Die Apokalypse von Valenciennes*, Linz, 1952

G. Warner, *Descriptive Catalogue of Illuminated Manuscripts in the Library of C. W. Dyson Perrins*, Oxford, 1920

J. Williams, *The Illustrated Beatus. A Corpus of Illustrations of the Commentary on the Apocalypse*, 5 vols, London, 1994–2003

F. Wormald, 'Paintings in Westminster Abbey and Contemporary Paintings', *Proceedings of the British Academy*, 35, 1949, 161–76

R. M. Wright, *Art and Antichrist in Medieval Europe*, Manchester, 1995

R. M. Wright, 'Living in the Final Countdown: the Angevin Apocalypse Panels in Stuttgart', in (ed). N. J. Morgan, *Prophecy, Apocalypse and the Day of Doom, Proceedings of the 2000 Harlaxton Symposium*, Harlaxton Medieval Studies, 12, Donington, 2004, 261–76

INDEX

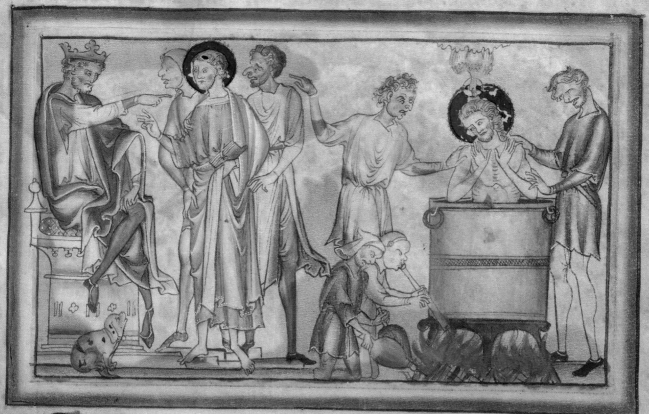

...ussimo cesari ⁊ semp au
gusto domiciano proconsul
ephesior salutem. Notifica
mus glozie uie qin quidē
uur nomine johannes ex
genere hebzeoy in asiam
ueniens ⁊ predicans ihm xpin cruciffixū
affirmat eum uerum deum ⁊ dei filium
ee. 6 culturam aut inuictissimoy deoy nob
euacuat. ⁊ templa ueneranda ab antecess
soribz nris construcra funditus euertere
festinat. Contrarius itaqʒ hic existens ut
magus ⁊ sacrilegus uro imperiali edicto?
suis magicis artibz ⁊ predicationibus om
nem pene populum urbis ephesine ad
culturam hominis crucifixi ⁊ mortui co
uertit. Sos aut zelum habentes erga
culturam imortalium deoy tribunalibz
nris presentatum admonuimus blandi
ciis ⁊ terrozibz ut uix uestri edictum in

perii xpin suum abnegaret atqʒ diis
omnipotentibz grata libamina offerret
6ut cum nulla ratione ista suadere po
tuissemus. hos apices uir potestati di
reximus. ut quiquid maiestati uie pla
cuerit? de eo. fieri notificetis. Statim ut
legit epistam insanus domicianus. scripsit
proconsuli ur sanciuit johannē uinctum
cathenis ab ephesio ad urbem adduceret
romam. Titue proconsul secundū imperiale
preceptum beatissimi johannem apostolū
cathenis uinctum romam secum adduxit
⁊ cesari domiciano eius aduentum nuncia
uit. Indignatus aute crudelissimus dome
cianus proconsul iussit ur ante portam que
latina dicitur ⁊ conspectu senatus in feruen
tis dolio scis johannes deponeretur. priusti
tu flagellis cederetur. Quod ⁊ fcū z. Vn pro
gente eum gra dei tam illesus exiit quam
inmunis a corrupcone carnis extitit

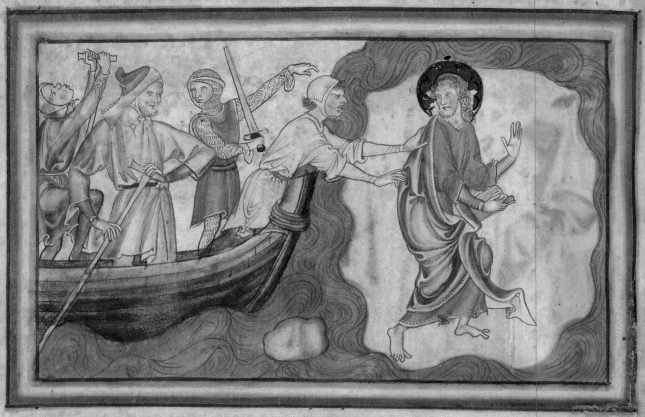

videns uero pconsul eum de doleo exisse
unctum ño aduistum obstupefactus uo
luit eum libertati sue restituere. Et fecissz
nisi timuissz uisitont regie contraire. Hoc
aut cum domitiano relatum fuissz: pcep
sanctum johannem apostolum in exiliu
out in insula que pathmos dr in qua z
apocalipsim que z nomine eis legitur z ui
dit z stripsit. Domitianus u eodem anno
quo uissit sanctum johannem exsitari a
senatu romano interfectus; Ad gmendam
dam porro ipius sanctissimi apli z euange
liste johannis digna memoria aplicam co
stantiam xpicole in supradicto loco ante
portam latinam preclaro ope ecciam cont
struxunt. Ubi festiuum concursum usqz
hodie fideles populi faciunt. Interfecto
aii a senatu domitiano exsito isolutus
recessit ephesum ibiqz ob hereticor refuta
das uersutias rogatus dicitur ab omnibz

aste eps z presbiteris. quia iam in tribz
euangelior libris de humilitate saluа
toris habebunt. ut eis de diuinitate sermo
nem faceret atqz ad memoriam futuror
stripta relinqueret maxime ad uincenda
illor heresim qui dicebant xpm ante ma
riam ño fuisse. Beatus apostolus quod
petebatur primum se negauit facturu
Sz precatoribz in prece psenerantibz ño
aliter adquieuit. nisi omnes triduano
ietunio dñm i omune precarentur. Qd
cum fecissent. die tercia tanta gratia
spiritus sancti secm sui nominis ggruam
inpretatione dicitur ee repletus ut usqz
ad otemplandi pris z filii z spe sci diuini
tatem mente raperet z de ecilie uite puris
simo fonte potarit quod nob sitientibz
xpmaret. Un z euangelii tale est exordi
um. In puncipto erat uibum. z uerbum
erat apud deum. z deus erat uerbum.

insula alis. · bosforū mare

Pathmos insula.

Garnosia insula. · insula sar dis

Incipit visio beati Jo-
hannis apostoli.
pocalipsis ihu xpi qua
dedit illi deus palam
facere servis suis que
oportet fieri cito z sig-
nificavit mittens per
angelum suum servo
suo Johanni. Ego Johannes frater ur z par-
ticeps in tribulatione z regno z paciencia
in thu' fui in insula que appellatur path-
mos ꝓ verbum domini z testimoniū thu
fui in spiritu in dominica die z audivi
post me vocem magnam tanqʒ tube dicen-
tis. Quod vides scribe in libro. ex mitte sep
tem ecclus ephesum z smyrnam z perga
mum z thyatiram z sardis z filadelphiā
ꝟ laodiciam. Et angelo ecclie ephesi scribe
Et angelo ecclie smirne scribe. Et angelo
ꝓgamī ecclie scribe. Et angelo thyatire ecclie

scribe. Et angelo ecclie sardis scribe. Et an-
gelo philadelphie ecclie scribe. Et angelo
laodicie ecclie scribe.

pocalipsis. Revelatio incipientis. Quod est revelatio
domini z ꝓ filio dedit secundum quod id eat
ille sacros scriptum. Divinitas scieus hominem
naturā assumꝑt. Et. Palam facere servis suis quecuqʒ
fieri cito. Sunt hic liber non solum ꝑtinet z ꝓsentia
z preterita narrat. cur hic sola futura communi ꝓpheta Je-
sum xpm servis suis manifestare dicitur. Olim fuit ecclia
ꝓsentia visus preterita auditu tactu deo ꝑsonatur.
futura aut no nisi aut ꝑ cogitationem divinam scripturam
aut ꝑ revelationem dei ꝡ aliter scire queunt. Et signifi-
cavit mittens ꝓ angelum suum suo servo Johanni. Do-
minus ihc avgelum suum visum z ꝓ eundem avgelum
servo suo Johanni manifestavit que oporter fieri cito
Ego Johannes et. Discipulos fratres vocat quos uno ꝟ
sanguine redemit z una matre ecclia ꝓgenuit.
Sequitur fecerat in ꝓseratione seruetis deo
ette dapibus in gloriam michi ꝟ ... Fui
in spiritu fuisse dicit. Et eum ministerio corporis
tui no carnalibus si spirimalibus oculis in ...
Minimavit est homo non pupter ea z sꝺ hec ꝟ
Dominica autem dies ꝓ ipsa evangelis resurg̈

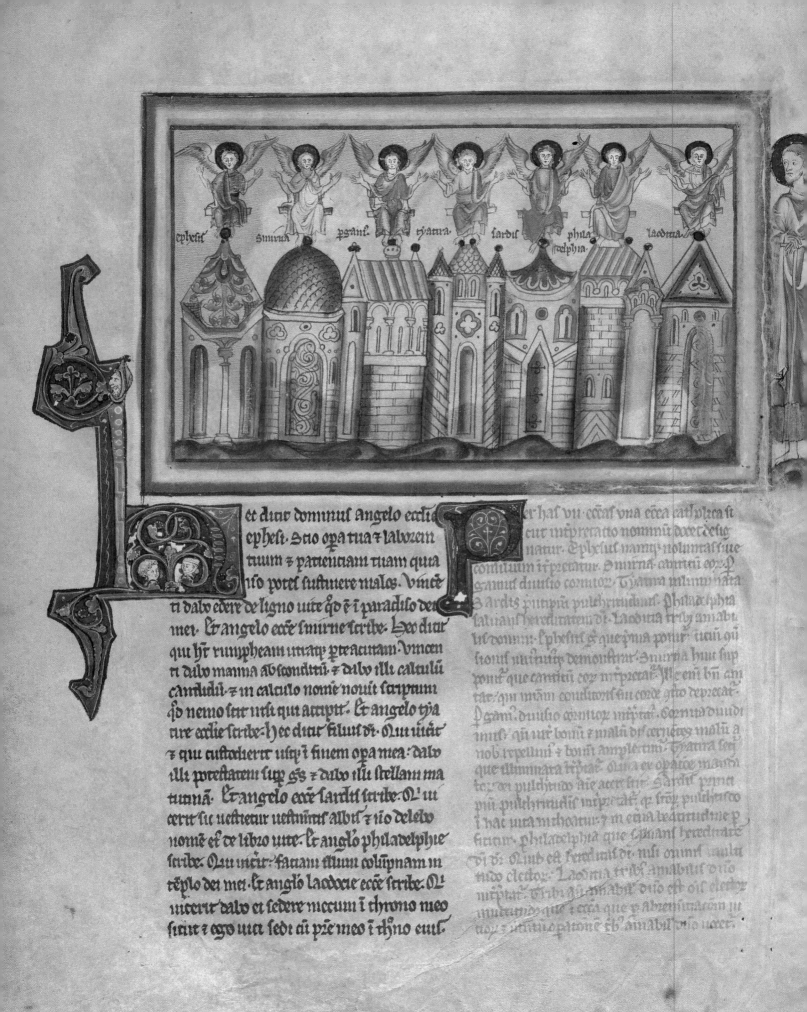

et dicit dominus angelo ecclie
ephesi. Scio opa tua z laborem
tuum z patientiam tuam quia
no pot[es] sustinere malos. Vince
ti dabo edere de ligno vite qd e i paradiso dei
mei. Et angelo ecce smirne scribe. Hec dicit
qui ht rumpheam utraq pteacutam. Vincen
ti dabo manna absconditu z dabo illi calculu
candidu z in calculo nome novu scriptu
qd nemo scit nisi qui accipit. Et angelo tya
tire ecclie scribe. Hec dicit filius dei. Qui vicet
z qui custodierit usq i finem opa mea dabo
illi potestatem sup gentes z dabo illi stellam ma
tutina. Et angelo ecce sardis scribe. Qui vi
cerit sic vestietur vestimentis albis z no delebo
nome eius de libro vite. Et angelo philadelphie
scribe. Qui vincit faciam illum columpnam in
templo dei mei. Et angelo laodocie ecce scribe. Qui
vicerit dabo ei sedere mecum i throno meo
sicut z ego vici sedi cu pre meo i thno eius.

per has vii ecclas una ecca catholica si
cut inpretatio nominu docet desig
natur. Ephesus namq voluntas sue
consiliu inpretatur. Smirna cantitu cor
gamus diuisio cornuor. Tyatira inluminata
Sardis principiu pulchritudinis. Philadelphia
saluans hereditatem dni. Laodicia tribus amabi
lis domini. Ephesus qd queq ponit titulu con
silionis inunitatis demonstrat. Smirna huic sup
ponit que cantitu cor inpretatur. Ille eni bn can
tat qui inteam conditoris sui corde gesto deprecat.
Pergamus diuisio cornuor inpretatur. Cornua diuidi
mus qn viros bonos z malos discernentes malu a
nobis repellimus z bonus amplectimur. Tyatira sed
que inluminata inpretat. Quia ex opatione manda
tor dei pulchritudine aie accrescit. Sardis principiu
pulchritudinis inpretat qr sicut pulchritusco
i hac uita inchoatur z in eterna beatitudine p
ficitur. Philadelphia que saluans hereditate
dni dr. Quid est hereditas dni nisi omnis multi
tudo elector. Laodicia tribus amabilis dno
inpretat. Tribus ga amabilis dno est oim electer
multitudo que z ecca que p abrenintiacem iu
tior z inscitia patrone eb amabilis dno uccet.

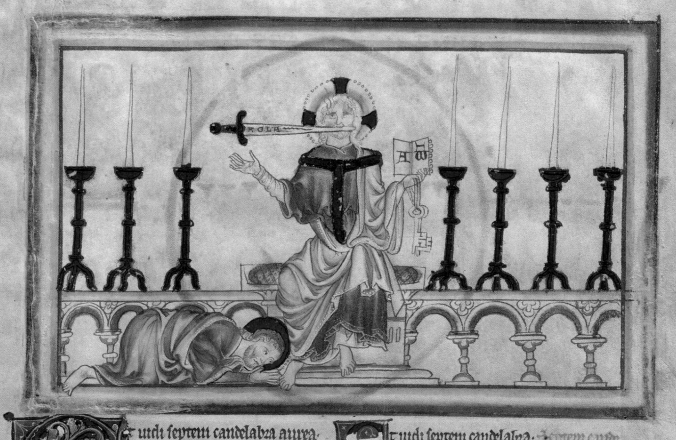

Et uidi septem candelabra aurea
z in medio septem candelabroz
auroz similem filio hominis
uestitum podere z precinctum ad
manuillas zona aurea. Capud autem et°z ca
pilli erant candidi tanq lana alba z tanqm
nix. Et oculi eius uelut flamma ignis. z pe
des eius similes auricalco sicut in camino
ardenti. Et halebat in dextera sua stellas. vij.
et de ore eius gladius utraq pte acutus exibat.
z facies eius sicut sol lucet in uirtute sua.
Et cum uidissem eum cecidit ad pedes eius tan
qua mortuus z posuit dexteram suam sup me
dicens. Noli timere ego sum primus z nouis
simus. z mortuus fui. z ecce sum uiuens in se
cula seculoz amen. Sacramentum vij. stella
rum que uidisti in dextera mea z vij candelab
aurea: septem stelle angeli sunt. septem
ecclesiaz. z candelabra vij septem ecclie st.
Scribe g° que uidisti. z que sunt z que o
portet fieri post hec.

Et uidi septem candelabra. Septem can=
delabra aurea. vij ecclias designant. et vij
ecclie unam eccliam catholicam figurant.
Que candelabra aurea dicuntur siue q per
secutiones quas sustinet in seculo perferunt siue q
sapientia qua illuminantur. In quoz medio
xpe stat uisus est sicut ipe dixit in euangelio.
Ecce ego uobiscum sum omnibus diebus usq ad con
summacionem seculi Septem. Vestitum podere zc.
Poderis que est talaris tunica iusque qui ante
aduentum fuerunt designat. P manuillas au pa
triarche z ceteri iusti qui ante legem fuerint desi
gnant. que aurea dicit multis tribulacionib sic
aurum in fornace probata ee noscuntur. P zonam
illas. duo precepta caritatis designantur. Cap
put eius z capilli erant candidi tanq lana alba
z tanqm nix. P capud lex. P capillos ii que de
capite nascuntur. multitudines designantur
eoz qui p legem saluti scti sunt. P oculos spe
phe designantur que ea que uentura erant longe
ante prouide uiderint. P pedes scti apli designant.
P gladium iis electi qui in fine mundi nascentur
atq contra antexpm pugnaturi designant.

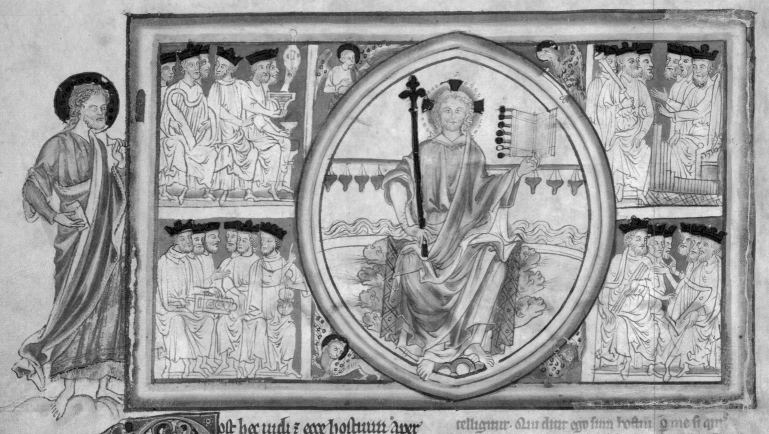

Poſt hec uidi ⁊ ecce hoſtuum aper
tuit in celo. Et ecce ſedes poſita e
rat in celo ⁊ ſupra ſedem ſedens.
Et yris erat in cucuitu ſedis ſimi
lis uiſioni ſmaragdine. Et in circuitu ſedis ſedi
lia uiginti quatuor ⁊ ſup thronos uiginti iiii
ſeniores ſedentes circumamicti ueſtimentis al
bis ⁊ in capitibus eor corone auree. Et de thio
no procedunt fulgura ⁊ uoces ⁊ tonitrua. Et ſepte
lampades aidentes ante tihonuu que ſunt
ſeptem ſpiritus dei. Et in conſpectu ſedis꞉
tanquam mare uitreuu ſimile criſtallo. Et
in medio ſedis. ⁊ in circuitu ſedis quatuor
animalia. Et animal primum ſimile leoni.
Et ſecundu animal ſimile uitulo. Et trium
animal habent faciem quaſi hominis. Et qr
tum animal ſimile aquile uolanti. Et requi
em non habebunt die ac nocte dicencia. Scs
Sanctus · ſanctus · dominus deus omnipz
Qui erat · ⁊ qui eſt · ⁊ qui uenturus eſt.

Poſt hec uidi hoſtium
p hoſtium xpc in
telligitur. Qui dicitur ego ſum hoſtium · qp me ſi quis
introierit ſaluabitur. Quod hoc iam capitm te
dz qa omnibus ad ſe uenire deſiderantibus ianua
multis ſcelibus deprimant ꞉ hoſtium miſericor
die ſue aperire non deſignatur. P celum aute
eccliam deſignatur. Et ecce ſedes poſita. Sedes ſi
que poſita erat in celo, cordi ſtor in eu gloria
eum deſignat. Qui uero ſup ſedem ſedens uiſus
eſt · deus eſt qui in cordibus ſuoru inhabitat
atqp ſedet ſunt apoſtoli dicut. Templum enim
dei ſanctum eſt, qp eſtis uos. Et yris erat ⁊c. yri
te idz arcus ſedem dei idz eccliam circundans xpi
ei miſericordia nos circumdando preterea gubernat
atqp ab inuiſibilibus hoſtibus defendit. Et in circui
tu ſedis ſedilia ⁊c. uiginti quatuor in hac libro
aliquando prioris ueteris teſtamenti non
alium ſed utriuſqp deſignat. Hii prioris uel noui
teſtamenti ſignificant. Et de throno
fulgurus uoces qp ſolquia mirabilia que per
ſiue iuſti apparent, prioris preuiſimus. P toni
truacio terror gehenne terris deſignatur.
ſeptem lampades ſunt vij · dona · ſci, ſicut ſu
pradixi de his diu noui teſtamentu intelligitur.
P iiij. animalia. iiij. euuangeliſta predicamus.

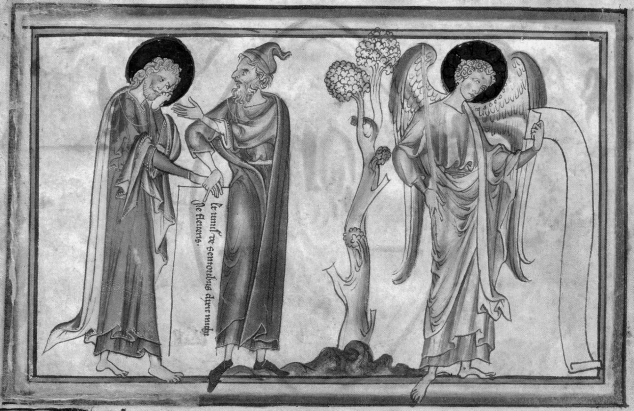

Et uidi angelum fortem predican-
tem uoce magna. Quis est dignus
aperire librum ⁊ soluere signacula
eius. Et nemo poterat in celo neꝗ
in terra neꝗ subtus terram aperire
librum. neꝗ respicere illum. Et ego flebam
multum. quia nemo dignus inuentus est ape-
rire librum. nec uidere eum. Et unus de seni-
oribus dixit michi. ne fleueris. Ecce uicit leo
de tribu iuda. radix dauid aperire librum ⁊
soluere septem signacula eius.

Angelus forti partes ueteris testamenti
significat. Voce magna predicauerunt
quia xpm ad redempconem humani
generis uenturum ee predixerunt. Quis est dignus
aperire librum ⁊c. Interrogatio angeli desiderium
sanctoꝝ significat. Desiderabant enim tantum uide-
re xpm in carne ⁊ audire sermones eius eo ꝙ scirent
omnia misteria ueteris testamenti ab eo ee reue-
landa. Et nemo dignus inuentus ⁊c. Nullus
nam angelus celum inhabitans. celum nichil

uitans. nullus iustus in terra consistens. nullus ꝗ egit
in morte ꝗ mortis debitum solueret ⁊ mundo uiuen
aparuit qui genus humanum de potestate diaboli
redimeret. Que redempcio aperta est ueteris testamen-
ti. Et ego flebam multum ⁊c. Iohannes flet eo ꝙ
nullus dignus ee aperire librum. Senior ui dicit
ꝙ per leonem tor; xpm aperiendus est lib. Per ange-
lum eni fortem hic designantur qui desiderio
aduentum xpi intueabantur quo tempore uen-
turus eet. Iohannes uero eos designat qui flebant
eo ꝙ tanto tempore tardaret. Senior ūt ꝓꝑhetis
designat qui dicebant quomodo ⁊ quo tempore uen-
turus eet. Per leonem ꝙ de tribu iuda xpm intelli-
gemus. qui ex tribu iuda ⁊ xpm secundum dauid ort;
Leo eo dicit ꝙ sentientibus uocatur quia diabolum
uincit. ⁊ electos suos ab eius potestate eripuit.
Vincit ꝙ leo de tribu iuda radix dauid dic-
tum ut aperiret librum ⁊ septem signacu-
la eius. quia librum non posset aperire nisi
prius uinceretur diabolus. Qui uiuebat in
aperitio fuit ueteris testamenti. Quomodo
ergo septem signacula leo de tribu iu-
da aperiret. in sequenti dicemus.

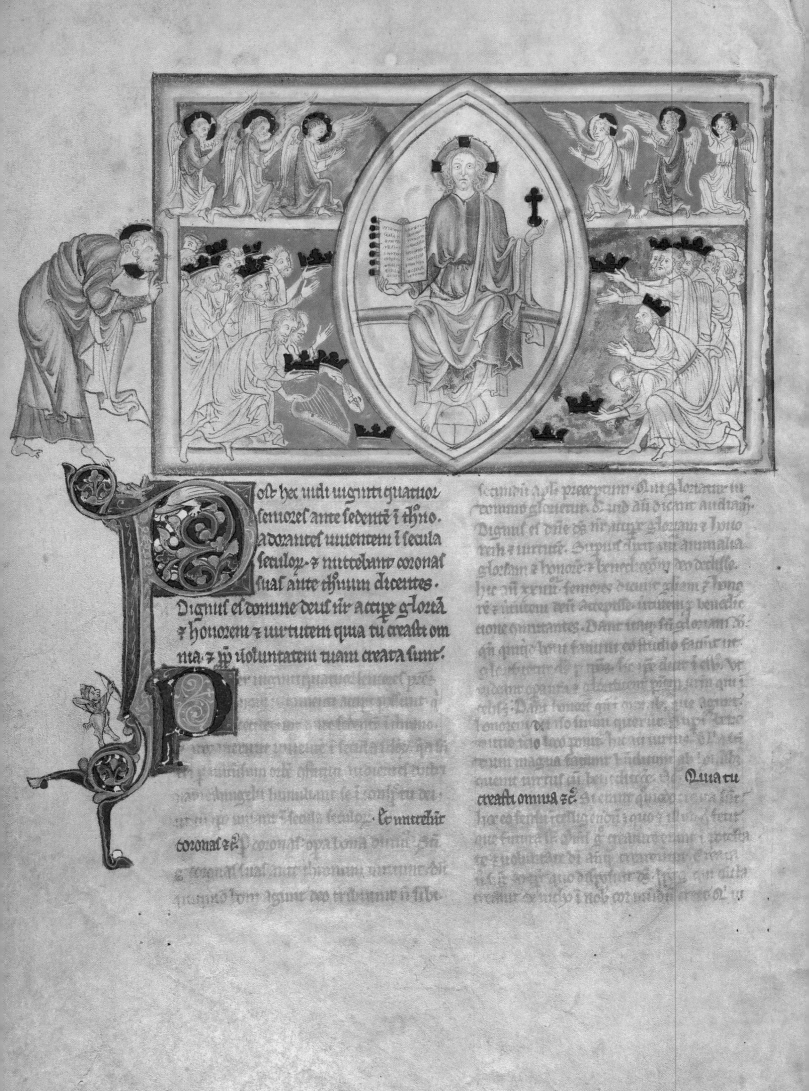

Pose hec uidi uiginti quatuor
seniores ante sedentē ī thro.
adorantes uiuentem ī secula
seculox̄ ⁊ mittebant coronas
suas ante thronum dicentes.

Dignus es domine deus nr accipe gloriā
⁊ honorem ⁊ uirtutem quia tu creasti om
nia ⁊ ꝓ uoluntatem tuam creata sunt.

secundū aʠ preceptū. Qui gloriarur ī
eterno gloriertur. ⁊⁊ vnd au dicunt audiaʠ.
Dignus es dn̄e ʠ nr acuꝑ glorianū ⁊ hono
rem ⁊ uirtute. Sunut dicit au animalia
gloriam ⁊ honore ⁊ benedicōij ꝓ deo dedisse.
hec aʠ xxiiij. seniores dicunt glōam ⁊ hono
rē ⁊ uirtutē deū accepisse. iuuerunt ⁊ benedic
cione ouuntantes. Dant itaʠ sūt glōrianū dū
aʠ quiiʠ bonū kouuirir eo studio faciūt vt
ele̍ cleberur. Ab ꝓ iꝑsa. hic iꝑe deur h ess. Vt
uideru opaura ⁊ clariores ꝑōm. arin qui ī
celiʠ. Dant bonae gar oua dē. iste aguir.
honorem dei iso fiuun quer iuʠ. Supi Abso
nudo ieo loco pout. hic ou uirus. Opater
iurum magua faciunt. Viidunut ab Loquiliʠ
euent uirtuʠ aū benediciaġ. Se Quia tu
creasti omuia ⁊ꝯ. Sieuiur quidē igura sūt
hoc ea ferili. teslig euōꝰ. ī quo ⁊ illiʠ. beut
aue fiuura ūꝰ. Oui ʠ creauure eruure ⁊ ꝓceba
r ꝓ uoluube de dñ . ereareuur. Creata
aū.ꝓ weꝯqr quo disposiur dē. hꝑe qui dicta
ereatur ex nucho ī noꝰ cor uiuus areu ꝗ̄ iiʠ

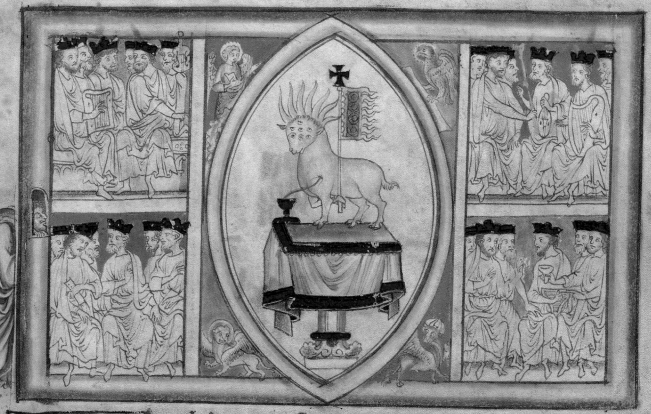

t uidi·et ecce in medio
throni·z quatuor ani
malium·z seniox agn
uum stantem tanquam
occisum habentem cor
nua septem·z oculos
septem qui sunt septem spiritus dei mis
si in omnem terram

er thronum·z quatuor ania
lia·z seniores una ecclia cui est
cus suus eadem·z deus pater·Ag
nus uero non occisus sed uiuus occisus in
sol·qui moriens in cruce occisus est
·z paulo post resurgens iam non morie ꝰ nec
ille ultra non dominabitur·Cur cornua
uit·z oculos septem habuisse prius est·
Cur sunt aurem septem oculi·qui ex
plent eum subiungit·Qui sunt sep
spiritus dei missi in terram·Per cor

nuam sepe regna designant·Videntur
q̃ michi aliam significatione hic cor
nua aliam oculi·P um nam q̃s cornua
orist electi designantur·qui regnum dei
merentur quoꝝ omne multitudine sup
in uii partes diuisimus·Ad primum q̃ cor
ni electi qui ante diluuii tuertiat p
uenere·Ad secundu it hui qui ꝑst dilu
uiu usꝗ ad legem fuerunt·Ad eciam aurē
hui qui sub lege fuerunt·Ad quartum
ꝗ ge·Ad quintu q̃ eos ex iudei credi
derunt in xpm·Ad sextum populi uii gē
ibus·Ad septimum hui qui in fine mundi
mundi nascenturis·z cum antixpo
pugnaturi·xpc dic aliꝗ agnus aliꝗ
leo uocatur·leo aū p̃ fortitudine uocatᷓ
q̃ diabolum uincit·z electos suos ab eiꝯ
potestate eripuit·Agnus aū p̃ uoca
p̃ mansuetudine·de qis subditur·

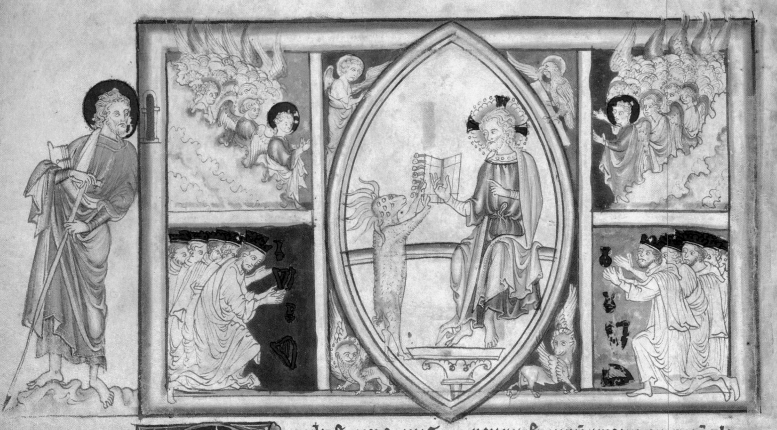

malia z uiginti quatuor seniores cecide runt coram agno habentes singuli cith aras z phialas aureas plenas odoramen tox que sunt orationes sanctox. Et can tabaut canticum nouum dicentes. Dig nus es domine ds apire librum z apire signacula eius. quia occisus es. z redemi ti nos deo in sanguine tuo. Et uidi z audiui uocem angelox multox z ceutu thronu z animalium z senior. z erat nu mus eox melia milium uoce magna di centu. Dignus est agnus q occisus est ac cipe uirtutem. z diuinitate z sapiam z fortitudine z honore z gliam z benedic

cionem. Et omne creaturam que i celo est z que sup terram z subt terram. z q sunt i mari. z que in ea sut oms audiui dicentes sedenti in throno z agno. Bene dictio z honor z glia z potestas in secula se culox. Et uiii animalia dicebant. Amen z.

Sequitur dicentes p sedente i throno. zc. xpm designatu fuisse. Si q. q. ihe dixit. ego in pre z pr i me. z qui uidet me uidet z prem. Qui lix lo qui sedens in throno prem designat. Dextera dextro xpi filius z. Agnus au hominem que xpe assumpsit designat. Agnus qz librum de dextera sedentis sup throniu accepit. qz homo xpe a sua diuinitate accepit. ut sacramenta diui nax scripturax reserauet. Cadunt u coram agno seniores. cu p meditarone diuinax scrip turax qlibz aures inuensam clementiam dei hunificant se in ipsoru creatox. sui phiale aurea. corda suo odorauertis plena dni.

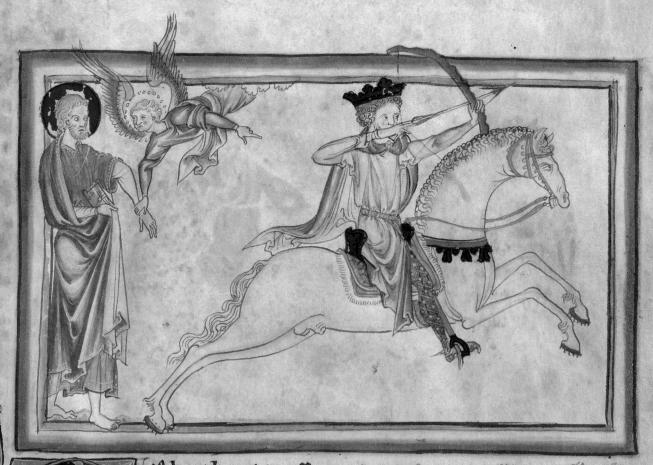

ost hec uidi quod agnuss
agnus unus de septem si
gnaculis z audiuit unus
de quatuor animalib; di
centem tanqz uocem toni
truis. Veni z uide. Et ecce
equus albus. z qui sedebat sup illum
habebat archum z data est ei corona.
z exiuit uincens ut uinceret.

Iquio pzit signaculi ad ea que ante
diluuiu fca sunt prouer. Lauius te
pzimi sigillum apuit quo ea qui
ante diluuiu gesta sunt uoluiss; ecce queli;
sciliz intelligerentur hic sz gza paterent

Et audiuit unus de uit animalib;. z c. Earu
dem significatonem habet pzuiu animal sia
z secundius trauit ur quartum Significant p̄
postores ecc. Qc aut autem dicit. Veni z uide
ea intelligendam spiritalem nos prouocat

ne si diceret. Veni non passib; corporis. set p̄
sibi mentis z intellige spiritualis ea que pzo
tempore historiatur facta legisti. Et ecce eqs
albus z qui sedebat sup eum habebat archu
z c. Equus albus iustos qui ante diluuiu fu
erunt designat. qui p̄ innocentiam albi
oruntur. Sessor uero equi domi̅us est
qui suis sanctis eternaliter presidet. Per
archum uero qui peul significat z uint
tit z uinuerat. uulititia comium preli z
signare. quia z pauucos dominius p̄ inob
uruente culpam uanqpuisi. z eam p̄
fraterticedi reatum septizlunis damin
Qz coronam uero nullomnis sunt z p̄
equum album iusti inuiure dituri hi
erunt uestig panitur. Exiuit g̅ uincus
uinuceret quatuo stadiuer erit prinat
diluuiu omnis miuliaido ezposiu de
leretur. Uiuttit q̅ ut uinceret homes
sit z gloria z uirtum, aseuda seuuos ap

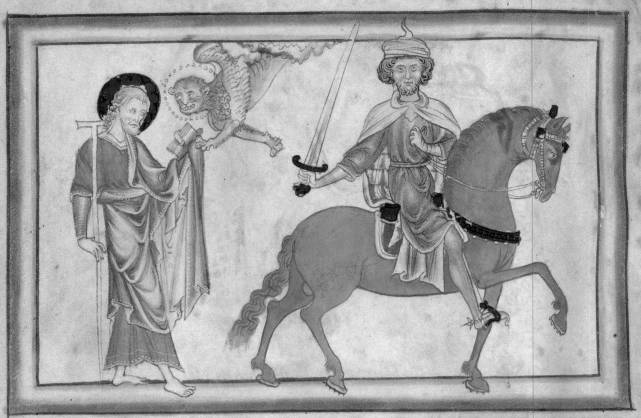

 t cum apuisset agnus
sigillum secundum? au
diui secelm animal dicens
Veni z uide. Et exiuit ali
equs rufus z qui sedebat
sup cum. datum est ei ut sumeret pa
cem de terra. z ut inuicem se interficiar
z datus est illi gladius magnus.

Secundi sigilli ad archa sionicam z ad
illos qui ante legem fuerunt primo
P equus e rufum iustos qui post deluuiu ut
ad legem fuerunt designat. Et q rufus co
t z aureo colea punicep appingiat uelut
et aureo colea sanguineum admiscuat no
uigruit sat uir quicquid legem fuerunt hu
te colea oparatur co que lapis electis que p
aurum figuratur z i plemendiz ad illis
ostantes fuerunt que p sanguine siguicant
z illos it huiu equi domini: qui in scis sui

mhabitat. huic sessore datum est ut pa
cem sumeret de terra. Si ipa bona ea z
a deo de terra qmodo sumpta est. Si est
pax bona z est pax mala. Pax mala dum
filii dei ante deluuiu cum filiis hominum ha
buerunt quico filias eor duxerunt z suat
eis dederunt. Ideo cum illas aquis deluuiu te
leti sunt. Si z filiis ista precepit dominus
ut sedus nd inreat cum chananeis nec
filias eor accipent. nec filias suas eis dent.
Iam de pace bona z mala. Psalmista loqui
dicens. Cum electo electus ea et cum pu
so peruertens. Hanc q z iuicem te pa semp
sit qui iustos homines ab impiis separatur
mente no corpore. Et ut iuice se interficiant
A quibz preabitare z consequenter in aliis ab
alio interfiatur. Iam sepe iusti iustos. z
iusti iustos interficiunt sicut agnust ille
t chaldeos z sic abraham iiii reges uice
it. P gladius iam magnus aute dicimus dia
pe posterum quibz omnes iuuia celetus est.

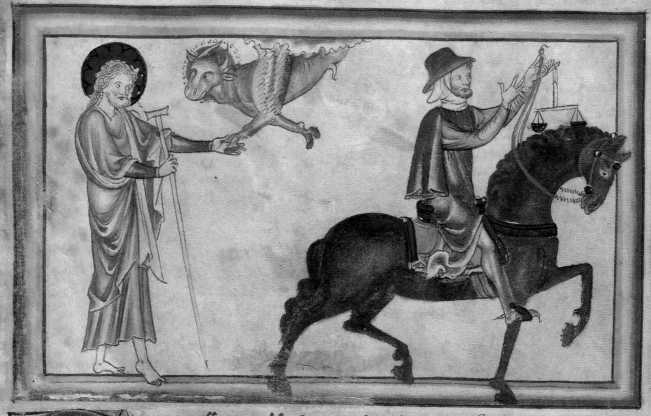

Et cum aperuisset agnus sigil
lum: audiui tercium ani
mal dicens. Veni ⁊ uide.
Et ecce equs niger. ⁊ qui se
debat sup eum habebat sta
teram in manu sua. Et audiui tanqm uo
cem in medio quatuor animalium dicē
tem. Bilibris tritici denario. ⁊ tres bilibres
ordei denario. ⁊ uinū ⁊ oleū ne leseris.

Per equm nigrum doctores legis possu
mus intelligere. Nigredo enim equi
siue obscuritatem legis quid durum
siue duriciam designat. Siam ⁊ moyses uelans
habebat sup facem suam eo quod splendo
multus est idest spiritales intelligentia in lege
Allepēntibz occultis non posset uideri. Doctor
aū equs dominicus. Statera equitatis iudicii
legalis demonstrat. Vt est anima p̄ anima
oculum p̄ oculo. dentem p̄ dente. pedem p̄ pe

de. Et audium uocem ⁊c̄. Potest p̄cem que
facta ē in medio quatuor animaliū uox ecc̄e
accipi dominū maiu implorantis. Bilibris
tritici denario. ⁊ tres bilibres ordei denario ⁊
uinū ⁊ oleum ne leseris. magna sunt que p̄
tulit. P tricticum ex quo panis optim̄ effic̄ur
diuinū scripturam possum accipe. que p̄
buus est anime. Duo si libre tritici duo testi
menta designant. quibz diuina scriptura di
uiditur. Et huius uidebus libris tricum magna
rū coprum nob̄ scripti patres appaurerit
qui eam multipliciter exposuerunt. Deus h̄ p̄s
aū deum designat. Bene ē libre tritici dena
rio copulantur qm h̄c sancta scriptura loqui
ad uiru det omnipotencia inde tenēbus
bonitatem atqm secundū priuet. et uirtutē
cū bonū erga p̄ inuacordinū. de ille est
nū de nob̄. P allpturatem ū ordei egra treb de
signant que aspa quidem uidentur p̄ oy terō
sp̄ spes ea benitia satur. sicut dominus dicit
iugum enim meum suaue ⁊ onus meum leue

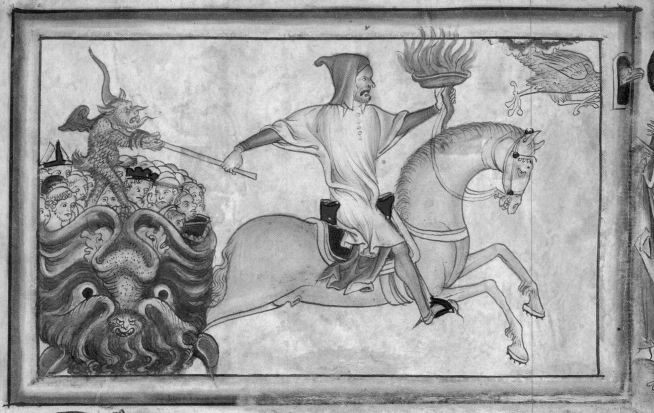

 t cum aperuiſſet ſigillũ
quartum: audiut uocem
quarti aĩalis dicentis
veni ⁊ uide. Et ecce eqꝰ
palltdus: ⁊ qui ſedebat ſuꝑ
cum nomen illi mors. ⁊ infernuſ ſeque
batur eum· Et data eſt illi poteſtas ſuꝑ
quatuor ꝑteſ terre mſficere gladio fa
me· ⁊ morte ⁊ beſtiıſ terre.

ner qui de ſentetia xꝓi paſſionem
rel apoſtolicã euitationem eꝓ
ꝑimam ⁊ aptıſ ſuorũ ꝙꝗariaſ ſignat
ꝓduxerut. Saluator · ut quartum ſigilli
aꝑuit· ad ıntelligendum aꝓluꝯ doſtorẽ
ecce uidur. Et ecce eqꝰ palliduꝰ ⁊ ꝯ. Eqⁱ palli
ꝯ qui ꝓ ſignıficat paſtoꝛ ⁊ uiſiã maiꝰ
patiuntur honũ; Nlıʒ ꝑnıqꝗ ſe nũ adı̃gı̃ꝯ
ꝑuiote coꝛa uenũ coꝛp ac̃ſuɴꝰ uiıl
tdꝰ aliꝰ anoꝛ̃ ꝑtıleſcunt honũıes · pbet


Ʒ qui ꝓpulo ꝓqꝛang̃; dıutur ꝙ ꝗm
piram ⁊ gladium ⁊ ꝑdicreꝰ ıllecꝰ noqueⁿ
ment coloꝛẽ pandınꝗ̃habu ı̃ge dıſſ. Geſtoꝛ
diã huiꝰ equi domınꝯ· qui n̄ ꝑaſſit ſuıſ tohı̃
bıdatur Sʒ neſt̃ durıı uitet · qpeonẽ ıne
al habiuıſſe ꝙ ıpſe enim eſt uita omniũ ele
toꝛ ſuoꝛ ſicut ıpe dicıt Ego ſum uıta. Eʒ ſı dı
lıgentı ſcrıpturaſ diuınaſ ır ſꝑ ımuıſ ıoıte
uteıs dũm uꝛm ⁊ morte uicarı ſta ſunꝰ
ſuıcl eſt omnıũ eletoꝛ; qbꝯ ꝯuchẽ uırlıꝗ
eſuam largıũ· ıta ⁊ morſ diũ poıẽꝰ ꝛꝓhꝰ
quıoꝭ ꝓ ſcelerıbꝰ ſuıſ corıılle moꝛtı uıdıꝰ ꝓ
tue. Ipſe enım hȝ poteſtatem aıam ⁊ coꝛꝯ
ꝯdere ı̃ iehennam· Huıc ꝙ eqⁱpⁱ uꝛſerıuꝰ
ſerquebatur ꝙ omeſ qui omnıũ dos̃· ꝓꝑha̕
ex oꝛe domũ ꝓtulerant oxempleꝛaﬀuⁱ
niuſ abſcõdıtur· Seꝗ̃ Et data eſt illi poteſꝰ ꝛꝯ
Ꝙ̃ uñ ꝑteſ terre· oıſ eⁱa iſrl dolı̃gnıꝰ ꝯꝯꝯ
dũ i gladıẽ · fame · ⁊ moꝛteⁿ ſꝑꝯ uı fuerıꝰ
lıbꝰ ꝑı̃ lıge atꝗ uıꝗ ꝗꝗ ꝗꝯꝗiolunꝰ.

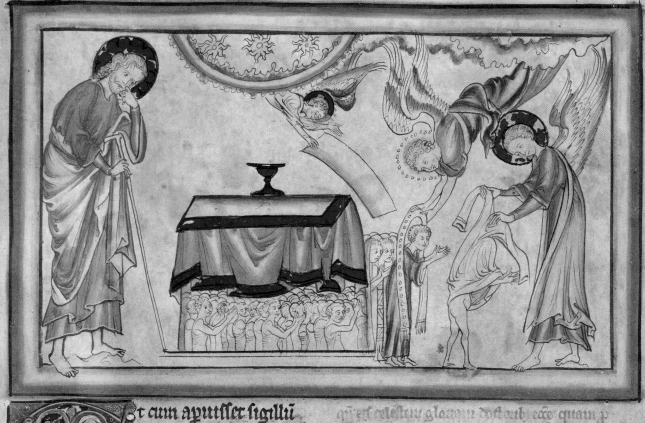

Et cum aputiffet figillu
quintum wivit fubtus al
tare aiumas intfectoz
xp uerbum dei z xp tefti
monium qued habelut.
Et clamabant uoce magna dicentes.
Ufqueq domine fanctus oz uerus non
uivicas z uindicas fanguinem nrin de
hus qui habitant in terra? Et date fu
ers fingule ftole alle z dictum eft illis.
ut refquiefcerent. Tempus aihuc invi
cum donec aifumpleantur conferui cox
z fres cox qui intficiendi funt fic z illi.

quintr figulli aperto fertir feptim
dicimus ad aperione noue
teftamenni pinet. Et quamuis uo
fu teftam orm aperto fit ueteris teftamen
fu multis ee obliuie pounit que uide eft in
pounentur? qut eft faluator pmiffi figulli

qus et celeftiu gloriam in vofotib ecce quam p
asfecat contulit eox in mixo apiop homines
di uefcitur. Et uidi fub altare di z z. Altare di
xps eft. Adhue op fanctox fub altare di quiefcit
qo ficut capit fuppofita funt menib ceps coheret
ita z oimie fcox z celefti gloria conftituiret z xpo
faluaton fubiecte funt. eteq qui necom mem
bros necteum. Et clamabant uoce magna z z.
cum fcriptura pcipiat malu p malo no re
dere z dominus dicat i euangelio diligue ini
micos uros bef facite hus qui oderunt uos. uid
eft qd fcis in celetib conftiteti chnoice de minib
fuit experiunt. Difiefuel fcox ex di z vilectina
vefiderare in deo z conftia ratioe e ipee conra
qui non valet exaudin? oftenduti quo ipeoru
te fufte ill z z. et da

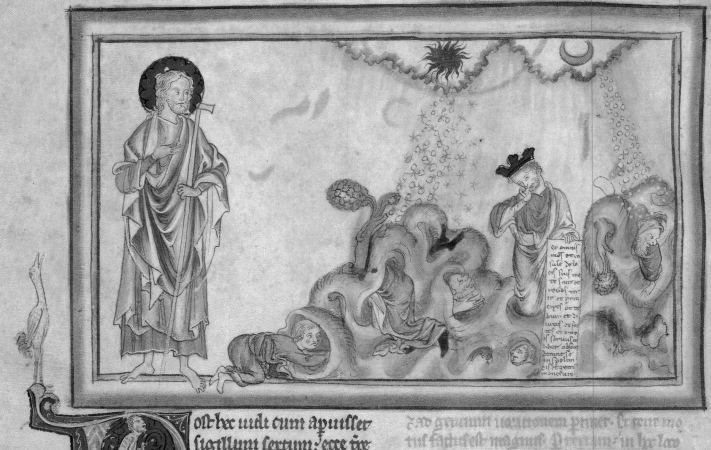

Post hec uidt cum aputsset
sigillum sertum: ecce tre
motus factus est magnus
z sol factus est niger tan
qm saccus ciliсinus· Et
luna tota facta est sitcut sanguis z stel
le celi ceciderunt sup terram sitcut fic
mittit grossos suos cum a uento mag
no mouetur· z celum recessit sitcut lib
inuolutus· z omnis mons z insule de
locis suis mote sunt· z reges terre z prin
cipes z tribuni z diuites z fortes z omnis
seruus z liber absconderunt se in spelun
cis z petris montium· z dicunt montib;
cadite sup nos z abscondite nos a fa
cie sedentis sup thronum z ab ira ag
ni qm uenit dies magnus ire ipor· et
quis poterit stare?

Sigilli sexti aptio· sto iudeor detectionem

z ad generum uexationem perti· et exit mo
tus factus est magnus Per tra· in hac lo
quider designantur gente ut pleta est magni
quido a romanis hec gens est deuastata· et
sol factus est niger. P solem z iudeor populu
designatur· Sol qz factus est nigra tanq sacc
ciliсinus ap populus iudeor quia in ei cognome
unius dei z iqa custodiam legis uetus sol in mu
do refulgebat inter ceteras gentes sez in omnib;
hominib; odiosus iqa in iniquitates situs· Iac
eo nauigз penitere uestiut ut iudicant se
ee prores· Sol qz ingreditur sacci habuit· quia
omnib; gentib; seruiora iudeor putuerunt·
Et luna fcã z z. Luna significat synagogã·
Luna qz spem sanguinis habuisse uia qz· qz olie·
clarius iudeos iqa effusione sanguinis xpi lac
torup ee relicos· et stelle ceciderunt· et P stel
las pricipes sacerdotum designatur scribe z
phariseI qz suum ab terram iudeor pollunt
intelligere· Grossi si eiusde in bonis frutibus i
iuulos uocamur· Qm uero lahumtur cum
arbor eadem uento concutitur·

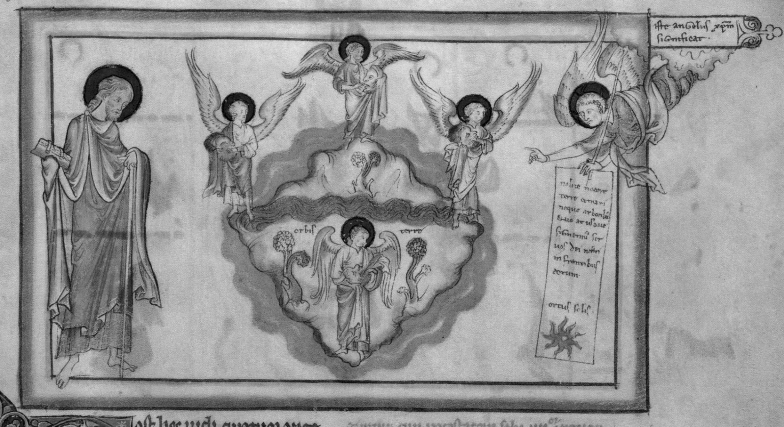

Hic angelus xpm significat.

nolite nocere terre neque mari neque arboribz quoadusq; signemus seruos dei nostri in frontibus eorum

ortus solis

orbis · terra

Post hec uidi quatuor ange
los stantes sup quatuor
angulos terre tenentes
quatuor uentos terre ne
flarent sup terram neq;
sup mare neq; in ullam arborem. Et ui
di alterum ascendentem ab ortu solis
habentem signum dei uiui. z clamauit
uoce magna quatuor angelis quib; da
tum est nocere terre z mari dicens. Nolite
nocere terre z mari neq; arboribz qu
adusq; signemus seruos dei nri z fron
tibz eorum. Post hec uidi quatuor angelos
ter quatuor angelos quatuor ugna
designantur aspiritue scilicet per
matoz uium atq; romanoz. Sed qua
tibi uiat ualde ip solos romanos ceu
dicat · iiii angelos soli romani intelli ·

cuntur qui potestatem sibi iiii regnoz
iudicauerant. P iiii uero angulos iuuiu
te gentes que iiii mundi plaga
oriuntur. designantur quas sibi romani
subiecerant. Tenentes iiii uentos z. Q uen
tos qui nibes excitant ut terram irrigante
facte ei hilaritatem reddant atq; fructiferam
faciant per nubes mortalibus optima desi
nante. Angelus ii ab ortu solis descendens
xpe est. De quo scriptum est. Et uocabitur
nomen eius magni consilii angelus. Ipse est
sol de quo scriptum. Uob aut timentib; no
men meum orietur sol iustitie. Ab ortu
solis xpe descendit. id a sorore ipsis qui cotti
die carnem i mortalem ex carne uirgio
creauit. Signu aut dei uiui est diuinitas
z clamauit z. Clamasse ii fecisse est di
cuntur ad uentis suo. facere; qz cepis iudi
olis deus qui dicere. factum; eius uoce uocat.

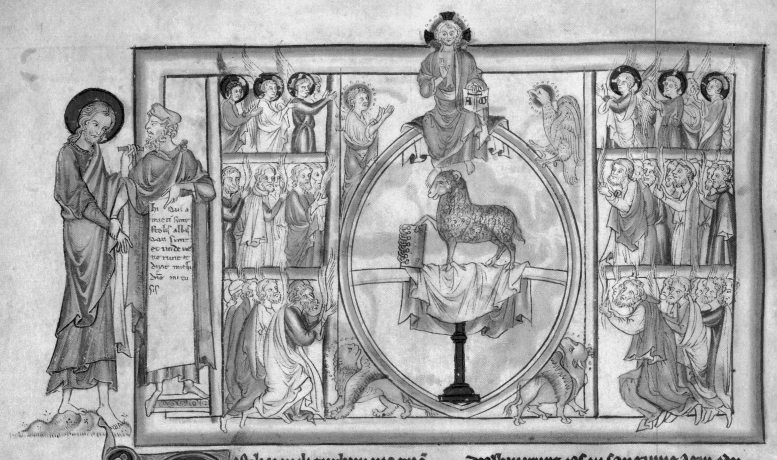

ost hec uidi turbam magnã
quam dinumerare nemo po
terat ex omnibz gentibz z tri
bubz z populi z linguis stan
tes ante thronum z in conspectu agni
amicti stolis albis z palme i manibus
eor z clamabant uoce magna dicentes
Salus deo nro qui sedet sup thronum
z agnum Et omnis angeli stabant i cir
cuitu throni z seniorz z uii animaliu
Et ceciderunt i conspectu throni z facies
suas Et adorauerut deum dicentes. Be
nedictio z claritas z sapientia z gr̃ap
actio honor z uirtus z fortitudo deo nro i
secula seclorum amen. Et respondens unus de
senioribz dixit michi. Hii amicti stolis
albis sunt. qui uenerunt ex magna tri
bulatione z lauerunt stolas suas z

dealbauerunt eas in sanguine agni. ideo
sunt ante thronum dei z seruiunt in
templo eius die ac nocte. z qui sedet in
throno habitat sup illos.

de senioribz z c.

Et unus

Et dixit michi

Hii sunt z c.

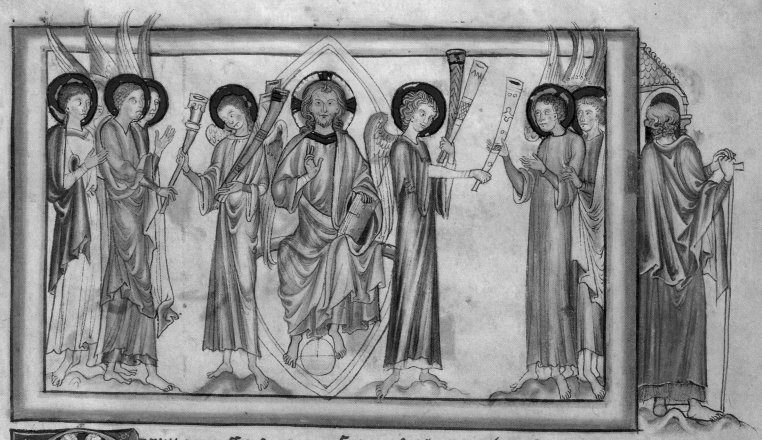

 t cuit aperuisset sigil
lum septimum: factu
est silentium in celo quasi
media hora. Et uidit vii
angelos stantes in con
spectu dei: z date sunt illis vii tube.

 perto septimo sigillo ad naturam
gratie xpi puent. Et pretendit
apertio est eius in septimo z non in
aliud loco ponitur. In genesi scriptum
est quia sex diebz fecit deus cuncta que
celo z terra originem sumpserunt sep
timo autem requieuit. Octauo uocatur die
septimum: dictum est requiem sed ne
est aut requies usq̄ ad xpm. Sed moriunt
eius z resurrectione illi. Apertione uocauit
dies septimus quia ipse est requies omniu
sanctorum qui septimi die figuratur.

Factum est silentium z c̄. Et silentium pax
que ab incuriatione regis eo naulentro.
Ipsi unuisum ecclesie facti est designatur.
Sed de hoc uere silentium fecit aequm per
quam ecclia in inicio fuerit aperta q̄ silentio
habuto, pauco tempore mortis sla
rone imperatore martirum esset z petris
loq̄s interfectis propriis omnes presbyte
nos. Et uidit vii angelos z c̄. Ordo iste
per angelos in sequentibz z statu seruit
preco ante regem aut principem uer
titur. Qui eius aduentum annuciante
terra z iohannes quia magna erant que
per angelos designabantur cor martir
ortam facere uoluit antequam eos cor
narrationem uenient.

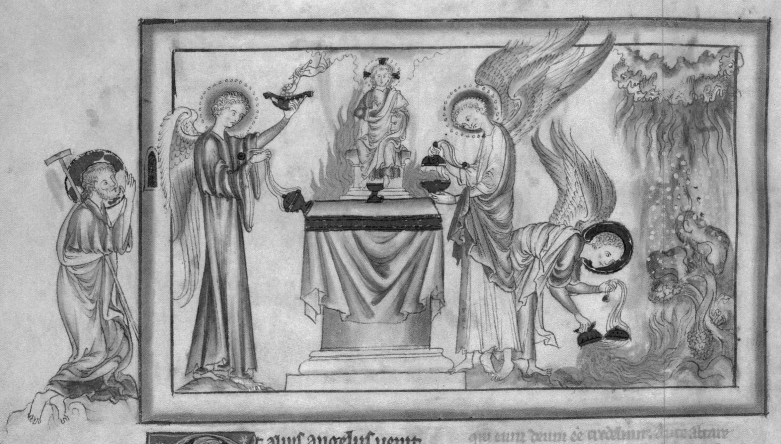

lauit angelus uenit
z stetit ante altare ha
bens thurribulum aure
um z data sunt illi ince
sa multa ut daret de ora
cionibz sanctox sup altare aureum qd
est ante conspectum dei· Et ascendit
fumus incensox de orationibz sanctox
de manu angeli coram deo· Et accep
angelus turribulum z impleuit de
igne altaris z misit in terram z sca st
tonitrua z uoces z fulgura z tre motus

[remaining lines faded and illegible]

qit eum deum ee credunt· igie altare
stetit quia aplis z ceteris credentibz·
ex quibz ecca uint cor statuit qd deus
eet manifestant· P thurribulum uo
qd mram reuelat corda pollex ceterorum
sanctorum demonstrant· ora aureum suut
se dz qui corda discipulos· z stiam pur
stcata z p stiam qicunt a· z qd discue
rant erant inancta· Et ascendit fumus· z e·
P fumu itaqz aromatum qui saliut o
rationes fidelium est flagrantia longa
spum designantis que ultraꝗꝭ anteferiut
ter ascendit in conspectu· stii bent
de manu illo est· cuius ordine aduertit
p quisphent trades sacium ut ano
deos sammit· Et accepit angls z e· Sar
chem sex est assignauit· Magna p
artuus etꝗ ꝗ illo ecclesia· ex res
pueriao p rorirem optime z mst
tenu p hic ritui oblectat oct· Videmut

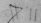

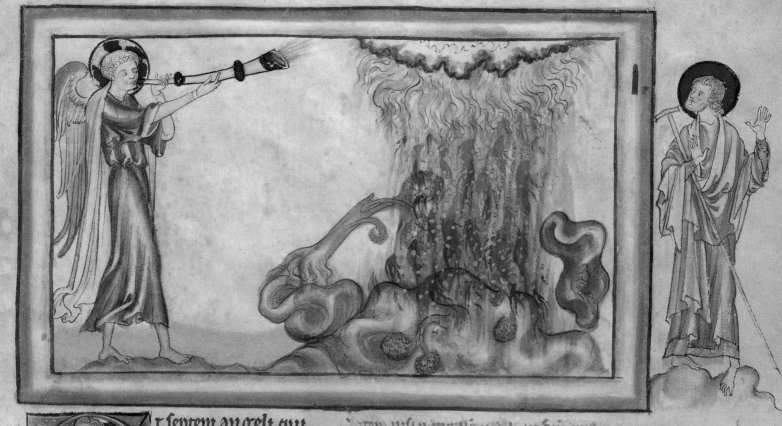

t septem angeli qui
habebant .vii. tubas pa
rauerunt se ut tubis
canerent. Et primus
angelus tuba cecinit ⁊
facta est grando ⁊ ignis mixta sangue
⁊ missum est in terram ⁊ tertia pʒ tre
conbusta est ⁊ omne fenum uiride
conbustum est.

P er tube canticum: predicatio de
ſignatur. Predicatores quippe ſu
ad hoc parati semper existunt: ut quoscūq
ſollerti ⁊ doctrinam sue predicationis deo re
ſtituant. Per primū ꝁ angelum sic dicimuſ
predicatore qui da legem fuit prefigniat
Primus ꝁ angls tuba cecinit qa hii iuri qui
ante legem fueruꝛ ut iaquis nullam hꝛenꞇ

legem nisi naturalē uidelz ut deū creato
rē suū timerent atꝗ diligerent. ⁊ qᵭ quiſ
pptio nō uellet. alteri nō faceret. Et facta est
grando ⁊ ignis ⁊c. Per grando ꝗ que per tu
tuba stoꝛ uiroꝛ que cordi prauoꝝ hominū
arguendo penitelmis designatur. Cur ue ig
nem ⁊ sanguinē ē prinerum habuisse des
tribuitur. Per ignem sps scs designatur. qui e
sic suis inhabitans eoꝛ illoꝝ nūuisꞇ extinc
Per sanguinē si ꝓe intelligitur. qui e ad pe
tribꝰ sepe prediciꞇus. ⁊ boꝝ militꝰ prefigu
ratus. terra aūt seculi hoi nuꝯ prin sū
uiros demonstrat. Et tertia pʒ terre ⁊c. Per
tertiam prem tre eos qui per doctrinam ⁊
exempla bonoꝛ hominū saluati sunt.
debemus intellige. Cū in igne timoris di
⁊ amoris quicquid in se prauum fuit con
busserant atꝗ deleuerint. Arbores ꝗ qui
perperam ꞇ conuertuntꝰ. Per fenum ē uiride
electi qui eo tempore fueruꝛ designaꞇ

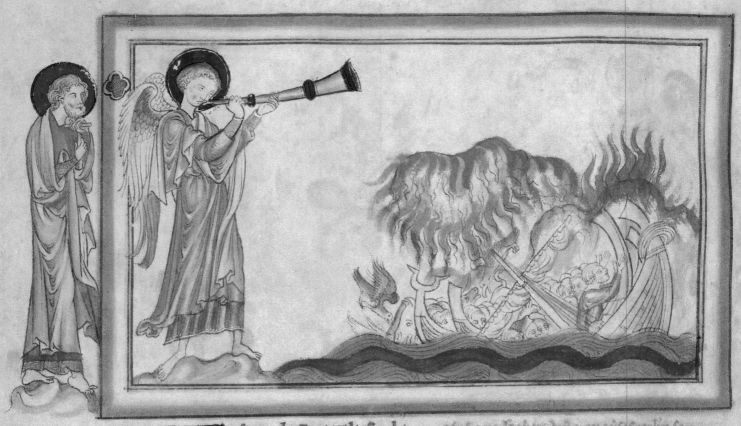

Et secundus angelus tuba
cecinit. et tanquam mos
magnus igne ardens
missus est in mare. Et
facta est tercia ps maris
sanguis et mortua est tercia ps create
que habebant animas. Et tercia ps
nauium interiit.

Post septimum angelum mos tes et cere
bros. doctores designant. Et ecce ta
tquin mos magnus et ⁊. Si monte
magnum lex moyse designat. qui p̄ gra
uitatem ponderis sui ipsius assimulat.
⁊ p̄ spiritualem intelligentiam que i lege
fulgebat. igne ardere di. ipse i eccl'ias
ipis p̄ magnitudinem celorum p̄ mare de
signatur. **Et facta est tercia ps m̄ ⁊c.** Di
uassio i lege sanguinis effusione Atp

alsphone dicitur. Ut ⁊ moyses p̄lin san
guine alspsit dicens Hic est sanguis tes
tamenti q̄d mandauit ad uos d̄s. Et A
aron ⁊ filios ei ut miisce exercerent ad of
ferendas hostias co idem mysterii sang ne
alspsit. Stet tune sanḡuinis effusione reuel
sio cc p̄teriat. p̄ tertiam ps̄ p̄teeunt maris
electu qui eo tempe hyerunt designaur. ⁊
p̄ sanguinē ū in hr loco resurection̄ p̄a
tor postium. Accipit. Sed ita q̄ ps̄ maris i
sanguinē is̄ laz qr electi qui eo tempo
erunt p̄ obseruationē legis. A p̄d ist
mundari meruerunt. Per ita si q̄ creau
ture que habebunt animas et mortua merue
tua huiste dī causa signifie notem hr q̄
⁊ tertia ps̄ m̄ri. que i sanguine ust
p̄ mare aū sunt diuersi. nauicaliae p̄
catoru designatur.

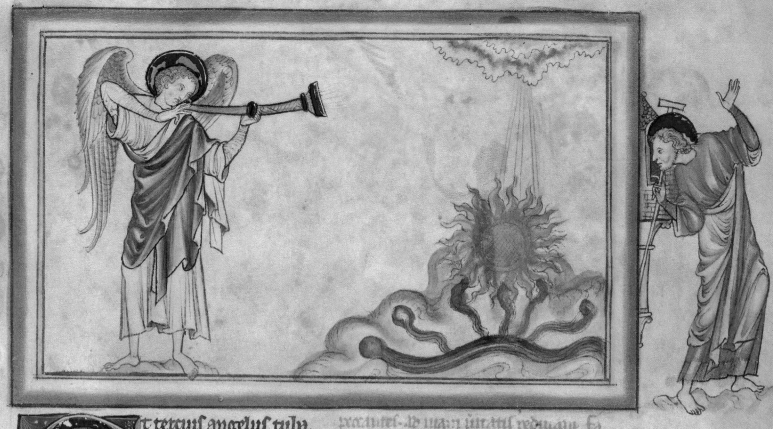

t tetcius angelus tuba
cecinit. 7 cecidit de celo
stella magna ardens
tanquam facula. 7 cecid
i terciam ptem flumi
num 7 in fontes aquar. 7 nomen
stelle dicitur abscinthium. lr fca z
est tercia ps aquar in ascinthium
7 multi homines mortui sunt de aqs
quia amare fce sunt.

E iudem significationem lr angle
queni z stella. significant naturã
ipsi as. 7 querendum nob est qui
te celo iste tam cecidisse dicat. scm i ec
lliam quomodo medio osceudant. cú eos a
mor abuas celestia grenagloudi ele
put. dacuunt in frám. cuiit eos ámo. pri
mez ab uita reclitant in predicacoe sua

pcantes. ad marm iustatul redeant. fa
cula si accenditur. ut tenebat noctis de
pellat. verba q ab hac facula fuerunt. z
tenebat teon z mentibz hominú fugare.
Possum. p tgnem facule spm scm intel
lige quo z flammart pphe z multos ad
iniquitatibz conterunt. z ea que ventura est
predrunt. lr cecidit i tciam pte z e. q flu
mina z fontes teu ects cidecst ter alius de
tignant. p terciam u z se huj ni en cos
ad uita ut etiam pscripti teruc tignant.
Cecidit g z stella in traim. pre flumina q
alle doctrinam pphay tecquerut i cordibz
sus plantaverunt qui ad uariã etiam
predestinati erant. lr nomen stelle z e.
sanctbu ualde est amari. p abscinthiu q
ommuit uocts ppbay designant. quas p pto
perau igitel. et in sentencia aget.

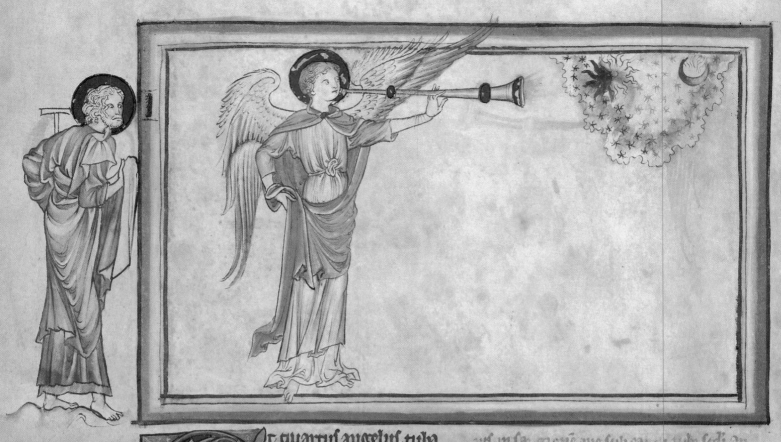

 t quartus angelus tuba
cecinit · ⁊ pcussa est ter
cia ps solis ⁊ tercia ps
lune ⁊ tercia ps stellaꝝ
ut obscuraretur tercia.
ps eoꝝ ⁊ diei non luceret ps tercia.
⁊ noctis similit.

pres in sa gyne᷑ que sub coꝝ ꝓ tube sedi an
gelt ꝼca fuisse usa est cenisione uidsoini
us tercie pres aquaꝝ �getaꝝ epe su᷑
cantu tube tercij angeli ꝼca esse legꝫ ꝫ
bona᷑ ꝑtem arripiendu᷑ ᷑ ᷑ demo᷑ traui
ideoꝝ ad elecꝫ ꝗ p᷑ine᷑ obscurꝗet est q
ut pcussus᷑ solis ⁊ lune ᷑ ᷑ ᷑ ᷑ idꝫ in bo
᷑ ᷑ ᷑ ᷑ ꝓ ᷑ ᷑ ᷑ ᷑ ᷑ ᷑ ᷑ ᷑ ᷑ ᷑ ᷑ ᷑ ꝓ ᷑ ᷑ ᷑ ᷑ ᷑

soliꝫ qui pcussa ᷑ ps᷑ obscurat est lu
quꝫ ex ꝓpulo ᷑ ᷑ ᷑ ᷑ ᷑ ᷑ ᷑ ᷑ ᷑ ᷑ ᷑ ᷑ ᷑
designantur᷑ obscuꝛ᷑ et huiꝫ ᷑ ᷑ ᷑ ᷑ ᷑ ᷑
iudeis si refusserint in ᷑ ᷑ ᷑ ᷑ ᷑ ᷑ ᷑ ᷑ ᷑
ꝓtercium prout buie᷑ ᷑ ᷑ ᷑ ᷑ ᷑ ᷑ ᷑ ᷑ ᷑
ritur est hij queꝛ Arch ᷑ ᷑ ᷑ ᷑ ᷑ ᷑ ᷑ ᷑
docꝫ ⁊ ex pla᷑ fesꝫ ᷑ usq᷑ ᷑ ᷑ ᷑ ᷑ ᷑ ᷑ ᷑
sqꝫ uiꝫ ᷑ ᷑ ᷑ ᷑ ᷑ ᷑ ᷑ ᷑ ᷑ ᷑ ᷑ ᷑ ᷑ ᷑ ᷑ fui qꝫ
ꝓprimꝫ obstaur᷑ serꝫ᷑ qꝫ ᷑ ᷑ culos
Diabolus obꝛeni᷑ꝛo ᷑ ᷑ ᷑ ᷑ ᷑ ᷑ ᷑ ᷑ ᷑

ta ᷑ ᷑ angelus ᷑ ᷑ ᷑ ᷑ ᷑ ᷑ ᷑ ᷑
᷑ ᷑ ᷑ pcussa est ᷑ ᷑ ᷑ ᷑ ᷑ ᷑
᷑ luna ⁊ stelle ᷑ ᷑ ᷑ ᷑ ᷑ ᷑ ᷑
lana ⁊ ꝓ solem populus ᷑ idoꝛ᷑ ꝓ lunam ᷑
᷑ ᷑ ᷑ ꝓpꝫ ꝓ stellas᷑ au ꝓincipes ᷑ ᷑ ᷑ doꝛ᷑
᷑ ᷑ ᷑ ᷑ designantur᷑ Et si obstuꝛ ᷑ ᷑ ᷑ solꝫ
⁊ ᷑ ᷑ ᷑ ᷑ tioꝛ᷑ eoꝝ qui in ᷑ ᷑ ᷑ ᷑ ᷑ ᷑
᷑ ᷑ ᷑ ᷑ ᷑ ᷑ ᷑ ᷑ ᷑ ᷑ ᷑ ᷑ ᷑ Ddo supꝛ᷑
ꝓuidabitur ᷑ ᷑ ᷑ eoꝛ᷑ ᷑ ᷑ ᷑ ᷑ ᷑ ᷑ te᷑
᷑ cie ᷑ ᷑ ᷑ ᷑ ᷑ ᷑ ᷑ tube prim᷑ angl᷑
᷑ ᷑ ᷑ diciꝫ · ꝓ᷑ ᷑ ᷑ ᷑ ᷑ ᷑ ᷑ ᷑ ᷑ ᷑ ᷑

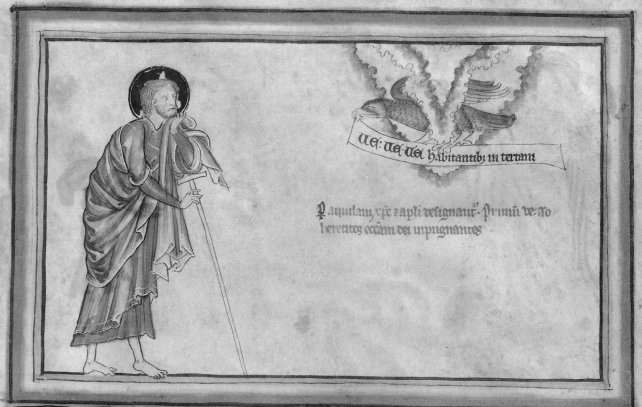

uel: uel uel habitantibz in terram

P aquilam, xpc z apli designant. primu ve:ao
hereticos ecclam dei impugnantes

T uidi: et audiui uocem
unuif aquile uolantif p
medium celum dicentif uo
ce magna. ve. ve. ve. habi
tantibz in terra. a uocibz trium an
gelor qui erant tuba canituri.

P [initial] ...um alhe leo ecca designat.
aquila uero epli z epostoles et
...designat. aquila ergo p medium
celum uolabit...r...uber quia x pc...
...um ...pc...ptuale uero p vniversaf
gentes ibidem euangelm predicantium...
...ptuatum ...ta...bicamus...ica...ez par
...ca ...lta uocef...predicauit. ideo ve fa
...palat. ez ...ve primum ad hereticof pti
net qui eccam dei multif medif impugno
ve conatur...Secundum il ve pugand
qui eandem...dei...ep precuti sunt may

...marinep fidelium multitudine interse
cerunt. Tercium ad antixpm. qui populu
dei in fine mundi debellatur z sicc putare
debemuf quod tria ve ad electos ptineat
qui duisas calamitates ab impus ptule
rū...s pocis ad eosdem impis. qui easdem
eebeu...tes ar...ulerunt. Vn z ve ve ve ho
bitā...usp...terā...dicat caru in simpu...dap
qui...nichil...aliud quia terram qrunt...habi
tatores deuocantur. Justi au. qui celestia
diug desiderant. celi habitatores recte uo
cantur. sicut dicit apostolus...paulus...Nea
aut conuersatio in celis est.

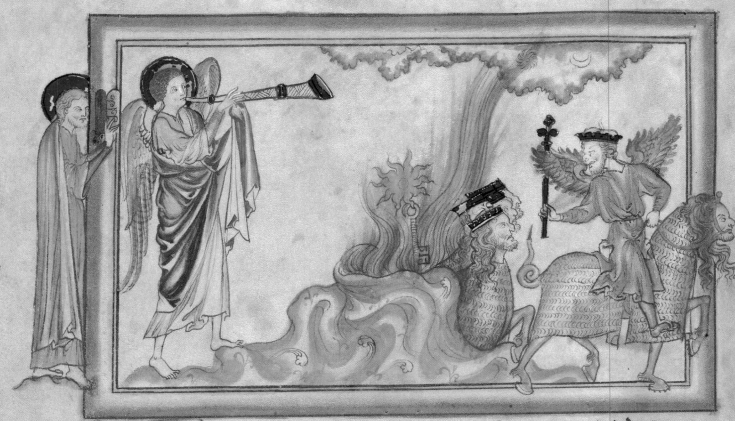

Et quintus angelus tuba
cecinit ⁊ uidi stellam de
celo cecidisse in terram ⁊
data est illi claius putei
abyssi ⁊ aperuit puteum abyssi ⁊ ascend
fumus putei sicut fumus fornacis ma
gne. ⁊ obscuratus est sol ⁊ aer de fumo
putei · ⁊ de fumo putei exierunt lo
custe in terram · et data est illis potes
tas sicut habent potestatem scorpiones
terre ⁊ preceptum est illis ne lederent
fenum terre neq omne uiride neq
omnem arborem · nisi tantum homines
qui no habent signum di ⁊ frontibz
suis. Et dictum est illis ne occiderent eos
sz ut cruciarent mensibz quinqz ⁊ cru
ciatus eoz ut cruciatus scorpii cu percutit
homine. Et in diebz illis querent homines

morte ⁊ no inueniet eam ⁊ desidabut mo
rt ⁊ fugiet mors ab ipis. et similitudi
nes locustaz similes equis paratis i pre
lium ⁊ sup capita eaz tanqin coronas
similes auro ⁊ facies eaz sicut facies ho
minum · ⁊ habebant capillos sicut capillos
mulierum ⁊ habebant loricas sicut lorica
ferreas · ⁊ uox alaz sic uox curruum equoz
multoz currentiu i bellum ⁊ habebant
caudas similes scorpionu ⁊ aculei erant
i caudis eaz · et habebant sup se regem an
gelum abyssi · cui nomen ebraice Abad
don grece au appollion ⁊ latine habens
nomen exterminans ·

Stella que de celo cecidit putei in ab
yssi aperuit quia hereticis ad ꝑteren
da mala que i cordib eoz ⸱ latuerant ora sua
aperuunt

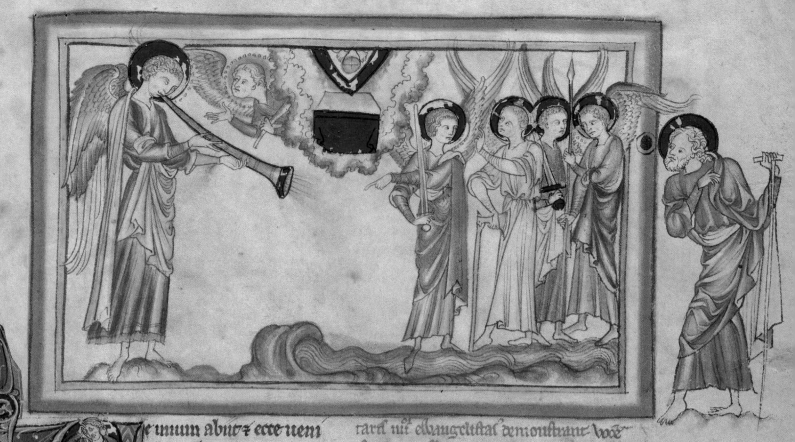

ie unum abut ⁊ ecce uen-
iunt adhuc duo ve post h
Et sertus angelus tuba ce-
cinit. ⁊ audiut uocem una
ex cornib; altaris aurei quod est ante
oculos dei dicentem sexto angelo qui
habebat tubam. Solue uiii. angelos
qui alligati sunt in flumine mag
no eufraten. Et soluti sunt uiii. angeli
qui parati erant i horam ⁊ diem ⁊ men
sem ⁊ annum ut occiderent terciam
ptem hominum ⁊ numms equestris ex
ercitus uiues milies dena milia.

P er sextum angelii martires desig
nantur. Sextus angelus tuba cecin
⁊ martires xpi doctrinam fidei ⁊
fidelib; aptauerunt. P altare aureum
ecta designatur. Quatuor si cornua al

taris uiii. eiiangelistas demonstrant uoce
⁊ una. ex uiii. cornib; altaris autem audi
se se dicit. quia una est fides una doctrina
quia uiii. libri eiiangeliox dixerunt. Quatuor
angeli isti uiii. regna significauit. Assyrior
medii, psar matedomin atq; romanios. P
eufraten si hic mundo intelligit. Virtutes
uiii. angelox illa sunt domini. Illo quod deus
precepit psecutorib; ut a psecutione testa
rent dou semina fidei p omnes gentes
spargerentur sy quod potestate hec sciet ⁊ f
illis precepisse Romani. nempt dure ⁊ que
trum xpi ecdeb; ⁊ raptus sang Christior
sanguis geris humani nullo in petant.
Soluti sur uiii. angli quia nuptis homines
pace abiecta manib; solutis quas par ⁊ f
ligniitar psecuti sunt populum dei. Eo
autem dicit parati erant nuptiox uo
luntatem demonstrat.

Et uidi equos in uisione z
qui sedebant sup habentes
loricas igneas z iacinctina
z sulphureas z captta eoꝛ
erant tanꝗ captta leonum z de oꝛe ip
soꝛ ꝑcedit ignis z fumus z sulphur.
Ab hiis tribꝛ plagis occisa est tertia pꝛs
hominum de igne z fumo z sulphure ꝗ
ꝑcedebant ex oꝛe ipoꝛ. Potestas eiu equoꝛ
in oꝛe eoꝛ z in caudis eoꝛ. ſam caude
eoꝛ similes serpentibꝛ habentes captta
z in hiis nocent. Et ceteri homines qui
non sunt occisi in hiis plagis neꝗ ꝑe
nitentiam egerunt de opibꝛ manuum
suaꝝ ut ꞃo adoꝛarent demonia z simul’
atra aurea z lapidea z lignea que ne
ꝗ uidere possunt neꝗ audire neꝗ am

bulare z non egerunt penitentiam ab
homicidiis suis neꝗ a uenesitiis suis.
neꝗ a foꝛnicatione sua neꝗ a furtti su
H hoc loco ꝑ equos insam populi. ꝑ sessoꝛe
ꞏ aꞏ equoꝝ princtpes terre designantur. ꝑ loꝛi
cas si que ictus gladioꝛ a se repellunt dur
tia coꝛdiu regboꝛ designatur. que ad coꝛda
eoꝛ gladium sie quod est sibum ꞇ accede
rio sunt. Que loꝛice ignee iacinctine z sul
phuree ꞇe diu ꝑ igne plane crudeliras me
tis ꝑsecutoꝛ. ꝑ iacinctium qui ꞇeli figura
ht honoꝛ deitatis qúe diu sint deferebanr
ꝑ sulphur it equ feter blasphemie quas i
xpm ꝑferebant designanꞇ. ꝑ captta etiam
imꝑatores romanoꝛ designanꞇ qui captta
ꞇe uidebanr omniu ꝑsecutoꝛ. Quiꞇ ip in
sactabiles rabie leonibꝛ assimulanꞇ ꝑ igne
impia precepta imꝑatoꝛ. ꝑ fumu ẏcola
ꞇe sinras. ꝑ sulphur aū blasphemie desig
nanꞇ.

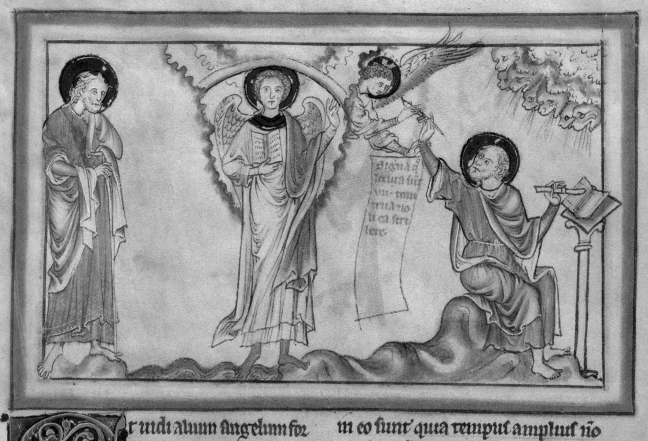

Signa q̄ locuta sunt vii tonitrua noli ea scribere

Et vidi alium angelum for-
tem descendentem de celo
amictum nube ⁊ iris in ca-
pite eius ⁊ facies eius erat
ut sol ⁊ pedes eius tanq̄ columpna ignis.
⁊ habebat in manu sua libellum aptū.
⁊ posuit pedem suum dextrum sup mare
sinistrum autem sup tram ⁊ clamauit
uoce magna quemadmodū cū leo ru-
giet. Et cū clamassz locuta sunt vii to-
nitrua uoces suas scriptur̄ eram. Signa
que locuta sunt vii tonitrua noli ea
scribere. Et angelus quē uidi stantē sup
mare ⁊ sup terram leuauit ad celum
manū suam ⁊ iurauit p uiuentē in
secula seculoq̄ qui creauit celum ⁊
terram ⁊ ea que in eo sunt ⁊ terrā
⁊ ea que in ea sunt ⁊ mare ⁊ ea que

in eo sunt quia tempus amplius no
erit. sz in dieb; uocis septimi angeli.
cum ceptit tuba canere q̄sūmabit mis-
tium dei sicut euangelizauit p suos
suos p̄phas.

Angelus fortis dominū nostrm ihū xp̄m
designat de quo dicit. psalmista dñs
fortis ⁊ potens dominus potens in prelio. Qui des-
cendens de celo amictus nube ee dr̄ qr dominī
nostri uenisse in mundū carne que p nubem de-
signata est induit uel p carnis assumpcionem
se hominibz ostensa maior quos redimere uene-
rat. ⁊ iris in eo misericordia designatur
sic sup dpris. p caput aū eius diuinitas in
hec loco intelligitur. Iris in capite habebat
qr eius diuinitas aut incarnatione sibi eam
misericordiam assumpserat ut homo fieret
p hominibz no dedignaretur. ⁊ ad ipsius
pessima morte dampnart. P solem dei
designatur sicut superius diximus

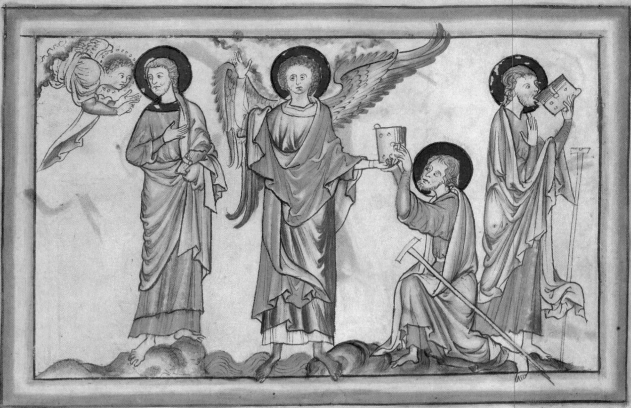

Et uox quam audiui de celo iterum loquentem mecum et dicentem vade accipe librum apertum de manu angeli stantis supra mare et sup terram. Et abii ad angelum dicens ei ut daret m librum et dixit michi. Accipe et deuora illum. et faciet amaricare uentrem tuu sz in ore tuo erit dulce tanqm mel. Et accepi librum de manu angeli et deuoraui eu et erat in ore meo tanqm mel dulce. et cu deuorassem eu amaricatus est uenter meus. Et dixit michi. Oportet te iterum ppharce populis et gentibz et linguis et regibz multis.

Per iohannem in hoc loco omis apostolo intelligere possum vir qm diuina io hanni locutus est ut iret ad anglm

et accipere ab eo librum quia scz sancti spm apli inspirauit ut relictis omnibz xpm sequerent ut doctrina euang. audit ab eo pppeur. Et abii ad angelm ostendit est dc ablecii apli ad xpm ut ab eo doctrina diuina scptura instruerent. Accipe librum et e. P oz in quo saporez discimus cord apploz intelligere possumus. P uentrem aut in quo ois spurciia corporis hominorum ut euomit peccatoz intelligi debet. Liber aut dn deuoratretur ut mel dulce fuisse dc quia a diuina scptura dum i mente reuoluitur di crinam mandata di afflicienda requiritur dulcis ut mel in corde effectum du in mente a superioribz ad inferiora io, a contemplatione patrie celestis ad peccat struenda deducit penasti qm aut intelligi pcit suis passi ut scat ostendit quc diuina fuerat dulcis dc de ostensione ostore celestis amara efficitur i ostensione peccatoz.

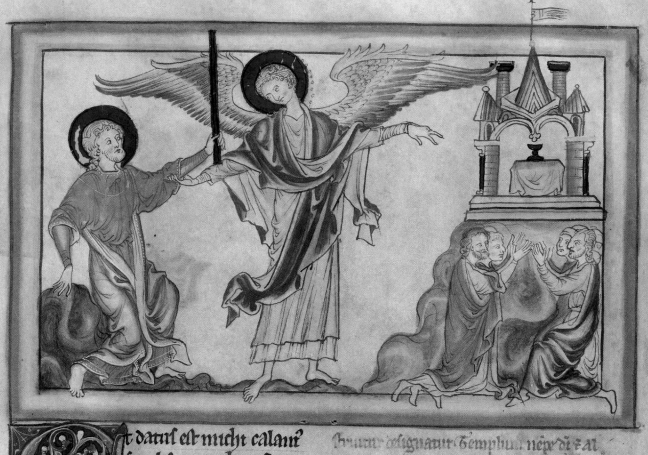

t datus est michi calam[us]
similis uirge dicens· Sur
ge ⁊ metire templum d[e]i
⁊ altare ⁊ adorantes in eo.
atrium aute[m] q[uo]d est foris templum
eice foras ⁊ ne metieris illud· q[uonia]m da
tum est gentib[us] ⁊ ciuitatem scam cal
cabunt mensib[us] quadragi[n]ta duob[us]

[column 2]

bratur d[e]signatur Templu[m] n[em]pe d[e]i ⁊ al
ct[er] illiq[ue] adorantes ⁊ eo unusq[uisque] p[re]di
cator metiri p[re]cipit d[omin]i unicuiq[ue] s[e]c[un]d[u]m pp[ri]
am capacitatem spiritual[iter] gr[ati]a d[o]ctri[n]am
administrat. Atrium au[tem] q[uo]d e[st] foris ecc[les]ie fo
ris q[uod] atrium [...]

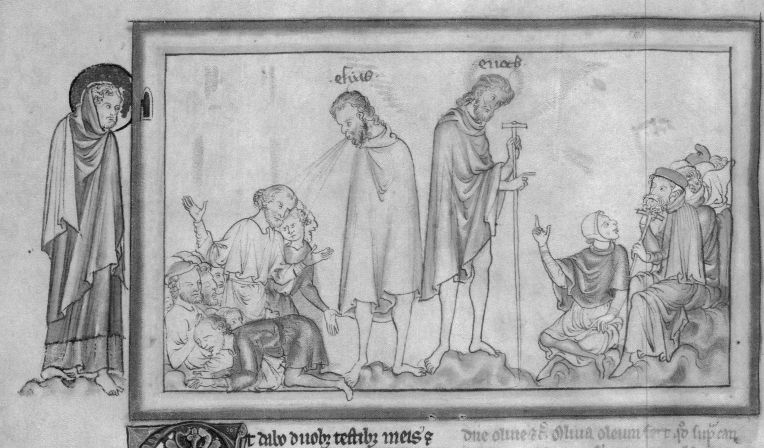

·elias· ·enoch·

Et dabo duobz testibz meis ·z
pphabunt diebz mille du
centis sexaginta· amicti sac
cis· Hii sunt due olive z
duo candelabra in conspectu domini i
medio terre stantes· z si quis eos voluerit
nocere ignis exiet de ore eoz z deuorabit
inimicos illoz. et si quis noluerit eos le
dere sic eum oportet occidi· Hii habent
potestatem claudendi celum ne pluat di
ebz pphtie eoz· et potestatem habent sup
aquas conuertendi eas in sanguinem z per
tere terram omni plaga quociescumqz
noluerint·

Testes suos dominus petiam z enoch uoca
qui aduenturi et secundum precurret
sicut Iohannes precurrit primi· Nam sun

dne olive z e· Oliua oleum fert ad sup can
delabrum postea ponst· ut viuat z omnibz qui
sut domo sunt· p oleum in hoc loc sapiam spi
ritualem possum intelligere· Vnde atqz eut oliua
iuic qn apud se quietens z oror plaozs
grum deo seruit suicet qn implere studet
qo dns elicit i els· sletciat sinistra tua quid
faciat dextera tua· Candelabrum q· nec sir
qn illicel implet qo d ns elicit i els· nec
pptea bona z gloficetur proui mois· Duo
s ist sci modo olive sunt cu in aliqua vsti
terre lap ubi eos minetar vinat om c
et pptepz p orontplaoos gram deo s uic
uit· Candelab· tunc fient i cu ad p pluara·
pdicaoos sue officui tribuut· qn oidt z i
delch iuidelu z reph is abum vis z usita vis
De hac candelabro d· elicit m esse· San ac
cendit lucernia z ponst ca sup rodis i sa
candelabru ut lucede omibz qui in ponio si

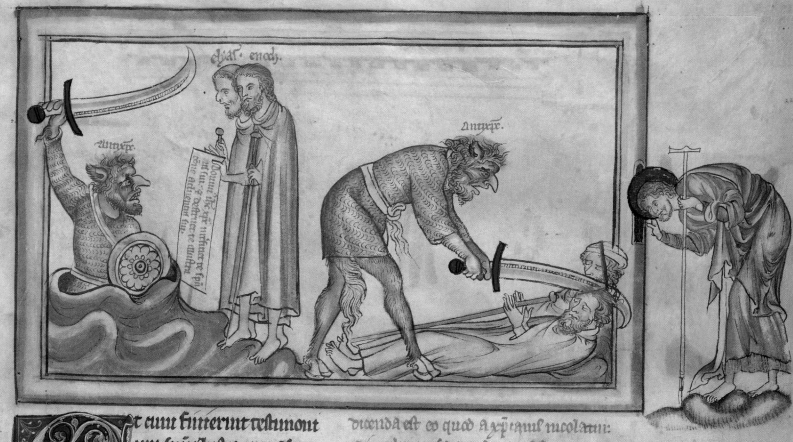

Et cum finierint testimoni
um suit: bestia que ascen
dit de abysso faciet aduis
illos bellum z uincet illos
z occidet illos z corpora eoz iacebunt in
plateis cuitatis magne que uocatur spi
ritualit sodoma z egyptus ubi domin
eoz cruciftzus;

Bestia hec antixpin significat: Faciet
aduius eos bellum? qn eos psequet.
Uincet st illos no supando ubil st inisticido
bot z sen te occidet eos zt. St p cuitatem
magnam terstin terrestrem uoluerimus
intelligere zp hec quod dicit ubi z domni
eoz cruciftzus est à ueritate aberrabim?
eo zp illa testin usep eo solum destructa sat
cesta que z ea edificata zt no in eo loco sed i
alio sita ee dicitur. sicep sodoma z egypt.

dicenda est eo quod a xpianis incolatur.
Simulep consideranda zt ubicumep in
hoc libro ciuitas magna ponit babilonie
que est ciuitas diaboli z ex omnibz costat
rephis significat. Quod au in platea cui
tatis magne corpora scoy pitienda ee dur?
possum sumpt intellige ut i quacumep
platea que ad uis alicuis rephi pitineat
tateam? Si mell michi uit ut sicut p cui
tatem magna omis rephos intelligendos ee
pdixi ita z p plateam corda rephos intel
ligam? Iacebunt itaep corpora scoy i pla
tea cuitatis magne. qz scm illis dicunt a
quibz nulli ee momenti existimant. Chris
fidelibz stant qui quanta sit eoy uirtus an
glia cordis oculis cernentur. Cuutati u dia
boli no inquement sodoma z egyptus uo
catur: eo zp sodoma cecitas. egyptus te
nebre interpretentur.

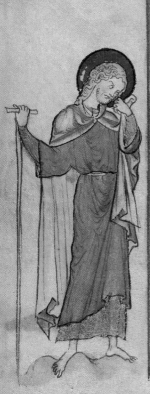

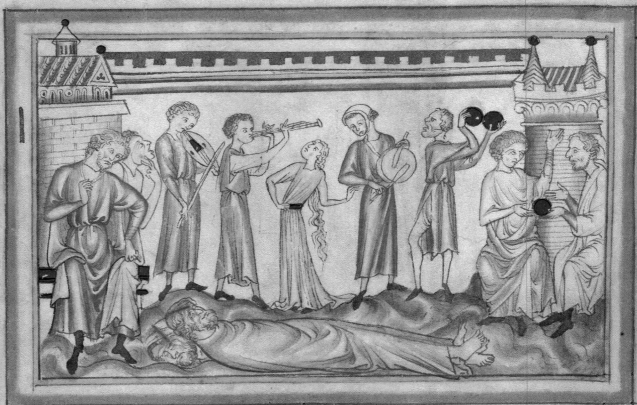

t uidebunt de populis
z tribubz z linguis z ge
tibz corpora eoz p tres
dies z dimidiu z corpora eow no sin
unt poni i monumentis. Et inhabi
tantes terram gaudebunt sup illos
z iocundabunt z munera mittent
inucem. qui hii duo pphe cruciauerut
eos qui habitant sup terram.

In platea i ciuitate magnue ubi dominus
crucifixus est corpora sanctorum pistenda
et describuntur qi sicut a membris diabo
li xpe crucifixus est: ita ab eisdem hii
duo pphe occiderentur. P tres aut dies z di
midiu possum tres annos z semis intelli
ge quibz hii duo pphe predicaturi sut. per
momnmenta i mentes reploz intelligere

possum. De huis monumentis ao loquit di
cens. Ve uobz scribe z pharisei qi estis sic sepul
chris dealbata. que aforis quide uident candidi
muliere aut plena est omi immundicia z ossibz
mortuoz. in monumentis gi reploz corpora sctoz
no sinut poni: qa doctrinam illoz a mentibz suis
einciet. Quod aut post tres z dimidiu tre uere a
deo intrare in eos dt z stare sup pedes suos au
post resurrecois tre accipere possum? qd post
tria tempora z dimidiu hminec no statim e
apparuo tn fiet. Stabunt appe sup pedes suos
qui post resurrecois tre quanta sit eoz dig
nitas z magnificentia oibz impiis manifesta
bitur. Timor aut magnus cecidit sup inimicos
eoz est uidunt eos quia i die iustiis est uide
runt eos. Glomauit eoz turbauit time
re horribili dicentes. Hii sunt ques ale spe
habuimus in derisum z z similitudine nae expe
peru.

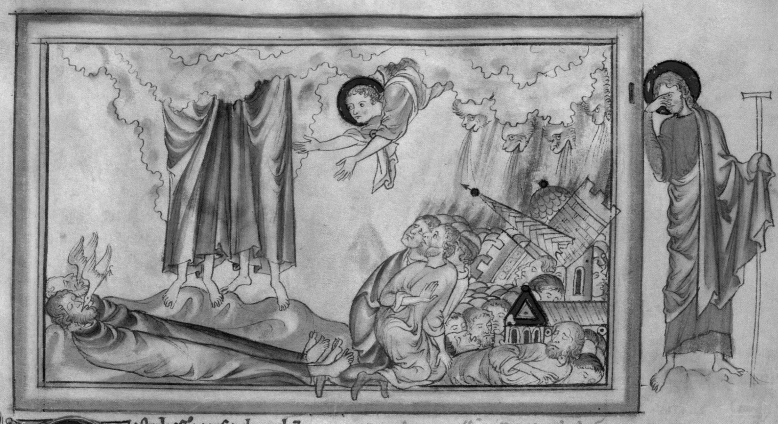

ost dies iu tres z dimidiū
spc uite a deo intrabit i eos
z steterūt sup pedes suos
z timor magnis cecidit
sup eos qui uiderūt eos. Et audierūt
uocem magnam de celo dicentem ille
Ascendite huc. Et ascendunt i celum i
nube. z uident eos inimici eoz. Et i illa
hoza factus est terre motus magn̄ z de
cima ps ciuitatis cecidit. Et occisa sūt
in terre motu nomina hominū septe
milia. z reliqui i timoze sut missi. z de
derunt gloziam deo celi.

Pssum z hos duos testes duoz populoz q
dicatoes intellige. iudeoz uidelicet atq
gentiū. Cum diebz mille ducentis sexaginta
pphabunt ee sihr. quia oīs tempe ē antixpi
psecutio atq deceptio p uniuilum oībem dese

uiet quoscunq pissint. ad uiam ueritatis re
uocare studebunt. Et in illa hoza eoz est tre
motus magn̄. siue ad itura predicacois he
lye z enoch reuersis. Terre tile moz tite tū p
predicacōnē helye z enoch multi ad penite
cia. multi ad side conuertent. Terre motus sm
sup tanu dium mocōnē cordium solet de
signari. Et decina a ps ciuitatis cecidit.
Illius ciuitatis in hoc loco decimam prem
corruisse dicit qua sup ciuitate magnā
sodomam atq egiptum uocauit a z cui
platea corpoza sidoz p tres dies z dimidiū
insepulta iacere dixerunt. Et quia p de
nariuum nuisisi sepe lex designat eo qd lex
p Decalogum sit accepta possim p decima
prem que corruit iudeoz obseruauit legis
intelligere. qui p predicacōnē helie sidē
xpi suscipientes a ciuitate diaboli corru
eni atq precident.

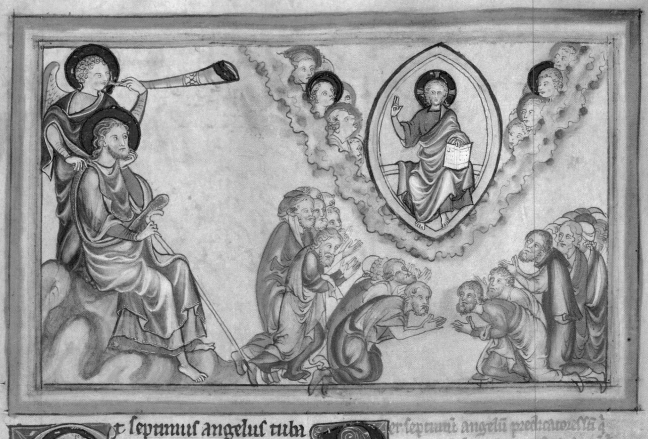

Et septimus angelus tuba
cecinit z facte sunt uoces
magne in celo dicentes·
Factum est regnum huius
mundi z domini nri z xpi ei· z reg
nabit in secula seculor· Et uiginti iiii
seniores qui in conspectu dei sedent in
sedib3 suis ceciderunt in facies suas
z adorauerunt deum dicentes Grat
tibi agim9 domine ds omipz qui es
z qui eras· qui accepisti uirtute magna
z regnasti z irate sunt gentes z aduen
nit ira tua z temp9 mortuoz iudicari
z reddere mercedem siuis tuis pphis z
sanctis z timentibz nome tuu pusillis
z magnis z extminandi eos qui cor
ruperunt terram·

Per septimu angelu predicatores q
hm sine modo ualetur ist designat
Tuba canet· ru ipi qn dn discernu
fabunt· Et sce sut uoces z e sostini p cel
tecam· p uoces ii magnas scoz iuba intel
lige qui in aduentu dni ad iudiciu uenerit
extrabunt· sicut dicit ds q est· Respicite z
leuate capita ura eo appinquat redempto ura
Regnu huius mundi homines uocant in etz
mentib3 dum regnat qz suu regnat diabol9
ipse est rex sup oms filios supbie· Regnu
z huius mundi dn ihu xpi tuc fiet· cu dia
bolus tuc oniub3 quos decepit in uultu dei fus
fuerit· P xxiiii seniores z hic loco aias scoz
que in celesti beatitudine cu domino gnoscar
possum intellige· Sedes n requie seimpitni
designat· uiginti iiii seniores in ospectu dei se
erunt in sedib3 suis q qz scoz aie sine corporib3 in
celesti beatitudine· modo cum domino regel
cutur sine fine·

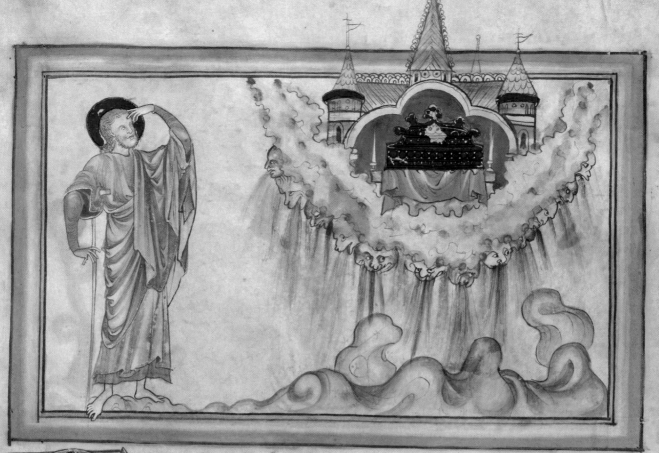

Apertum est templum dei
in celo z uisa est archa tes
tamenti eius in templo eius
z facta sunt fulgura z uo
ces z terremotus z grando magna.

Possunt p templum di beatam ma
riam intelligere p archam u testam
tu xpm qui ex ea carne assumpsit. templi
autem dei non ideo aptum dr qd uteris be
uirginali in pariendo dm aptus sit quia
huic sit partum uirgo. uirgo in partu
uirgo post partum. sed ideo aptum dicit
qd p ipm uisibilis nob factus est domin
eius ihs xps. Possum z p templum uetris tes
tamentum intellige. p archam sacmenta
que de xpo in uetri testamento ptinentur
ueniente quippe xpo in carne aptum est

uetus testamentum atq spuitalis intelli
gentia que in eo latebat fidelibz est reuela
ter scta sunt q e. p fulgura miranda que p
xpm scta sunt. p uoces uero eius predicatio de
signatur. terre motus au morte stem cordiu
designatur. cciti sunt nature mutati p predica
tionem xpi ad penitentiam de pctis suis pa
gendam. cciti siut de infidelitate ad fidelitate
uiori siut de malo ad bonu. Et quia cristo
terram solet petris post...
ruinatores tgant...
sepe tenium intellige...
priuntur ut recipiant...

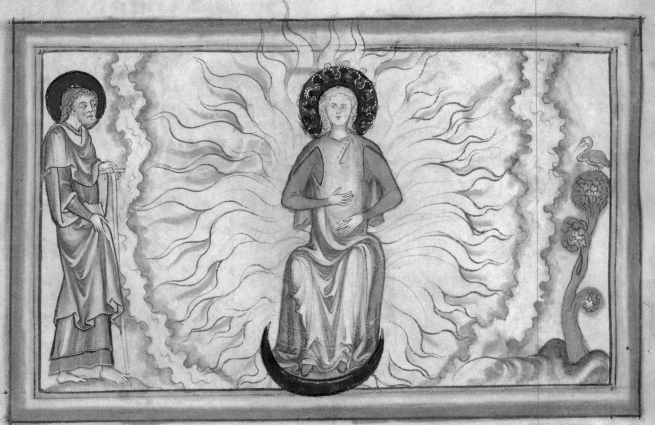

Et signum magnum ap
paruit in celo. oc mulier a
micta sole oz luna sub pe
dibz eius. oz in capite eius
corona stellax duodecim oz in utero
habens oz clamabat parturiens oz cru
ciatur ut pariat.

Hec mulier ecctam significat. conse
quens quippe erat ut p predicatonem
xpi et sorma describeretur quam predicato
xpi genuit. Possum̄ aū p celum in hac loco
hunc mūdum intelligi̅. P signū aū mag
nū caloreui magnā qm aduentus z pre
dicatio xpi mūdo constitit. P solem autē
xpe designatur sic dicit ipsa dc vob aūtime
tibz nomē meū orietur sol iustitie z sanitas
i pennis ei. amitta itaqz amicta erat sole

qua fideles ex quibz ecctam constat i baptisma
te xpm induit sicut dicit apti. Omn̄ qui in xpo
baptizati estis xpm induistis. P lunā aū qua̅ sub
pedibz habuisse uisa z que crescit z deficit unst
dū istud possum intelligi̅e que ecctam despiciendo
calcat ut libiut ad celestia tendat. oz qz luna
nocte illuminat: meli̅ mihi uidet ut p lu
na sacram scripturam intelligam siue tullu
mine i noctē huc seculi p uiuat redemptius
mercede nō ualent. De hoc lumine. Habuisse d
Lucerna pedibz meis uerbum tuū. z lumē semi
tis meis. oc mulier qz sub pedibz lunā habuis
se uisa z qz ecctam gressum mentis sue i pre
ceptis diuinaz scripturaz figens ad celestia
cotidie nouit tendere. Que z in capite
suo coronā stellax xu habuisse uisa est.
Caput ecce xpe e. duodeci̅ u̅ stelle. xii sf apti
P caput mentes fidelium intelligi possunt.

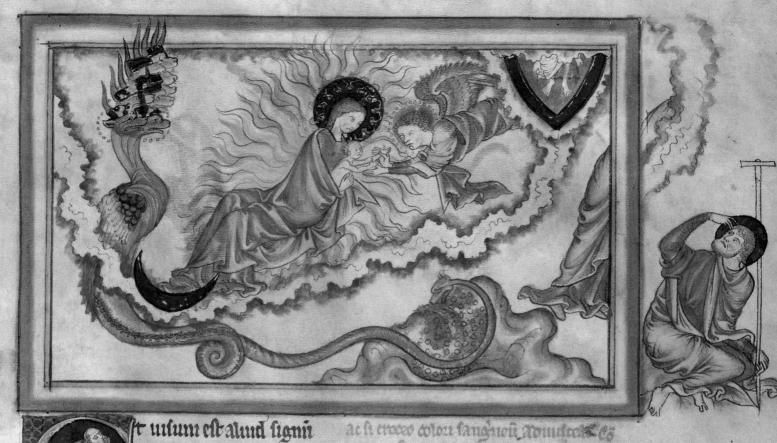

t uisum est aliud signu̅
in celo · et ecce draco mag
nus rufus h̅abe̅s capita
septem ⁊ cornua decem ⁊
in capitib; suis septem diademata · et
cauda eius trahebat terciam parte̅ stel
lar̅ celi · ⁊ misit eas in terram · Et draco
stetit ante muliere̅ que erat paritura
ut cu̅ peperisset filiu̅ ei' deuozaret·
Et peperit filiu̅ masculu̅ qui rectu
rus erat gentes in uirga ferrea ⁊ rap
tus est filius ei' ad deu̅ ⁊ ad thronu̅
ei' ⁊ mulier fugit in solitudine̅ ubi ha
bebat locum paratum a deo ut ibi pas
cant illam diebz mille ducentis sex
aginta·

Draco iste diabolum sig
nificat · Rufus ait color talis est·

ac si croceo colori sanguineu̅ admisceret· Con
cordat si pallens color or̅ · crecens tu̅ sang
ineo quia sanguis du̅ effundit· mortem
addu̅t · pallor au̅ totum corp' mor̅teriu̅
coopit· Recte g̅ diabolus h̅ te or̅ colore mol
est· quia alio imisit· mor̅ introiuit i or̅e
terrar̅· q̅ uir̅ u̅ capita repbr̅ quibz diabol'
ad decipiendu̅ genus humanu̅ usus est·
designa̅tur· Diademata regia̅ potesta
te̅ significa̅t· H̅ est eu̅m rex sicut dicit
scriptura· sup or̅e̅ filior̅ superbie· Sicut briu̅
q̅ u̅ cornua decem or̅e electi designa̅ sig̅
ntd̅ p̅ u̅ capita dextronis regibr̅ qui est i ma
pr̅ ep̅issa̅t sunt designa̅tur· Primu̅ ca
pud dracois fuerit repbr̅ a̅t' diluuiu̅· Se
cundu̅ br̅ qui so̅domu̅ br̅u̅ bri̅ qui p̅
q̅m̅ lex dicit⁊· Glaciriu̅ eli zele repres̅e
impu̅· Qu̅tu̅ impr̅ iudei· Sextu̅ pscuto
res ecc̅e· Septimu̅ cap̅d diabole s̅ antixp̅

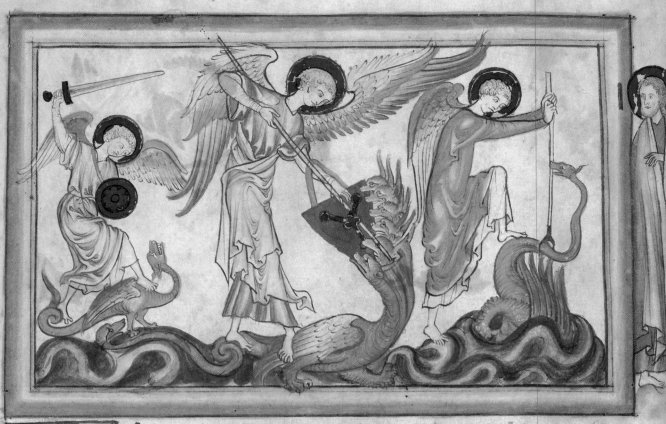

Et factum est in celo prelium
michael ꝥ angeli eius prelia
bantur cum dracone ꝥ dra
co pugnabat ꝥ angeli eius ꝥ
non ualuerunt neqꝫ locus inuentus est
eoꝛ amplius in celo. Et prectus est dra
co ille magnus serpens antiquus qui uocatur
diabolus ꝥ sathanas qui seducit uniuꝰ
sum oꝛbem ꝥ prectus est in terram· ꝥ an
geli eius cum illo missi sunt. Et audiui
uocem magnam de celo dicentem· Nunc
facta est salus ꝥ uirtus ꝥ regnum dei
nostri ꝥ potestas xpi eius qꝫ prectus est ac
cusator fratrum nostroꝛ qui accusabat illos
ante conspectum dei nostri die ac nocte·

uel supius natiuitatem ꝥ predicatio
nem xpi uincit comprehenditur· conse
quies est ut qualiter p passione sua diabolum uincat
sub iungat· michael qui interpretatur quis ut deus
xpm significat· Prelium in celo significat· qꝫ ce
lum· p salute uidelꝫ omnium electoꝛ· prelietur est
michael cum dracone qꝫ xpꝰ predicando ꝥ salubo
ꝥ monendo p salute genꝰ humani prelietur·
ꝥ prelietur sunt angeli michael· i· discipli xpi cum
dracone· predicando uidelicet mirabilia faciendo
ꝥ ad ultimum p xpi nomine moriendo· Pugna
uit draco ꝥ angeli eius huꝫ michaelem· qꝫ dꝫ diabolꝰ
ꝥ cetera multitudo demonum uidebꝫ qꝫ xpm ex
citabant uiri· ut eum interficerent· Pugnauit ꝥ qꝫ
angelus michael qui aplos xpi· ꝥ p iudeos ꝥ
paganos tam diu psecutus est· usqꝫ dum eos
interficeret· Isto ualuit diabolus neqꝫ ministri
eius uincere xpm ꝥ apostolos eius· quia unde puta
uerunt uincere uicti sunt· Qui uiderunt namqꝫ
xpm se p morte interisse· s; ex morte nomen
eius claruit in mundo·

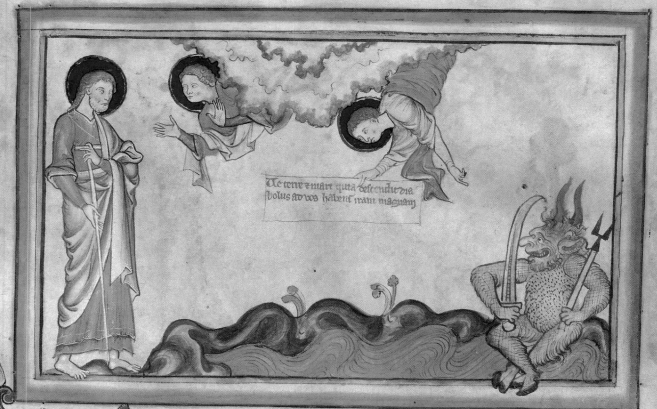

Ue terre ⁊ mari quia descendit dia-
bolus ad vos habens iram magnam

P e terre ex mari quia descen
dit diabolus ad vos habens
iram magnam sciens qd
modicum tempus habet

billimus p terram iudeos p mare u pa
ganos ceterosq; reples intelligere ve q
hudei atq; gentib; incredulus quia qu iram qu
sit diabolus eo qd ingentnam multitudine anu
seru iram dturns reples dampnat ⁊ in iiuitit fla
gitiis detur ur nullo modo digni sunt quin ad
uite uras reurtant ⁊ sauentur Drut q dialolum
seure qd modicum tpe hst quia quto appinquare
cernunt die iudicij tanto callidior estinatur ad de
cipiendos homines Iste diabolus accusabat f
tres nrs an conspectum di nrt die ⁊ nocte Ac
tusant noru homines apud iudices ⁊ cu eou scee
lera eis manifestant In conspectu u dei qui

non solum dra sz cogitata considerat quo
modo diabolus aliqué accusare potest Sed
accusan in ospectu di cum peccan- accusat
⁊ diabolus cum in pctis mala suadendo deicit

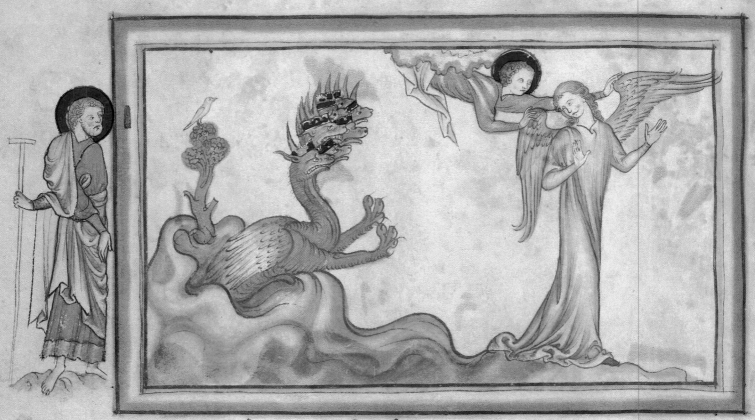

Et postquam uidit draco quod
pteffus est in terram: pseru
tus est mulierem que peperit
masculum. z date sunt mu
lieri due ale aquile magne ut uolaret
in desertum in locum suum ubi alitur
p tempus z tempora z dimidium tpo
ris a facie serpentis.

Sicut diabolus se maxima multitudinē
....tctor amisisse. z intra angustias cordi
um cr....tor se gluisum.pseruitur e mulerē
ld; eccam comitatur cū imparores roma
nox omniers impior multitudine ad pse
grendit populum di. Et date sur muliere
due ale. z c̃. P aquilam xp̃m possum in
telligere. Due n̄ ale duo sunt testamenta.
Due g̃ ale date sunt mulieri quia duo uel

....ramenta eccā accepit. ut eox doctrina z diabo
lum euadat z ad celestem pram cotidie con
scendat. Hanc nāmq̃ pram desertum uocat
quemadmo? z dns z eluangelio cū se nonagi
ta noue oues in deserto dixit amisisse z una
abiisse querere que errauerat. Hanc pram lo
cū eccē uocat sic ipse i iudicio dicturus. Venite
benedicti patris mei percipite regnū q̃ uob pa
ratum e ab origine mūdi. P temp ū z tempra
z dimidiū tporū. temp a passione xp̃i usq; ad
finē mūdi designat. In hoc g̃ spatio tempor
alie stoy ldz eccā dapibs glie celestis prie i ce
lesti beatitudine pascuntur.

21

Et misit serpens ex oze suo mu
lierem aquam tanqz flumen
ut eam faceret trahi a flu
mine. Et adiuuit terra muli
erem z aperuit os suu z absozbuit flumē
qd misit draco de oze suo.

Flumen aque desideria sunt. Videns qz
qz diabolus ecciam nõ posse deici psecu
tionibz; sz prius crescere z roborari nutrimenti
ue desideriox carnaliu et inuitie uoluit qbz
decepta ad mala opanda reiceret. Et adiuuit
terra mulierem zc. Possum9 p terram repbos
intelligere qui susceptores fuerint desidiox car
nalium. quibz diabolus fideles uoluit z ad se p
trahere. Possum9 z p candem tram xpm intel
lige. Et quia i smoibz domino magna po
testas est. Dixit eni z facta sunt mandauit

z creata sunt. Haud absurde p os tre pores
tas er intelligi potest Adiuuit qz tra muelie
rem idz xps ecciam z aperuit os suu z suscepit
flumen qd misit serpens ex oze suo idz smu
mie sue aperut. flumentz iniciox potestas er
fmuliuit exmirit

z post

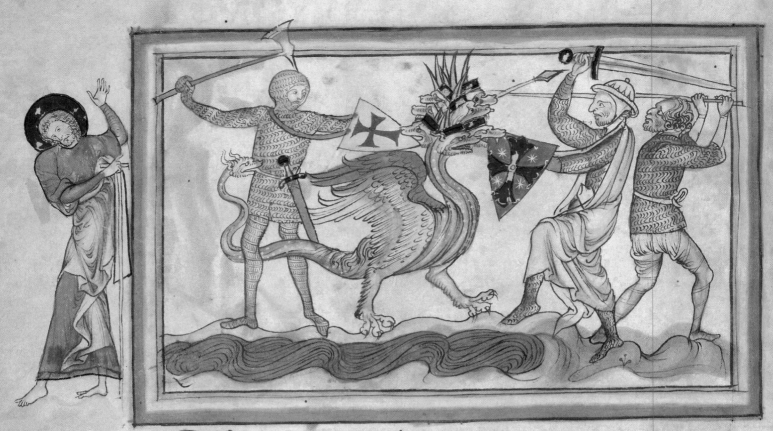

Et iratus est draco in mulierē
et abiit facere prelium cum
reliquiis de semine eius qui
custodiunt mandata dei et habent te
timoniū ihū. Et stetit suꝑ harenā
maris.

Reliquie de semine eorū electi sunt qui
in fine mundi nascituri sunt. Quo
quomodo autem hoc prelium diabolus ꝑ
agat ut sequentibus manifestatur. per hare
nam maris multitudo reploꝝ que eo te
pore futuri sunt designant.

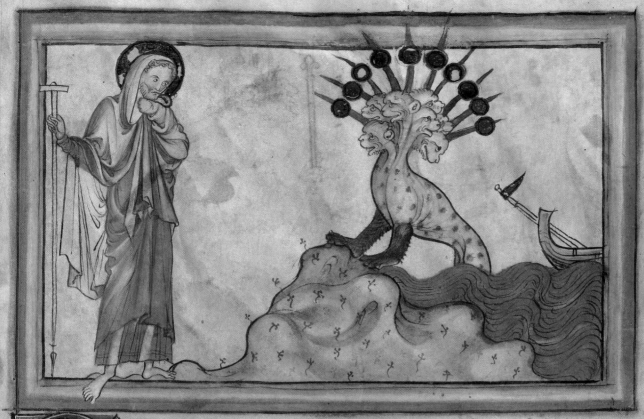

Et uidi de mari bestiam ascen
dentem habentem capita vii
z cornua decem z sup cornua
et: decem diademata. z sup
capita eius nomina blasphemie. Et bel
tia qm uidi similis erat pardo z pedes ei
sitit ursi. z os eis sitit os leonis.

Hec bestia anticpm significat. Qui uero
designantur p harena ipi z p mare
multitudo seluez reploz. De mari cp bestia co
tendere uisa: quia de societate reploz anticpe
erunget. Que bestia capita vii z cornua dece
hr describitur. Similis z dicto sup vii ca
pita habuisse cp z in capitibz vii diademata
p que ostendit reploz quibz diabolus ad decipiedu
gen humanu usuz duturus fuisse designa
tos. hec au bestia no in capitibz sp iiii x cornit

ly decem diademata habuisse describitur.
Ideocp x x cornua gentes quas sibi anticpe
subiugaturus est designatur. z epte u capita vii
uitia principalia significant. Que sut cilla
y dolor. sedu libido. tertiu ira. quartum su
pbia. quintum luxuria. sextum auaritia
septimu blasphemia siue discordia. Et bes
tia qm uidi similis erat pardo p pardum qui
fertur diuisis coloref iste hy potrisis anticpi
designatur. cp cum fuerit sit homio nequissime
uariis uirtutibz se decolorabit ut fanus stul
tos quosp decipiat. p ursum u ad callidit
simu est animal cp astutia ad decipien dos
homines demonstrari potest. P leone nichilo
minus cp crudelitas ad dilacerandum aptu
ut designatur.

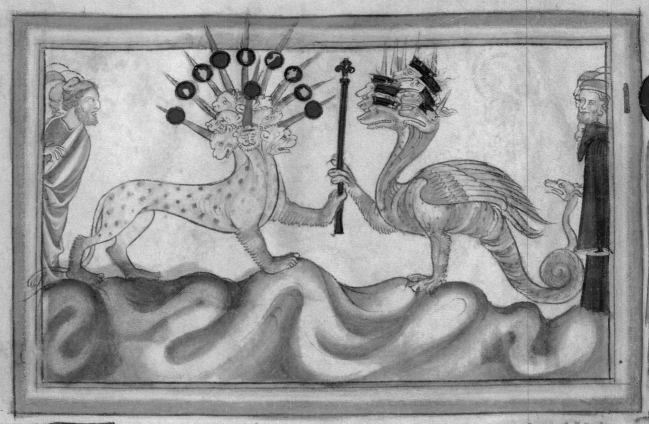

dedit illi draco uirtutem
suam ⁊ potestatem magnã
Et uidi unũ de capitibʒ eꝰ
quasi occisum ĩ morte̅ ⁊ pla
ga mortil̃ eꝰ curata est. Et admirata̅
uniũsa terra post bestiam.

Virtute̅ suam diabolus que tota mã
lia est antixp̄o dabit quia in illo ha
bitabit ⁊ ꝑ eum quiquid nequicia diabo
li excogitare potest opabitur. S; tñ scrip
tura dicat no est potestis nisi a deo. quis
diabolus potestatem magnã antixp̄o
dabit? Deuꝰ dabit potestatem antixp̄o?
si ipm̄ potestate̅ ĩ tantũ pmittit ĩ
malũ ut tota diabolica ē creditur ⁊ sit
Et uidi unũ de capitibʒ ⁊c̄. Dictũ supiuſ ꝑ
septem capita antixp̄i septem uicia pn
cipalia ē designata ꝑ capud q̄ quod no

occisum sed quasi occisum uisum est blasꝑ
hemia designatur. Quereduꝰ ueꝛcʒ noꝰ
est quonĩ blasphemia quasi occisa ē dicat

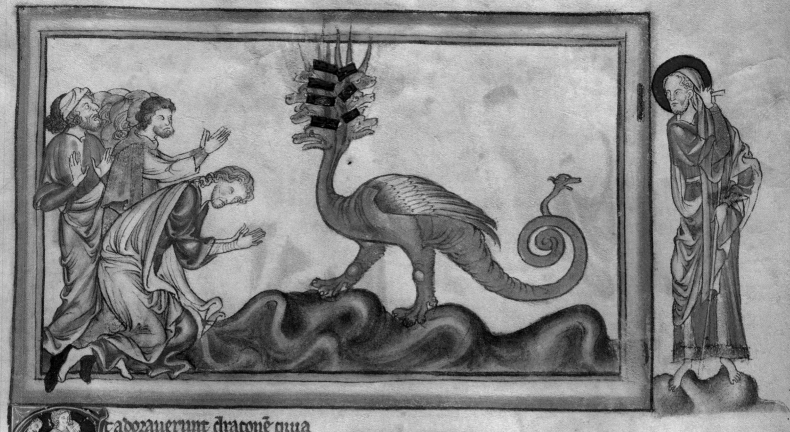

t adorauerunt draconē quia
dedit potestatem bestie

nomodo draconem idest diabo
lum adorabitur quem non uidebunt? Di ado
rabunt antixpm ille qui p eram designa
tur? ut antixps diabolum dicentes nulli
ee antixpo similem nec ee qui eius forti
tudini posset coequari.

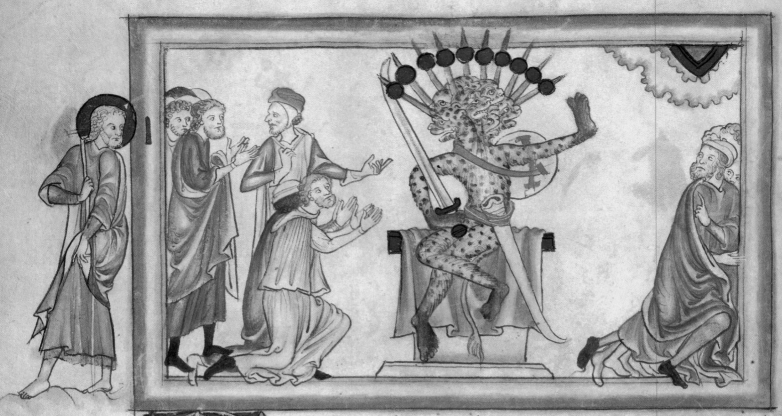

Et adorauerunt bestiam
dicentes. Quis similis be-
stie & quis poterit pugna-
re cum ea? Et datum est ei
os loquens magna & blasphemias. Et data
est illi potestas facere menses quadragin-
ta duos & aperuit os suum in blasphemias
ad deum blasphemare nomen ei & tab-
naculum ei & eos qui in celo habitant. Et
datum est illi bellum facere cum stis &
uincere illos. Et data est ei potestas in om-
ne tribum & populum & linguam & gente
Et adorabunt eam omnes qui inhabitant tra
quoy non sunt scripta nomina in libro ui-
te agni qui occisus est ab origine mundi
Si quis hit aure audiendi audiat. Qui
& captiuitate duxit in captiuitate uadet

Et qui in gladio occiderit. oportet eum
gladio occidi.

Datum est illi os loquens rc, ymissum
est a deo ut loquatur magna de semet-
ipso dicens se ee filium dei & ut loquatur blas-
phemias de deo. Et data est illi potest ac facere
mentes xlij duos. Difficile ui ut in tam
paruissimo tempore rc, in ttribus annis & dimidio
& omnes gens sibi subicere & ad suam culturam gen
humanam preter paucos electos possit perducere Et eo-
rum multi electi sunt in operacione istorum milia
pauissimi. Eos au qui obstitere noluerint & dixit
& variis tormentis affliget ut coacti facian
quod uoluntarie facere detrectabunt. Aperi gs su
um ad blasphemandum dum pam uidelz & filium
& spum suum. Blasphemabit nomen dei dicens
xpm non ee dnm. Faciet bellum cum stis qm
cum blandiendo quosdam terrendo & deo ul-
timum eis pessima tormenta inferendo

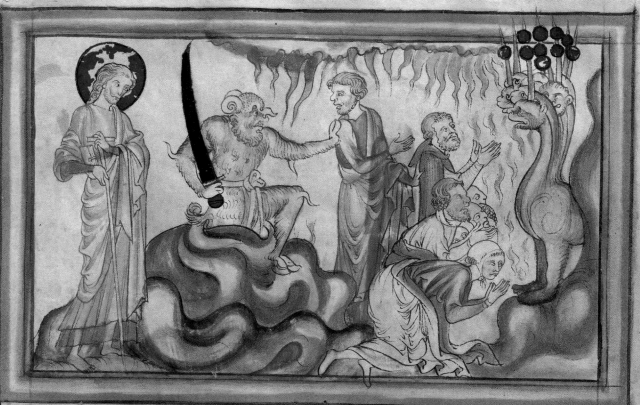

ost hec uidi aliam bel
tiam ascendentem de
terra z habebat cornua
duo similia agni z lo
quebatur sicut draco.

Et potestatem prioris bestie omnem faci
ebat in conspectu eius. Et fecit terram
z inhabitantes in eam adorare bestiam
primam cui² curata est plaga mortis
Et fecit signa magna ut z ignem fa
ceret de celo descendere ut terram in co
spectu hominum z seduxit habitantes
terram ꝗ signa que data sunt illi face
in conspectu bestie dicens habitantibus
in terra ut faciant ymaginem bestie qui
ht plagam gladii z uixit.

Et uidi aliam bestiam z c. Bestia
halens duo cornua similia agni z lo
quebatur ut draco designat unu ex
Antichristi principibus aut multos qui eum predica
verunt una phlr de terra ascendisse insuꝑ ꝗ de so
cietate replis venerit. Duoꝗ cornua similia agni
habuisse insuꝑ. Quips dicunt ꝑ un cornua signi
onis electos eo designatos eo in uni ptas ducunt
P quia aut cornu dicunt iudeos qui in xp̄m cre
derunt fuisse designatos. P certum n genuis que
sancte in xp̄m crediderint. Bestia uero cornu
duo similia habebit agni qui z uideos z gen
decipiendo ꝑseueribit. Multa quantis uult credan
ex uideos ꝑ predicationem helie in xp̄m credent nu
ꝑ haut uiui xp̄m secuturi. Sic dicit Ihs d̄l̄t gē
uium z none p̄is met z uo recipitis si aluit ue
nerit i nomie suo illu suscipiens gē z humanitate
de celo descendit. Sicut sc̄s Iohs ex ꝑmissa dei
gne sensit de celo deicente z ques Iob ꝑueritt
eui combuississe.

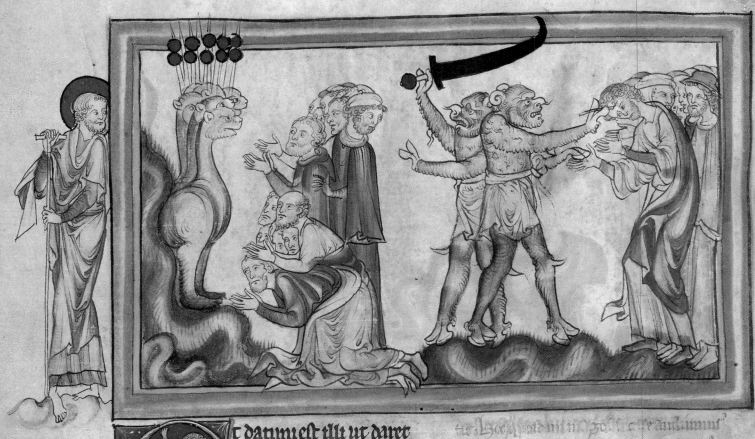

 t datum est illi ut daret
spiritum ymagini bestie
⁊ ut loquatur ymago bes
tie. ⁊ faciet quicumⱥ non
adorauerint ymaginem bestie occidant.
Et faciet omnes pusillos ⁊ magnos ⁊ di
uites ⁊ pauperes ⁊ liberos ⁊ seruos habere
caracterem in dextera manu. aut in fron
tibⱥ suis. ⁊ ne quis possit emere aut ue
dere nisi qui ht characterem ⁊ nomen
bestie aut numerum nominis e╵. hic
sapia e╵. Qui ht intellectum ꝓputet
numerum bestie numerus e╵ hominis
e╵. Et numerus e╵ sexcenti sexaginta sex.

d datum est illi ut daret spiritum yma
gini bestie ⁊ ut loquatur ymago bes

tis. Hoc quod dint ut ꝑolt ee auditum
faciebat quippe ꝑ negromantie arte ut sta
tue uiderent moueri ⁊ loqui. Solꝰ deꝰ hic aut
ꝉ intelligere. ymago cꝫ sibi ht hominem hunc lo
quentem ⁊ antecꝛ̃ qꝫ ꝙd omem uirtute atⱥ
honorem putauerunt. ⁊ hec fallissimii erat
Sic enim potest fieri ut homo ꝉ missimꝰ dic
deutꝛdica in se habⷭ magnitudie q corrumpi faciet
qui eum adorauerit ceteros habere aut
Ipsi si qui ꝓut ad uirtute ꝉ se coꝛ qui
ostendunt aute ꝑꝫ ypocri ↄmedite ꝉ ꝉ
leuent. Et faciet ut quicumⱥ qꝫ ipsom cui
appꝛ̃o quolit agnouꝛint ꝉ ꝉ atet
ut uere seu ꝉ. Sic
ut dom se ꝉ ꝉ qui ꝉ ꝉ ab
no recipiet ut ue in empꝛo ꝉꝫ
si fieri potest. Sicut dico ꝉ subuꝛ ꝉ hii
⁊ ut eum quis sequant ut ꝉ se ꝉ
qui ꝉ ꝫ ꝉ ab qꝫ dicii ꝉ hii ꝉ ꝉ ⁊
qꝫ ꝉ hoc seu eam in qꝫ dicii ꝉ hui alii ꝫ
teredidunt. ꝉ uel ꝉ ꝉꝫ eam qꝫ ꝉ

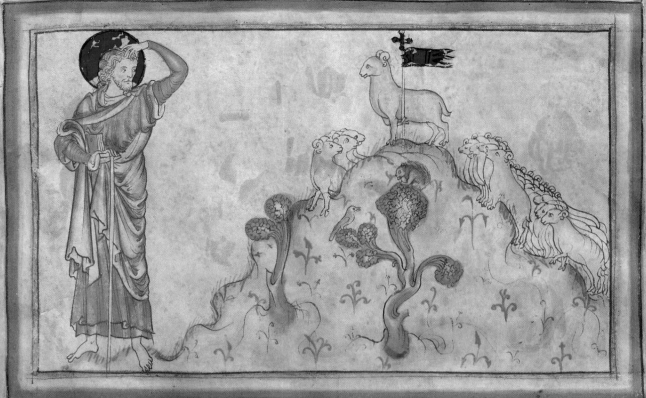

t uidi z ecce Agnus ſtabat
ſuꝑ montem ſyon· z cum eo
centum quadraginta iiii
milia habentes nomen eiꝰ
z nomen patriſ eiꝰ ſcriptum in frontibꝫ
ſuis

S... [text damaged and illegible — initial decorated letter S followed by worn text]

...ꝑ textuſ lectioniſ ſecun
...pria eſt· que de centū electiſ
...ꝭ cuniuſ nobelioſ ꝑeſꝙ
...celeſti beatudine tn domino exultant
...ad eoſ ꝰ ſi libera latantes ꝯſti· ꝑer
...er· Agnuſ ſcdit ꝵpm̃ bemꝛaſ· ꝯ ſotꝭ ſpe
...uliꝛ ꝰ nrꝑeraſ· Quoniā ſ ſyon celeſtm̃ ꝓaꝛ
...intelligere debent· ꝗa monte ſ ſyon Agn̄ uiſuſ e
...gnuſ z celeſtiā uuidue cū ſctꝭ ſuiſ ꝵpo glaꝛ
...ꝯ aꝛꝯ ille ꝑinꝛ a ꝙraginta iiiꝑ milia z eꝯ
...ꝑ ꝯꝛed uaꝼoue omꝛ hunc ꝑcedir centuṁ ꝗ

...au uolt ago dund ꝗꝛibuſ electa z ſigno ſi
...ꝯ ſignꝛe ſaſſe dicꝛuſ· lectū ꝵpū mhe und
...labmane ꝑiuere· ſicut celuſ iꝓ iuu̇ milia
...electꝛa cuiꝯ officʒꝛ glꝛm̃ cū domino lecutuꝛ
...ſigꝰ nrꝛaut· ſicut textuſ preſentiſ lectioniſ mꝛ
...textꝛ mꝛat· Et tur nomꝛ pꝛs z ſilii tm̃ aao
...ſi ꝵꝛ abꝫ ſuiſ eoſ ſeptura hīc dicit z de ſpū ſcō
...ueruit· Et una uidꝫ ub atuiꝯ ꝓiēm z ſiliū
...leginuꝛ ꝰ debemuſ intelligere ſpiritum ſctm̃
...Debemuſ au ꝑ froutes cozaã ſtoã uielligꝫ
...ſtomen urꝛꝙ pꝛs z ſilii a ſpē ſcti i ſrouiſ ſuiſ
...ſcorũ hūc quia moueabr eoſ amoꝛ deſ uruiʒ
...uelle poteriꝛ ſitū auiuꝼuſ· a ceruib ꝗꝓi
...Angeloã ꝗſ ꝑ ſuꝛbiā eꝯ ceſ aeiꝯ ōr·

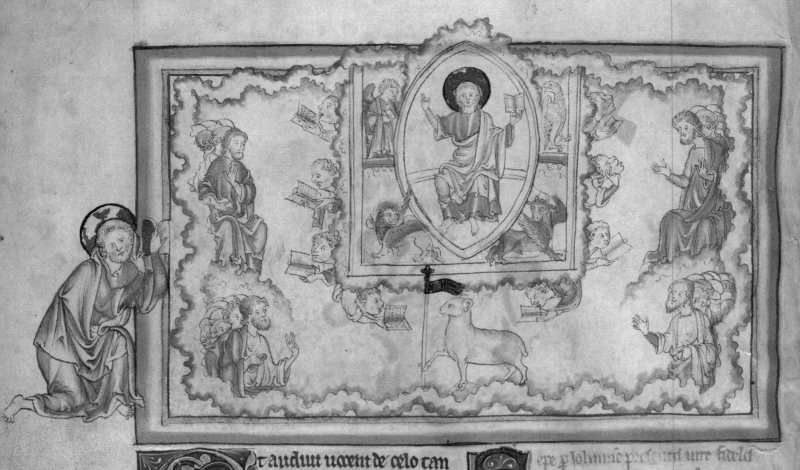

Et audiuit uocem de celo tan
quam uocem aquazmulta
rum · z tanqz uocem tonitrui
magni · Et uocem psn audiui
sicut cythardoz cytharizantium in cyth
aris suis. Et cantabant canticu nouum
ante sedem z ante quatuor animalia z
seniores. Et nemo poterat dicere canticu
nisi illa centum quadraginta uil milia
qui empti sunt deterra · Hii sunt qui cu
mulieribz non sunt coinquinati uirgi
nes enim sunt · Hii secunt agnum quo
cumqz ierit · Hii empti sunt ex homi
nibz primitie deo z agno · z in ore eorum no
inuentum mendatium sine matula eni
sunt·

Sepe p̃ solennie presentari urte fideli
dem onstrantur q̃ aquas in populi
designantur Et quia de omnibz gen
tibz cotidie colligunt electi z i celesti beatitudie
collocant scti dei in tra constituit qui p iohem
designantur uocem aquaz multarz assidue audiui
qz doctrina scoz i celis piectentiu z cordis auribz
sentiut z uirtute q possunt eoz aff inuentiantur ·
Uox eade uox tanqz tonitru iti ee di qd corda
audientiui terrere soleat feruntur ad eum
ad eoz pfectioni se conscendere no possint side
rant · Et uox tanqz audiui t ee · Uox cythardicium
ualde eos dulcis amanabz siue audientibz · Et qd
uiltz fidelibz qui memoria scoz i celis comen
tui du quanta sit eoz glia mente peuitut · di
ut ad bene qqz puentut supplici · quomi
sor cantabunt canticum nouu · Et uiderim no
ui di · nouu testimentum eo quod Auro pre
cedat · Sine pro eo qd nouos puentiti fecit

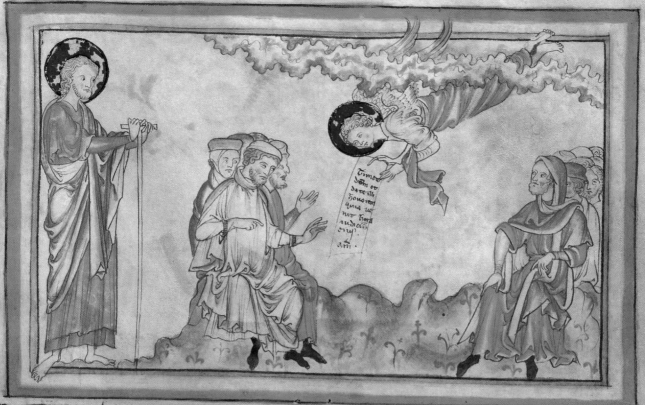

t uidi alterum angelum uo
lantem p medium celum
habentem euangelium et
num ut euangelizaret ha
bitantibz sup terram 7 sup omne tribu
7 linguam 7 populum dicens magna
uoce. timete dominum 7 date illi ho
norem quia uenit hora iudicii eius.
7 adorate eum qui fecit celum 7 terra
7 mare 7 fontes aquarum.

Iste angelus xpm 7 apostolos significat cete
rosq xpi predicatores. Qui euangelium eter
num habuisse dr quia doctrina euangelii ab
apostolis ceterisq predicatoribz uera est qui gen
tibz predicerent. Quod euangelium eternu ee dr
quia eternam prestat omnibz facientibz

aluid. Quod 7 sup terram sedentibz predicatu
ee dr. Gentes namq quibz euangelium predica
tum est. nichil aluid qm terram querebant toto
q requiem suam infra posuerant. Quid aut iste
angelus predicaret dicens. Timete dnm 7c. co
uenient timore qm primo posuit 7 postea bono
re timor etenim dnm ad penitentiam impellit hoi
pniam u ad bona opa agendi est precur. ho
nore inde deo deferimus cum bona opa agi
sit ipe dicitur. uideant opa uestra bona 7 glorificent
prem urm qui in celis est. Ille qm atrociter istud in
dicii inculcabunt qm uerbum euangelii audiet q
aludiq spnentes fidem xpi suscipe noluerunt
Simili 7 illi qui susceperunt quos fidem xpi per
eam operibz implere noluerunt. Cui enim plz
committitur plus exigetur ab eo.

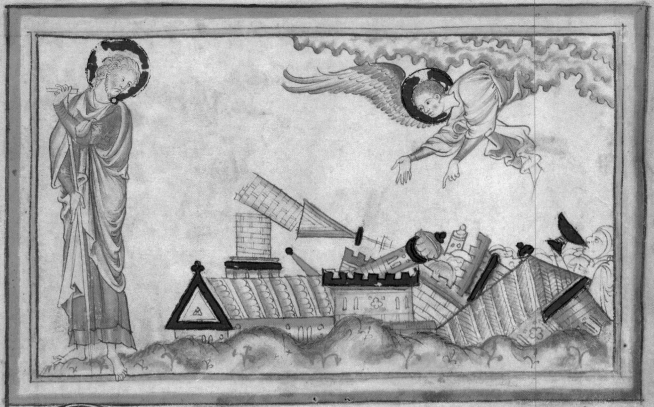

 alius angelus secutus est dicens. cecidit cecidit babilon illa magna que a uino fornicationis sue potauit omnes gentes

quam omnes gentes idest omnes repln quedo omnes gs a uino ire sue potauit. uerum cum unus alterum docuit. z ille unum z tercs hrm z tra in omis homines error diabolicus transm uticp babilon omis gs a uino ire dei potum.

Alius angelus doctores ecce qui finitis pse nam ipbs cecidit de gulia dicuntur desig natur. cecidit cecidit babilon magna q babi lose sicut lupus dicuntur tuuat diabolic desig natur que ex omnibs impiis constat. e cecidit iste q omnis cultura demonum p fidem xpi delera fuerat. sed bis cecidisse dz qp ex pter p se tror z cepere tillime diabolice cecidernt. qp a uino ire sue potauit omis gs. uini ire ero zel tunc gentius quibs deum ad uacundiam puerauerint. Sz eat babilon unde sit alused

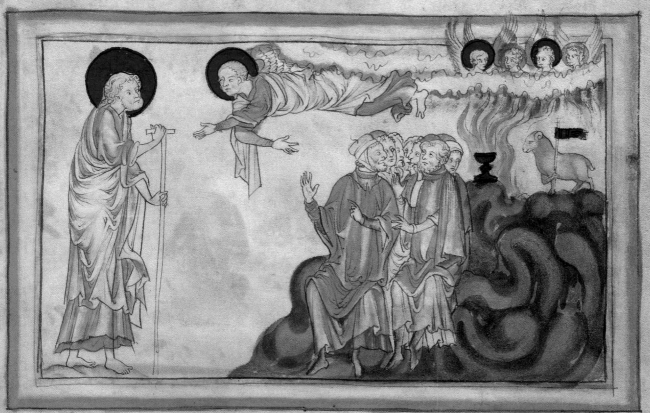

Et angelus tercius secutus est
illos dicens uoce magna. Si
quis adorauerit bestiam z
ymaginem eius z accepit caracterem
in manu sua aut in fronte sua z hic
bibet de uino ire dei. qui mixtus est mero
in calicem ire ipsius z cruciabitur igne z
sulphure in conspectu agni z fumus
tormentorum eorum in secula seculorum ascen-
det. Nec habent requiem die ac nocte
qui adorauerunt bestiam z ymaginem
eius. Et si quis accepit caracterem no-
minis et Hec pacientia sanctorum est qui
custodiunt mandata dei z fidem ihesu

Angelus tercius predicatores sunt qui
temporibus antixpi futuri sunt. Pre-

ditabunt enim ut nullus antixpm adoret neque
ad eius pessimam doctrinam. Aures cordis suo-
modo neque opa eius inuertetur. Quod si quis
fecerit apertam penam eum se damnandum re-
testabuntur. Per uinum ire dei damnacio ultima
que in die iudicii impiis irrogabitur designa-
tur. Quertum aure pluriam sicut. Per mero si noste-
ris dei designetur. Per calicem si iudicium dei
accipe possimus. Vinum itaque mixtum mero in
calice dei op damnacio ultima qua impii
damnabuntur magni eorum qua iusticia in calice
dei scz in iudicio op pessimus dei iudicio fe-
cietur. Bibent ergo impii uinum ire dei cum illis
dicetur. Ite maledicti igitur etim qui preparat-
tus est diabolo z angelis eius. Igni crucia-
sulphuroso feroze de se possunt crucian. Igne
au corporali cruciabunt qui igni uitiorum se ex-
tinguere noluerunt. Fetore sulphuris torque-
buntur quibus dictus est Sion hyeritis.

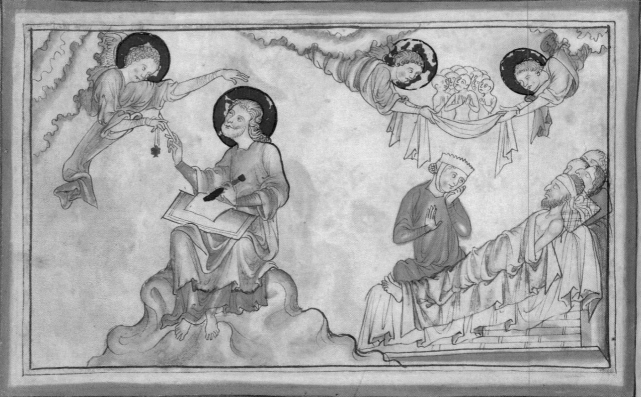

Et audiui uocem de celo dice
tem. Scribe. Beati mortui qui
in domino moriuntur. Amodo
iam dicit spiritus ut requiescant a labo
ribz suis. Opa enim illoz secuntur illos.

Beati mortui qui in domino moriuntur. Tales
sunt qui patientia sto̶z qui custodiunt man
data dei z fidem ihu ut sunt beati i apertum. Sed
quo est quod dicit. beati mortui qui i domino
moriuntur. Quis enim moritur non potest. Jste
q̶ sindubio presens mortuus non potest nisi pul
ueris recipiat ut ch̶i mori possit. Sed illi s̶t
beati z illi in domino moriuntur qui h̶ui mori
untur seculo p̶ost carne. Qui prius uocem
hominie to̶z omnes u̶oz̶u̶alis z spuales z carnalē
in se extingunt u̶t possint dicere cum apl̄o
ch̄ihi cruci̶ꝯ uis crucifixus est z ego mundo.

sut nam̶q̶; in domino moriunt̶ de quibz do
dicit. Qui a̶u̶t̶e̶ pseueraue̶rit usq; in finem
saluus erit. Amodo iam dicit scm ut requies
cant a laboribz suis. Amodo id est a tempe mort̄
sue requiescunt scm a laboribz suis. Opa enim
illoz secuntur illos. Q̶ no̶is serm̶ quia in
eos opera illoz connectit illos i apertum
Possumus z hoc de illis scire̶ intelligere qui
temporibz antixp̶i q̶ no̶ie domini ih̄u xp̄i
i̶nficiendi sint. Beati e̶rg̶o q̶ ex uic̶ ille
z in domino moriunt qui p fide dominini
ihu xp̄i moriunt. Istam qui pe̶na illoz qui
antixp̄m creditur sint. nam ut h̄c. Istam
d̶m̶e̶m̶ q̶ illoz qui in fide x̄p̄i pseuerauerint
usq; in sua̶m̶ b̶reu̶ complect̶u̶r consequ̶
estur d̶ie̶ uic̶hor̶e surrectur u̶t p̶ hoc e̶ri̶t
ta complebuntur.

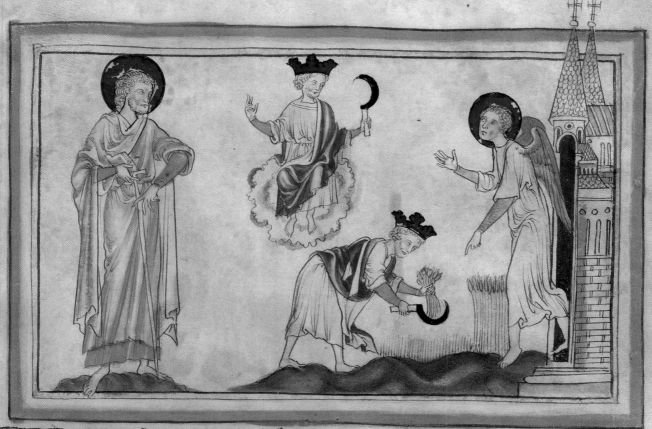

t uidi ⁊ ecce nubem candida
⁊ sup̄ nubem sedentem simile
filio hominis habentem in ca
pite suo coronam auream ⁊
manu sua falcem acutam. Et alter an
gelus exiuit de templo clamans uoce
magna ad sedentem sup̄ sedem · oʒ tʃe
falcem tuam ⁊ metere quia uenit hora
ut metatur qm̄ aruit messis terre. Et
misit qui sedebat supra nubem falcem
suam in terra ⁊ messuit terram.

otam sententiam pos̄ in. i̅ꝯ. leꝗs er
tiꝯ exꝑfecta ꝯ ā frater̄ aquel̄ sude
uenir. Dicer̄ꝯ narit̄ iste Angelus i̅
significat̄. ꝯmul̄ ⁊ due falces meteꝑ significa
tionem hūt̄. Designant enim illum igne ꝑ
quo vn̄ꝰ mundus delend̄ est. Cl̄ ua

sicut ꝑmo tempore mund̄s ꝑ aquam deletꝰ;
ita ⁊ in fine tempor̄ ꝑ ignem delebit̄. Ez que
rendum ē cur mundꝰ xpr̄ ꝑ dꝰ angelos ⁊ una eꝯ
timatio ꝑ duas falces figuret̄. Pm̄i quippe
angelus sup̄ nubem candidam sedisse ⁊ corona au
rea habuisse uis̄ est. secund̄ꝰ neꝗ corona au
rea habuisse neꝗ sup̄ nube candidum sedisse dic
tē ꝗp̄ messe terre sz n̄ botris surꝯ Dꝰꝰ pre
tuliste dicit̄. Si ꝑmi quo loco messem tꝯ ꝑ
fuerit isto dr̄ sec̄s botris uinee tꝯ ⁊ Latum ue dc̄
magnum messe dcꝰ ꝑ. Vider̄ itaq̄ michi ꝗ mes
sem ꝑe electos ꝑ botrꝰ au ex quibꝰ uin̄ ūt̄ ōm̄
ad ūentes alios ꝗ reꝓbꝰ ēe designat̄ꝰ. Ista ⁊
messis ꝯ qꝰ dr̄ dic̄ in ell̄. In tempore messis
dicam messe · abꝰ · collecte ꝑm̄i ʒizania ⁊ lit̄
te eꝯ falciculꝰ ad ꝗburendum · ⁊ triticū n̄ re
condite in horreis meis. Qui enim alios ꝑ triti
cum ꝑ in hoc loco ꝑ messem designat̄ n̄ ꝗ qui
alios ꝑ ʒizania ꝑ in hoc loco ꝑ botrꝰ uinee terre
significant̄

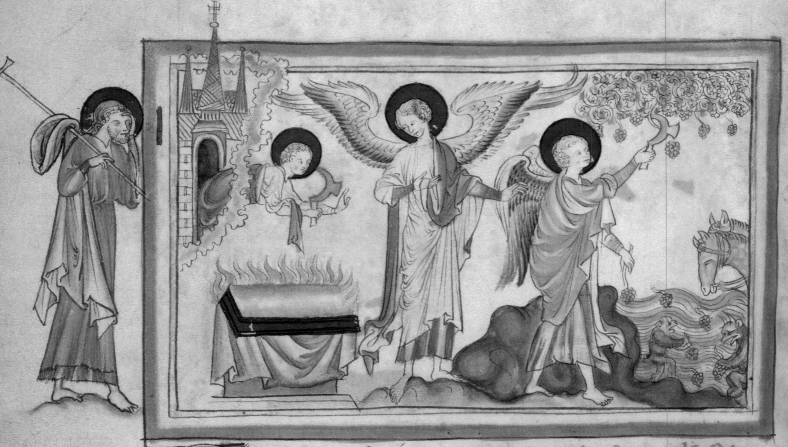

t aluis angelus exiuit de
templo quod est in celo ha
bens ☩ ipse falcem acutam
Et aluis angelus de altari
qui habet potestatem supra ignem cla
mauit uoce magna ad eum qui habe
bat falcem acutam· dicens· mitte fal
cem tuam ☩ uindemia botros uinee ☩
re qui mature sunt uue eꝰ Et misit
angelus falcem suam in terram ☩ uin
demiauit uineam terre ☩ misit in lacu
ire dei magnum ☩ calcatus est lacus ex
ciuitatem· ☩ exiuit de lacu sanguis
usꝗ ad frenos equoꝝ ꝓ stadia mille
sexcenta.

ngelus iste xpm significat. Similit ☩

due falces unam significationem hñt· Desig
nant enim illum igne quo uniuersus mundus
delebitꝮ· Quia sic pmo tempore mundus ꝓ aquam
deletus ꝫ ita ☩ in fine temporis ꝓ ignem delebit
Sz querendum nob ꝫ cur

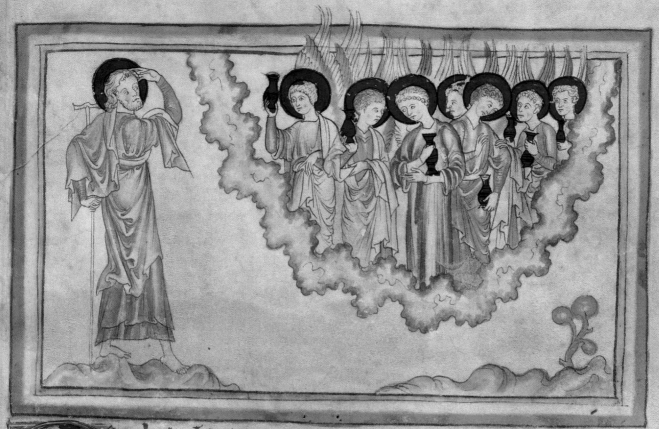

t uidi aliud fignum mag
num z mirabile m celo ange
los. vij. hauentes vij. plagas
nouiffimas qm in illis confu
mata eft ira dei·

Sequitur fupius antefm ad narratonem vij
Angelorum tubis canentium uenter eor
mentione facere ftuduit ira z hic antefm ad
vij Angeloz fialas hidentium narrationem
ueniat eor mentionem fatur ut induter
magna mifteria i eor uifione contineri.

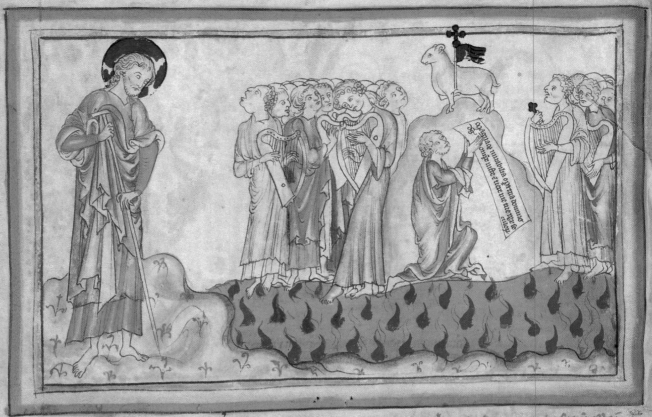

Et uidi tanqͥuam mare ui
treum mixtum igne ⁊ eos
qⁱ uicerunt bestiam ⁊ yma
ginem illⁱ ⁊ numerū noīs
eius stantes supra mare uitreum halen
tes cytheras dei ⁊ cantantes canticum
mͦysi serui dei ⁊ agni canticum dicen
tes. Magna ⁊ mirabilia opͣ tua dñe
deus omͥpͥns iuste ⁊ uere uie tue rex se
culoꝝ. Quis non timebit te domine ⁊
magnificabit nomen tuum? Quia tu
solus pius es qͥ omnes gentes uenient
⁊ adorabunt in conspectu tuo qͥ iu
dicia tua manifesta sunt.

Quid significet mare uitreum̄ supͥ in
secunda uisione dixim̄ Sed illⁱ tanqͥ
cristallus hic aī mixtum igni. Sed qͥa es

tallus eximie claritatis; igitͥ qͥ de se cū calore
solis arreptͦ solet emittere emit significatͦm
sic illⁱ cristallus quam ⁊ hic ignis. Significa
uͣmqͥ spͥtualem intelligentiam que ī diuinis scͥ
pturis inuenit. Dicitͥ qꝛ uitreum mixtū ⁊ igni
qꝛ diuina scͥptura mixta � spͥtualibͥ intellectibͥ
Sup mare itaqͥ uitreum hi qͥ bestiam interfi
stare uisi sunt qꝛ scͥ dei qͥ cō antixpm pugna
turi sunt i preceptis diuinaꝝ scͥptuꝝ grest
figent nullaqͥ impulsione uenti. Ita ficeꝛ
moueri possunt. P cytheras vo quas habebant;
mortificatio carnis designatur. Canticū sī mͦy
se ueteris testamentū. Canticū agni nouū de
monstrat. Canticū il mͦysi ⁊ canticū agni cā
tabunt qͥ uetͥs ⁊ nouū scͥm predicabunt. Quod
canticum quale sit aufcultans cōsigna ⁊ mira
bilia opͣ tua domine deus omͥpͥns iuste ⁊ ue
re uie tue rex sentioꝛ. cōtemplat hec canti
cum tuum ueterͥ ⁊ nouo testamento.

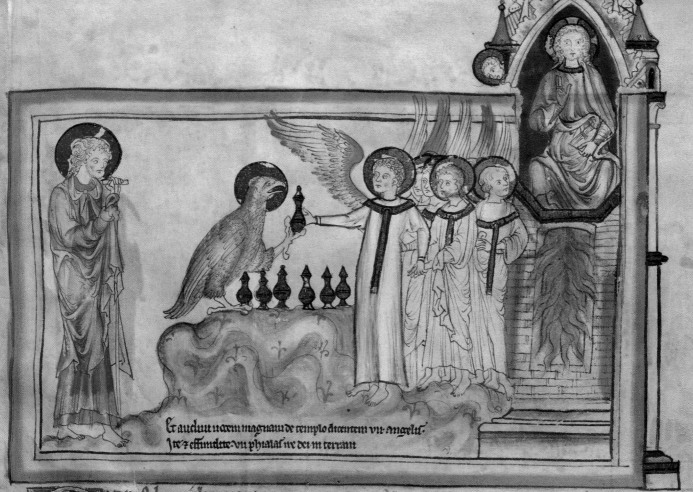

Et audiuit uocem magnam de templo dicentem vii angelis.
Ite 7 effundite vii phialas ire dei in terram

Do post hec uidi 7 ecce apertum
templu tabnaculi testimonii
in celo. Et exierut vii angeli ha
bentes vii plagas de templo uestiti lapide mudo
candido 7 precincti circa pctoza zonis aureis. Et
vnu ex uiii animalibz dedit vii angelis vii phi
alas aureas plenas iratudine dei uiuetis i secula
seloz. Et ipletu est templu fumo a maiestate di
et de uirtute ei. Et nemo poterat introire in
templum: donec consumerentur septe
plage septem angeloz.

Datioz sunt ista quamuis i n euange
celis significat eu 7 sanct. singillati
septis significant. Qa oil maiestas xpm intel
ligni. phiale si corda sunt ista. qa cp sapiam
Aurea recte uor nii noi qa ex uiii animalibz dedit
septem angel. vii phialas aureas. p xpe corda
secdz sap. ipia repletur. xpi sa pia replea
tur. quomodo iratudia dei plena cp dicunt

Dotui dicit i euangelio de impiis uidet. Si no
uenissem 7 locutus eis fuissem pcin no hrent
slumqud uidet ante aduentu m xpi sine pcto
erant? Erant 7 antea pcozes. Si quin intre
duritatis peccatum blasphenie quo eu belze
bub uocauerunt. pctm homidiu quo eum cru
cifixerunt. 7 uidta alia scelera que ex hoc enim
et expuerunt no habebant. In phiala nam
xpi i qua uirt mudi continebat. uidet su
culpis exigentibz morti iuerunt. phiale qi
vii angloz plene fuerunt iratudie di qa
quidem ad replos ptinet predicatio stro
nam dei i se continuit. q 7 eo ip eor predi
cationem cntempserint maiu di i auretur.
Et impletum e templu fumo a maiestate
di 7 de uirtute ei. Q templum celestis pnra
designat

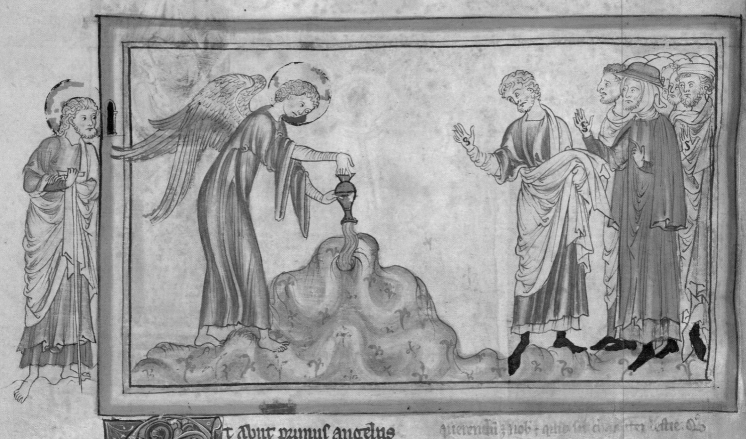

Et abiit primus angelus
z effudit phialam suam i
terram. Et factum est uuln
cerium at pessimum in hominib, qui ha
bebant charecterem bestie z eos qui ado
rauerint ymaginem eius

P...

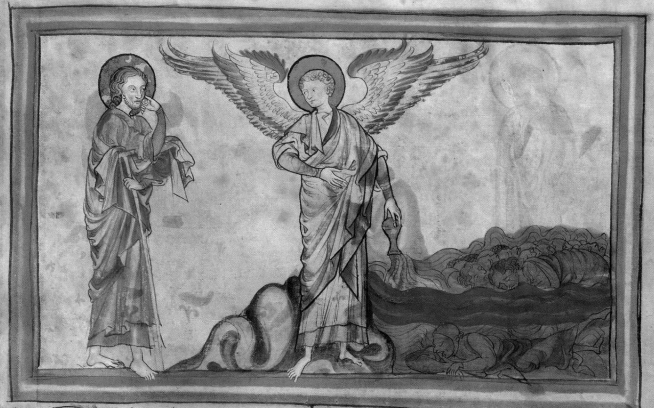

Et secundus angelus effudit phialam suam in mare: et factus est sanguis tanquam mortui: et omnis anima vivens mortua est in mari.

Iste angelus doctores legis significat sicut et ille qui supradictum significat secundum tubae cecinitis...

...scriptum est quia... exspectant diu de...

...habet.

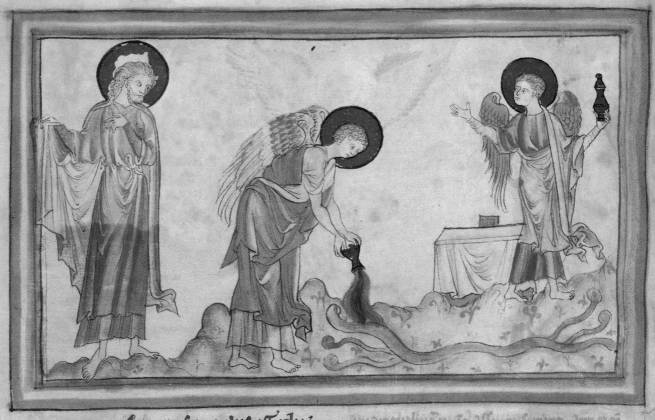

Et tercius angelus effudit
phialam suam sup flumi
na z sup fontes aquaru et
factus est sanguis. Et audi
ui angelum quartum dicentē. Justus es
qui es qui eras scs qui hec iudicasti quia
sanguine scoz z phaz fuderunt z san
guinem eis dedisti bibere ut digni sunt.
Et audiui etiam altare dicens. Dne ds
omps uera z iusta iudicia tua.

Per flumina uero z fontes aquaru ducēt in cla
ssiu sus sanguis designans scam i predici
passione z tunc angelum tuba canente phias
dicīa ee designatos. Sed ibi tercis ps flumi
num atqz fontum uersa ee dicitur i absim
thiu. p quaru ee qui p doctrinam phaz

amaritudinibus pnse assumpserunt. Atqz p ea
salus ee meruerunt dicunt. s nunc designa
tos hic aū in effusione phiale teren angli flu
mina z fontes aquitz effudit in sanguinē
Anglis qz phialam sua sup flumina z fontes
aquaru effudit qui pphie sci viripio populo ubi
dei ānunciauerunt. s illi ex predicatione
sioz multo decoractes effecti no solum i nda
taxta dei ecemplu irunt. s z ipsi ubi dei mini
stros tederunt. s sanguine us iusti sunt q
ipi sibi mecipis morte ppetua muerunt.
Per angelum ecenim pnsm angelicam illoz
spuali intelligo. Qui uidentibus dei indicio
populum uexisti ee dimputanim. Undeit sen
tentiam uerissi nam dei omnipotentis. Ec q
sanguine scoz z phaz fuderint sanguinē
biberint quia z morte temp pdi quam i
tu meruerut morte ipetuam recipiunt.

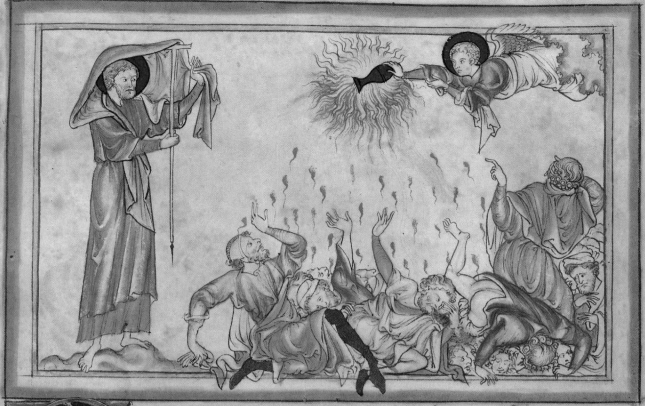

Et quartus angelus effudit
phialam suam in solem ⁊
datum est illi estu afficere
homines ⁊ igni ⁊ estuaue
runt
runt homines estu magno ⁊ blasphemaue
nomen dei habentis potestatem sup has
illi gloriam
plagas neq egerunt penitenciam ut darent

Quartus angelus xpm ⁊ apostolos eius
ceterosq predicatores significat ut qrtm
angelm in superiori visione significasse diximus. Et
ideo p solem populos iudeos p terciam prem solis ⁊
lune atqz stellaz fideles qui ex illo populo in xpm
crediderunt esagrantur. Qua tus q angelus phi
alam suam in solem effudit qz xre ⁊ apli eius
qo impii iudei a romanis delendi cetur april uo
tibz predixerunt. Nam sicut quilibz suus accipit a
homine sto gladium no unde ire inculetur sed
unde reatu inquiret. tra ⁊ romanis effusionem

phiale in qua ira di continebitur no ad hoc susce
punt ut ipsi in ea puirent. sz ad uindicandum xpi
sanguinem in iudeos effunderent. Vnz ⁊ sequit. Da
tum est illi estu afficere homines ⁊ igni. Pos
sumus p estum obsidionem. p ignem tribulacionem ⁊
gladium quibz uidez pene omnis osumpti sunt in
tellige. Datum est q soli afficere homines estu
⁊ igni. quia romanus datum est a do. ut impios
iudeos diuersis tribulacionibz afflictos quosdam ca
uiderent. quosdam a sua terra euellerent. Et
estuauerunt homines estu magno. Quam mag
nus fuerit ille estus quo romani iudeos affli
xerunt. qui uult scire legat iosephum ⁊ in
ueniet multam gentem in omnibz regnis terre
arroris pisse. Et blasphemauerunt nomen
dni habentis potestatem sup plagas. his
sic egerunt purram ut darent illi gloriam

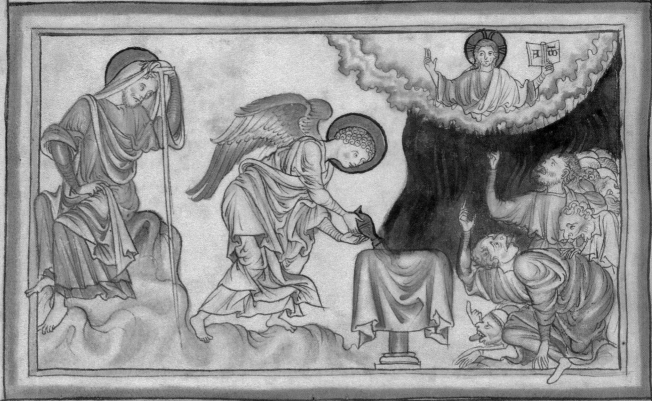

Et quintus angelus effudit
phialam suam sup sedem bes-
tie z factum est regnum eius
tenebrosum z cōmanducaue-
runt linguas suas pre dolore z blasphema
uerunt deum celi pre doloribz z uulicibz
suis z non egerunt penam ex opibz suis

Quintus Angelus orthodoxos patres q̄
contra hereticos dimicauerunt sig-
nificat quinq̄demꝰ z illum diem̄ significat
se qui in superiori uersione quintus tuba ce-
citur. Et sic ut illut p̄ secutus hereticos de-
signari sunt sed z his p̄ sedem bestie he-
rie designantur. Bestia aū diabolum
significat . scilicet z sedem bestie diuin̄ q̄a
in cor eoru cecidit z diabolus inhitar. Illũd q̄ an
gelus p̄hialam suā sup sedem bestie effudit
az sci uiri errores hyuic detegues que pe
nes ille istares manifestare studerit . Factum

est uero regnum eī tenebrosum quia tlic̄hb;
doctrina hereticor fulgida uidetur. p doctriā
sc̄opum prin̄ q̄d mitera z tenebrosa eēr demonstr-
tum est. Cōmanducauerūt aū linḡs suas pre
doloribz suis q̄ z singult sinḡlor errores reph̄e-
debant. nam neꝗ arri secutus est euanomil ut
tabellium nec queuꝗ mor neꝗ alt alii si mi
quisꝗ heresim sua stabilire uolent ceteror erro
res reph̄endebat. Oru s̄ dm̄ pre doloribz z uul-
ueribz suis blasphemasse dr. Dolebant aꝑe
henri eo q̄ a catholicis uiris sp̄ q̄uincebāt. Vul-
nera si eor errant errores sinḡlor. Blasphe-
mauant aū herendm̄ pre doloribz suis q̄a q̄ā
to amplis a catholicis uiris superbant tāto
ampliores blasphemias ad eos reuincendos
inueniebāt. Oru s̄ sine p̄nia fuisse dicuntur.

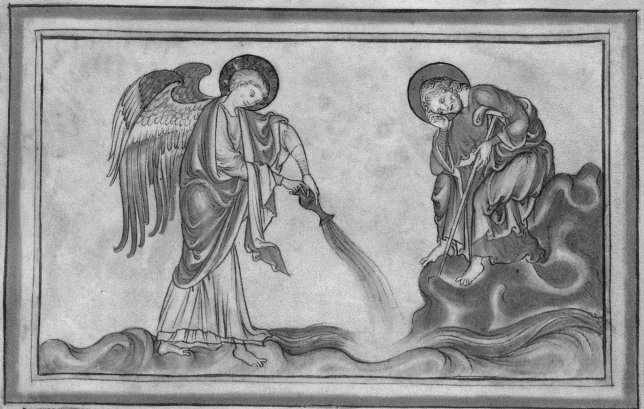

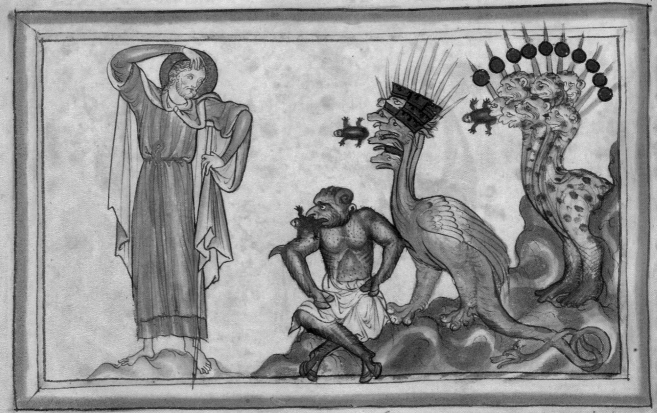

E t uidt de ore draconis τ de
ore bestie τ de ore pseudo p-
phete spiritus tres immundos
i modum ranarum. Sunt eni
spus demonioru facientes signa. Et predent
ad reges terre totius congregare illos i
prelium ad diem magnum dei omni-
potentis. Ecce uenio sicut fur. Beatus qui
uigilat τ qui custodit uestimenta sua-
ne nudus ambulet τ uideant turpitudine
eius. Et congregauit illos in locum qui
uocatur ebraice ermagedon·

S unt aut spus demonioru facientes signa
uocatione gentium descripta quasi ad
ad fidem xpi ueniunt mentione facit antexpi
qui ape finem mundi uenturus e· Spus aut tres
immundi discipulos designant antexpi qui p

uniusum orbem predicaturi sunt. Qr homines
homines sunt futuri xpe inimici τ spus demo-
nioru uocantur. qr demones in ipsis habitabunt τ
p ora eoru loquentur. Qui de ore antexpiz de
ore pseudo xpe ei exisse uisi sunt: qr p eoru doc-
trinam filii diaboli efficientur. Qui τ de ore dra-
conis exisse uisi sunt. qr p os antexpi diabolus
loquetur. Ranis nichomin que sunt reptilia immu-
da τ luto uiuentia recte assimilant qp si-
cut in sordibus deliciis gii morantur ita τ discipuli an-
texpi eos facile decipiet qui deliciis ineptis τ sor-
dibus uis timuerit sordidari. Nam τ rauce uox
rance τ turpis impurissima eoru predicationum
blasphemiis plena designat. Et predent ad
reges etc. P reges terre nō solum reges sz
τ populi designant. Dies aut domini sic fur in
nocte uenier. Cum et dixerint pax τ securitas
tunc repentinus eis superuenier interitus.

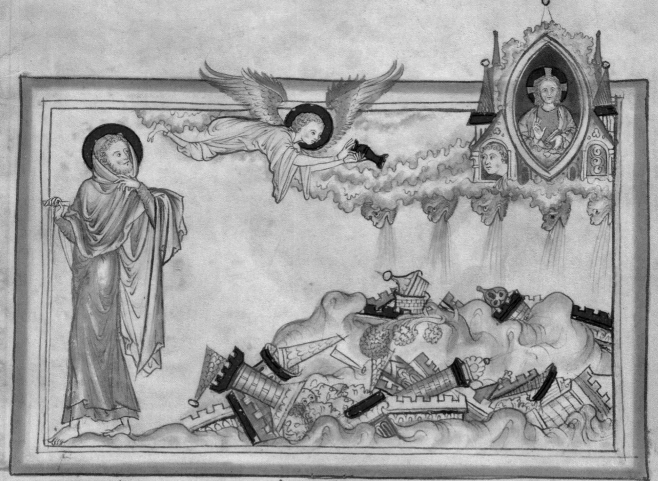

septimus angelus effudit
phialam suam in aerem et
exiuit uox magna de templo
a throno dicens factum est.

Et fca sunt fulgura et uoces et tonitrua et
terre motus factus est magnus qual' nuqj
fuit ex quo homines fuerunt sup terram ta
lis terre motus sic magnus. Et fca est ciui
tas magna in tres ptes et ciuitates gentiu
ceciderunt. Et babilon magna uenit i me
moriam ante dm dare ei calicem uini
indignationis ire eius. Et omnis insula fu
git et montes non sunt inuenti. Et grando
magna situt talentum descendit de ce
lo in homines et blasphemauerunt dm
homines ppter plagam grandinis qm
magna fca est uehemens.

Per septimum istum angln predicatores sti
qui temporibus antixpi fuerut designat
Angls qz phialam sua i aerem effudit qz pre
dicatores sui uanis et impiis hominibz qd pena
pena sunt dampnandi denuntiabt. Et exeuit
uox magna et c. uox magna uox est predica
toz scoz. p templum eccia intelligit. A templo
qz uox exiit qz ab eccia uox scie predicationis
pcedit. Que z a throno exisse dm qz eccia dm thro
nus e dm et in illa sedens requiescit. Quid aut
hec uox dicat subdendo manifestat fcm e
tdz finis mundi instat in q omnia que pdca
sut a dno za scis complebunt. p fulgura si
miracula que p scos suos facturus z dc desig
nant. Legimus namqz i supioribz helyam
et enoch plurima signa ee facturos. p uoces
si predicatio scoz. p tonitrua aut terrores
eius exprimunt.

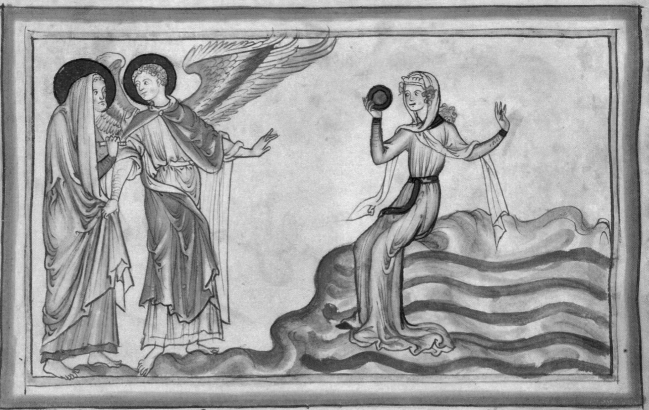

Et uenit unus de septem anglis
qui habebant vii phialas. et lo-
tuttis est metum dicens. Veni
ostendam tibi dampnacionem
meretricis magne que sedet sup aquas mul-
tas cum qua fornicati sunt omnes reges t
re t mebriati sunt qui inhabitant terram.
de uino pstitutionis ei

Situr suprus sub centu rube septem angli
vicin nudut breuut comphendes ad ea
que premiserat redut atqp scam eccam sub spe
mulieris que amicta erat sole t luna sub pedibz
ei eccam describens passiones qual a diabolo
ptulit t qs ab inicip i fine mudi passura est
amiccit ita t hic sub effusione phiale septimi
angli diem iudicii sumatim pstringens ad
ea que premisit redut atqp sb spe mulieris
meretricis ciuitate diaboli describes qual penas

p sceleribz suis passura sit i sequetibz manifes-
tat. Anglis su phialam huis predicatores sus
designat Johannes aut typum teuet omniu
fideliu. coherede ista i aliquibz locis romia sedit
que tunc eccam di plsequebat. in quibz il ge-
uualit ciuitate diaboli id t omnne corpus reprobo-
demonstrat. Anglus ergo Johanni ostend dampna-
cione meretricis magne. p predicatores sancti t u
bis t scriptis fidelibz ostenditur qual penas i
pnu p sceleribz suis puiane ut eor penis territi
a peis abstineant. Que sup aquas multas sede
dicit. qz ex multitudine genciu que p aquas
designatur ciuitas diaboli construitur. sunt
qz reges tre fornicati ee dit qz scelera diabo-
lis potius adgerentur qm destruerent. Et mebri-
ati sunt omnes qui inhabitant tram de uino
pstitutionis ei vini pstitucois dixit erro
res duica sunt scelera impie ciuitatis

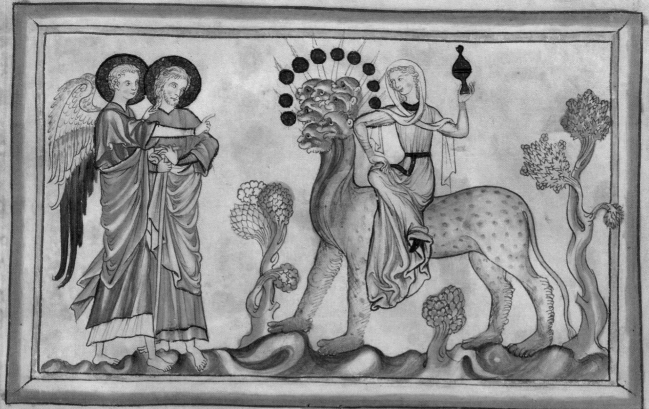

Et abstulit me in desertu. in spu̅ ⁊ uidi mulierem sedente sup bestiam coccineam plenam nominibus blasphemie· habentem capita vii ⁊ cornua decem. Et mulier erat circudata purpura· ⁊ cocco ⁊ inaurata auro ⁊ lapide pretioso ⁊ margaritis habens poculum aureum in manu sua plenum abhomina cione ⁊ immunditia fornicationis eius/ nomie scriptum mistium· Babilon magna ma͞r fornicationum ⁊ abhominationum terre

ei

Per desertum om̅is impior multitudo de signat͛ eo quod ip̅i deserueru̅t d̅n̅m ⁊ ideo de relicti sunt ab eo. In desertum g̅ mulier missa in uenit͛ q͛ multitudine impior̅ ciuitas diaboli constat· Bestia au̅ iste i͡n sequentib; expo nit͛ diabolum significat· Coccine̅ au̅ colorem

sanguinis h̅r· ⁊ p̅ sanguinem sepe mortem desig natur· Diabolus itaq; sanguineus est· q̅r auctor est mortis om̅ibusq; peccatorib;· Q̅ue bestia plena nominibus blasphemie e̅e dr̅ eo quod ip̅e diabol͛ auctor sit om̅niu̅ blasphemiar̅· Q̅d͡ ͛su̅t au̅ capi ta vii ⁊ cornu̅a· Angelus in sequentib; exponit Et mulier erat circudata p̅pura ꝉ̅c· Purpura ⁊ sanguine tingit͛· Coccus v̅ sanguinis h̅r colore· Si cut vestimenta regalia p̅ que potestas secularis designat͛· Purpura ⁊ ⁊ coccus sanguinis sp̅m̅ h̅r· quia potestas secularis mortifera e̅ ⁊ pͨ iu̅ lum sempiternu̅ affert huic qui eam ampli̅ sp̅m celestem gloriam amplectit͛· Possunt ⁊ p̅ vestimenta sanguinea op̅a impior̅ intellige p̅ quibz morte p̅petua dampnabunt· Q̅d͡ qr se Et inaurata auro p̅ aurum sepe sapia̅ desig nat͛ seculari· P̅ g̅ m̅as ⁊ ⁊ margaritas eloque̅tia sclariꝰ· P̅ poculu̅ aureu̅ doct̅i͞a philosophor̅

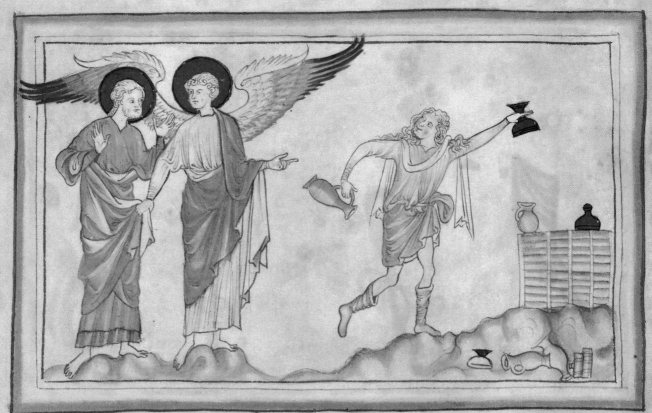

Et uidi mulierem ebriam de
sanguine sanctoz & de sangine
martirum ihu & miratuf sū
cum uidissem illam admira
cione magna. Et dyxiv michi angeluf ob
mirarif? Ego dicam tibi facramentum
mulierif & beftie que portat eam que habet
capita vii· & cornua decem.

Per mulierem babylon defignatur que san
guinem ſtŏꝛ bıberat· z ebria ent idest
ab omni rōne ſpeciali aliena· Ebria erat qa
iftiuo ſanguinif ſtŏꝛ ꞇeṫ eam dampnabileu fe
cerat z a miſericordia dei alienam uꞇ ꝟo eēt
digna quātinuf aliquo modo ſue ſaluti poſſ�ı
conſulere· ꞇ miratuſ ſū cū uidiſſem z ꞇ· cᵹ̄mf
fidelef cum uident reꝓbof cū a timoꝛe dī alieno
uꞇ ſine ulnꝑa trepidatione z uiuentibꝫ plu̅ıa
pſiala ſuꝃ erant ꞇꝺ omnibꝫ flagguuiſ ſemetipſ̄

demergant iuentes dm̅ nullu̅ ꝼꝼꝰ ſpm̅tuu̅
relinquere nifi ſpl̅ penitentia ceriſqꝫ medullul̅ꝫ
quibꝫ peta ſanantur fuerit deletu̅· Et dyxit
michi angꝉꝶ· quare miraruſ? Cuiuſ̄ ſignifica
cōm hr̄ beftia in hr loco quāṁ z ſupꝉ cōfe
dyciü habuiffe. Significat name diabolu̅m
ᷓuo ſincatī capita vii· ꞇ cornua x· ipſe ſe
quentibꝫ exponit· Beftia ꝟo· diaboluf ſiuꝶ an
aduentum xp̄i poffiderꝶ genuſ humanu̅· ſıꞇ
ent modꝰ idest ꝟo poffidet genuſ hmanu̅ ſiṫut
aurea quia ꝑ xp̄m ab electoꝛ̄ cordibꝫ expulſꝰ
eft· Aſcenſura ū eft de abyffo qꝛ temporibꝫ
antꝑxp̄i ſoluetur ſathanaſ de carcere ſuo ꞇ exı
bıt ꞇ ſeducet ᵹᵹ ſıut ſequentia plenıꝰ ma
nıfeftant· ꞇ in ınferıu̅ ıbıt qꝛ cū omnıbꝫ ꝛ
ꝓbıſ quoſ decepıt ꞇ cū omnıbꝫ ſatellıtibꝫ ſuıſ
eterna pena dampnabıtur·

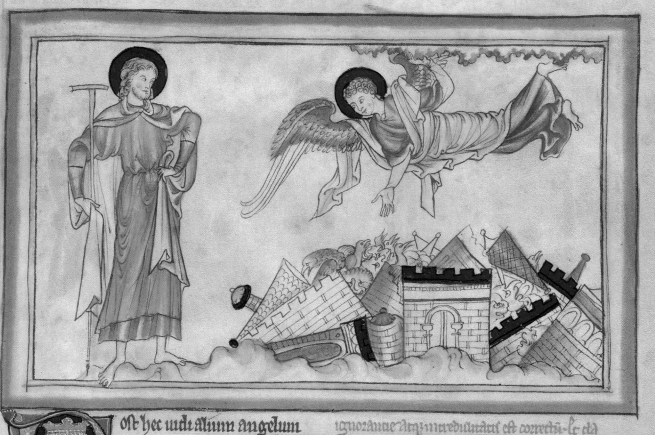

ost hec uidi alium angelum
descendentem de celo h̄ntem
potestatem magnā ⁊ terra il
luminata est a gloria ei̅ ⁊ exclamauit ⁊ for
ti uoce ditens· Cecidit cecidit babilon illa
magna· ⁊ facta est habitacio demonioꝝ ⁊c̄
todia omnis sp̄s imundi ⁊ custodia omniꝰ
uolucris imunde quia de ira fornicatiōis
ei̅ biberunt omnes gs̄ ⁊ reges terre cum illa
fornicati sunt ⁊ mercatores t̅re de uirtute de
litiaꝝ ei̅ diuites facti sunt.

ngelus iste xp̄m significat qui de celo ad
terram descendere dignatus⸱ ut homines ad
celestia sustenaret. Qui potestate magnā h̄e
dr̄ qm̄ eandem potestatē h̄t quam ⁊ p̄r eo q̄d cecidit
sic p̄ ōuia p̄r· t̅ra illuminata ē a gloria ei̅.
q̄r p̄ doctrinam fidei ei̅ gen̄ humanū a tenebis

ignorātie atꝗ incredulitatis est correctū· Et cla
mauit i forti uoce ditens· Vox xp̄i ⁊ doctrina est ellā
gelu. Quid aū h̄ uox clamauit· subdendo mā
nifestat· Cecidit· cecidit babilon magna· Dreis
se dei fecisse est· Dixit enī cecidisse babilonem·
quia ipse fecit ut caderet· Que bis cecidisse dr̄
qp̄ cecidit p̄ino cum p̄ doctrinam ellāgelu inp̄i
niam multitudine electoꝝ amisit qui ab ea p̄
fidem xp̄i precisi ciues st̄e ciuitatis· i· ecc̄e facti
sunt· Cadet secundo tn̄ i ultimo die morte p̄pe
tua que in hoc libro mors secunda uocāt· pimū.
Et facta est habitacio demoniū· Siuiuqꝗ aute ad
uentum xp̄i demones in babilone nō inhabi
tabant· Habitabant quidē s; eoꝝ habitatio
ignorabāt· Cm̄ aū multitudo electoꝝ ad fidē
conuersa ⁊ babilon hitatio demonioꝝ facta est·
q̄r illi qui fidem xp̄i susceperunt q̄d hitacio de
monioꝝ in babilone fuit eoꝝ noūitur·

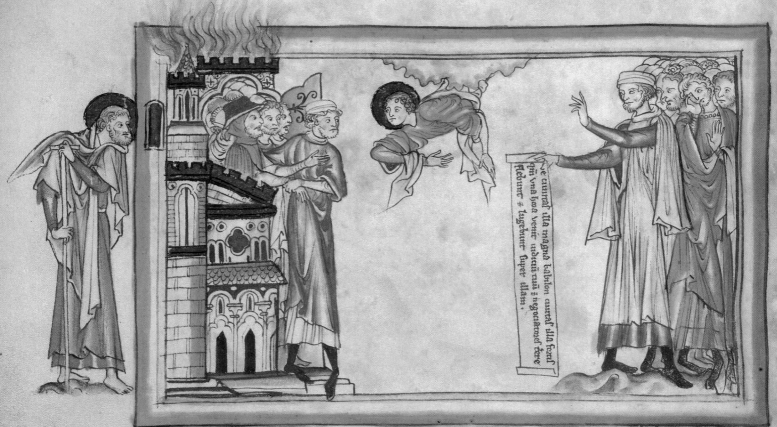

ve ciuitas illa magna babilon ciuitas illa fortis qn una hora uenit iudictum tui z negociatores flebunt z lugebunt super illam.

t audiuit aliam uocem dicentem de celo. Exite de illa populus ms z ne particeps sitis delictoy eius z de plagis eius non accipiatis. qa puenerunt pcca eius usq; ad celum z recordatus est deus iniqtatum eis. Reddi te illi sicut ipa reddidit uob z duplicate duplicia secundum opa eis. In poculo quo miscuit miscite illi duplum. Quantu glo rificauit se in delicus suis tantum illi da te tormentum z luctum. quia in corde suo dicit sedeo regina z uidua no sum z luc tum no uidebo. Ideo in una die uenient plage eis mors z luctus z fames z igni com buretur eam. quia fortis est deus qui iudicauit illam z flebunt z plangent se sup illam re ges terre qui cum illa fornicati sunt z in de licus uixerunt. Cum uiderint fumum incen

du eius longe stantes pp timorem torme torum eius dicentes. ve ciuitas illa magna vabilon ciuitas illa fortis qn una hora uenit iudicium tui z negotiatores flebut z lugebunt sup illam qn mercedes eoy ne mo emet amplius.

Per celum in hoc loco ecca designat uox de ce lo uox est predicatoy de ecca precedens. Sed ho diuit uox illa. Exite de illa apple ms. Domin z predicatores suader electis suis ut exeant a babi lone non corpore set mente. Quemadmodu a u ia bilone exire debeant in sequentibus docet dicens Et ne particeps sitis delictoy eius. Illi enim a vabilone conuenient exierunt qui a malis op ibus eis se alienos reddunt sicut psalmista dicit de semetipso loquitur dicens. No sedi in cocilio uanitatis z cum iniq gerentibus non introi et de plagis eius no accipiatis.

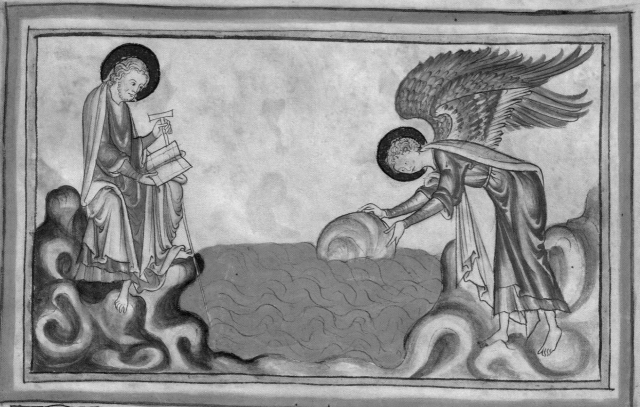

Et sustulit unus angelus fortis
lapidem quasi molarem mag
num z misit in mare dicens.
Hoc impetu mittetur babilon magna il
la ciuitas z ultra iam non inuenietr. z uox
cytharedoz z musicoz z tibia canentium
z tuba non audietr in ea ampli2z uox mole
ñ audietr in ea ampli2z lux lucerne non
lucebit ibi ampli2z uox sponsi z sponse
non audietur adhuc in te qz nicatores
tui erant principes tre qz in uenefitiis
tuis errauerunt oms gs z in ea sangis
pphaz z stoz inuentus est z omniu qui in
fecti sunt in terra.

Iste angelus xpm significat. Qui fortis ee dr
quia fortitudinem xpi quanta sit humana
mens comprehendere non potest. Per lapidem il
molarem significatr omnis multitudo

impioz designatur. mare aut infinium desig
nat in quo oms impiu demergentr. Angls z la
pidem molarem in mare misit qz dominus nr ihs
xps in die iudicii omnium impioz multitudinem
suo iusto iudicio z infernum demerget. Et uox cyt
haredoz z c. Querendum nobz cur artes z uoce mole
z lumen lucerne z uicem sponsi z sponse. mr sce
lera babilonis computet cum ista omnia sine
culpa exercere possint z sine istis humana ui
ta subsistere non possit. Spualit itaqz omnia ista
intelligenda sz. Possum9 gz p artes sapiam hui9
seculi que stultitia; apud dm intellige. Oz in
artifices malignz z filii babilonis ad hoc du
tunt ut in malitia babilonis possit psistere. Sa
pientes aut sunt ut faciant mala bene aut fa
cere nescierunt. Mola aut quicquid sub se atte
petro conterit z minuit. Possumus gz per
molam iudices impios atripere

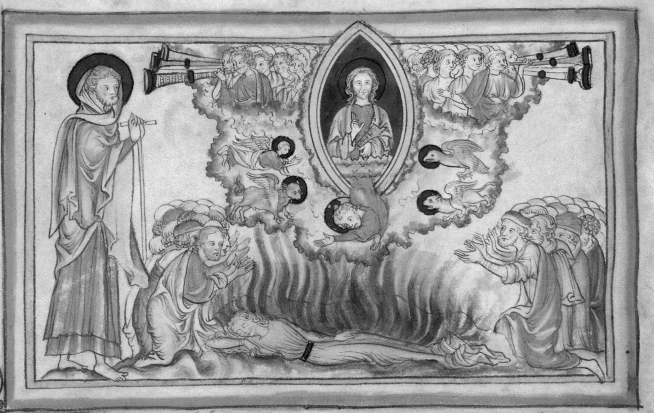

P ost hec audiui quasi uocem
magnam tubax multaꝛ in
celo dicentiu Alla. Laus ⁊ uir
tus ⁊ gloria deo nostro quia
uera ⁊ iusta iudicia eꝯ sunt qui iudicauit
de meretrice magna que corrupit terram
in ꝓstitutione sua ⁊ uindicauit sanguinẽ
seruoꝛ suoꝛ de manib⁊ eꝯ. Et iterum dixerūt
alla. Et fumus ascendit eꝯ in secula secu
loꝛ. Et ceciderūt seniores uiginti iiii ⁊
iiii animalia. Et adorauerūt dm̄ sede
tem sup thronum dicentes am̄ Alla. Et
uox de throno exiuit dicens. Laudem di
cite dō nro omnes serui eꝯ ⁊ qui timetis
eum pusilli ⁊ magni

A septem uocib⁊ quinquies alla decanta
tur. Primo ⁊ secundo a uoce tubaꝛ mul
taꝛ. tercio a xxiiii seniorib⁊ ⁊ a iiii aialib⁊

quarto a uoce que de throno exiit nō ꝑ a se
sed et̄ inꝑꝑetatio decantata est ioꝛ laudem
dicite dō nro omniꝛ sti eꝯ. Alla quippe laudate
dominū sonat. Quinto ū a trib⁊ uocib⁊ semel
decantata; v et̄ uoce tube magne ⁊ a uoce aꝗ
multaꝛ ⁊ a uoce tonitruū magnoꝛ. Septimū
huiꝰ libri sepe demonstrat om̄ electoꝛ multi
tudinẽ i septem ꝑtes eō diuidenda si eꝯ intel
ligentia subtiliuꝰ ꝑstruxeꝛ. Iusti uerꝯ ꝗ ante
diluuiū fuerūt ad prima ꝑte illi qui post di
luuiū usꝗ lex data; ad secundā ꝑtinent
sic sepe iam demonstrauim. Q tribat ꝗ multaꝛ
electa qui ante diluuiū fuerūt ⁊ qui p̄ dilu
uiū usꝗ ad illud tp̄r quo lex data est designant.
Vocē emiserūt qꝛ p predicatōnis sue doctr̄a
quoscūmꝗ potuerūt a suis errorib⁊ reuo
cauerūt. Alla decantauerūt quiaꝗ bo
na opa deo place⁊ struxeꝛ.

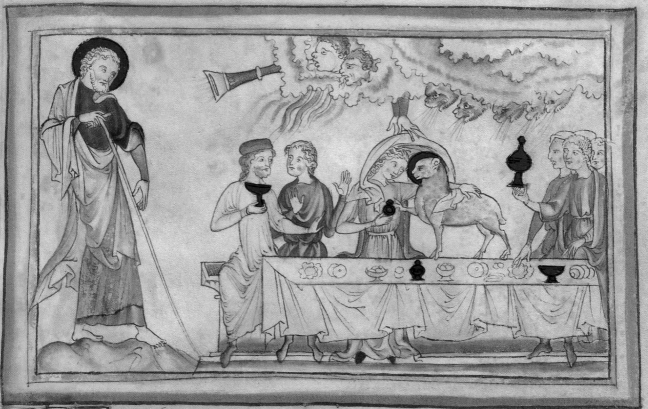

E audiui uocem quasi tube
magne 7 sicut uocem aquar
multar 7 stm uocm tonirum mag
nor dicentiu alta. qm regnauit do
nir omnipt. Gaudeamus 7 exultemus 7 de
mus glortam et quia uenerint nuptie
agnt 7 uxor eius sparauit se 7 datum est
ut cooperiat se bissinum splendens can
didum Bissinum enm iustificationes
sanctor sunt

luba magna xpm significat. uox tube sz
ortatio est euuangeln. p uocem au aqar
multar multitudo gentiu xpm ostententiu
designat. p uocem ii tonitriu magnor elect q
ufine mudi nascituri sunt intelligimur. te
ure p tonitrua qua troiem. dietrt iudicii au
ctiabunt. tres q uoces semel alla decantauert
quia fidem ste trinitatis doctrinamq euange

lii que a magna tuba id; a xpo pcesst suaue
runt 7 snabunt ustp in finem. Due g pntes
sz prima 7 secunda ad legem qua naturalem
se durmi pnnet. Due que setuur i tertia 7 tsira
ad legem que p moysen dicta est tres ii que rel
cant. r quinta 7 serta 7 septima ad legem euan
gelii ut imbuent eos in fide ste trinitatis ustp
ad fine mundi pinauere debere. Quid aut
iste tres ptes decantent audham. Alla. Oth reg
nauit dns ds nr omnipz. sz laudem dom. id;
eo q destructo regno diaboli pditoris nr ipz
in nob regnare dignat qui est dominus 7 sal
nator noster. Gaudeamus 7 exultemus 7 de
mus glortam et quia uenerint nuptie agni
7 uxor ei sparauit se. ideo gaudeamus ideo
exultemus eo quod misericordia conditoris
nri ecctam suam que sumt uox ista sibr cun
gere sit dignatus est ut sponsa or angrtur
sponso suo quatinus sumt cu ipso una d cato.

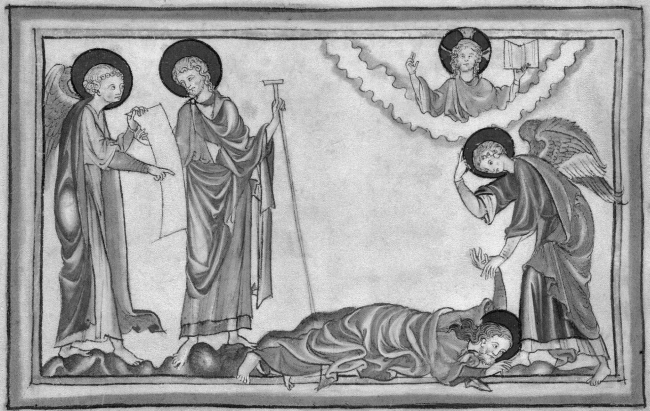

Et dicit michi scribe. Beati q̃
ad cenam nuptiaꝝ agni uo
cati sunt. Et dicit michi. Hec
uerba uera dei sunt. Et cecidi
ante pedes ei ut adorarem eum. Et dicit m̃
vide ne feceris. Conseruul tuuſ sum ⁊ fra
trum tuoꝝ habenciũ testim oniũ ihu. Deũ
adora. Testimoniũ ihu est spirituſ ꝓphie

Sperandum electoꝝ nunc est qui in eccã
baptiʒ; eiuſ nupciur prſeuiꝰ. Cena u̾
eoꝝ tunc erit qui post resurreccõm i celeſti be
atitudine cẽna gloria ꝑfruent̾ Et quia hu
iuſmō q̃ uitt̾ agitur ⁊ bonos ⁊ malos recipi
et siō onıſ uıſ sunt qui i eo uident̾ trẽuıſse
Illi aũ soli beati sunt qui in illa cena que p̃
fine mũdi futura est recipient̾ Et dyeit m̃
bet ũba uera dei sunt. Sedempao sanguiſ

xp̃i hoc fidelib; contulit ut filii dı ſociicq̃ an
geloꝝ efficerentur. Ideoꝗ̃ ꝓmeruit anglſ ado
rari ab homine: qui sup se adorabat t̃dum dñı
Quaꝗ̃ conferuuſ se iohannıſ eciōꝝ uocat
fidelium . Testimoniũ et ihu est sp̃e ꝓphie. Pa
treſ ueuſ teſtamenti qui aduentum xp̃i paſ
sione ⁊ resurreccõnem ei ꝓdyẽunt spm
ꝓphie habuiſſe certiſſimũ est. Sõı ⁊ ꝓphe uo
cantur. Cuiunꝗ̃ ſ testimciũ ⁊ plithet:
spm ꝓphie habet.

t uidi celum apertum ⁊ ecce eq́
albus ⁊ qui sedebat sup eum
uocabatur fidelis ⁊ uerax. ⁊ cũ
iusticia iudicat ⁊ pugnat. Oc-
culi eꝰ sicut flamma ignis ⁊ in capite eius
diademata multa habens nomen scriptũ
q̃d nemo nouit nisi ipe ⁊ uestitus erat ues-
tem aspsam sanguine ⁊ uocabatur nomē
eius uibum dei ⁊ exercitus qui sunt in celo seq-
uantur eũ in equis albis uestiti bissino Al-
bo mundo ⁊ de ore eꝰ procedit gladius Acutꝰ
ut in ipso percutiat gẽs ⁊ ipe reget eas in uir-
ga ferrea ⁊ ipe calcat torcular uini furou-
re dei omnipotentis ⁊ habet in uestimēto
⁊ in femore. rex regum ⁊ dominꝰ dominanciũ

N ullo modo estimare debem̄ q̃d h̃c capłm
ad aduentum xp̃i pueat in s̄ do tũ

dituã uentur ꝗt sȝ pocuis ad electos qui ĩ fine
mundi uastur̃ sk̃ fine ⁊ tt mundi istante ue-
met dñs in sc̃is suis ut pugnet p ipis q̃ adũpꝑ
⁊ ministerio eˢ ⁊ qual̃ à sc̃is uł p̃dicabile uer
⁊ bonia eˢ in h̃ loco describitur. Iam p celũ
ecc̃a designat̃ ⁊ equũ album homo q̃ sũuꝰ
dr̃ assumpsit sup que ⁊ sedisse uisuꝝ ⁊. q̃ ⁊ fidel̃
⁊ uerax est. hec duo nomina cor fidel̃ ⁊ uerax
unũ sensum habet ĩ h̃c loco Pecte fit uis dr̃
fidelis uerax de q̃ dicit psałmista. Fidelis dñ̃s
⁊ omnib; uerbis suis ⁊ sc̃s ĩ omnib; opib; suis ue-
racem se ipm ĩ euangelio uerar dicens. Ego
sum uia uerit̃ ⁊ uita. Et iusticia iudicat ⁊
pugnat. Sicut armis dñ in die iudicii cor-
ruptios dimicatur; sȝ sĩ dei iusticia expug-
nabim̃ ⁊ conterem̃. Omnia u̇ pesł im
p̃op asꝑis scelera i cospectu eor adducet de-
ur suam se iudicissimo dñ iudicio ee dãpna-
tos p̃ aceos dñs sub sc̃s designatur. ꝗ diadema-
ta multa nistitudo fr̃ori exhinuim̃.

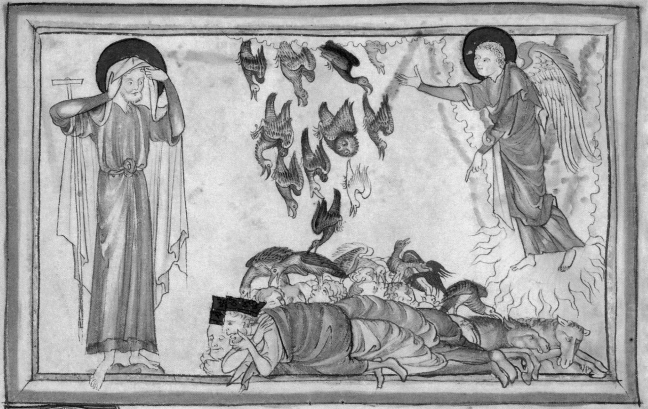

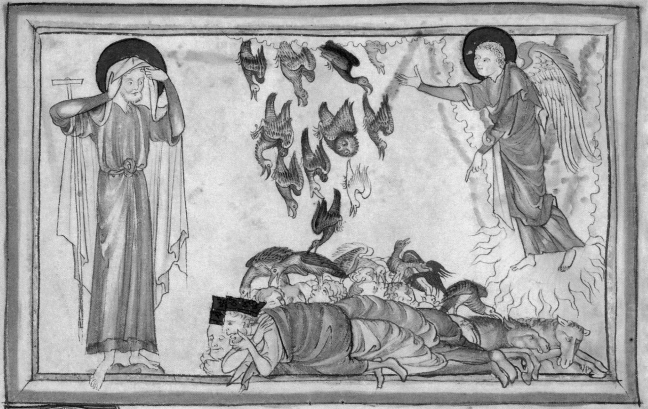 Et uidit unum angelum stantem in sole z clamauit uoce magna dicens omnibз auibз que uolabant p medium celum. Venite congregamini ad cenam magnam dei ut manducetis carnes regum z carnes tribunoτ

Per angelum predicatores qui in fine mundi futuri sunt significat. Qui z p equites paulo supi designati sunt. p solem si xpm intelligi debeꝰ Angeloꝵ cũ in sole stetit q̃ p̃dicatores sc̃i in xpo tr̃ solidabunt ut ab ei amore nulla in psecucione auelli possunt. p aues aũ fideles omis qui eo tempe futuri sũt designant. p celum uolare quia in terris positi mente i celestibз habitare possunt. nichominꝰ p celum terram intelligi. p celum sc̃m uolant qꝝ duas alas hr̃res tor duo p̃cepta caritatis seruare z⁊ uolant quibꝝdam

nitatem impendendo q̃sdam ab iniquitatibз reuocando. Venite congregamini ad cenam magnam dñi omnipotetis ut manducetis carnes regum z carnes tribunoτ z carnes fortium z carnes equoτ z sedentium in ipsis z carnes liberoτ z seruoτ z pusilloτ z magnoτ. Qui designant p reges z p principes liberos z seruos ceterosqⁱ ipsaqⁱ p equos corpa ascensores principes scilicet terre ac populi qui eis subiecerunt. Cenam i uero quid aliud est nisi examinacio impioτ carnes aũ impioτ uiste manducabut cũ immunditiam ex malis que eis intulerunt recipient. Et quia uisi iudentes penas impioτ z bonis op̃tebit p̃uenire dicit scilicet nisi. Letabitur iustus cũ uideⁱt uindictam impioτ manus suas lauabit i sanguine p̃catoris.

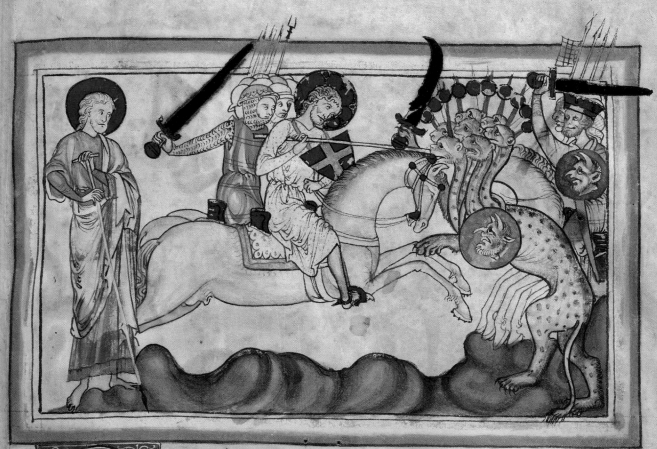

t uidit bestiam 7 reges
terre 7 exertitus eor
congregatos ad faci
endum prelium cum
illo qui sedebat in

equo 7 cum exercitu eius.

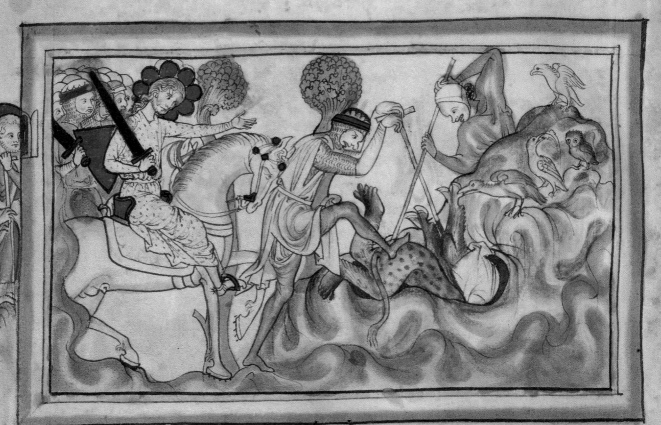

t apprehensa est bestia
z cum illa pseudo p
pheta qui fecit signa
coram ipo quibz sed
uxit eos qui accepe
runt characterem bestie qui z adoraint
ymaginem eius uiui missi sunt hui
duo in stagnum ignis ardentis sul
phure z ceteri occisi sunt in gladio
sedentis sup equum qui pcedit de ore
ipsius z omnes aues saturate sunt
carnibz eor.

preedet bestia z pseudo pphetam eus
quia illud implebit qo dicit aple pauls
olaie ons ipm interfiet spu ons sui z destruet
illustrate aduentus sui. Si enim spu ons ons
uirificiabiz, qui qz pseudo oppha est in stag
niu missi sunt. eos qd uistoz z est uioz un
pior. Isti uo uiegie morte neciat uitalu un
pior. Similite z impst uitam uioz motis est
manit sunt in iuditio daxuet sliz. hui suzquis
aliusq habunt z deristi z z creatuidine speri
illos uisensani uiteh illoz estuia phi isiaulz z
uisem illoz siue uoues uisleit tuz g z pseudo
ppha est uin uoisse osl uz z stagnu ignis to z
malitia sua uiuu in ea uideliz ois lute uio
psenerantes. Gueo uiu dituz gz ceti ociusi suz
z gladio sedeuis sup equu uiterseteum uium
ostisione postuz. stam set quoz dechna pt
gladiu eius comu desiguatuz. un isto xpo
diuerso uisustubunt z fidelibz eo qd boiuine
impissimu atqz omibz homuibz deteriou
Antipu imou ale deumq existuaueriut
qui constabit pessina morte perptuus. Ac
rili osundeguz z chabesceut in uniputibz
suis.